JOHNSTOWN
PENNSYLVANIA

JOHNSTOWN PENNSYLVANIA

A HISTORY
PART ONE
1895–1936

RANDY WHITTLE

Charleston — London

History
PRESS

Published by The History Press
18 Percy Street
Charleston, SC 29403
866.223.5778
www.historypress.net

Front cover image: The Penn Traffic building during World War One.
Back cover image: New traffic signal at Franklin and Vine. This traffic signal, the second in Johnstown, was installed on April 17, 1925. The trolley is destined for Jerome in Somerset County. The brick building is Dan Shields's then-new Capitol Building.

First published 2005

Manufactured in the United Kingdom

ISBN 1.59629.051.X

Library of Congress Cataloging-in-Publication Data

Whittle, Randy G.
 Johnstown, Pennsylvania: a history / Randy G. Whittle Jr.
 v. cm.
 Contents: Pt. 1. 1890-1936
 ISBN 1-59629-051-X (alk. paper)
 1. Johnstown (Pa.)--History. I. Title.
 F159.J7W48 2005
 974.8'95--dc22

2005023094

CONTENTS

PREFACE AND
ACKNOWLEDGEMENTS

Almost every community has monuments, markers and plaques that call attention to important persons, landmarks and significant events from its past. Though important mementos of local heritage, such memorials often fade in importance as time moves on and the general public becomes oblivious to them.

Few communities have good and complete histories that document and interpret their past. Given that a locality's past has shaped its present and will continue to fashion its future, such omissions are unfortunate.

Thanks to the late Dr. Nathan Daniel Shappee (1903–1966), a faculty member in history at the University of Pittsburgh at Johnstown from 1930 until 1942 and again briefly in 1945–46, the Johnstown community was given a first-rate work: "A History of Johnstown and the Great Flood of 1889: A Study of Disaster and Rehabilitation." Dr. Shappee developed his study, a doctoral dissertation, between 1936 and 1940.

There has been a spate of works describing the Johnstown Flood of 1889, the most notable version being David McCullough's first published book, *The Johnstown Flood* (1968). McCullough's work also provides a brief overview of early Johnstown, leading up to the 1889 tragedy.

The present work begins where these earlier histories end, after the city has been reconstructed and has returned to some semblance of normalcy following the disaster of 1889. It seeks to describe the key events and issues that the community's institutions and many of its leading personalities have wrestled with from the mid-1890s until the recovery following the Johnstown Flood of 1977. Volume one begins in the mid-1890s and continues through the Saint Patrick's Day Flood crisis of 1936. Volume two opens with the steel strike of 1937 and ends after the flood of 1977.

In addition to a community history, this narrative presents many topical histories through the same timeframe—the Johnstown city government, the local school system, the chamber of commerce and other civic groups, the steel corporations and other leading businesses, political parties, the floods of 1936 and 1977, the major steel strikes (1919 and 1937), Prohibition and countless other matters.

Persons who have helped me in this undertaking are so numerous that mentioning anyone does an injustice to the many others I would negligently omit. Complete coverage would go on for pages. The able staffs and volunteers at the Glosser Memorial Library in Johnstown and the Johnstown Area Heritage Association have been invaluable. More than once I have sought the wisdom of my college mentor, Dr. William A. Jenks, a professor emeritus of history at Washington and Lee University. I am also grateful to my wife, Lucie, and other family members who have both aided and put up with me during the enjoyable time I have been working on this book.

Garlic and Sapphires in the Mud

Johnstown at the Beginning of the Twentieth Century

I. Cambria Steel Stays Put

Cyrus Elder, arguably the wisest man in Johnstown, delivered the keynote address at the centennial commemoration on October 5, 1900. He described economic trends affecting "not only the location of new industries but the removal of the old." He discussed the importance of location to the city's steel industry, which had been "intensified by the recent revolution…of trusts, new concerns with vast aggregations and consolidations of manufacturing plants, free from local influences, and having as one of their purposes the operation only of the most favorably situated works."

Elder, solicitor for the Cambria Steel Company, discussed Johnstown's recent encounter with the unthinkable—an effort to move his client's facilities to a site on Lake Erie:

> *The Cambria Company, having made provision for a large increase in capital… was confronted with the question, should this go forward at Johnstown or in some more favorable locality? The judgment of the business men who had pronounced against Johnstown and in favor of Lake Erie could not be ignored. There were strong inducements to remove, among which was the offer of a site…free of cost.*

The theme of Elder's speech was that Johnstown had come into being because of its environment, broad geographical factors. Conditions, however, were changing perhaps ominously. The community must anticipate and address a continuum of challenges.

The Community around 1900—An Overview

Johnstown had begun as a frontier village. With the coming of the Allegheny Portage Canal in 1830, it became a small bustling town. Thanks to local iron ore, coal, rail transportation

and a growing need for iron products in the developing Midwest and West, the Cambria Iron Company was formed in 1852. Its remarkable success made Johnstown into a city.

On Memorial Day 1889, a dam near South Fork broke during a sustained intense rainstorm. Much of Johnstown was destroyed and 2,209 people were killed. By 1900, the Johnstown Flood was a nightmarish memory. The community had rebuilt itself. The economy and population were growing rapidly. Among all America's steel-producing communities, Johnstown ranked third in tonnage output and steelworker employment.

The Cambria Iron Company

As in many one-company towns during the mid- to late-nineteenth century, the Cambria Iron Company had assumed a position of paternal indispensability and leadership in Johnstown. When something was needed, Cambria Iron or its officials caused it to happen or to come into being.

The company directly or through its officers owned large holdings of stock in the leading local corporations. Cambria Iron had also acquired vast acreages of land and mineral rights throughout the Johnstown area that were often used to promote and locate community projects. The company employed about 16,500 in Cambria County alone. Company officials served on civic boards. Cambria Iron contributed to many worthwhile causes, one being the operation of the local library, and provided leadership in other ways.

After the flood of 1889, Cambria began refocusing its corporate resources into producing and marketing steel. Nonessential operations were discontinued or spun off. Cambria's wool and flour mills, destroyed when the 1889 waters surged through Woodvale, were not rebuilt. The company commissary—Wood, Morrell and Company—was reincorporated as the Penn Traffic Company. While its offering stock was acquired by Cambria officials, Johnstown's largest and most complete department store was divorced from Cambria Iron. In May 1899, the company-owned hotel and restaurant—the Capital—was sold to its popular lessee-manager, Peter Carpenter.[1]

Through its benevolent association, Cambria Iron continued to own and operate a hospital on Prospect Hill, but the post-flood, community-created Conemaugh Valley Memorial Hospital provided an opportunity to limit the use of the outgrown facility to its own employees and their dependents.

Cambria went on producing coal and metallic ores from its vast holdings. It leased, sold and continued building homes for its workers. Westmont, an upscale company residential development on a plateau upwind of the smokestacks, was connected to the city in 1891 by a funicular constructed, owned and operated by a subsidiary, the Johnstown Incline Plane Company, which had a five-member board who were all Cambria company officials.

The Gambit

Cambria Iron leaders were aware of the worldwide changes sweeping their industry. Steel was being used in buildings; in bridges of all sizes; in ocean-going vessels, whether men-of-war, luxury liners or merchant ships. Railroads were rebuilding and doubling many of their tracks

and were adding sidings and marshalling yards. Railroad rolling stock used in hauling coal, stone and ores was beginning to be made from steel and the results were promising.

With speculation ongoing in steel company stocks, Cambria Iron seized the opportunity to reorganize and to recapitalize to generate needed funds for its own capital financing. On August 20, 1898, a proposal to create the "Cambria Steel Company" was announced. It would "lease" Cambria Iron for $320,000 per year—a 4 percent return on Cambria Iron's capitalization of $8,000,000. Every Cambria shareholder would be given the opportunity to purchase three shares of Cambria Steel for each share of Cambria Iron he or she owned. The plan would generate the capital needed for modernization and expansion without affecting ownership of the company. Cambria shareholders could acquire the new shares by installment buying.[2]

The original proposal underwent slight modification. Cambria Steel's capitalization was being set at $16,000,000, to be realized from each shareholder of Cambria Iron being able to purchase two (instead of three) shares of Cambria Steel at $50 apiece for each share of Cambria Iron held. As a sweetener, if all went well, a 6 percent stock dividend would be declared.[3]

Courtships and Matchmakers

Prior to the 1890s, the production facilities of American steel companies were located in and around some single community. Although the Sherman Antitrust Act had become law in 1890, major transformations were underway nurturing larger corporate conglomerations called "trusts."

In 1898, J.P. Morgan began forming a major steel industry combination through the creation of Federal Steel, a holding company.[4]

In the late spring and summer of 1898, amidst the very creation of Cambria Steel Company, speculative rumor-type articles began appearing in iron and steel trade publications and in the Johnstown press describing steel industry changes emanating from investment bankers. The following is typical:

> Reports have been current in financial circles lately concerning a large consolidation of steel interests, the advance in the stock of the Illinois and Cambria Companies being coupled with the project…it is a fact that negotiations looking to a great consolidation have been resumed lately after having been in abeyance.[5]

On June 26, the *Pittsburgh Dispatch* stated:

> From Chicago comes the old, old story of a gigantic iron and steel combine which will include the Pennsylvania Iron Company, Cambria Iron Company, Bethlehem Iron Company, Illinois Steel Company, Colorado Fuel and Iron Company, and the Carnegie Steel Company. The combined capital of these concerns is nearly $100,000,000. The story has been denied.

On August 29, the *Philadelphia Telegraph* stated that Pennsylvania Iron and Cambria Iron would be united.[6]

The next day, the creation of Federal Steel was announced, a new holding company capitalized at $200,000,000. It would acquire Minnesota Iron, Illinois Steel, the Elgin Joliet and Eastern Railroad Company, and Lorain Steel. Lorain had plants both at Lorain, Ohio, and Johnstown, Pennsylvania.[7]

A *Johnstown Daily Tribune* editorial on that same day noted that Cambria Iron's stock price had risen rapidly. "The stock touched fifty-eight," the newspaper reported. "Officials of the company say they know nothing about such a deal [with Federal Steel]." The editorial concluded that informed opinion assumed Cambria "will be taken into the combination made by the merger of the Illinois Steel Company and the Minnesota Iron Company."[8]

Cambria officials' most public comment was a closely watched silence. Andrew Carnegie stated privately, "I think Federal the greatest concern the world ever saw for manufacturing stock certificates. But they will fail sadly in steel."[9]

The year 1899 brought no end to the rumors and press accounts that Cambria was to be acquired, if not by Federal Steel, by something similar. On May 1, 1899, the *Johnstown Tribune* featured these headlines:

> *GREAT STEEL COMBINE—ALL THE BIG CONCERNS OF THE COUNTRY WILL UNITE—CAPITAL BETWEEN $700,000,000 AND $800,000,000. DETAILS NOT YET COMPLETED. JOHN W. GATES, NOW IN NEW YORK, CONFIRMS THE STORY.*[10]

There was a simple sentence at the end of the article:

> *The Carnegies* [Andrew and his brother, Thomas] *make it a rule to refrain from commenting officially on such reports, and will make no exception in this instance.*

Again on May 6, 1899, the *Johnstown Daily Tribune* offered a front-page news item with the tell-all headline:

> *CAMBRIA IS IN THE DEAL. RUMORED STEEL COMBINATION TO OPPOSE THE FRICK TRUST.—BETHLEHEM AND PENNSYLVANIA STEEL COMPANY INCLUDED: FIVE CONCERNS IN ALL.*

Buried at the end of the article was a simple statement: "Mr. Powell Stackhouse, president of the Cambria Steel Company, refused to either deny or affirm."

A clue as to what basic policy was guiding Powell Stackhouse and other Cambria Steel officers is best gleaned by reexamining the centennial speech given by the company's solicitor, Cyrus Elder, seventeen months later.[11] Trusts were seen as:

> *new concerns with vast aggregations and consolidations of manufacturing plants, free from local influences, and having as one of their purposes the operation only of the most favorably situated works.*

Cambria's officials undoubtedly sensed their company's possible subsumption within Federal Steel or another holding company like it—other officials calling the shots, capital expansion in locations other than Johnstown and their own plants and jobs being phased out. In response, Cambria did all it could to remain independent. No corporate official uttered a statement of encouragement about Cambria's being acquired by Federal Steel or a similar trust. Every significant action seemed to have been geared to Cambria's remaining intact and alone. Indeed, Cambria Steel did remain completely independent from other steel concerns for the next eighteen years.

Staying Put

The Cambria management and directors had to contend with another late-1890s issue—the question of phasing out its Johnstown works and expanding on Lake Erie.[12] In late April 1899, the *Pittsburgh Dispatch* described a large steel furnace—"the largest ever built in the United States"—planned for Johnstown. The article continued:

> *Johnstown people will hardly realize just how near the city came to losing the prospective plants. When the matter was first seriously considered the intention was to locate the new furnaces somewhere on the lakes, and this would probably have been done had not influential Johnstown people secured from the Pennsylvania Railroad Company a concession on freight rates which enables the Cambria Company to compete with the large mills in the vicinity of Pittsburgh.*[13]

One can weigh the probable considerations: Local iron ore had been functionally depleted for two decades. Cambria's Johnstown sites were hemmed in and followed lengthy stream valleys subject to flooding. Steel had to be moved around inordinately as it underwent finishing. Industrial water was inadequate and subject to dry-spell depletion. The population center of the nation was moving steadily westward and steel mills at Pittsburgh, in Illinois or in Ohio would be closer to growing markets than Cambria's Johnstown works.

Cambria's leaders also knew the company had a competent, non-union workforce and good management in place. Cambria could always get its way in municipal and civic matters. Quality local coal was abundant. Rail service from the Pennsylvania Railroad Company (PRR) and the Baltimore & Ohio Railroad (B&O) was outstanding.

Putting it all together, no analysis could have foretold the implications or have calculated the true costs, unforeseen problems and benefits that might have been generated by such a major change. Cambria's officials doubtless remembered the fate of the Johnson Company (later Lorain Steel), which had made a major expansion on Lake Erie. The company had gotten overextended and suffered a "time of troubles."

The way to avoid Federal Steel gravitation, they decided, was to stay put in Johnstown, and use the speculative fever in steel stocks to generate major capital funding. The plan had to be handled deftly so as not to risk losing control of the company to new faces who might have been puppets of Morgan, Gates or even Carnegie. A first-class expansion and state-of-the-art modernization would be undertaken, enabling the company to compete head-to-head with any trust. Such was Cambria's strategy. Bold and clever, it also worked.[14]

II. NATURAL AND CULTURAL GEOGRAPHY

When Cyrus Elder had spoken of environment influencing Johnstown and its economy, the October 1900 audience understood him: Johnstown is situated at the confluence of the Little Conemaugh and the Stony Creek Rivers, draining mountain-ringed basins totaling 657 square miles. They meet at "the Point" to form the Conemaugh, a larger river that flows north through the Conemaugh Gap, an impressive gorge several miles long. All around Johnstown and throughout its drainage basins, one finds steep topography.

The Railroads

The main line of the Pennsylvania Railroad connected Johnstown to the outside world—Philadelphia to the east and Pittsburgh and beyond to the west. There was also the single-track Rockwood Line of the Somerset and Cambria Railroad, owned by the B&O, now Chessie-CSX, which snakes its way south generally through stream valleys. The Rockwood Line provided passenger and freight service from Johnstown through coal-rich Somerset County into Maryland where other tracks led east to Baltimore and west into Ohio.

The PRR had made possible the development of Johnstown's steel and related industries. The railroads afforded the only sensible pre-automobile travel to locations away from the city. Even Ebensburg, the county seat eighteen miles away, took about three risky hours each way in a conventional buggy. Everyone used the Pennsylvania Railroad to Cresson and changed onto the Cresson and Irvona to Ebensburg. Including the layover, the trip took about two hours each way.

Thanks to the railroads, Johnstowners could get almost anywhere—New York, Philadelphia, Altoona, Harrisburg, Washington, Baltimore, Pittsburgh and points beyond. More local lines provided service to Hooversville, Somerset, Latrobe, Ligonier, Bedford, Cumberland and other communities.

Roads and Turnpikes

Wagons brought farm produce to Johnstown over a network of roads serving farms, rural hamlets, churches, graveyards, and the like. Ultimately this web of roads—most having come into being thanks to years of continued, seemingly natural, usage and the work of farmers who depended on them—fed into the more heavily used roads and turnpikes entering Johnstown.

There was no consistency as to who was responsible for important roads. Some were turnpikes—toll roads—owned and managed by turnpike companies. During the 1900 era in and around Johnstown, the maintenance of these roads was covered by the tolls paid only if the roads were essential to important commercial firms, or were heavily used or newly built. As time passed, some turnpikes became unsustainable. The stagecoach lines serving Johnstown, a dependable source of tolls, had all vanished by 1890. By 1900, many turnpike companies around Johnstown were facing insolvency because of dwindling revenues.

It often happened that users were unable or otherwise refused to pay the required tolls. In addition, many turnpike customers went toll-free thanks to legal precedents that gave free passage to adjacent property owners going from one part of their property to another, persons on foot, anyone hauling the mail, volunteer firemen going to a company meeting or fire, persons going to and from church or attending funerals, those going to militia parades or meetings, and on and on. The concept of tolling was too unpredictable for dependable road maintenance except along turnpikes with high teamster volumes or those vital to one or more businesses willing to pay assessments. As a result, by 1900 many turnpikes around Johnstown had become public roads, and the others would soon follow.

The last turnpike installed near Johnstown was the Indiana and Cramer Pike built by the Johnstown and Cramer Turnpike Company whose engineer was John Fulton. It opened in April 1899 to improve farm produce delivery to Johnstown.[15] In 1920, the Cramer Pike also became a public road, the last local turnpike to do so.

With the exception of the Valley Pike and the Haws and Cramer Pikes (the latter two passing through the Conemaugh Gap on opposite sides of the river), all of the roads entering and leaving Johnstown at the turn of the century were difficult to use due to their steep grades. The main roads leading into the city around 1900 were:

• The Ebensburg Road (today's Old Ebensburg Road) passed at-grade over the PRR tracks near the passenger station and then worked its way up and over Prospect Hill, eventually reaching Ebensburg.

• The Clapboard Run Road connected Franklin Borough's Main Street eastward and south until it joined the Frankstown Road, which, although it continued to Frankstown, also became known as the South Fork Road.

• The Frankstown Road dated back to 1792 and led to Johnstown's Main Street and into downtown (as it does today). One wonders how any horse-drawn conveyance could have negotiated its steep descent into or ascent from the city.

• Bedford Street (Bedford Pike) was the road to Windber and Bedford. After passing through Dale and Walnut Grove, it became a toll road. This turnpike was also quite steep until it reached the crest of the hill in Richland Township.

• Valley Pike began at Franklin Street and the Stony Creek River in the former Grubbtown part of the Eighth Ward, below the then-new Conemaugh Valley Memorial Hospital. It followed the Stony Creek River's left bank through Moxham, Ferndale and Riverside to Benscreek, where it rejoined the continuation of Franklin Street here known as the Upper Valley Pike. In Moxham it was called Central Avenue but there was a tollhouse near the river.

• Franklin Street continued from downtown through Kernville, past the hospital, up Whiskey Springs Hill (above the present Southmont Boulevard intersection) and eventually past Roxbury Park, where it became known as the Somerset and Ligonier Pike. One of the last official acts of the Roxbury Borough Council (before its dissolution due to the borough's annexation into the city) was to open to traffic what was then called Fourth Avenue (today's Roxbury Avenue). The expense was

justified because it permitted horse-drawn vehicles to avoid the steep grade on Whiskey Springs Hill. The work had apparently been done so poorly it had to be redone later.[16]

• Mill Creek Road left Water Street (later a part of Somerset Street, abandoned in 1981) in Kernville then snaked its way up to Westmont and through Upper Yoder Township to the Mill Creek-Benscreek area. This was probably opened to provide an overland route from Johnstown to the second entrance to the Rolling Mill Mine, situated near the Mill Creek Reservoir, which was eliminated in 1980.

Streets and Alleys

Most roadways in 1900-era Johnstown were dirt streets and alleys made more usable by their being graveled from time to time. They were often dusty or muddy depending on the weather.

Streets that had been improved were either macadamized or made with brick or cobblestone. A macadam street consisted of a roadbed several inches deep that was packed using medium-size stones. Small gravel and sand were used to fill the interstitial voids. If correctly done, the macadam was elevated and crowned and the sides of the street were ditched. Properly constructed and maintained, macadam streets held up surprisingly well.

Brick or cobblestone streets at the turn of the century were mostly located downtown or in the roadways bearing trolley tracks. These streets were the easiest for pedestrians to cross, were more mud and dust-free and held up better than other pavement types. Aside from their high cost, the only complaint about brick or stone streets had to do with the problems they caused for horses, especially when icy.

The Iron Street Corridor

The rivers, steep hills and railroad tracks divided the city into discrete sections. Johnstown at the turn of the century was grouped into two major, but separate, parts—a northwest section consisting of Morrellville, Cambria City, Minersville and Coopersdale; and everything else, chiefly downtown, Kernville, Hornerstown, Moxham, Prospect, Woodvale, Old Conemaugh Borough and the Eighth Ward including Roxbury.

Only one good roadway connected these two urban clusters—the narrow band of the city served by Iron Street, a corridor that went from the Walnut Street Bridge-Pennsylvania Railroad Station area, beneath the eastern arches of the Old Stone Bridge, and through the Lower Works. Here one could either cross the Cambria City Bridge (also called First Avenue Bridge) at McConaughy Street, or continue on Iron Street through Minersville into Coopersdale.[17]

The western side of the Conemaugh River from the Point to Cambria City was the site of the Haws Brick Company and the narrow-gauge railroad serving the Rolling Mill Mine. There was no bridge over any river at the Point during the era.[18]

Fords

There were only two spots where the rivers were still forded around 1900—the general location of the Horner Street Bridge between the Eighth Ward and Hornerstown, and the present location of the Riverside Bridge. A place of frequent stream fording by wagons and early automobiles usually marked the site for a future bridge. Stream fording could be treacherous for a horse pulling a conveyance through swift water.

Grade Separation—Rail and Street

During the 1900 era, the railroads, streets and trolleys competed with one another for space. Railroad crossings presented serious hazards and traffic delays. Public officials were constantly trying to get the railroads to provide bridges or underpasses.

One hundred years ago, the PRR mainline tracks were situated the same as today's (Norfolk-Southern) trackage. To avoid flooding and to provide for grade separations from streets, the PRR began systematically elevating its tracks in increments of several inches a year over a twelve-year period that ended around 1915.[19]

Prior to 1915, only two grade separations between rail and street highways existed in Johnstown City—the Old Stone Bridge with Iron Street and a bridge over the PRR in Woodvale east of Third Avenue (modern Cresswood Avenue). There was also a joint pedestrian-vehicle bridge between East Conemaugh and Franklin Boroughs that passed over the PRR and the Conemaugh River east of the city.

Dangerous at-grade crossings along the PRR mainline existed at Fairfield Avenue, Laurel Avenue, the Brownstown Road (Gilbert Street), Delaware Avenue and the Ebensburg Road. Along the B&O, they were at Main, Bedford and Jackson Streets; at Clinton near Washington Street; and at both Valley Pike and Osborne Streets.

The Johnstown Passenger Railway Company

The 1889 flood totally destroyed the horse-drawn, fixed-rail trolley system that had been serving Johnstown for six years. Tom Johnson, president and part owner of the Johnson Company, which manufactured trolley rails and switching equipment, formed a group that acquired the Johnstown Passenger Railway Company franchise and began building and operating a modern electric-trolley system.

By 1901, service to Franklin through Woodvale was ongoing. Trolleys were reaching Cambria City by way of Iron Street and the Lower Works. There was a line to Hornerstown, Moxham and Ferndale. A route served Dale and Walnut Grove by using Bedford Street. Another line terminated with the loop at Roxbury Park, having reached it through Franklin Street and Kernville. A central hub was downtown using Main, Washington, Walnut and Market Streets. The trolley barn for maintenance and storage was in Moxham at Central Avenue and Bond Streets. A steam-electric power plant had been installed on Baumer Street near the edge of downtown. By 1907, the Johnstown Passenger Railway Company had thirty-one miles of line and operated 110 trolley cars.[20]

The Population

At the beginning of the twentieth century, Johnstown was undergoing a growth spurt that had started in the 1880s, which would continue in the city proper until the 1920s. The city population, 21,805 in 1890, grew to 35,936 by 1900. Taken together, these figures are deceiving because the areas of Morrellville and Coopersdale, totaling 4,876 persons in 1900, were both added to Johnstown proper in time for the 1900 census. Even had these annexations not taken place, the population within the 1890 city boundaries would have reached 31,060 in 1900, a growth of 46 percent. Roxbury Borough, with a population of 808 in 1900, was annexed in September 1901.

Outside Johnstown, the boroughs and townships adjacent and near the city were also growing.

Locality	1890	1900
Conemaugh Township including Daisytown	764	1,213
East Conemaugh Borough	1,158	2,175
Franklin Borough	662	961
East Taylor Township	845	698
Richard Township	920	1,378
Westmont Borough	nil	

Cambria County as a whole grew from 66,375 in 1890, to 104,837 in 1900, and to more than 166,000 by 1910.

While the 1900 census did not tabulate age-group breakdowns, the community was a young one. According to the Johnstown Board of Health, there had been 903 births and 586 deaths in the city in 1889, a natural increase of 317 in one year.[21]

III. THE JOHNSTOWN ECONOMY

In an open letter to the community dated March 4, 1899, N.F. Thompson, the paid secretary to the Johnstown Board of Trade, a civic betterment and economic development group, stated:

> *Johnstown was recognized at home and abroad as only a Cambria Iron Company town, and her citizens had become educated in the belief that no material progress could be expected save through the direct work of that company...Take the outlook for Johnstown today and compare it with that of three years ago, and some idea may be had of the benefits accrued and to be had from community feeling and community work...This city is on the threshold of a future brighter than any of its most sanguine friends have ever dreamed.*

The Johnstown Board of Trade was a precursor organization to the Johnstown Chamber of Commerce, founded in 1910. The board of trade was created in March 1888 with about 150 members. It sought to promote the city, attract industry, generate new business enterprises by helping to raise capital privately, lobby for pro-business local government policies and similar matters. T. Coleman Du Pont was its 1899 chairman. Its members were upper-class Johnstown leaders, including a number of merchants. Thompson's insight that the organization's true purpose was to wean the civic and economic community from an outmoded dependency on the Cambria Iron Company probably reflects the viewpoint of the more astute Johnstowners such as T.C. Du Pont. The Johnstown Board of Trade seemingly vanished from Johnstown after Du Pont left in 1899.

N.F. Thompson was a Confederate veteran of the Civil War, having fought with Nathan Bedford Forrest. In April 1899, Thompson sued the *Daily Tribune*'s editor-publisher, George T. Swank (a Northern veteran of the Civil War), for libel. Soon thereafter, he left Johnstown to head the Huntsville, Alabama, Chamber of Commerce. He returned briefly to Johnstown in 1902 and helped to create the Johnstown Real Estate Company, a concern that specialized in industrial real estate.[22]

The Rose Blooms

The steel companies, the coal industry and several other manufacturers were the engines that drove the 1900-era Johnstown economy. Rails produced in Johnstown were being installed throughout the United States, and had even been used with Russia's Trans-Siberian Railroad.[23] Pre–Great War trolley systems in London, England, and St. Petersburg, Russia, had also made use of Johnstown-made components.

Johnstown's turn-of-the-century economy was a very locally owned, self-contained and interwoven system of enterprises characterized by much buying and selling within the community itself. Once brought into the economy in exchange for goods produced locally, dollars tended to turn over many times before being exported outside the broader community.

Although Cambria Steel was headquartered in Philadelphia, most of its steel-making operations were centered in and around Johnstown where its mills and other facilities produced rails, axles, steel railroad cars and basic steel products to be shaped into other forms and products by the manufacturing customer.

The steel was made from iron ore dug from Cambria-owned deposits in Michigan and Minnesota and shipped over the Great Lakes in company vessels. The coal used for making coke, done in Cambria coke ovens near Johnstown, came from company mines that were also mostly local. Cambria Steel was developing its own water resources, and extracted the limestone it needed from company quarries.

Cambria's blast furnaces and hearths made use of firebrick, ceramic tuyères, crucibles and other refractory items produced by such Johnstown firms as the A.J. Haws Brick Company, Hiram Swank and Sons Brick Company and the Basic Brick Company. The Haws Brick Company, situated across the Conemaugh River from Cambria's Lower Works, had gotten underway some forty-five years earlier with capital loans, promises

to purchase and other inducements from the Cambria Iron Company to produce its industrial refractory products then being imported at high cost from Europe. Soon able to produce superior tuyères and other items for half the cost of imports, Haws began selling throughout the United States and Canada. The largest of the Johnstown brick companies, Haws dug from its own nearby clay and quartz pits and mined the coal needed to fire its kilns from nearby company mines.[24]

The other major employer in Johnstown at the turn of the century was the Johnson Company. In early 1894, a major decision had been made to establish basic steelmaking and trolley rail production at a new location in Lorain, Ohio, rather than at Moxham and the nearby Riverside area in Stonycreek Township—a move based on the economics of ore availability on Lake Erie and closeness to markets. There had also been bitterness over the company's inability to connect its Johnstown and Stony Creek Railroad (J&SC) with the PRR mainline.[25]

While its principal capital expansion was being made at Lorain, the Johnstown plant continued to produce other trolley infrastructure. This Moxham site became known as "the switchworks." During this boom era for trolley installations in North America and elsewhere in the world, the Johnson Company (Lorain Steel after 1898) was a dominant provider and its systems were installed in numerous cities.

Between 1898 and 1902, the leading Johnstown manufacturers besides Cambria and Lorain Steel were the Johnstown Tin Plate Company (until 1901)—a division of the American Tin Plate Company;[26] A.J. Haws Brick Company; Hiram Swank and Sons Brick Company; the Basic Brick Company (Williams Brick Works); the Johnstown Pressed Brick Company; Fowler Radiator Works (later National Radiator Company); and De Frehn Chair Manufacturing Company.

Cambria Steel Triumphant

Even before it was decided that Cambria would not move to Lake Erie, and the company had avoided an initial courtship from the likes of J.P. Morgan, the management was already addressing its next challenge—making a modern steel plant able to compete with the emerging steel trusts.

Rumors that Cambria would become entangled with U.S. Steel, another major steel conglomerate, founded in 1901,[27] continued.[28] In March of that year, unnamed Johnstown business leaders were interviewed about the impact of the steel trust on Johnstown:[29]

> Q. Then you think Johnstown will forge ahead in spite of the combine?
> A. Most assuredly. Drexel Morgan and Company knows that Johnstown is the greatest field for steel manufacture in the world. Here labor is cheaper than anywhere else in the United States; here coal is right at the doors of the furnaces; here is the cheapest coal in the whole country and an immense quantity of it. Coal is cheap in Pittsburgh, but not as cheap as it is in Johnstown. Pittsburgh is constantly disturbed by union labor trouble; there is never any trouble in Johnstown.

By early June of that same year, Cambria's stock had jumped ten points, closing at $31.25 per share on June 6.

Earlier estimates of capital costs for modernization and expansion had been too low. The company aggressively sought to generate more capital. A new corporation, the Conemaugh Steel Company, was created to buy out and own Cambria Steel.[30]

Refinancing Cambria Steel, The PRR's Controlling Interest

The Pennsylvania Railroad Company had been orchestrating a reorganization in cooperation with Cambria's top management, especially Powell Stackhouse. The PRR first bought out the Pennsylvania Steel Company and then moved to acquire a controlling interest in Cambria Steel by purchasing just over half its voting stock. At this time, an unnamed spokesman, described as a "gentleman high in the business and financial world," was quoted as saying the PRR's move was to protect the railroad from a "possible squeeze from the steel trust." The location and production volume of the acquisition was also quite attractive, as Cambria tended to "develop and retain on its [PRR] lines an enormous freight business. The purchase of Cambria rails [would make] it possible for PRR to furnish them to its entire Western system with a haul only seventy-five miles longer than if it bought the same rails from the former Carnegie [now U.S. Steel] mills."[31]

The settlement of the capital-generation question was good news in Johnstown. Community leaders had a new faith that, thanks to PRR's controlling interest in Cambria stock, the company was well protected against a takeover by one of the trusts. PRR control had brought no management shake up. If anything, the pace of capital additions would be accelerated.

The Franklin Works

Major new works were already being constructed on a 160-acre parcel of land located in Franklin Borough, just east of Johnstown's Woodvale section. In 1895, a group of by-product ovens were installed on the hillside at the site to produce coke from the coal mined nearby.

The mill site, located on comparatively flat land situated between the ovens and the Little Conemaugh River, was known as the Franklin or Upper Works. Development was started in 1898 and by early May 1901, Franklin was producing steel and filling orders.[32]

In February 1902, *Iron Age Magazine* published a description of the new mill and its finishing facilities. The article portrayed the open hearth, blooming mill, slabbing mill, structural department, plate mill and car works; and an electric plant that generated the current needed for operations including power for massive cranes. (Ingots cast at Franklin weighed seven thousand pounds.) To supply the coke ovens, there was an impressive overhead 3,350-foot-long wire-rope tramway capable of hauling eighty tons of coal per hour over both the river and some site buildings. Everything built was described as modern, high quality and designed for maximum future output.[33]

Industrial Water

A major expansion at Johnstown demanded additional industrial water—a sustained flow of up to eighty million gallons per day. In January 1900, a charter was sought for the Manufacturer's Water Company with Charles Price, Cambria's general manager, as president. By July, planning was started on a huge impoundment in Somerset County and a smaller one on Hinckston Run, closer to the city.

The company retained John Birkinbine, a national authority on water supply and earth-dam construction. The challenge was to satisfy a skeptical and anxious public that the proposed dam over the Quemahoning Creek would never break and cause another Johnstown Flood. In an interview, Price released a statement of his own and a letter from Birkinbine assuring residents that any proposed dam would be safe even in the most extreme storm and snowmelt conditions.

Construction of the Hinckston Run Dam was begun in the late summer of 1900. Work on the Quemahoning Reservoir, delayed by a lawsuit, was to come much later (between 1908 and 1912).[34]

Steel Railroad Cars

The nation's demand for all-steel railroad hopper cars had begun to take off during the turn-of-the-century era, following the successful production of all-steel coal cars by the Pressed Steel Car Company of Pittsburgh. Steel cars were such an improvement over the wooden cars then commonplace that the latter's complete replacement was inevitable. In 1900, the Cambria Steel Company set out to tap into this vast market. By the third week in January 1901, the company began displaying its first full-size, steel bulk railcar. Everyone allowed to see it was asked to pick out and note every defect observed.

By June 1901, Cambria's first delivery on a five-hundred-car order from the Reading Railroad Company was so satisfactory that another five-hundred-car order was placed. Cambria was turning out two 100,000-pound capacity cars per day for about $1,000 apiece.

The chaotic demand for steel railroad cars, coupled with the growing needs of the PRR, dictated the construction of a major facility to be part of the Franklin Works, a new car-shop 800 by 160 feet in size that was served by massive cranes. When finished, the shop was supposed to be capable of turning out 40 steel cars per day. In November 1901, the PRR placed its second 1,000-car order with Cambria Steel. At that point in time, the PRR had ordered 17,000 steel cars at an average price of about $800 each.[35]

Coal

The iron and steel industries in and around Johnstown would never have developed without abundant, quality coal resources. While there were mines in the Johnstown area as early as 1825, nothing of consequence had gotten underway until the Cambria

Iron Company opened its famous Rolling Mill Mine in 1856. There were 137 mines in Cambria and Somerset Counties in 1899 that produced 10,694,627 tons of coal and employed 14,873 persons.[36]

Mining technology was also undergoing change and upgrade. In his 1900 report, J.T. Evans, a state inspector, reported about the changes in Cambria and Somerset Counties:[37]

> *Quite a number of costly changes have been put in at the various mines, involving changes from mule haulage to a mechanical system, and from pick mining to machines. Nor has ventilation been neglected. Furnaces have been taken out and fans put in, while small fans have been replaced by larger ones. J. T. Evans; District-Six Inspector*

Technological advancements aside, the mines were still very dangerous operations. On July 10, 1902, a major explosion took place in the Rolling Mill Mine that killed 112 people. The accident was blamed on a "Hun" (Hungarian) miner lighting a cigarette. Since it would have been unlikely for anyone to have witnessed the carelessness and survive, the story may have been rooted in ethnic scapegoating.[38]

Banks

The growth, prosperity and general optimism affecting turn-of-the-century Johnstown fostered additions and changes in the city's financial institutions.

The First National bank had been founded in 1863 and was Johnstown's oldest and largest bank. The Cambria National bank followed in 1897, and in late 1899, after it was settled that Cambria Steel would modernize and expand in Johnstown, another new bank, the Johnstown Trust Company was created by a group of local leaders. This new bank was capitalized at $125,000. Its founding president was Charles Price, Cambria Steel's general manager.

Another new institution, the U.S. National Bank, capitalized at $200,000, was founded about a year and a half later.

Challenged by these two additions to the local banking scene, the Cambria National merged with the First National Bank, the institution next door that owned Cambria-National's premises.[39]

These institutions, together with the thirty-year-old Johnstown Savings Bank, were all located comparatively near one another on Main Street near Franklin, generally across from Central Park. The U.S. National Bank was immediately around the corner facing Franklin. There were no branch banks in this era.

Retail Trade and Services

Almost anything one needed could be bought at the Penn Traffic Company store on Washington Street, the one comprehensive department store in Johnstown. After having been exhaustively refurbished and enlarged, the new modern store underwent a well-promoted grand opening on October 3, 1901. The massive building was decorated with flowers; an orchestra was brought in from Greensburg; there were promotional staffs from

such companies as H.J. Heinz of Pittsburgh. A near give-away sale lasted all day. The new building featured its Crystal Café with both a lunch counter and formal dining room.[40]

Penn Traffic's merchandise varied, including a full line of groceries including meats; furniture; clothes for men, women and children; toys; household goods of every description; and even hats and shoes. Johnstown had several other department stores less comprehensive in coverage. These included Nathan's, John Thomas and Son, Quinn's, Foster's and others.

Some idea of the structure of the retail and service economy with short-term trends may be derived from the following table made up from data extracted from Hoerle's City Directories for 1899, 1901 and 1903. The coverage area is Johnstown City and contiguous urban areas:

Category	1899	1901	1903
Professionals			
Attorneys	29	38	36
Blacksmiths	12	12	16
Dressmakers	27	13	12
Morticians	5	5	6
Physicians	44	54	71
Retail			
Department Stores	inconsistent	11	11
General Stores	50	74	82
Groceries (Retail)	73	91	115
Jewelers	11	14	17
Liquor	6	6	14
Hardware	9	7	8
Meat Market	29	35	46
Wholesale			
Wholesale Grocers	2	3	6
Other			
Bakeries	9	11	inconsistent
Breweries	4	6	5
Confectioners	21	11	25
Whiskey Distilleries	1	1	1
Wagon and Carrier Makers	5	5	4
Hotels (Including Boarding Hotels)	44	63	109

Johnstown's stores, large and small, were local institutions free from national chain or franchise ties. Candies, bread, cakes, soft drinks, ice cream and beer were made by local confectioners, bakers or brewers. Clothing, hat and shoe production was in either the work of local tailors, dressmakers, shoemakers and hatters; or produced in factories for wholesale and retail marketing.

Public Utilities

Domestic water distribution, electricity, steam heat, natural gas and telephone services were all provided by private companies that were almost entirely local. Until January 1914, no state public utility or other commission existed to protect the public interest by granting franchises and regulating rates and service standards. What little control there was came from the city government through its powers to restrict street and alley usage.

The Johnstown Electric Light Company, chartered in 1885, began offering "after-dark" service in 1886. Its generation equipment was located downtown. The only initial need for electricity was for lighting, a rapidly growing use. Other applications followed. The power supply had to be upgraded periodically to prevent being outstripped by demand.

A separate but parallel company, the Johnstown Steam Heating Company, was formed to sell the otherwise wasted steam heat (from power generation) to downtown customers. When steam proved profitable, the two networked companies were recombined in 1900 into the Johnstown Light, Heat and Power Company, which soon began making costly investments, mostly at its Vine Street power plant.

On August 20, 1901, a group of downtown merchants met to form a new electric utility, the Consumers' Electric Light, Power and Heating Company, to compete with Johnstown Light, Heat and Power. When the merchant founders were accused of making a "bluff" to force a speculative buyout by the existing company, the charge was denied. "We think there is or will be business enough for two companies at fair rates," a spokesman said.[41]

Soon a third group, the Citizens' Light, Heat and Power Company, was seeking a city franchise. After debate, untraceable political arm-twisting and temporary rejections, the city government granted a franchise on August 28, 1902, both to the Citizens' and to the Consumers' groups, creating a chaotic but hilarious situation.[42]

As time unfolded, only the Johnstown Heat, Light and Power Company survived. Consumers' never went into operation and Citizens' was acquired by the Johnstown Light, Heat and Power Company.[43]

Telephone Tempest

In early August 1901, the Johnstown Telephone Company completed the installation of a major upgrade of its system. New battery-free telephones were issued that got their signal power from the central exchange. A customer merely lifted the receiver and an operator at central knew a caller was on the line, got the number to be reached, and made the connection. When the call was over, returning the receiver to the unit signaled an operator to disengage the switch. The upgrade affected all 1,387 Johnstown customers. A new building on Jackson Street was constructed and the company boasted it was equipped to serve 3,000 units — double its current customer base.[44]

In March 1902, a rate increase was announced to finance recent improvements. A few merchant businessmen who had just organized a campaign to stamp out a new Sperry and Hutchinson trading-stamp promotion, went on a similar "warpath" to fight the rate

increase. They sought to sign up a large number of telephone customers, threatening to boycott all service. If they were successful, other subscribers would join the crusade because as fewer citizens remained customers, telephone service would be less and less useful to telephone loyalists. Should they, the more loyal customers, also cease telephone usage, the company would be brought to its knees or forced to roll back the rate increase.

The boycott idea quickly turned into the Peoples' Telephone Company of Johnstown. This new company was being proposed as an overlapping, competing company whose customers would be stockholders—all ex-boycotters of the Johnstown Telephone Company—an approach seen by an ad hoc "committee of ten" as preferable to the vague and incomprehensible proposal the same group had been soliciting from the Bell Company, which had been seeking to enlarge from its weak presence in Johnstown. Peoples' Telephone, a sort of customer-owned "co-op," proposed to provide service at favorable rates that would not go up.

The Peoples' Telephone Company, however, was never incorporated, and quietly dissolved into insignificance. The Johnstown Telephone Company weathered the tempest and began to initiate service to Ebensburg, Somerset and Altoona.[45]

Trolley Trials, Tribulations and Triumphs

The Johnstown Passenger Railway Company was a major turn-of-the-century Johnstown institution. Neighborhoods and streets served by trolleys were at a distinct advantage over those that were not. Good trolley service was especially essential for the Franklin Works.

Granting franchises to one or more private companies for little or no money was a divisive issue with the city councils and served as an editorial football among the leading newspapers. The same was true when a new trolley line was approved or a franchise was awarded to a new company for any ongoing uses of public streets. A new trolley line proposal would precipitate a vocal constituency backing the service addition, and such a group would naturally oppose costly franchise fees and service charges. Moreover, the Johnstown Passenger Railroad Company was known to be making buckets of money. A reputable New York financial publication reported that the company had earned more than $100,000 in 1900.[46]

In October 1898, a new company was created, the Johnstown and Somerset Traction Company. Its objective was to connect downtown Johnstown with Scalp Level and Windber. The line was intended eventually to continue to Somerset, providing service to places in between. A city franchise was granted at no cost in August 1899. The concept was not feasible, however, unless the new company could use Johnstown Passenger Railway tracks inside the city, an arrangement the latter refused. The denial led to a Johnstown Passenger Railway Company leveraged buyout of Johnstown-Somerset, prompting an outcry that the franchise had been granted for free and sold for profit while the city got nothing.

The new route went by way of Moxham, Ferndale and Scalp Level, using the Paint Creek Valley. Windber to Johnstown service began in January 1902. Plans to reach Somerset were dropped, although the line did serve Boswell.

In early May 1901, Tom Johnson, recently elected mayor of Cleveland, Ohio, sold his common stock to a group of persons mostly from Johnstown. The largest stockholder was T. Coleman Du Pont, who had moved to Wilmington, Delaware, in 1899.[47] Du Pont became

the president of the reorganized Johnstown Passenger Railway Company. His brother, Evan, was general manager.

Public Water

Up through the turn of the century, the Johnstown Water Company, founded in 1866 and subject to heavy guidance from its controlling stockholder, the Cambria Iron Company, had been steadily adding new reservoirs, storage tanks, pumping facilities and distribution mains to keep pace with rapidly-growing consumption. There being no water meters, customers paid "flat rates," meaning there was little incentive to conserve water. There was no purification. Chlorination did not get underway until 1917.

In 1887–88, the company had constructed a small dam and water intake on the Stony Creek River, upstream of Bens Creek, that supplied a thirty-six-inch main into Johnstown through Ferndale Borough. By 1897, however, the source had become polluted with mine effluent and had to be discontinued for domestic purposes although industrial usage was continued.

The development of the Dalton Run Reservoir near Bens Creek got underway in 1901. When finished in 1904, it added another 130 million gallons of storage.

Ice

In the 1900 era, home refrigeration was done in "ice boxes" kept cool in warmer weather by large blocks of ice delivered in horse-drawn wagons.[48]

In 1899, Evan Du Pont and his cousin, William Du Pont, bought out Charles Suppes's Cambria Ice Company, including its plant in Woodvale. A group of hotel owners and other major users organized a rival, the Consumers' Ice Company, in 1901 and hired James Shumaker, a well-connected ex-sheriff, as its president and general manager. A sustained ice price war and battle for customers erupted in April 1901 and continued for many months.

In December, the Consumers' Ice Company began constructing a large and modern ice plant in Hornerstown. In November 1902, William Du Pont sold his Cambria Ice interests and moved to Wilmington, Delaware.[49]

Hospitals

Immediately after the 1889 flood, a number of military-type hospital tents were set up by the Red Cross to care for the sick and injured. The tents soon became so essential to Johnstown that their removal prompted civic action to establish the Conemaugh Valley Memorial Hospital. Its capital financing came from unused flood-relief donations. The new hospital opened on February 4, 1892, with sixty beds and a staff of nine physicians. In 1898, fifteen more beds were added in a new wing.[50]

Through the Cambria Mutual Benefit Association, the Cambria Steel Company continued to operate its hospital, built on Prospect Hill in 1887. The patients were mostly Cambria employees and their dependents. By 1903, there were forty beds.[51]

Through the Johnstown Board of Health, the city also operated a contagious disease hospital known as the "pesthouse," located near St. Clair Run in Lower Yoder Township not far from the city-limits boundary. Because of the inadequacy of the pesthouse during the serious 1902 smallpox epidemic, a new contagious-disease hospital was built on a Prospect Hill site donated by the Cambria Steel Company.[52]

In April 1902, a group of physicians began to organize a new general hospital. Of the sixty or so practicing doctors in Johnstown, only twenty were connected with either Conemaugh Valley Memorial or the Cambria Steel Hospital, a situation that generated complaints of medical-practice discrimination.[53] A site in Dale Borough was purchased for the Johnstown City Hospital, which opened in 1906 as a general public hospital. Despite its name, there was no municipal role.

The Sale of the *Johnstown Tribune*

On Saturday, April 12, 1902, a brief but anticipated announcement appeared on the editorial page of the *Johnstown Daily Tribune*:

> *With this issue Anderson Walters assumes control of the Tribune and asks the indulgence and friendly criticism of its readers and patrons. The Tribune, in politics, will be straight Republican, in business, straight business. It is the organ of no faction or clique, and will aim to be in truth, a tribune of the people, "standing up" for Johnstown always.*

Swank had sold his paper for $82,000. Walters, born in 1862, had been superintendent of the Johnstown Water Company, a Republican member of the common council and a prohibitionist. He was married to ex-Mayor Woodruff's daughter, Jessie Octavia.

Under Walters's leadership the *Tribune* became a more modern newspaper. When George Swank had been publisher, the paper had no topical sections. Unimportant sports items might appear next to leading international news articles. Walters developed a sports page, an obituary section, a local news page and so forth. Photographs were soon appearing in every issue, and the *Tribune* hired its own cartoonist.

Onward and Upward

As the twentieth century dawned each new Johnstown city directory was thicker than the one before. Only the negatively skeptical doubted Powell Stackhouse's assertion that Johnstown soon would have a population of 75,000.

The optimistic spirit was contagious. Johnstown was full of young and middle-aged people. New corporations were springing up through stock subscriptions often bought by local investors. Local architects had as much work as they could handle. New homes were being built all over the area. Morris Nathan bought the site for a new "Nathan's" department store on Main Street across from Central Park at Park Place. John Thomas and Sons, another department store east on Main Street, in 1902 undertook a major overhaul and added a new four-floor addition covering an area 110 by 112 feet. The

store was even installing a pneumatic tube cash-carrier system that was already being used in big cities.[54]

IV. THE LOCAL POLITY

Aside from several magnificent churches, the most impressive surviving architectural work from Johnstown's 1900 era is the city hall designed by George Wild and C.M. Robinson. The cornerstone was placed in October 1900, and the building was opened in late 1902. While its somewhat Romanesque design may delight architectural historians intrigued by the elaborate stonework, arches within arches and balconies, the interior layout confuses anyone who might wonder whether any thought was given to the building's use as quarters for the city government.

Like many municipalities throughout the United States at the turn of the century, Johnstown's local government was as complicated as its city-hall stonework. Reform movements had not arrived. Like other cities in its population group, Johnstown operated under the Pennsylvania Third Class City Code, a state law governing all cities other than Philadelphia and Pittsburgh.[55]

After the Coopersdale annexation in 1898, Johnstown comprised twenty-one geographic units called wards. The largest in population were the Sixteenth in Cambria City, whose 1901 population was about 3,900, and the Seventeenth (Moxham), with 3,450. The smallest were the Third Ward in downtown with approximately 700 people and the Twenty-first (Coopersdale), with some 740.

Despite wide population disparities, each ward elected two of its male residents as councilmen—one for each house of a bi-cameral legislative branch. The "select" council members had to be at least twenty-five years old and were elected for four-year terms. The "common" council (lower-house) members had to be twenty-one or older and were elected for a two-year term. To take effect, ordinance bills and resolutions had to pass both council bodies.

The mayor was elected for a three-year term and could not succeed himself. Although the mayor could veto an ordinance, his powers were carefully limited. He functioned as a municipal judge and heard cases arising from alleged violations of city ordinances. He could impose fines and jail sentences. The mayor's standing in the judicial hierarchy was the same as a justice of the peace or alderman, but his "municipal court" had jurisdiction only in municipal-ordinance or city-revenue violations.

With the approval of the select council, the mayor chose three street commissioners for one-year terms. Each was paid a salary and was made responsible for a district composed of several wards. The street commissioners supervised the street work, sewer installations and connections, general cleaning and similar matters within their districts.

An elected treasurer billed, collected and recorded tax and license receipts, and an elected city controller approved all expenditures before payments were made. Two key officials, the solicitor and the city engineer, were both appointed by the councils. An election for both mayor and any of the council members could occur only once every six years. Since the mayor could not seek reelection, developing a slate of team supporters was almost impossible.

The mayor did appoint the chief and all members of the police force. Each new mayor changed many officers after inauguration, an arrangement causing the police force to be very political. Aldermen were judicial magistrates elected by wards, but some wards did not have an alderman. Each alderman had an elected constable to work with him. The constables served judicial papers and had arrest powers.

Meetings of one or both of the councils often could not get underway for want of a quorum. Policemen went about rounding up missing members so that business could be transacted. Joint sessions were commonplace, as were conference committees made up of select and common council members. Make-up sessions to pursue the agendas of the many scheduled sessions not held for want of a quorum took place so frequently, one might suspect they had been staged so no citizens would be present. Newspaper reporters often missed call meetings, and editorials persistently rebuked councilmen for not attending scheduled sessions.

It would have been highly unlikely for the limited resources of the city to have been wisely invested over twenty-one semi-autonomous wards, each with two leaders working and trading votes back and forth to gain expenditures for street paving, lights and sewers in their own parts of town.

Politics infected everything in Johnstown to one degree or another—a condition exacerbated by the presence of three daily English newspapers: the *Daily Tribune*, the *Leader*, and the *Johnstown Democrat*. The first two were Republican, although the *Tribune* was for Prohibition and the *Leader* was against it. The *Democrat* did not favor Prohibition.

The Key Issues

Around 1900, the still-new city government was dealing with rapid growth while assimilating the several communities that had combined with Johnstown Borough in 1889 to form the new City of Johnstown.[56] Under the state law in effect around 1900, a borough or defined area could be annexed into a third-class city by a process in which three-fifths of the property-owner residents would sign a petition favoring the change; the borough or locality affected might then pass an ordinance of approval; and finally the two city council bodies would enact an ordinance of acceptance. This procedure had been followed in the 1897–98 era with both Morrellville and Coopersdale, but Mayor George Wagoner, a Democrat, vetoed the city's Morrellville ordinance, an action delaying not only Morrellville's entry but also that of Coopersdale, which otherwise had no common boundary with Johnstown itself. Blasted by the *Tribune* for his veto, said to have been motivated by Morrellville's being predominately Republican, Wagoner countered that the city was unable to extend its services and capital improvements into the new area without sacrificing programs elsewhere in town.

The whole issue became entangled in legal appeals that eventually culminated with both boroughs becoming part of the city. Although Coopersdale had voted three to one in November 1889 in favor of being annexed into Johnstown, by law it could not join the city until there was a common boundary. Because of the delay of Morrellville's entry, Coopersdale's coming in was delayed until December 1898 by what proved to have been a frivolous legal challenge initiated in the hopes (which failed) of dragging things out so its predominately Republican electorate would be unable to vote in the 1899 city election.[57]

Roxbury's citizenry was more divided. One faction wanted to remain a borough; another sought to join Ferndale; but a majority wished to join the city of Johnstown. Annexation opponents in 1900 and 1901 also resorted to litigation. When the county court ruled that the initial petition had been defective, a new one was executed and a fresh round of court challenges were filed. In September 1901, the matter was finally decided and Roxbury's 825 citizens joined Johnstown as part of the Eighth Ward.[58]

Johnstown's civic leadership boosted annexations using arguments of prestige related to size and economies of scale. Citizens in outlying areas wanted to join largely because of Johnstown's comparatively good, nine-month school system.

River Encroachment

An examination of early maps showing Johnstown's rivers reveals that banks and lowlands along their watercourses have been filled in drastically, destroying natural floodplains and squeezing the streams' capacities to carry peak flows. These consequences often went unnoticed because the filling had been happening gradually. The encroachments increasingly worsened Johnstown's flood tragedies.

In the 1860s the Stony Creek was said to have been about 300 feet wide while the steeper, swifter Little Conemaugh ranged between 132 and 175 feet. Henry Storey, in his *History of Cambria County*, provides more specific measurements. In 1870, "the average width of the Little Conemaugh, within the limits of the city, was 195 feet, and that of the Stony Creek was about 288 feet, and the Conemaugh below the Point about 350 feet."[59]

Having experienced waters rising into streets and basements, and alarmed by an awareness of what the riparian filling was doing to the community, the Millville and Johnstown Borough Councils in 1882 imposed setback lines to define the width of the rivers and to halt further filling. The Stony Creek was made to be 175 feet wide, and the Little Conemaugh was set at 110 feet. Being outside Johnstown Borough in 1882, the Conemaugh received no setback.

The 1882 lines were so inadequate, however, they seemed like an effort to recoup concessions in an already lost cause and to make a new beginning no one could contest. In 1890, after the great flood and municipal consolidations that took place later, the new city sought to widen the old borough setback lines. A new ordinance made the Stony Creek 225 feet and the Little Conemaugh 125 feet wide. The Conemaugh, now within the city's boundaries, was given a width of 260 feet.[60]

Since these were more restrictive changes to earlier ordinances, a legal question arose: did the new setback lines constitute a "taking" (condemnation) of private property? Another question involved whether the boroughs or the city had any true authority to define the Commonwealth's riverine rights-of-way, since there were legal precedents that navigable streams were state property. As state property the encroachments created no riparian rights because prescription (adverse possession) did not go against the state. Some riparian owners, Cambria Steel and the two major railroads, were reported to have been extending encroachments of their own despite the ordinances, the recurring flooding and even the trauma of 1889.[61]

The legal issues surfaced again in 1901 through a city lawsuit against Thomas and Catherine Fearl. The Fearls had been filling in the Stony Creek in Kernville for a residential development, relying on the older 1882 borough ordinance, which they were pleading had not been repealed by the newer 1890 law.[62] Cambria County Judge A.V. Barker's decision held that the city could impose a more restrictive setback but would have to compensate the Fearls for a "taking." He sidestepped the bigger question of whether the borough or the city had any authority to regulate stream widths since they were "navigable waterways." The judge worded his opinion in a way that encouraged an appeal to higher courts and suggested that the Commonwealth, through the attorney general, be a party to any case.

Like so many matters that got lost, the issue seemingly disappeared for a while. In late February and early March of 1902, however, high waters were raging once again. Flood-induced anxieties prompted action, and the city sought to bring the river boundary matter to the attorney general in an effort to force a high-court determination that all its setback lines were invalid, including those of 1882. While this might erase the city's awkward dilemma of two conflicting setbacks, it would have created serious title defects for major parties—steel companies, railroads, the Fearls and others who had built upon the filling they had been doing for over forty-five years. The proposal also assumed the state's highest court had enough fortitude to determine that the corporations—political powerhouses—had encroached into sovereign lands and easements.

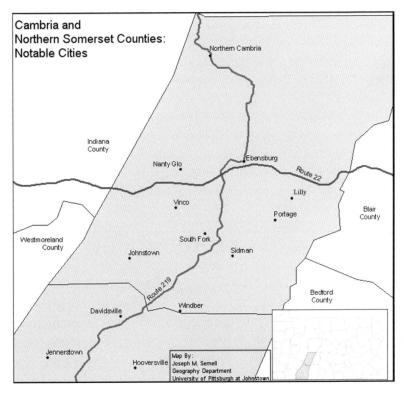

Communities of Cambria and Northern Somerset Counties.

On the other hand, the court might somehow uphold the newer, wider river lines in a way that would not have required the city to pay compensation. In October 1902, the lame-duck attorney general passed the "hot potato" to his successor. As an "agency of the Commonwealth," Johnstown could bring a test case.[63]

Horses, Buggies, Bob Sleds and the Automobile

Another radical change was underway in Johnstown around 1900—the coming of the automobile. The city code at the time forbade any animal to be driven faster than one mile in five minutes. Ordinances also forbade "breaking in wild horses" in the streets.[64] From time to time a buggy or wagon pulled by a donkey would stall so as to block everything. Horses were spooked by trolleys, trains, dogs and the occasional automobile. Street cleaning to remove animal excrement was constant. The alleged service inadequacy was a continuing complaint.

In a 1900 editorial, the *Tribune* pointed out that the city's 248-page code of ordinances had numerous safety restrictions governing horses, bicycles, buggies, wagons and bobsleds. No law restricted this new thing called the "automobile." The omission was partially rooted in the fact that its revolutionary advent was unthinkable: Johnstown had about fifteen livery and sales stables, sixteen blacksmiths, at least one horse and mule exchange, five wagon and carriage makers, four vehicle dealers, five saddlers and harness makers and an indeterminate number of feed suppliers.[65]

But the automobile was unstoppable. In 1897 or 1898, Adam Trabold, once a mechanic for the Cambria Iron Company, managed to install a one-cylinder motor onto a buggy and used it around town. Fred Leitenberger produced a four-cylinder vehicle of his own in 1898 and drove it about the city. In 1900, William Du Pont became the first Johnstowner to purchase a manufactured automobile, a one-cylinder Winton. Shipped to the city by rail, the car cost $2,000. In July 1900, C.A. Pierce, a bicycle repairman with a shop on Main Street, announced he would soon manufacture automobiles. On Sunday August 5, he gave his self-made car a test run on Broad Street. Two young boys were in the way and when Pierce swerved to avoid them, his vehicle flipped over. Pierce forewent automobile manufacture.[66]

Toll Roads and Bridges

By the early twentieth century, most privately owned turnpikes and toll bridges, essential nineteenth-century Pennsylvania institutions, were on their deathbeds, especially in and near cities. Since the city streets were free for anyone to use, tollgates were a hated nuisance. The city councils seemingly took pleasure in ordering the Valley Pike Company to make improvements.

One of the reasons for the 1902 opening of McKinley Avenue (named for the assassinated president) in the Eighth Ward was to provide a free public way around a tollgate located on Franklin Street between the bottom of Whiskey Springs Hill and the Conemaugh Valley Memorial Hospital. The addition was a repeat of an 1896 coup when Ash Street and Grove

Avenue were linked together for a new trolley route and a way for Moxham residents to go downtown and back toll free.[67]

Nearly everyone wanted the swinging footbridge crossing the Stony Creek at Haynes Street to be replaced with a span for both vehicular and foot traffic. A group of businessmen approached the city to gain support for what might have become the Haynes and Bedford Streets Bridge Company. Instead of support, though, the city gave the governor eighteen reasons why the charter should be refused. In the end, Johnstowners preferred no vehicular bridge at all to one requiring a toll for crossing.[68]

Refuse Collection and Disposal

The Johnstown city government neither collected nor regulated the collection of garbage at the turn of the century. The 1900-era press made occasional reference to a City Garbage Company, a private firm that collected much of the residential and commercial garbage and hauled it to open dumps outside town. Other haulers—mentioned in the press as a Johnstown Refuse Company, a citizen named William Bogus, "Italians" and others—had begun using William Adams's dump in Stonycreek Township. Neighbors complained; a public nuisance suit was filed and a number of parties testified about foul odors, garbage being dumped into Solomon Run, rats and other conditions.[69]

The City Garbage Company offered to build a "garbage furnace" and to give the city an option to buy it over a ten-year period for vague stipulations that the city would not compete with the company. The matter was referred to a committee of council. Nothing was accomplished.

In the midsummer of 1900, the *Daily Tribune* printed a short but telling editorial, "Let There Be a Garbage Furnace But Let the City Own It." The headline conveyed its message but there was also another recommendation—the city should closely supervise the collection of garbage with extra attention to areas having poor and "foreign persons." Garbage was being thrown into the rivers by those unable to pay for collection.[70] By the summer of 1902, however, nothing significant had been done.[71]

Epidemics

Turn-of-the-century Johnstown was often ravaged by severe communicable diseases, especially smallpox, typhoid fever, diphtheria and scarlet fever. Deaths from pneumonia were also common. Smallpox was highly contagious, often deadly, and everyone felt helpless fighting it. Any new case in a community that had been enjoying a comparatively healthy period would create a civic panic that another epidemic had arrived. In the spring of 1902, sporadic cases were reported in Johnstown. By the summer and fall, an epidemic was underway.

One smallpox case placed its victim's household under quarantine. Since a number of people lived in boarding hotels, a single case within the premises would result in the red flag and smallpox quarantine sign being posted. No one was supposed to go in or out. People afflicted were sent to the pesthouse, where they stayed about a month. Approximately one in ten died.[72]

In June 1902, Johnstown required vaccinations against smallpox. Many employers ordered their workers to be inoculated. Children were not allowed to attend school unless they had either been vaccinated or showed proof of recuperation from the disease. The *Johnstown Democrat* questioned the wisdom of vaccination and a newspaper debate got underway. The *Tribune* beat its rival with statistics showing that people not inoculated had greater risk of death or suffering a more serious case. Evidence was also convincing that vaccinated people were infected with the disease less often.[73]

On New Year's Eve, the month-by-month data on smallpox, diphtheria and scarlet fever for 1902 was tabulated. Smallpox had peaked in September with 54 new cases. Of the 222 afflicted in 1902, 25 had died. Scarlet fever had been even more deadly—425 cases and 46 deaths. Diphtheria had killed 17 of 82 afflicted. Typhoid fever had been comparatively easy on Johnstown. Its 1902 statistics were not even published.[74]

The Johnstown School System

Each ward in the city elected one of its residents to a four-year term on the twenty-one-member Board of School Controllers. The tenures were staggered so that half were elected every other year. The controllers chose their own chairman and hired all personnel including the superintendent. The board set its tax rate and issued bonds.

During the 1900 era, the major problem was keeping pace with a rapidly growing school-age population. An aggressive building program and constant additions to the teaching staff were essential. In 1899 a new Johnstown High School building was opened on Market Street downtown. New elementary schools were added in Moxham on Cypress Avenue (1900), in Hornerstown at Meadowvale (1900) and in Woodvale (1901). Additions to existing buildings were frequent.

In September 1901, there were around 5,600 pupils in the Johnstown schools including 250 in the four high school grades. The first eight grades averaged about 670 pupils per grade level, while each high school grade averaged only 60 students. The number attending high school in the fall of 1901 was up from 214 the previous year, a 16 percent increase in one year.

At the turn of the century in Johnstown, high school students were mostly from the upper classes and expected to attend college. Others usually quit after the eighth grade.[75] The city's schools were free to its citizens. Non-resident children often attended by paying tuition.

The Public Library

The Johnstown Library, started in 1870 by the Assistance Volunteer Fire Company, was managed by the trustees of the Cambria Library Association. The library quickly became an important institution. The Cambria Iron Company bought a site at Washington and Walnut Streets and in 1881 provided an impressive building that the flood destroyed eight years later. Andrew Carnegie paid for its replacement. The new library building was dedicated in February 1892.

At the beginning of the century, the library board was made up of Cambria Steel officials plus a few other prominent Johnstowners. Its 1901 collections contained 11,201 books and 4,690 government documents.[76]

The New-County Issue

When Joseph Johns had laid out the streets and public areas of a future Johnstown in 1800, he believed it would become a county seat. Downtown's Central Park was the intended site for a county courthouse. Cambria County was established in 1804 and Ebensburg became county seat. In 1848, and again in 1860, efforts were made to create a new county, Conemaugh, from parts of Cambria, Westmoreland and Indiana Counties. The legislation failed. An 1870 effort to make Johnstown Cambria County's seat also failed.[77]

In 1899, the Johnstown Board of Trade revived the new-county issue, but the initiative was burdened by a recent constitutional prohibition against establishing a new county or changing a county seat by special legislation.[78] The organization prepared a report that addressed the problem logically: half of Cambria County's population lived in or near Johnstown; the only acceptable way to travel to Ebensburg was by railroad, a seventy-mile round trip requiring a traveler to change trains each way. A whole day was needed for a Johnstowner to transact business in Ebensburg. Jurors' travel, moving prisoners, lawyer-client visits and other county matters were costly and inconvenient.

Only three cities in Pennsylvania with populations greater than ten thousand were not county seats: Altoona, very close to Hollidaysburg; McKeesport, convenient to Pittsburgh; and Johnstown. In 1889 the Board of Trade commissioned Robert Cresswell to draft a new-county bill that would meet the constitutional constraints. The bill was not enacted.

In 1903 an ad hoc committee of leading citizens, including Cresswell, sought to revive the issue. Despite favorable indications, the House Committee on Counties and Townships voted on March 18 by twelve to eleven against a bill similar to the one that had failed in 1899. Political reality prevented it becoming law. Enactment would have altered the constituencies of influential leaders.[79] There were no more new-county efforts.

V. THE PEOPLE

European Immigrants

For many European nationalities and sub-nationalities, the latter part of the nineteenth century was a time of migration, seasonal and permanent. Peasants and impoverished people from rural villages and smaller communities in eastern and southeastern Europe, often driven by necessity, sought temporary employment in countries other than their own,

including the United States. Many came to America to try and earn a modest fortune and return home. Others sought U.S. citizenship from the outset. Some arrived, worked, saved money, went back home, became disillusioned and returned to the United States for permanent settlement.

Johnstown's earliest immigrants were Welsh, Irish, German, English, Scottish and Swedish. In the late 1870s and the 1880s, a few Poles and many Slovaks arrived in Johnstown and accepted unskilled jobs usually with the steel companies or nearby mines. Others followed. Johnstown's population spurt, having begun in the 1880s, included a wide variety of eastern and southeastern Europeans—Poles, Slovaks, Magyar Hungarians, a few Italians, Croatians, Serbians and others. Beginning in the late 1890s, the influx intensified with the arrival of even more Croatians, Serbians, Bohemians, Moravians and Italians (two-thirds from southern Italy).[80]

As a general rule the newer immigrants started at the bottom of the social and job prestige ladder, and those already on the scene moved up. At the beginning of the twentieth century, the Welsh, Irish, Scots and Germans were in the top stratum and the Poles, Slovenians, Croatians, Serbians, Slovaks, Bohemians, Slavs and Italians were generally at the bottom. An interesting attitude was revealed during a survey conducted later, when a Johnstown man with a German accent announced, "We are not foreigners; we are Germans."[81] Another distinction was maintained between northern and southern Italians—a separation probably encouraged by the few northern Italians who sought not to be identified with their then comparatively new compatriots from southern Italy who were poorer and less educated.

The term "chain immigration" has been used by sociologists to describe a pattern where an individual or family became situated in a community such as Johnstown and then encouraged others in the family or village to follow. Steamship agencies were instrumental in helping this "chain" relocation. These firms in Johnstown were usually managed by enterprising immigrants and were something of a hybrid between a travel agency and an unregulated bank. A foreign resident of Johnstown could save for a family member's or friend's passage by making periodic deposits with the agency. When the fare price had accumulated, the agency booked passage to Johnstown.

Because of chain immigration, many of Johnstown's immigrants came from the same villages and areas. Ewa Morawska's Johnstown research showed these Balkan sub regions to be counties and small towns, which, plotted on a map, are comparatively near one another, generally in the Carpathian Mountains within a one-hundred-mile radius of the eastern tip of Slovakia. The area included modern Hungary, Galicia and the southwestern Ukraine. A second cluster is concentrated in Slovenia and Croatia—the northwestern part of former Yugoslavia.

These areas were mostly small-town and rural in character. Morawska also noted that their climate and geography were similar to those of Johnstown. The 1900 census lists 7,318 "foreign-born" residents of Johnstown, which at the time had a total population of 35,936. With no distinction as to duration of residence, the "foreign born" registered the following counts tabulated to the native country:[82]

Austria[a]	923	
England	570	
Germany	1663	
Greece[b]	?	
Hungary[a]	2107	
Ireland	581	
Italy[a]	381	
Poland[a]	334	
Russia	78	
Scotland	75	
Wales	446	
Other	250	
Total	7318	

a. During this era, Austria and Hungary had separate governments and bureaucracies but were united through the dual monarchy of Emperor Franz Joseph, a Hapsburg. Austria included the Bohemian or western half of one-time Czechoslovakia, while Hungary contained the eastern part peopled largely by Slovaks. Slovenia was in Austria, whereas Croatia was part of Hungary. The Galicia sections of southeastern Poland and part of the modern Ukraine were also in Austria. Serbia was an independent nation. Italy had been united in full only since 1870. As a nation, Poland did not exist from 1795 unitl 1918.

b. Indications are that there were only a very few Greek immigrants in Johnstown by the turn of the century. As late as 1911, the Greek peoples were being grouped with the Syrians for the infant mortality study done by the U.S. Labor Department in 1913 and 1914.

Tracking this fluid population was difficult because of its coming and going—people returning to Europe permanently or for visits and others moving to and from other places in the United States with people of their nationality.

The Italians came to Johnstown comparatively late, a trickle in the 1880s and many more in the 1890s. According to the Immigration Commission, they tended to keep to themselves and settled in the Twelfth Ward (Prospect—mainly southern Italians), and the Ninth and Tenth Wards (Old Conemaugh Borough—northern and southern Italians).

Morrellville—the Eighteenth, Nineteenth and Twentieth Wards—had a small number of mixed immigrant groups, but the Croatians and a few Macedonians tended to live in and near those sections adjacent to the more densely populated parts of Lower Yoder Township. Minersville (Fourteenth Ward) and Millville (Fifteenth Ward) had small populations in general, which included Poles, Croatians, Slovaks, Magyar Hungarians and Germans.

Kernville and Hornerstown—the Fifth, Sixth and Seventh Wards—had citizens born in the United States and some second-generation immigrants. Johnstown's downtown residents were mostly white Americans and immigrants from the British Isles.[83]

The Foreign Section

Johnstown's most polyglot section, the area of town called "the foreign section," was Cambria City (the Fifteenth and Sixteenth Wards), a small quarter extending from north of the Old Stone Bridge to Fairfield Avenue and between the Conemaugh River and the PRR main line. Cambria City was near the original Cambria mills (Lower Works), the Haws Brick Company and the Rolling Mill Mine entrance across the Stony Creek from the Point.

From its inception, Cambria City had been home to the earliest miners and mill workers, especially the Germans and Irish. As immigrants continued to come to Johnstown, members from all nationalities, except the Italians, settled there. After the more recent arrivals began flooding the section, generally from 1890 to 1910, the Irish and most Germans began

relocating. The Immigration Commission, whose fieldwork was done in the 1907–08 time frame, reported that all foreign immigrant groups were represented in Cambria City except the Welsh and Italians.[84]

Cambria City's population was 5,300 in 1900. By 1910 it had grown to more than 8,700. Both figures were probably low due to undercounts. The foreign section covered only 146 acres, including half of the Conemaugh River, a small bit of steep hillside and the Haws Brick Company works. An area of about 120 acres including streets, alleys, shops and church sites, was home to this population—a density varying from 27,000 per square mile in 1900 to more than 45,000 by 1910.

At the turn of the century, one would have heard Polish, Hungarian, Russian, Czechoslovakian, Serbo-Croatian, German, some Yiddish, and English in Cambria City. Of the 112 people killed in the July 1902 Rolling Mill Mine Disaster, 95 of the funerals were conducted by Cambria City parishes.[85]

As eastern Europeans flocked into Cambria City, other long-time residents moved out.[86]

Immigrant Housing

Chapter VII of the Immigration Commission report describes conditions of housing among immigrants in Johnstown:

> *The houses of Welsh, German, Irish, and English immigrants are generally on an equality with those of natives in the same grade of employment…The housing conditions of southern and eastern European immigrants…are generally quite different.*

The commission noted that there were health regulations not being enforced "for want of staff." One might read a bigger, more symbolic meaning in the concluding paragraph:

> *The foreign section is situated below the other sections of the city and below where the two rivers join. The people…who are chiefly immigrants thus get the full benefit of the filth that is emptied into the two rivers for several miles above. In the dry season…the odor…is offensively evident.*[87]

From Old Animosities to New Collaboration

One might have expected the packed quarters to have been places of constant strife among the ethnic groups made up of ex-peasants and people from Balkan and Russian villages, some with histories of strife toward other ethnic peoples in the city. In fact, the various groups repeatedly pulled together, probably because their new challenges dissolved old-world antagonisms. Immigrants from disparate ethnic backgrounds shared common challenges. In some cases, they had come to America to escape hostilities. Cases of brawls involving Johnstown immigrants were usually confined to the same groups, often when drinking together. One national group often helped another by sharing its church building until the other had one of its own.

Interestingly, the leaders of the ethnic peoples of Johnstown—men such as Bozo Gojsovic and Victor Faith—were usually businessmen whose commercial interests transcended ethnic groupings.[88] Such men were also better equipped in the early years to work with well-established Johnstown leaders.

The parish priests, however, were often leaders who guided their own discrete nationality groups in harmony and occasionally in antagonistic discord with other groups. Clubs for singing, athletics, citizenship preparation and other purposes were formed, usually along ethnic nationality lines. Often aligned with the parishes, the clubs usually sponsored benevolent insurance programs that paid benefits when tragedy struck an immigrant and his family.[89]

The Disdain by "Old Johnstown"—Ethnic Bashing

The first purchase made by a Slovak or Polack when he comes here is a revolver, by Italian or Sicilian, a stiletto, then the newcomer buys a silver watch; and after that is secured, he begins to save money. If the Slovak or Polack is particularly thrifty, he postpones purchasing the revolver for several months, and carries in one pocket a round hard stone, large enough to crush a man's skull, and in another a piece of iron filched from the colliery scrap heap. The Italian or Sicilian, too poor or too penurious to afford a stiletto, buys, begs, or steals a long file, and sits down in his shanty or by the roadside, with two or three stones, and grinds it to a keen edge and needle-like point. Then he fastens the blunt end in a corncob, and has ready for use a weapon of no mean possibilities. Once armed, however, and provided with a watch, the foreigner manages to live at a total expense of about six dollars a month—and this may be regarded as a liberal estimate in most instances. The remainder of his wages is saved toward the purchase of a vineyard or a farm in the old country, whither almost all expect to return and spend their days.

This item, ascribed to Henry Edward Rood and appearing on the front page of the *Johnstown Tribune* on April 23, 1898, had been taken from a contemporary but unnamed magazine.[90] The writing is a product of American attitudes about recent immigrants in places like Johnstown. The Slovaks and Italians were seen as dangerous and up to no good—a temporary nuisance. After having acquired the weapon and watch, they would start saving for permanent return to their native lands. In a word, they were not conventional consumer-spenders in the local economy but were transients soon to leave.

Some insight into the attitude and thinking of Johnstown's upper-class leadership can be derived from an ex-Johnstowner, James Moore Swank.[91] In his 1908 book, *Progressive Pennsylvania*, Swank bemoans immigrant arrivals:

In the last thirty or thirty-five years the lack of homogeneity among the people of Pennsylvania has been conspicuously and most painfully emphasized in the invasion of large sections of the state by hordes of Italians, Slavonians [sic], and other immigrants of distinctly lower types.[92]

This *Tribune* cartoon from October 2, 1906 is an example of ethnic bashing in early Johnstown. The foreigner is depicted as dangerous and prone to crime.

A Shakedown That Would Save Lives.

An Americanization class after the First World War. Eighty-four foreigners completed the course leading to naturalization and citizenship. One representative from each of the nineteen nations represented in the class was chosen to appear in this March 16, 1925 photograph.

Such ethnic bashing by Johnstown's white, Anglo-Saxon upper classes was ongoing and, though declining steadily, continued until after World War One. Positive gains were made when Anderson Walters acquired a controlling interest in the *Johnstown Tribune* in 1902 and became its publisher and editor—the paper stopped using words like "Pollack," "Hun" or "Slav" loosely to describe any grouping of Eastern European immigrants.

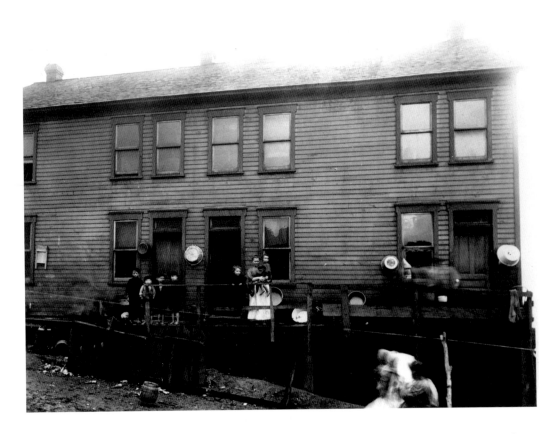

Tenement housing, probably in Cambria City around 1905. The tubs and washboards are for doing laundry outside.

Johnstown's Early Jewish Community

Nathan Shappee had so little to say about Johnstown's earliest Jewish citizens, one might conclude there were almost no Jews in early Johnstown. Leonard Winograd, in his richly detailed *The Horse Died at Windber*, however, indicated a presence in earlier Johnstown of a substantial number of Jews, mostly of German origin, many of whom he believed were no longer practicing their heritage.[93] Morris Nathan, who had arrived in 1872, was said to have been the first Jewish merchant. L.M. Woolfe, who in 1880 owned both home and store, was said to have been second. There had been a temporary synagogue established in the Singer Building in 1884.[94]

Driven by a desire for a better life economically, and to escape mounting anti-Semitism following the ascension of Tsar Alexander III in 1881 (ending the long reign of his assassinated father, "the great liberator," Alexander II), large numbers of Jews from eastern Europe and Russia began moving into the United States. As pogroms became more unrestrained, a cry among Russian Pale-settlement Jews was, "To America!" Morawska tells of an "American fever" between 1880 and 1914, which resulted in about 27 percent of eastern and Russian European Jews coming to America. Unlike the seasonally migrating rural peasants, the Jews departed with no intention of returning.[95]

Some earlier Jewish peoples probably came to the area because they were familiar with the languages and customs of the eastern European Johnstown immigrants with whom they were hoping to trade symbiotically as they had in Europe. Few if any Jews worked in the steel mills or mines, probably uncontested company policy. Jews had no old-world experience in these industries. From all indications, they sought quietly to establish their place and role in the new land, observe their religion and live in hopes of not triggering or experiencing an unforeseeable anti-Semitic outburst caused by the unknown.

The Johnstown English-language newspapers scarcely mention Jews at all. The press was eager to report crimes committed by Italians, "Huns" or "Slavs"; drunken brawls and bigamy among ethnics; and any manifestation of social dysfunction rooted in conflict between old-world culture and Johnstown-American norms. One concludes Johnstown's early Jews were law-abiding and moral, otherwise the then press would have ridiculed them.

The few Jews who arrived in the latter part of the nineteenth and very early twentieth centuries tended to settle in Cambria City and in the "old Millville" section across the Little Conemaugh from downtown—the area of the PRR passenger station. Their occupations were store merchants, peddlers and small artisans. As of about 1910, 83 percent of Johnstown Jews were "self-employed in trade."[96]

On August 31, 1899, an article appeared on the front page of the *Daily Tribune* that gives an insight into the early Jewish community in Johnstown as depicted by a non-Jewish writer:

> *The Orthodox Jews of Johnstown who are now more numerous than at any time in the history of the city, it is believed, have decided to permanently organize, and on the 25th of next month will make application at Ebensburg for a charter under the name of the Congregation Rodef Sholem.*
>
> *Congregations of the Orthodox Jews have been formed here frequently in the past, but the organization has never had any legal form, and on the removal from the city of a family or two most interested in the cause, they have lapsed. The membership was always small, scarcely ever reaching more than a dozen. In the present instance, however, the Congregation Rodef Sholem will start out with some thirty members.*

In September 1902, a brief article appeared describing the local celebration of Rosh Hashanah and Yom Kippur:

> *The Bnai Brith congregation of this city will hold services…in its quarters in the new Ellis Building, Main Street…The reformed Hebrew congregation will observe the occasion in the Cohen Building, Main Street.*[97]

By 1902, there were apparently three Jewish congregations in Johnstown.

The Johnstown Black Community

Prior to the Civil War, Johnstown had been a safe haven along certain routes of the Underground Railroad, paths commonly taken by escaped slaves destined for Canadian

freedom. Many prominent Johnstowners in the 1900 era had once aided fugitive slaves. Friendly relations between blacks and establishment white persons were prevalent.[98]

Only a few blacks lived in the Johnstown area prior to 1873, when an earlier abolitionist, William Rosensteel, opened a tannery in Woodvale and actively recruited former Maryland slaves as workers. When his plant was destroyed in the 1889 flood, he rebuilt north of Coopersdale, and continued hiring blacks.

Blacks had also come into the area to construct new railroad lines and facilities, especially the Somerset and Cambria Railroad in 1881. Some were miners. Most lived in Old Conemaugh Borough, Prospect, Kernville and Rosedale. The 1900 census enumerated 314 blacks, less than 1 percent of Johnstown's population. In Cambria County as a whole, only ½ of 1 percent was black. The black population would grow slightly from 1900 to 1910.

Johnstown had two black churches early in the twentieth century. The first was the Cambria African Methodist Episcopal Zion Church, founded at their Woodvale worksite by tannery workers. The building itself was constructed in 1898 at the corner of Haynes and Grant (Menoher Boulevard) Streets, where it remains active. The second was the Mount Olive Baptist Church, founded by railroad workers in Old Conemaugh Borough in 1876. It later merged with the St. James Missionary Baptist Church on Hickory Street. Black children attended the public schools nearest their homes. Few, if any, continued into high school in this era.

Through the prism of English-language newspapers, the black community was something of a curiosity. Lynching in the South and in West Virginia was reported as news, not intimidation pieces. Accounts of brothels housing black and white prostitutes usually originated from reporters covering the courts. Illicit relations between blacks and whites grabbed headlines. Accounts of blacks getting drunk and saying and doing amusing things were also reported.[99]

Although race relations were generally friendly, there were still instances of discrimination. In late February 1900, a theatrical troupe with a predominately black cast had been denied accommodations by most Johnstown hotels. In time, the group's advanced agent did secure quarters "after considerable trouble."[100] The beginnings of a civil rights organization, the Afro-American Union League, got underway in August 1900. Forty people attended the organizational meeting, and officers were elected.[101]

Each year the Johnstown black community celebrated the signing of the Emancipation Proclamation on what was called "Freedom Day," a commemoration usually held in late September or early October. While the program would vary from year to year, there were parades, church services and festivities at Roxbury Park. Civil War veterans, white and black, participated.

Usually on Freedom Day, people looked forward to Jerry Spriggs's ox roast. Spriggs, a barber by trade and an ex-slave, would roast an ox for hours, usually at Roxbury Park. The animal had to be "fat, juicy, nine-months old, and dressing an even four hundred pounds." Spriggs worked tirelessly for twenty-four hours, had his own special sauce and rotated the carcass over a very hot pit. Everyone, black and white, anticipated his barbecues. The money he earned went to the First Cambria A.M.E. Zion Church.[102]

VI. LEISURE

Theater

There were two downtown theaters at the turn of the century. Both were leased to the same enterprising manager, I.C. Mishler of Altoona and Trenton, New Jersey. Mishler orchestrated Johnstown's dramatic and vaudevillian entertainment.

The Cambria Theater was on Main Street near Market, while the Johnstown Opera House, having 1,700 seats and the larger of the two, was at Franklin and Locust. Both institutions accommodated the many traveling actors, vaudevillians, magicians, acrobats, musicians and lecturers who went from city to city providing professional entertainment during the era.

Being on the mainline of the PRR, Johnstown fared well in attracting quality itinerant actors, touring shows and entertainers scheduled for Philadelphia and Pittsburgh. As they went from one city to the other, they often gave performances in Johnstown.

The theater season started in late August and continued until the middle of May.[103] Several times each week during the season, Johnstown was treated to a new play or musical, often with a matinee performance.

If they thought about them at all, the traveling performers were not yet bothered by the rare but occasional motion picture offerings—something of a curiosity. Brief one-reel showings were sometimes included among the dozen or so features of vaudeville shows. Any sound was from an announcer accompanied by piano or orchestra.[104]

Wild West Shows and Circuses

Nothing swept Johnstown like the Buffalo Bill Wild-West Show held at the Point the afternoon and evening of May 30, 1901. The six-hundred-member company included Annie Oakley and Johnny Baker. The troupe performed for crowds estimated at fourteen thousand. Led in person by Buffalo Bill, a promotional parade circulated through a packed downtown. Johnstown's hotels were so full that, "Many a man was forced to spend the night out of bed." Tickets were oversold. Refunds did not include the ten-cent vendor commissions, a rip-off that angered hundreds of people.[105]

On May 11, 1902, the Forepaugh and Sells Circus came to town by train from Pittsburgh. "Circus Day" drew people from a wide area. Passenger trains arriving in town had extra coaches.[106]

Concerts and Lectures

John Philip Sousa brought his band to the Cambria Theater on Thursday, May 23, 1901. Composer Victor Herbert, also conductor of the Pittsburgh Symphony, led his orchestra in Johnstown on February 2, 1901.

Johnstown attracted speechmakers and lecturers. William Jennings Bryan, a populist and a close friend of W.W. Bailey, *Johnstown Democrat* publisher, came to Johnstown often. On January 14, 1902, Bryan delivered a speech, "A Conquering Nation." Condemning recent

U.S. policy in the Philippines, Bryan went on for two hours, was enthusiastically applauded and was even praised by the *Tribune*.[107]

Clubs

The 1903 City Directory listed 134 separate clubs, lodges, societies and local chapters of national organizations. Other similar groups escaped the compilation. Some of these clubs were exclusively for men or women, although a few of the male-only organizations had an affiliated group for wives or other women. Membership requirements were quite exacting, being rooted in church affiliations, national or ethnic origins, occupations or other factors. A number of groups were Masonic while others used Masonic-like rituals and concepts such as ascending elevations or degrees of standing attained after a member had accomplished sequential requirements and passed through various rites often veiled in mystery. Some groups had entrance blackball screening, secret grips and passwords, ethical goals and prohibitions, and pledges never to reveal the details of their organization and its mystery rites.

Most of these groups had three basic functions: social fellowship among like persons, undertaking worthwhile causes and special insurance with club member or member family benefit provisions. Indeed, some clubs with nationwide affiliations were later chartered as mutual insurance companies.[108]

The most socially elite group was probably the Amicus Club, founded in 1881, an organization with about one hundred members. The club held dinner dances several times a year in its Hannan Building facilities. Guests often came from distant cities to attend the events that went on until two o'clock in the morning. Music was usually provided by the Cambria Theater Orchestra.[109] Another group, the Albemarle Club, was similar to the Amicus Club and was also socially prestigious.

Parks

Roxbury Park, later to be called Luna Park and then Roxbury Park again, was a privately owned amusement park about thirty acres in size surrounded by a wooden fence. Its main entrance was near the trolley line terminus, a loop turn-around for the double-track streetcar line that brought people to the park from all over town. An artificial lake was surrounded by a racetrack used for harness and other horse racing. The park catered to group picnics and other events. There were rides, boxing matches and occasional motion pictures.

Johnstown had no public playgrounds in 1900. Children played in the streets and alleys, on vacant lots and open areas including schoolyards.[110]

Athletics

The many baseball and football games in and around Johnstown at the turn of the century were played at Roxbury Park, Westmont and often at the Point Park downtown. Use of the Point for paid admission to sporting events was difficult. In December 1900, the city councils denied a Johnstown Baseball Club request to fence it.[111]

Many cities, including Johnstown, had community teams that played one another. Altoona's team, the Monarchs, was a bitter Johnstown rival, especially in 1901 when the teams' managers had scheduling troubles—both were seeking home-field advantage.

On September 30, 1901, Brooklyn's National League team visited Johnstown and defeated the city team before three hundred spectators. The Johnstown Baseball Club often played the Pittsburgh Athletic Club, the Altoona Monarchs, Uniontown, Charleroi, Punxsutawney and others. Amateur leagues were formed around sponsoring employers and mill units. In 1901, the Physical Culture Club coordinated the activities.[112]

Vice

News accounts of brothels, bawdy and tippling houses and unusual man and woman stories appeared regularly in the English-language press in the 1900 era, a turn-of-the-century version of today's talk shows. Articles about fathers retrieving daughters from houses of ill fame or children in bordello environments were recurring news items.

An ongoing cluster of brothels was situated up Frankstown Road. A few gambling places operated in and around downtown, generally near the PRR station. Calls for crusades to permanently close these places were ongoing. The Republican mayor, John Pendry, whose three-year term began in April 1902, set out to tame guilty patrons and operators with stiff fines and jail sentences. Yet vice continued.

Johnstown was like many other communities. Vice could not be eradicated. Fines were imposed regularly, and efforts were made to keep children away from illicit houses. A Johnstown policeman, Fred Goebert, whose beat included the Frankstown Road, once testified in 1901, "Every Saturday and Sunday night, from two to three hundred men visited the house, and the uproar they caused was oftentimes very loud." When Goebert was asked why he had not "pulled the place," he replied that he was told not to make raids without instructions from the mayor, and no orders had been given.[113]

Good Times and Bad Times

The Johnstown Economy from 1900
until the Great Depression

I. Johnstown Industry

Cambria Steel Company, 1903–1916

Powell Stackhouse, Cambria Steel's president, presented a glowing report at the annual stockholder meeting in 1903. The company had earned $5,660,000 in 1902—a new record. The order backlog was the best ever. In April, a new blast furnace was authorized for Franklin and another would be overhauled.[114]

The enthusiasm was short lived. Cambria shared in a steel-industry downturn.[115] On the whole, 1904 was a bad year. Cambria had more than earned its dividends and other fixed charges, but the residual earnings were meager. A drought had affected what little water there was. Operations had to be curtailed.[116]

Things picked up in 1905. Rail, railcar and general steel orders improved. Cambria received a 13,000-ton order for battleship plate and was shipping six daily carloads of structural material for New York's subway system. Work was completed in 1905 on the Hinckston Reservoir and its pipeline, a system to sustain a 9-million-gallon-per-day flow to the Lower Works. A decision was made to increase the capacity of the rail car shop, and a 200-ton-per-day, twenty-four-inch universal plate mill was added to the Gautier Plant. When busy, it would employ two hundred more workers.[117] In November, Cambria announced its plans to construct a seven-story office building on Locust Street downtown.[118]

The Dark Clouds Gather

At the March 1906 meeting it was revealed that Cambria had earned a net of $4.4 million in 1905. There were sixteen thousand employees, four thousand more than during most of 1904. Capital plans for installing ambitious, state-of-the-art technology were being implemented.[119]

In 1906, Cambria's stock (trading on the Philadelphia Exchange) hit $37.50 per share. John Gates and Henry Frick were investing heavily in Cambria Steel. While the Pennsylvania Railroad Company (PRR) owned over half of Cambria's 900,000 outstanding shares, Frick's acquisitions were viewed with alarm by those worried about Cambria being pulled into U.S. Steel. Frick owned a lot of PRR stock and sat on its board. A major shareholder in U.S. Steel, Frick was also on its board. Speculation about Cambria's being folded into a major conglomerate was revived. The rumors were denied, but kept resurfacing.[120]

Straight Talk

In March 1906, Charles Price, Cambria's general manager and the most important man in Johnstown, invited prominent but unnamed "gentlemen" to a social dinner followed by a "straight talk" discussion, which found its way into the newspapers. Price's theme was that Cambria's ore, coal and limestone resources alone, even if modestly appraised, were equal in value to that of the company itself as measured by its stock price. Cambria shares had to be a good buy. Price was urging his townsmen to invest heavily in Cambria and "keep the dividends in Johnstown."[121]

Throughout 1906, Cambria's stock remained strong. In December it went above $39.00. The leading rumor in investment circles was that Henry Frick wanted PRR's Cambria stock or the railroad's backing a scheme to add Cambria to U.S. Steel.[122]

In April 1906, Charles Price was named vice-president. The promotion brought no change in duties but was welcomed in Johnstown. Price would succeed the aging Powell Stackhouse as Cambria's next president. In mid-1907, Cambria's stock reached a new peak—$46 per share. Speculation persisted: Cambria would be acquired by U.S. Steel; it would be combined with Pennsylvania Steel (in Steelton); Cambria would be merged with other independents to form yet another trust.[123]

The 1906 death of A.J. Cassatt, the railroad president who had engineered PRR's controlling acquisitions in Cambria and Pennsylvania Steel, served as a new opportunity to free up PRR's Cambria shares. Frick was close to Cassatt's successor, James McCrea.[124]

By the time McCrea had become familiar with his new responsibilities, the Rich Man's Panic—the Panic of 1907—was affecting the economy. The stock market plummeted in October and money got scarce. Business was down. The time was not right for the PRR to unload its Cambria stock. Despite the panic, 1907 turned out to have been profitable because of good times earlier in the year. Cambria Steel's earnings had been almost $5 million before dividends and fixed charges. By 1908, however, business had dropped 40 percent. There were layoffs; wages were cut by 10 percent; and the company earned only $800,000—a precipitous drop.[125]

The Quemahoning Reservoir

A major item occupying Cambria management's attention had been the Quemahoning Reservoir and pipeline to supply industrial water to the Cambria mills. For three years the company's leaders were engaged in site assembly and right-of-way acquisition for

the impoundment and the large gravity-flow pipelines. An entire town, Stanton's Mill, was acquired. Work started in 1908. Engineers who had worked on the Panama Canal designed the dam. New machines bored tunnels for the 73,000 feet of pipe, some of them 6 feet in diameter.

The reservoir captured the runoff from a ninety-square-mile watershed. Covering one thousand acres and containing eleven billion gallons of water, it became the largest man-made lake in Pennsylvania. In 1911, the company was testing pipes for reliability, and Cambria Steel began using Quemahoning water in 1912.[126] While solving a longstanding company problem, Cambria Steel had become an even more attractive takeover prize.

From 1909 through 1915, the company's net income (after fixed charges but before dividends) was:

1909	$2,500,000
1910	$5,461,000
1911	$2,777,000
1912	$3,411,000
1913	$6,735,000
1914	$1,961,000
1915	$6,403,000

Donner

On March 14, 1910, Charles Price and Fred Krebs, members of Cambria's board, mounted the train for Philadelphia and the annual stockholders' meeting. Already on the same train was a William H. Donner from Pittsburgh, a newcomer to the board.[127]

Donner had a history of founding companies that got acquired by U.S. Steel. His creations, the National Tin Plate Company of Indiana and the National Tin Plate Company of Pennsylvania, were both acquired by the American Tin Plate Company, the very trust that also acquired and closed Johnstown Tin Plate in January 1901 (this was the Johnstown Corporation referred to by Cyrus Elder in his October 1900 centennial address). American was soon folded into the new U.S. Steel Corporation. With the blessing and backing of Henry Frick and Andrew Mellon, Donner had also created Union Steel at Donora, Pennsylvania. (Donora is a fusion of names: Donner, and Andrew Mellon's wife Nora.) To this was joined the Sharon Steel Company—a Frick scheme to irritate Andrew Carnegie. Once again, the new hybrid joined the U.S. Steel Corporation. Donner's being on the Cambria board was Frick's doing.

Charles Price and Fred Krebs knew that Donner, Frick and others would be trying to get control of all or at least some of the PRR-owned Cambria Steel stock. Should they succeed, no one could predict which of the rumored corporate combinations might entangle Cambria.

To Charles Price, the Johnstown booster and "get-it-done" guy who had fought the pressures to relocate Cambria Steel to Lake Erie and who had been involved in every company endeavor from the Quemahoning to the car shop beginnings, the new wire mill to the modern coke ovens, whatever Donner was trying to accomplish was bad news.[128]

Charles S. Price, probably taken around 1910, the year he became president of the Cambria Steel Corporation.

The Price Presidency

At the 1910 meeting, Price became president of Cambria Steel, a reconfirmation of his appointment made earlier in November.[129] The headquarters were moved to Johnstown. Price was given an "assistant to the president," J. Leonard Replogle, a man whose career he had shaped. In Johnstown, Price would be isolated from Philadelphia intrigue, the world of finance and the wheeling and dealing soon to be underway.

During Price's two and a half years as president, the Quemahoning Reservoir and pipeline began full usage. The rod and wire mill at Morrellville produced its first rods. By early 1912, Cambria was making nails, fencing and wire nets. The company was prospering, but Price's health was declining. He had developed a heart condition. How active he had been during his presidency is not known. At its September 19, 1912, meeting in Philadelphia, Cambria's board tabled a motion to accept Price's resignation submitted due to poor health.[130]

The Philadelphia press was immediately awash with the Frick-Donner speculation. The assumption was that PRR would unload its Cambria and Pennsylvania Steel stock. There was also speculation that Charles Schwab was working with Donner and Frick to acquire Cambria. Schwab was said to have offered the PRR $50 per share, but the railroad had countered with a $60 offer. On that fateful day in September, 3,300 shares sold at $48 each.[131]

A New President

On September 26, 1912, Price's resignation was accepted and Donner was named president. He would continue living in Pittsburgh. J. Leonard Replogle, the newly elected vice-president, would be the hands-on boss, but as it turned out, only for a short time. As

an absentee president, Donner needed someone he could trust to assume the top position. Almost as soon as he became president, Donner replaced Replogle with Edwin Slick, a Pittsburgh colleague.

Replogle, an assistant to Price, was now placed over the sales department, a critically important position but one in which he was inexperienced. Donner probably figured if Replogle did a first-rate job, Cambria Steel would be the winner. Should Replogle fail, Donner could comfortably sack him and be rid of another Johnstown-connected official. Meanwhile Fred Krebs, the former sales director, was ousted. Krebs announced after considering "several flattering offers in the steel business," he would become vice-president of the United States National Bank.[132]

Edwin Slick was a native of Johnstown who had started out as a draftsman in the Cambria Iron Company pattern shop. After the 1889 flood, he became a draftsman for Carnegie Steel, where he developed and held seventeen industrial patents.[133] Slick now became a vice-president of Cambria and a member of its board.

On December 6, 1912, a group of Johnstown business leaders put on an elaborate "get acquainted" reception and banquet for Donner. For whatever reason, James Farrell, president of U.S. Steel, and Daniel Coolidge, president of Lorain Steel, a subsidiary, were also invited.[134] In the speeches that night, Johnstown business leaders were listening for any change in Cambria's corporate policy or a hint of U. S. Steel acquisition.

After opening pleasantries, Donner gave his "get acquainted" speech. He started talking about the remarkable growth of "your" city and credited its success to people owning their own homes and to Johnstown's freedom from "labor troubles." Never referring to Cambria as "our" enterprise, he must have come across as the aloof outsider he was. Farrell discussed Johnstown's historical contributions to the steel industry and dropped no hint of any corporate merger or acquisition.

The Antitrust Case

There had been an earlier development affecting the fate of Cambria Steel, a "fly in the ointment" to Donner and Frick—the antitrust suit filed October 26, 1911, by the U.S. Justice Department. Former President Theodore Roosevelt openly criticized the suit, and historians debate whether President Taft authorized its filing. Its underlying purpose was to break up U.S. Steel.

As long as the suit was unresolved and not withdrawn, U.S. Steel could not acquire Cambria. The environment was ripe, however, for another mega-corporation to offer true competition. The U.S. Steel Corporation was not broken up, but the talk of Cambria's being folded in with it temporarily ceased. U.S. Steel's lower-court victory was appealed by the Justice Department during the Wilson administration.

Back to Philadelphia

While the decisions probably had been made prior to the Great War in Europe, it was announced in September 1914 that Donner had decided to move from Pittsburgh to

Philadelphia. The sales department would be returning to Philadelphia largely to boost foreign trade. Cambria would be opening offices in Mexico City, Rio de Janeiro, Buenos Aires and London.[135]

Instead of acquiring a Philadelphia residence, the Replogle family stayed at the Bellevue-Stratford Hotel. In less than three months, Replogle had tendered his resignation. He was accepting a position in New York.[136]

The Deals

Some might call 1915 the "Year of the Cambria Rumors." The key principals were: Henry Frick, William Donner, Charles Schwab, Leonard Replogle, Alfred Du Pont, Coleman Du Pont (formerly of Johnstown), Effingham Morris (an attorney, president of Girard Trust and a director both of Cambria Steel and the PRR), Henry Tatnall (vice-president of finance, PRR), E.V. Babcock (a wealthy Pittsburgh lumber magnate, formerly of Somerset County, and popular in Johnstown), William Corey (a former president of U.S. Steel; the next president of Midvale Steel), Charles Harrah (president of Midvale Steel), J.P. Morgan and E.T. Stotesbury (senior partner of Drexel and Company). These men typically did business privately without leaving a paper trail of what was said or decided. Press accounts are also unreliable because news items were often leaked for purposes other than giving factual information.

The general picture unfolding began with repeated rumors that Pennsylvania Steel and Cambria would be combined. William Donner, Cambria's president, had recently been named chairman of the Pennsylvania Steel board. It was also reported that Donner personally had options not only for a large amount of Cambria stock but also for a controlling interest in Pennsylvania Steel.[137]

In early August, Cambria Steel stock was in the $55 to $56 range, largely because Cambria had become unusually busy in 1915. There was also the war raging in Europe. On September 18, a Midvale-Cambria merger became the latest speculation.[138] One week later, the *Philadelphia North American* asserted that Cambria and Midvale were combining. Cambria shares in the open market reached $68 on September 26.

The *Tribune* headlines that followed revealed every reasonable possibility: "Schwab May Yet Acquire Cambria Steel is 'Press Guess,'" (September 30); "Donner-Frick Get Control of Cambria Steel," (October 2); "Cambria Again Factor in News," (October 5); "Cambria in Big Merger is a Wall Street View," (October 6); "Cambria Not in Latest Merger" (October 7). These sorts of headlines and gossipy news articles flowed throughout the autumn of 1915.

The Replogle Coup

On Wednesday, November 10, 1915, a new headline appeared on the front page of the *Tribune*: "LEONARD REPLOGLE REPRESENTS INTEREST COMPETING WITH DONNER FOR CONTROL OF CAMBRIA STEEL COMPANY." The article was

a speculative one—full of "no comment" and "he could not be reached for comment" statements. The very next day, the PRR issued a statement that an offer by Replogle had been made but was rejected as inadequate.[139]

Replogle, with solid Drexel Company backing, had put together a buying syndicate to acquire a controlling interest in Cambria Steel stock. Unannounced, Henry Frick had apparently begun to unload his Cambria shares. Without Frick in the picture, Donner began bailing out. He next purchased the New York Steel Corporation, a company he reorganized as the Donner Steel Company. Apparently Replogle raised his previous offer to $80 and the PRR had accepted.

Replogle had successfully acquired a network of options and pledges indicating he had momentary control of Cambria Steel. To make the whole thing work, he had to put together a grouping of corporations that would merge with Cambria, otherwise the options would lapse and the whole deal would collapse. Ostensibly, Donner was working with Replogle to convince recalcitrant stockholders to support his initiative. Exactly how the enormous capital needed to acquire the corporations other than Cambria would be arranged was never made clear.

Evidence soon indicated that Replogle had been seeking deals to unite Lackawanna Steel, Republic Iron and Steel, Inland Steel, the Youngstown Tube and Sheet Company and Cambria into some giant steel trust—a counterweight to U.S. Steel. Charles Schwab's Bethlehem and the empire-seeking William Corey were also being mentioned constantly.

Press gossip also stated that while Donner seemed to be going along with Replogle, he was basically against the whole thing.[140] A reliable report surfaced that Donner had refused a James Campbell permission to examine Cambria's plant and accounts—an inspection sought by syndicate participants. The rumor was probably true, because Donner's instructions would have gone to senior Cambria officials at Johnstown. A news leak was unavoidable.[141]

Replogle's syndicate to create an American Steel Corporation began to fall apart for many reasons. Some of Replogle's PRR options had expired although their renewal was said to have been a certainty.[142]

Midvale

Edwin Slick, a former official under William Corey at U.S. Steel and a loyalist to W.H. Donner, had managed to establish a buying syndicate with enough capital to extend an $81-per-share offer to Cambria shareholders and to reorganize and capitalize the Midvale Steel Company. Included were the Cambria options recently acquired by Leonard Replogle.[143]

Slick's deal was consummated on Saturday, February 5, 1916, at the home of Edward Stotesbury of the Drexel Company. Those who attended were Stotesbury, Arthur Newbold, W.H. Donner, Leonard Replogle, William Corey (now president of the Midvale Steel and Ordinance Company) and Samuel Vauclain (a Midvale director). Edwin Slick was not listed as attending although his presence may have been assumed.

On February 7, 1916, an announcement was made that the Midvale Steel and Ordinance Company had acquired the Cambria Steel Company. Donner was gone. William Corey would be Midvale's president and CEO. Edwin Slick would remain as vice-president and general manager in Johnstown. Cambria's new president was Alva C. Dinkey.[144]

Ironically, the giant, Cambria, had been taken over by a comparative midget. In a New York Stock Exchange application reported in both the *Wall Street Journal* and the *Johnstown Tribune* in March 1917, the Midvale Steel and Ordinance Company consisted of the following subsidiaries with their values:

Midvale Steel Company	$9,749,500
Worth Brothers	$250,000
Cambria Steel Company	$43,753,400
Wilmington Steel	$100,000
Union Coal and Coke Company	$5,000
Remington Arms	$50,000
Buena Vista Iron	$500,000
Midvale Steel and Ordinance Company total	$54,407,900

Midvale invested heavily in its Cambria subsidiary. Blast furnace Number Nine in the Franklin Works, installed in a record eighty-five days, created a news sensation. In December 1916, two new blast furnaces were authorized—Numbers Ten and Eleven costing $3 million. A $4 million wheel plant was also approved.[145]

Bethlehem Steel Comes to Town

After acquiring the Cambria Steel Corporation, the Midvale Steel and Ordinance Company prospered because of the war. The change back to peacetime, coupled with the steel strike in 1919, caused a sharp drop in production.[146] Nevertheless, 1919 turned out to have been a moderately profitable year. While Midvale's 1920 output had almost returned to wartime levels, net profits were down due to skyrocketing labor and railroad costs. Midvale's 1919 and 1920 profits combined were well below each war year.

In both 1921 and 1922, times were bad throughout the American steel industry. Midvale actually lost money and omitted its dividends.[147]

Aside from the war-related earnings, the several Midvale years were not memorable ones in terms of cutting-edge innovation or contributions to steel making. Nothing suggests outstanding management. The following table summarizes Midvale's operations during the several years when it owned Cambria Steel. Cambria Steel operations comprised about 80 percent of Midvale's total.

Midvale Steel and Ordinance Company—Annual Data, 1916–1922[148]

Years	Steel Output in Thousands of Tons	Net Profits
1916	1,558	$32,215,000
1917	1,614	$35,577,000
1918	1,449	$29,209,000
1919	853	$10,559,000
1920	1,310	$12,425,000
1921	510	-$5,313,000 (loss)
1922	not available	-$1,901,000 (loss)

The Urge to Merge

In March 1920, the U.S. Supreme Court finally disposed of the long-standing antitrust action against the U.S. Steel Corporation and ruled that the conglomerate was not a monopoly in restraint of trade. The decision made other industrial mega-mergers easier to accomplish.

In early May 1922, leaders from Youngstown Sheet and Tube, Lackawanna, Inland, Republic and other steel companies joined with William Corey and Alvah Dinkey for a firsthand inspection tour of the Cambria Steel facilities at Johnstown.[149] A few days later, the Bethlehem Steel Corporation, led by Charles Schwab, made arrangements to acquire the Lackawanna Steel Company. Rumors next began to circulate that, despite a bitter feud between Eugene Grace of Bethlehem and William Corey of Midvale, Bethlehem would acquire Midvale or at least the Cambria Steel part of it.[150]

Five companies—the Brier Hill Steel Company, the Tube Company of America, Inland Steel, Republic Iron and Steel and Midvale—reached a tentative merger agreement. For some perplexing reason, especially so in the wake of the Supreme Court decision, the group decided not to finalize an agreement until a review had been undertaken by the Federal Trade Commission, an understanding reached at a meeting on May 24 with the U.S. attorney general, Harry Daugherty.[151]

On June 2, 1922, an announcement was made stating that only Inland, Republic and Midvale were still in the agreement. But in less than two weeks, the shaky proposal was awash in scandal.[152] A grand jury was being impaneled in New York to investigate alleged irregularities involving participating investment houses. At the same time, dissatisfaction had begun to surface over the comparative gains to be had by stockholders of the three merging corporations.

Shortly afterward, B.C. Forbes, founder of *Forbes* magazine and a noted author who covered business matters, spent several days in Johnstown doing an article for the June 28 issue of *Public Ledger*, a Philadelphia publication. Forbes had attended an open forum about the steel merger sponsored by the Johnstown Chamber of Commerce, where he heard one criticism after another.

Underway was probably a carefully orchestrated ploy masterminded by Bethlehem's Charles Schwab of Loretto (near Johnstown) and New York City. Schwab had often

expressed a desire to own Cambria Steel. As such, he would have had every reason to shatter the North American Steel Corporation before it was founded. Schwab's brother-in-law, David Barry, president of the First National Bank, was enormously influential in Johnstown. In addition, J. Leonard Replogle, a close friend of Schwab's and now a respected figure in the American steel industry, knew almost everyone in town and returned to Johnstown often. There was much to be said, from a Johnstown well-being perspective, in favor of the Cambria Steel Company becoming part of Schwab's Bethlehem Steel Corporation and everything to lose by its joining with Republic and Inland into some new venture clouded with uncertainty as to management, board, headquarters location and agenda.[153]

In his article, Forbes wrote:

> *If Cambria is to figure in any merger, Johnstown would prefer to have Schwab get it. Charlie Schwab is a nearby neighbor, popularly regarded as extremely able, trusted, friendly toward his own country folks.*[154]

Next, the Federal Trade Commission decided on September 1 that the three-company merger would violate the Federal Trade Commission Act. Its ruling stated there was reason to believe that the consolidation of the three companies "will eliminate competition… and…create a monopoly in iron and steel production."[155]

When one considers that only two years earlier the mammoth U.S. Steel Corporation had been judged non-monopolistic by the Supreme Court, the trade commission's objections leads one to conclude that there was an untold story. Three weeks later the Midvale-Inland-Republic deal was scrapped.[156]

Enter Bethlehem

On July 28, 1926, two hundred friends honored Charles Schwab at an Ebensburg gathering. In a relaxed atmosphere, Schwab told of his Cambria Steel negotiations four years earlier:

> *I could not bargain with my old associate, W.E. Corey, so I sent Eugene G. Grace, president of Bethlehem Steel Corporation. Grace wired me, "Can get it for ninety million." I wired back, "Get it for eighty-five." Grace wired back, "Can get it for ninety." I wired back, "Get it." In three minutes came the message, "Got it."*[157]

Bethlehem's acquisition of Midvale was announced on November 25, 1922. For every two shares of Midvale, the owner would receive one share of Bethlehem stock.

Meeting with a delegation of Johnstowners in New York between Christmas (1922) and New Years Day, Schwab assured everyone their new Bethlehem shares would be voting stock. He also informed them that Bethlehem planned to spend $100 million upgrading the Johnstown mills.[158] Two weeks after the acquisition announcement, Schwab—needing no press leaks or public-relations consultants—had an opening to "show his stuff" to the

Johnstown community. George Clemenceau, France's wartime premier, traveling with Bernard Baruch on Schwab's private railroad car the "Bethlehem," visited the Schwabs at Immergrun, their palatial Loretto home.[159]

On March 12, 1923, the Midvale and Bethlehem merger got shareholder approval. Bethlehem President Eugene Grace soon arrived in Johnstown. John Ogden, general superintendent, retired. A Cambria vice-president, Louis Custer, became general manager. Grace announced, "The general manager of the plant is in control of the work." Custer's assistant was R.J. Wysor, a man familiar with Bethlehem's methods. The new faces represented modest changes. Several had worked in Johnstown before and were now asked to return.[160]

Bethlehem Steel at Johnstown in the Roaring Twenties

> *I want to make the Cambria mills a credit to Cambria County. It is our policy to build when times are dull, and they certainly are dull at the present time. We raised $30 million in New York a short time ago, and at least $20 of the $30 million will be spent here and in the next eighteen months. I want to make the Cambria works one of the greatest in the world...*
>
> *I spent my youth here and it was a happy youth. I want to spend my last days here...for the good of old Cambria County.*

Schwab delivered these words to Johnstown's Rotary Club on June 18, 1924. The speech was happy news all over Johnstown.[161]

Bethlehem's president, Eugene Grace, had confided that management's biggest problem throughout 1923 was fitting Cambria, Midvale and Lackawanna into Bethlehem Steel. The fiscal results from 1923 operations marked a big improvement over 1922. As soon as Bethlehem had acquired Midvale and its Cambria subsidiary, a modest improvement program of about $1 million had gotten underway. The larger program mentioned by Schwab in his Rotary speech would be invested chiefly in the Gautier Works near downtown.

Late in 1924, the steel industry slump began abating. By mid-December, the Cambria Works at Johnstown were operating at almost 80 percent. The workforce numbered about twelve thousand. New orders were coming in faster than shipments. Despite the late-year surge, Bethlehem had earned only $8,916,000 in 1924 compared with almost $14.5 million in 1923.[162]

Cambria's finished products in the mid-1920s included steel freight cars, wheels and axles; wire and wire products; rolled steel blanks for gears, flywheels and circular forgings; bars; multipurpose small shapes; steel mine ties; steel plate; and ingots, blooms, billets, bands and slabs. Cambria also produced coke for internal use locally as well as for sale to others. It was also turning out twenty different coke by-products including Benzol, a chemical Cambria had begun producing at the urging of Thomas Edison early in the European war when the supply from Germany ceased.[163]

Capital Improvements in Bethlehem Mills

In late April 1929, L.R. Custer, Bethlehem general manager, announced a capital program of $10.5 million to include a long list of plant items, especially by-product coke ovens and a new blast furnace to replace Number Seven at Franklin. In December 1930, Bethlehem Steel began to showcase its Johnstown plant, normally off-limits. A group of over one hundred Johnstown leaders were given a special tour, a forerunner of the public-relations tours for customers nationwide to see the massive capital improvements made at Johnstown during the past six years. The company issued photographs and news items that boasted facilities as modern as those anywhere in the world. A dozen separate articles about Bethlehem's Johnstown mills appeared in local newspapers in December 1930 and January 1931.[164]

The Franklin site was crowded with facilities—the corporate design philosophy was to add much larger units where possible. The Number Seven furnace, for example, was two hundred feet tall, and its furnace chamber was ninety-five feet high. Enlarged and rebuilt, it was rated 850 tons daily (previously 500 tons). The two batteries, each with seventy-seven coke ovens, could turn out 2,600 gross tons per day. Their designers were using combinations of coke and blast-furnace gases to fire the ovens.

The plant tours were part of a Bethlehem strategy to sell steel in an eroding economy.[165] The Johnstown Works had benefited from $30 million capital improvement upgrades in anticipation of robust markets. The Great Depression had arrived, however, and the anticipated steel boom would be a decade in the future.

Lorain Steel

Lorain Steel, after 1901 a part of the U.S. Steel Corporation, continued to modernize its site at Moxham. In January 1903, an enormous investment (for the times) of $500,000 was spent on general additions and improvements. Again, in September 1904, the company authorized construction of a new hammer, bolt, shear and truck facility, 250 by 165 feet in size.

In early 1906 a new building, 175 by 375 feet in size, was constructed as part of an improvement program that continued well into 1907. The new buildings and other modernization work were part of a program intended to double the plant's output and increase its workforce from 1,000 in November 1906, to about 1,600.[166]

Lorain was installing trolley systems worldwide. An announcement in the *Johnstown Tribune* on November 30, 1904, revealed that a Milt Brown had been overseeing the installation of a Lorain Steel trolley system in Wolverhampton, England, over a period of about a year and a half. He and his wife were returning to Johnstown. In 1905, Lorain Steel was installing street rail systems in Glasgow, Scotland; Cape Town, South Africa; Montevideo, Uruguay; London, England; Melbourne and Sidney, Australia; and Tokyo, Japan.

The Lorain Steel Company also remained a dominant provider for U.S. communities, a role that would continue until after World War II.[167] Even after streetcars were becoming obsolete, the plant continued to produce special tracks and components for trolley systems, mines and factories—product lines that were continued by U.S. Steel until November 1959.

National Radiator

Johnstown's third most significant manufacturing enterprise was the National Radiator Corporation, an outgrowth from the earlier Fowler Radiator Company acquired by John Waters and his brother, Samuel, in 1896 and moved soon afterward from Norristown to a Moxham location adjacent to the Lorain Company plant. Eventually owning factories in Trenton, New Jersey, and in both Lebanon and New Castle, Pennsylvania, National Radiator prospered in the 1920s, recovering from a lean war period. In 1926, the company added its new office building on Central Avenue (today's Cambria-Rowe Building).

On August 8, 1927, establishment of the National Radiator Corporation of Delaware, capitalized at $25 million, was announced. John Waters of Johnstown, president of National Radiator, would be chairman of the new corporation to include the Union Radiator Company on Bridge Street; Gurney Heater Manufacturing Company of Framingham, Massachusetts; Continental Heater Company of Dunkirk, New York; Niagara Radiator and Boiler Company of North Tonawanda, New York; and Utica Heating Company of Utica, New York.

National Radiator had become the dominant American firm in the manufacture and distribution of radiators and small boilers and John Waters remained chairman; his brother and son continued to hold top corporate positions. Local employment remained around five hundred. The headquarters would remain in Johnstown.

Like many mergers, there were power struggles and clashes of corporate cultures. Knitting former competitors together proved formidable. Despite an earlier statement that the headquarters would remain in Johnstown, it was moved to New York City, and a Grant Pierce was named president. While the corporate infighting can only be imagined, the headquarters returned to Johnstown in 1930 with several executives. John Waters was president and CEO.[168]

Trucking

Commercial trucking, limited to comparatively short hauls, also got underway in the period after the First World War. Growing in importance for Johnstown was the American Railway Express Company (later the Railway Express Agency). Jointly owned by all U.S railroads, Railway Express developed its own local trucking system and storage facilities as adjuncts of the two passenger railway stations. Items to be shipped were picked up by agency trucks, loaded onto special freight cars attached to trains, off-loaded at the destination city and delivered by truck to the addressee. Railway Express service in Johnstown got underway near the end of the war and was well established by 1920.

Johnstown's Smaller Industries

Johnstown was home to a number of smaller industries between 1900 and the Great Depression. The leading ones are briefly detailed here:

Firm	Location	Product	Employment
A.J. Haws	Cambria City; Coopersdale	fire brick; tuyères for steel mills	450 (c. 1910)
Century Stove	Moxham	stoves	100 (c. 1905)
Hiram Swank	Woodvale	fire brick for steel industry	85 (c. 1905)
Globe Iron and Foundry	Morrellville	iron foundry products	75 (c. 1905)
American Spec. Stamping Co.	Hornerstown	pots and pans; enamel productss	60 (c. 1905)
Bruce Campbell Co.	Oakhurst	building bricks	60 (c. 1905)
W. De Frehn	Hornerstown	wooden chairs	40 (varied)
Johnstown Shirt	Hornerstown	shirts	400 (varied)
Brooklyn Hospital	Woodvale	metal hospital furniture	75 (varied)
Brown-Fayro Co.	Oakhurst	coal-mining equipment pumps	70 (varied)
Davis Break Beam	Morrellville	brake beams for railcars, etc.	100 (varied)
Flood City Brass and Electric Co.	Hornerstown	brass; bronze; aluminum castings; machinery parts	50 (varied)
Harris-Boyer Bakery	Morrellville	bread; pies; cakes	varied
Penn Cigar Co.	Cambria City	"Solitas" cigars	60
Allen Cut Glass	Hornerstown	cut glass	8
Buser Silk Co.	Hornerstown	ribbons; decorations; etc.	varied
Hartmann-Schneider	Hornerstown	overalls; work clothes	22 (c. 1905)
Penn Machine Co.	Ferndale	specialty metal; mining equipment	80 (varied)
Griffith-Custer Steel	Downtown, Washington St.	structural steel products	30–40

Other Johnstown Industry—1920s

While the Johnstown economy grew and underwent modification, there were no fundamental structural changes during the 1920s. The leading industries were iron and steel, and some products made from them, coal and coke, bricks and clay refractory products and, to a lesser extent, lumber, wood products, food and clothing.

More specifically, Johnstown products included but were not limited to: railroad cars, mine cars, wire and wire products, nails, gears, bushings, brake beams, fencing, fire escapes, washers, lock nuts, sheet steel, pumps, hoists, trolley infrastructure items, specialty track, street car wheels, tires, coal loaders, bricks, industrial refractory products, radiators, boilers, stoves, springs, folding and set-up boxes, soaps and washing powders, playing cards, coke by-products, wooden chairs and porch swings, wood furniture, pants, shirts, overalls, mattresses, cut glass, packaged meats, bakery goods, soft drinks, ice cream, candy, beer and cigars.

In terms of comparative volume of Johnstown products shipped, the following is an estimate of certain lines measured in annual railroad carloads shipped in the 1928–29 period:

Product Category	Railcar Loads
coke	7,986
coal-coke by-products	2,314
brick	1,315
clay products	514
iron and steel	32,457
coal	17,445
ferro manganese	1,846
radiators	3,964
stoves	75

II. JOHNSTOWN BANKS

The general growth and prosperity of Johnstown in the fifteen years prior to the United States' entry into World War I is reflected in the progress of its financial institutions. Johnstown's banks were locally owned and managed. Using the First National as its central nexus, they operated their own clearing house to facilitate daily inter-bank settlements.[169]

Johnstown Bank Resources in Thousands of Dollars

Institution	1904	1908	1910	1912	1914
First National	$2,730	$4,680	$7,005	$7,047	$7,605
Citizens National[a]	$1,438	$1,485			
U.S. National	$1,296	$1,855	$2,501	$2,698	$2,911
Union National	$124	$983	$1,334	$1,414	$1,613
Johnstown Trust	865$	$1,495	$1,911	$2,074	$2,225
Dollar Deposit[b]		$375	$510	$545	
National Bank of Johnstown					$1,069
(National) Title Trust	$664	$1,232	$1,394	$1,394	$1,494
Cambria Trust				$239	$479
Farmers Trust				$465	$605
Johnstown Savings	$2,785	$2,713	$2,848	$2,9112	$2,956
Grand Total	$9,238	$14,285	$17,341	$18,788	$20,957

a. Citizens National Bank was taken over by the First National Bank in December 1909.
b. Dollar Deposit Bank was renamed and became the National Bank of Johnstown in March 1914.
Source: "Barry Shows Bank Growth," Johnstown Daily Tribune, March 4, 1915.

When the United States entered World War I, there were eleven banks in Johnstown including two in East Conemaugh Borough. These were:

Institution	Total Resources (1917)
First National Bank—Johnstown	$9,425,000
U.S. National Bank	$3,693,000
Union National Bank	$1,739,000
Johnstown Trust Company	$2,786,000
National Bank of Johnstown	$1,608,000
Title Trust and Guarantee Company	$1,763,000
Cambria Trust Company	$954,000
Farmers' Trust and Mortgage Co.	$670,000
Johnstown Saving Bank	$3,062,000
First National Bank of East Conemaugh	$817,000
Conemaugh Deposit (E. Conemaugh)	$307,000
Grand Total	$26,818,000

Postwar Banking Complexities

On May 10, 1919, the Moxham Deposit Bank, which would become the Moxham National Bank in 1922, got started at a temporary location on Ohio Street. Its permanent quarters were later built on Central Avenue.[170]

Six weeks later, a new Johnstown State Deposit Bank opened at 544 Central Avenue next door to the site for Moxham Deposit's new building. In 1921, Moxham Deposit directors failed in an effort to merge with its new rival.

In June 1919, the U.S. National Bank acquired the Hannan Building on Franklin Street, the site for its new "tallest building in Johnstown."[171] In mid-April 1921, the Pennsylvania Trust Company opened in the former Tribune Building on Franklin Street but it soon moved to 504 Main Street, a few paces west of the Johnstown Trust Company on Main Street.[172] In June 1921, the Dale Deposit Bank opened at 719 Bedford Street in Dale Borough.[173]

In April 1923, the U.S. National Bank acquired the National Bank of Johnstown and soon afterward effected a merger between the Cambria Trust Company and the Farmers' Trust and Mortgage Company. The combined entity became the U.S. Trust Company, an affiliate of the U.S. National Bank.[174] U.S. Trust occupied the former U.S. National Bank building on Franklin Street (between the First National and the newer U.S. National buildings) but also retained the Cambria Trust location in Cambria City, creating the first branch bank in Johnstown. Not to be outdone, the First National also opened a branch in Cambria City.

On September 30, 1924, the Title Trust and Guarantee Company acquired the Morrellville Deposit Bank on Fairfield Avenue. After the acquisition, Morrellville continued functioning, however, using the same name. In November 1924, the U.S. National Bank bought the First National Bank of East Conemaugh, which reopened as the United States Savings and Trust Company.

Title Trust, in October 1927, acquired the Pennsylvania Trust Company on Main Street, but closed down at that location. In December 1927, Title Trust acquired a controlling interest in the Johnstown State Deposit Bank adjacent the Moxham National Bank on Central Avenue, but it continued to operate as the Johnstown State Deposit Bank.

In early November 1927, the First National Bank and the Title Trust and Guarantee Company (which controlled the Morrellville Deposit Bank and was soon to control the Johnstown State Deposit Bank) had become governed by an interlocking directorate—all First National Bank board members. This had come about when major stockholders at First National successfully acquired a controlling interest in the Title Trust and Guarantee Company, a competitive counterweight to its rival's U.S. Trust. On January 23, 1928, the First National Bank acquired the Union National Bank.[175]

The Way Things Really Were

The early twentieth century had seen the rise of many small, poorly financed banks in Johnstown. By the end of the 1920s, many of the smaller banks had been absorbed into one of the two dominant ones—the First National or the U.S. National. A beginning system of branch banking was getting underway, almost always a result of neighborhood banks being acquired by a major institution.

The U.S. National Bank was governed by a twenty-five-member board that tended to be reelected annually. The First National's board had only eight members including David Barry and its cashier, P.F. McAneny. For the most part, bank presidents served as board chairpersons. The cashiers served as the chief executive officers. David Barry, president of the First National and Charles Schwab's brother-in-law, was an exception. Barry ran the bank. His connection to Schwab gave the First National an image of strength and solvency.

While some of First National's board members were Protestant, most were Catholic. Unlike the U.S. National's board, there were no Jewish members. It was said that most Catholics banked at the First National.

Tacit informal arrangements were taken for granted. If you got your construction loan at the U.S. National Bank, for example, it was smart to buy building materials at the John W. Walters Company. Representing a huge slice of Johnstown commerce, the U.S. National Bank's large board doubtless brought corporate accounts to the bank, spawning countless arrangements benefiting the bank and its board members.[176]

III. PUBLIC UTILITY DEVELOPMENTS

The Guffey-Queen Syndicate

In June 1908, a Pittsburgh financier, Emmet Queen, acting for his Guffey-Queen Syndicate, began a lengthy venture to acquire both the Consumers' Gas and the Citizens' Light, Heat and Power Companies. After repeated difficulties and sweetened offers, the acquisitions

First National Bank at Main and Franklin as seen from Central Park. The building appears to be nearing completion, which would date this photograph likely from the winter of 1911–12.

were finalized before Christmas in 1909. Queen was named board president but would remain in Pittsburgh. Herbert Weaver, an assistant to the general manager at Cambria Steel, became the full-time general manager in January 1910.[177]

Joe Cauffiel, a local real estate broker who had fought everything about the transaction, continued trying to nullify the Citizens' charter. Although unsuccessful, the efforts served to keep his name before the public as a sort of crusader.[178]

Hodenpyle and Walbridge

Queen had been a front for a New York investment group, Hodenpyle and Walbridge, owner of almost all the new Citizens' Company stock. Specializing in gas and electric plants, the firm controlled about forty operations in the United States, including some large city systems.

A transformation was already underway in the power industry. Numerous small electric plants were being absorbed into bigger, more centralized systems. Hodenpyle and Walbridge was active in the trend.[179]

Other centralization initiatives were getting underway nearby. A large Altoona-based concern, the Penn Central Light and Power Company, had constructed an immense 7,500-kilowatt hydro-steam complex at Warrior's Ridge on the Juniata River to supply Lewistown and Altoona. Centralization was necessitating another comparatively new technology—high-voltage wires.

To the west of Johnstown, West Penn Electric, another giant, had developed and was operating a large power plant at Connellsville that was supplying forty-three scattered western Pennsylvania communities. The company was planning a new subsidiary, the Johnstown Power Company, to serve Johnstown—a future challenge for Citizens'.[180]

Also thinking regionally, Citizens' had been developing a new subsidiary to sell power to sawmills, mines, feed mills and some of the boroughs in Somerset County. By early 1913, the company was seeking to acquire the eleven franchises in outlying areas that it was already supplying wholesale.[181]

The Mega Deal—Penn Public Service

In the postwar years, the large regional utilities continued cross-connecting their transmission lines. Besides Citizens', the leading power utilities were the Penn Electric Service Company and the Penn Public Service Company, whose territory included parts of Indiana, Clearfield and Center Counties.

In May 1919, the three interconnected utilities negotiated a merger agreement to form the Penn Public Service Corporation (PPS) with headquarters at Johnstown. Stockholders approved the consolidation in early June 1919. By April 1920, PPS gave its Johnstown employment as 175. Several months later, the PPS Corporation announced the proposed construction of a massive, mine-mouth generating plant at Seward. The trend toward fewer, larger generating plants was ongoing. With a 100,000-horsepower initial rating and specifically designed for future expansion, Seward would supply electricity to several counties including Cambria.[182] Financed through $50 million in bonds, it was completed in 1921.

In September 1921, PPS began an even larger plant in Clarion County. When this partly hydroelectric plant came on line in 1924, it could generate 400,000 horsepower, one of the biggest plants east of the Mississippi.[183] In 1925, the Deep Creek Station in Western Maryland, a PPS hydroelectric plant, also went into service.

Not only was PPS constructing what were then called "super power plants," but it also continued extending high-power transmission lines and interconnecting them with other regional electric utilities. In 1927, the Penn Public Service Corporation took a new name— the Pennsylvania Electric Company, often shortened to "Penelec."

Telephone

In the very early 1900s, the Johnstown Telephone Company was locally owned, controlled and managed. The company policy was to expand its customer base, to facilitate long-distance connections, to keep the local plant equipped with state-of-the art technology and to avoid acquisition by outside interests.

Since the American Bell Company had a weak presence in Johnstown, the local company had to outdo its rival. The Bell and Johnstown Telephone systems competed side by side. A customer of either system could not dial into the other except "at excessive cost." Many businesses were customers of both companies. In late 1905, Johnstown Telephone had over 3,500 customers to Bell's approximately 100.[184]

In April 1906, the Johnstown Merchants' Association passed a resolution:

> *Inasmuch as the Johnstown Telephone Company's rates are about one-half former Bell rates and it is giving a satisfactory service...be it: Resolved...we hereby declare ourselves as being favorable to our home-telephone company, the Johnstown Telephone Company exclusively, so long as it operates under the present policy and maintains the present schedules of rates.*

Bell had been engaged in an aggressive campaign to secure more customers by lowering rates. Local businessmen could sense a growing need to maintain connections in both systems. Merchants were thinking that if everyone enrolled with Johnstown Telephone alone, the Bell presence would wither.[185] Bell, however, continued operating in Johnstown, competing with the local company until the late 1930s.

The Rate Increase

The Johnstown Telephone Company in the early 1920s was experiencing something of a public-relations nightmare. Service complaints were frequent. Petitions were filed with the Pennsylvania Public Service Commission alleging inadequacies. The PSC in turn conducted hearings that provided an outlet for public criticism but accomplished little.[186]

On February 26, 1927, the company filed a new tariff with the PSC, raising its rates dramatically. An individual with a private line would be paying $3.50 instead of $3.00 and a business line was increased from $4.00 to $6.00 per month. There was a community-wide protest bringing an unusual unity among all classes and factions—politicians, city government leaders, the Johnstown Chamber of Commerce and even the local newspapers.[187]

On April 5, the city council instructed Tillman Saylor, city solicitor, to file a protest prior to the effective date. The proposed tariff took effect on May 1. Two years later, on May 11, 1929, the PSC finally made a ruling revising the rates downward.

Five months after the rate-reduction ruling, it was announced that the Johnstown Telephone Company would be sold to an unnamed national telephone corporation. On January 24, 1930, the Associated Telephone Company acquired the Johnstown Telephone Company. There had been about one thousand local stockholders. The headquarters moved to Erie.[188]

Water Supply

The Johnstown Water Company, an entity controlled by the Cambria Steel Corporation, struggled in the early twentieth century to address several conflicting problems and goals:

- *Increasing its water system to keep up with population growth and industrial need.*
- *Phasing out water sources spoiled by contamination.*
- *Providing treatment (chlorination) to combat disease hazards.*

The company's biggest early project was the 800,000,000-gallon Saltlick Reservoir constructed between 1908 and 1914. A smaller impoundment on Laurel Run, developed between 1915 and 1919, provided another 101,000,000 gallons of storage.

In January 1910, the company initiated a multi-year program to install water meters. It was finished in 1930. Chlorination started in 1917.[189]

During a great drought in 1922, planning got underway for a major addition, the North Fork Reservoir. Constructed between 1925 and 1932, the impoundment had a 1.1-billion-gallon capacity—the largest in the company's inventory.

The idea of the city acquiring the Johnstown Water Company surfaced from time to time. Joe Cauffiel's mayoral campaign platforms always called for municipal acquisition, and the newspapers sporadically editorialized generally in favor. The issue would fade away but would resurface later.

IV. HOSPITALS

Conemaugh Valley Memorial Hospital (CVMH)

The patient load at CVMH continued to reflect general population growth. In 1903, Boyd and Myton, a local architectural firm, was retained to design a fifty-bed addition directly in front of the administration building. Work was finished in May 1905.[190]

The number of hospital patients continued to grow. During the first decade after the hospital's founding, it had averaged about 1,000 patients per year. By 1910, CVMH was handling almost 2,500 and the hospital was crowded in the extreme.

The hospital received budgetary appropriations from the Commonwealth and modest ones from the county. There were constant fund drives and ticketed events to generate money.[191] CVMH admissions reached 2,662 in 1914, although Mercy Hospital had opened in January 1911 and was in full use by July 1912.

A major expansion to CVMH was inevitable.[192] In July 1916, a campaign to raise $125,000 for expansion and modernization got underway. The effort quickly generated over $140,000.[193] Before construction was started, however, the United States entered the First World War and the project was deferred for the duration.

In early January 1927, a major new $800,000 addition was dedicated providing Memorial with a 350-bed capacity that could be increased by another 50 beds in an emergency.[194] CVMH remained a busy but financially strapped institution. There were constant appeals for money to meet capital needs and operating deficits.[195]

Johnstown City Hospital

Construction of the Johnstown City Hospital was largely finished by January 1906, and it went into operation in July. The promising start-up soon became troubled. By November there were policy and management disagreements exacerbated by a rising deficit. The start-

up leaders, Dr. J. Swan Taylor and Dr. William Rauch, resigned in a management dispute, as did the matron and a few nurses. The new leaders were Dr. A.S. Fichtner and Dr. William George. In 1907 there was a fund drive to meet an operating deficit.

Johnstown City Hospital was poorly located on a hillside in Dale Borough. The site was inconvenient to the trolley at Bedford Street and was not on a major thoroughfare.[196] Johnstown City Hospital merged with Conemaugh Valley Memorial Hospital in late May 1920. The building served as a maternity unit until closing in 1923.

Mercy Hospital

The Sisters of Mercy had begun planning for a Johnstown hospital several years before resolving its location, the Henry Fritz home on Franklin Street near Valley Pike. On January 20, 1911, Mercy Hospital opened on a modest scale. The former Fritz residence was the initial hospital. Seven Sisters made up the nursing staff. The facility could care for twelve patients.

Plans were immediately developed to construct a new but somewhat small hospital on the hillside. A three-story building with a forty-bed capacity plus a children's ward was erected in 1911. It featured concrete floors, porches and spacious halls that were connected with the old homestead.

Mercy had a modest but promising start. During its first year, it had cared for 339 patients at an average cost of just over $2.05 per patient. By 1915, Mercy began constructing a new wing for nurses and a maternity ward. By April 1916, the Sisters were developing plans for extensive wing additions to occupy the general area north and west of the Osborne-Franklin intersection.[197]

Lee Hospital

Mrs. Emily Munson (Swank) Lee died in March 1916. She bequeathed her Main Street home plus $100,000 to establish a homeopathic hospital as a memorial to her husband, Dr. John K. Lee, a Johnstown flood victim. Mrs. Lee had been a sister of James and George Swank.

In the beginning the hospital made use of the Lee home, remodeled into a twenty-five-bed hospital. In April 1928, the trustees authorized a three-story building to cost $150,000. It opened in late March 1929.[198]

Municipal (Contagious Disease) Hospital

In November 1902, the Johnstown Municipal Hospital opened in Prospect. Miss Margaret Waters, a recent graduate of the Conemaugh Hospital nursing school, was named superintendent. The nickname "pesthouse" was dropped, and the facility was from then on typically called the "contagious disease hospital." Its patients were those with highly infectious diseases—smallpox, diphtheria, scarlet fever, typhoid fever and whooping cough. The new sixty-bed facility with a full-time nurse superintendent drew few start-up complaints.[199]

By the mid-1920s, however, the institution had fallen into disrepair. It had been averaging only fifty-five patients a year and was operating at a loss. On November 30, 1928, an agreement was made for an all-physician committee of the Cambria County Medical Society to be responsible for the hospital.

V. LOCAL OWNERSHIP AND CONTROL

The Chain Store Vilification

Among many Johnstown businessmen, the term "chain store" had become a dirty word—probably a reaction to the price competition from the F.W. Woolworth, W.T. Grant and the McCrory stores—all being on Main Street throughout most of the 1920s.

In 1927, the Johnstown Credit Exchange, a consortium of local proprietors, brought in a keynote banquet speaker from Chicago, R.H. Nesbitt, who blasted the chain store movement. Nesbitt praised a nameless town in the Midwest where the population had boycotted the chain stores and drove them out of business, a civic crusade to support local merchants. The community had sensed that the chains would strip away its wealth, dry up locally owned stores and curtail community bank business. Nesbitt stated:

> *Persons who help the foreign chain store are hurting themselves…It is the home merchant who supports your churches, your lodges, pays your taxes for the making of community improvements.* [200]

Homegrown Chains

While the Johnstown Credit Exchange might exhort the community to shun doing business with the chains, the organization was unable to address the reverse situation—local merchants evolving into chains themselves—exemplified by the McCrory stores.

John G. McCrory, a native of Indiana County, had come to Johnstown in 1887. After the 1889 flood, he had started a small store on Washington Street with two salesladies. By 1912, McCrory's enterprise had evolved into a twelve-store chain scattered over such places as Wheeling, Altoona, York and Jamestown, New York. The corporate headquarters later moved away. [201]

In November 1929, Nelson Elsasser, president of Nathan's department store, announced that Nathan's on Main Street was withdrawing from merchandising in Johnstown—a major jolt, as the store had expanded all the way to the Vine-Franklin corner in the early 1920s. Elsasser's statement had included even more shocking news—the Kresge Company, a chain firm, had leased the original Nathan's building for one of its stores to open in January 1930. Nathan's had also evolved into a chain operation, the "Nelson Stores," with seven scattered locations. [202]

Chain operations were not limited to retail merchandising. In 1913, two brothers, Harry and George Cupp, owners of a grocery store on Fairfield Avenue, began a slow process of

opening companion grocery stores and acquiring others that became available. By 1920, there were twelve Cupp Stores, one bakery and a warehouse all in Johnstown. The firm next began locating outlets outside the city, even in Somerset County. By 1928, there were more than sixty Cupp Stores. In December 1928, the Cupp chain was sold to the American Stores Company of Philadelphia.[203]

The Johnstown City Directories of 1920 and 1929 listed the following numbers of retail groceries, meat shops and confectionery outlets (there was some overlapping):

Approximate Numbers of Retail Grocery Establishments

	1920	1929
Retail Grocers	250	135
Retail Meat Dealers	59	87
Retail Confectioners	77	135

The 1920 figures included four Atlantic and Pacific Tea Company (A&P) stores in Johnstown. By 1929, the number had grown to thirty. With the vast number of small grocery stores, butcher shops and confectionary establishments in Johnstown, a shakeout was inevitable as chain store optimization and purchasing advantages continued to influence the grocery business.

VI. COMMERCE, RETAILING AND SERVICES: THE CHANGING FACE OF DOWNTOWN

Johnstown's central business district, the first four wards, is a compact, level, floodplain area at the confluence of the Stony Creek and Little Conemaugh Rivers. In the 1900–1930 era, it was the busy hub of the Johnstown region's commercial, professional, entertainment and transportation industries. The earlier residents (population 5,944 in 1910 and 6,064 in 1920) came from all but the lowest social strata. Mostly white, they were generally either American-born or from the British Isles and Ireland, and some were bi-lingual Germans.

With one exception in East Conemaugh Borough, all the chartered banks of Johnstown were headquartered downtown until the 1920s. Almost all Johnstown lawyers, insurance agencies, real estate firms, professional engineers and architects, and public accountants had their offices there.

The area also housed every major department store except John Widmann and Sons, which was on Railroad Street nearby.[204] This especially included the Penn Traffic Company that used 250,000 square feet of floor space for retail sales, another 65,000 for inventory storage, and had approximately five hundred employees. Prior to the war, Penn Traffic boasted being the largest store in Pennsylvania, excepting those in Philadelphia and Pittsburgh.

The downtown area also had the best restaurants, the post office, the Western Union, the farmers' market, all stage theaters and most movie houses, the three

Johnstown daily newspapers, and all the quality commercial hotels. Cambria Steel's office building, the management offices of all public utilities and many other corporate offices were downtown. There were drug stores, very complete men's and women's clothing stores, jewelry shops, variety stores, the library, the YMCA, several large churches, city hall, one enormous hardware store (Swank), John Pender's Livery and Stable, the Point Park Athletic Grounds, the Johnstown Automobile Company and Lee Homeopathic Hospital.

All the trolley lines and most major regional highways converged downtown, and the PRR passenger railroad station—the old one and its replacement—was located just across the Walnut Street Bridge from the central business district. The B&O passenger and freight stations were at the edge of downtown near Washington and Clinton.

In the general period between 1900 and 1930, Johnstown's central business district underwent a transition from a small-city hub to the energetic core of an important, middle-size city. It experienced land-value escalation and a "tallest-building" competition.

New Buildings

In March 1903, celebrating its fortieth year in Johnstown, the John Thomas and Son department store opened a new addition—five floors, each 110 by 112 feet, at Apple and Bausman Alleys. The new wing was connected to the original store that faced Main Street by a basement tunnel and two enclosed walkways, one at the second and the other at the third floor. That same spring Peter Carpenter erected a major addition to his Capital Hotel at Main and Walnut Streets.[205]

In 1905 another important project moved closer to fruition when it was announced on March 5, that government officials favored the corner of Market and Locust Streets (behind City Hall) as the location for the new Federal Building. The site was eventually approved and acquired. The cornerstone was laid on November 19, 1912, and the building went into service about one year later in 1913.[206]

Nathan's department store was four floors tall and was located on Main Street across from the western corner of Central Park. In 1921, Nathan's began a large expansion that extended all the way to Lincoln Street and was connected to the main store building by an underground walkway fourteen feet wide.[207]

Fire-Induced Urban Renewal

The four major downtown fires early in the first two decades of the twentieth century provided a sort of urban redevelopment stimulus. In all cases of destruction, decisions were made to rebuild.[208]

The Johnstown Opera House was replaced by the Franklin Building, designed in 1904 by Henry Rogers.[209] Its ground floor became home to several small shops facing Franklin Street, one being a small Glosser Brothers clothing store that located in the new structure in 1906. The Franklin Building also housed other firms. In future years the entire Franklin Building would become part of the large Glosser Brothers Department Store.

The Penn Traffic building was thoroughly and solidly reconstructed following its devastating fire, and it was made more modern than ever. The store underwent another three-day, grand opening beginning on March 5, 1908.[210]

While the Fisher building faced both Main and Clinton, it was not a corner building—the corner being occupied before the fire by the Wild Building. As part of his redevelopment, P.C. Fisher acquired the adjacent, burnt-out Henderson Furniture Company so as to expand eastward on Main Street. Fisher and Company, a wholesale liquor business, used the new building's first floor at street level. The upper floors were leased out for offices and apartments.[211]

The Wild Building site on the corner of Main at Clinton was sold to a consortium of Johnstown businessmen for their new Title Trust (National Trust) Company. Like the new Cambria Steel Office Building, it would have seven floors.[212]

The Swank Hardware building was also completely rebuilt, and on May 6, 1908, as the Penn Traffic Company had done two months earlier, Swank reopened with a splashy three-day promotional sale.[213] In 1920, the company had sales totaling $2,250,000, employed around 175 people and occupied a total of 250,000 square feet of space.[214]

Tall, Taller, Tallest

In April 1908 the officers of the Johnstown Trust Company, then only eight years old, decided to construct the tallest building in Johnstown, a ten-story structure near the John Thomas and Son department store on Main Street.[215] The new edifice was three floors higher than the recently built National Trust building about 250 feet away.

Not to be outdone, especially after having acquired Citizens' National Bank, the First National Bank of Johnstown commissioned Samuel Hannaford and Sons from Cincinnati to design a twelve-story building to house the city's largest bank. Work got underway in late June 1911. The contract was given to the Thompson-Starrett Construction Company of New York, the same company that had built the Woolworth Building, then the tallest skyscraper in the world.[216]

In 1921 the directors of the U.S. National Bank decided to build a new bank and office building even slightly taller than that of the First National. In late October 1923, the new twelve-floor edifice was opened to the public.[217]

A Grand Hotel

Construction of the Fort Stanwix Hotel was undertaken by the Johnstown Hotel Corporation, owned by a group of local and Pittsburgh businessmen headed by Joseph K. Love. In July 1913 an announcement was made that a seven-story building would be constructed on a site at Main Street and Lee Place Alley generally across from the Cambria Theater. Costing about $750,000, the Fort Stanwix opened in July 1915.[218]

The Pennsylvania Railroad Passenger Station

In May 1904 the Pennsylvania Railroad leaked a press item that at long last it was contemplating a new, large passenger station for Johnstown. The PRR, however, had a good

excuse to delay. The proposed "viaduct" crossing the tracks to provide grade-separation street access to Prospect had to be located before the station was designed so that neither project interfered with the other.

After years of waiting, the impressive Pennsylvania Railroad Station was dedicated on October 12, 1916. A crowd of several thousand turned out for the many speeches concluding the day's festivities that had begun with a parade. The station marked the culmination of a number of PRR city improvements including underpasses (subways) at Fairfield, Delaware and Laurel Avenues; the Prospect Viaduct and an improved bridge between Brownstown and Cambria City over the mainline tracks.[219]

The Glosser Brothers Department Store

Glosser Brothers ("Glossers") was to become a significant institution in the Johnstown economy, and its buildings were important downtown features during most of the twentieth century. This establishment was the work of an amazing and generous Jewish family from Antopol, some fifty miles east of Brest-Litovsk in Russia. A father and head of a sizeable family, Wolf Laib Glotzer (who would take the name Louis Glosser), arrived alone at Ellis Island on January 7, 1903. A short time later, a twenty-year-old son, Nathan, joined him. Nathan moved on from New York City to join his uncle, Moses Glosser (Louis's brother), then living in nearby Stoystown. Moses Glosser would soon become a Johnstown resident and establish an important scrap-metal business. Nathan also settled in Johnstown and his father joined him shortly afterward.

Scarcely able to use English, Nathan Glosser borrowed $200 from Morris Miller, a men's clothing merchant with a store on Main Street, and used the loan to buy a tailor and laundry shop at 105 Franklin Street where he had been living and working. Known as L. Glosser and Son, the small shop prospered. In time Louis and Nathan had saved enough money to bring Nathan's brother, David Glosser, to Johnstown. By 1906, the father and his two sons were able to reunite the entire family, ending a separation of more than three years.

In 1906, the brothers, by then including Saul, acquired Jacob Fisher's small store at 118 Franklin Street in the new Franklin (Ellis) Building. The business, Glosser Brothers, began by selling men's clothing and shoes. Over the next ten years the store was successful, expanded its floor space several times and diversified its merchandise.

In 1917, L. Glosser and Son, which had become a dry cleaning and pressing business, closed, and Louis Glosser began helping manage the growing department store. Bella (later to become Mrs. Samuel George Coppersmith), the twenty-year-old daughter, joined the family team and concentrated on women's wear, a new line. In 1918 Glosser Brothers started its "Glosserteria," a self-service package and canned-goods food store. Patrons would gather their own merchandise and pay for it in a checkout line, an innovation for the times. By August 1921, Glosser Brothers had occupied the entire first floor of the Franklin Building and in 1923 the firm occupied the whole building, thereby adding another 41,100 square feet of retail space. In about fifteen years, Glosser Brothers had grown from a modest one-room shop with about 1,100 square feet into an important department store fifty times its original size.[220]

In October 1925, Glossers bought the Reese property, 128 by 66 feet, at Franklin and Washington Streets. The company was planning eventually to erect a new building to be connected to the main

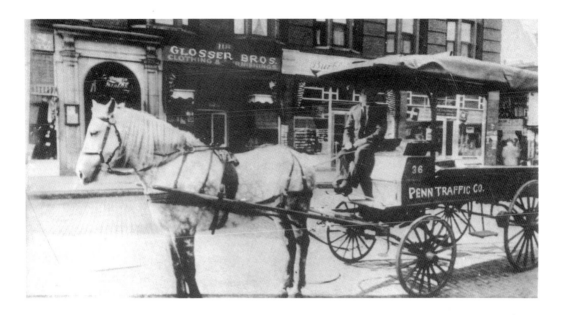

A view of the original Glosser Brothers store at 118 Franklin Street, c. 1908.

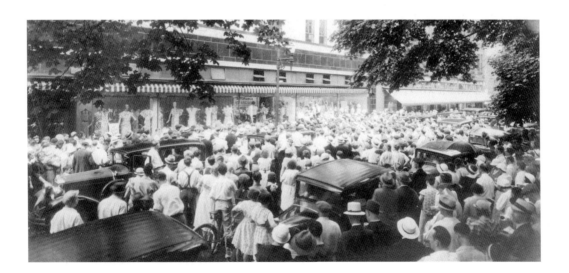

Part of the Glosser Brothers store's promotion was a chance drawing for a Chevrolet. The drawing was held in the late afternoon, June 28, 1933.

store by an enclosed walkway over Good Alley. Glosser Brothers had also acquired the Parkview Building on Locust Street and a 60- by 50-foot site at its rear on Good Alley where a new five-floor addition to the store was being constructed for occupancy early in 1927.

Glossers used many innovations in its promotions. It priced aggressively. To promote its 1926 sale, the store issued free trolley passes. There were fashion shows and at least one Glosser Brothers parade every year.[221]

Public Affairs from 1900 until the Great Depression

I. The Struggle Against Civic Futility

The main municipal challenge in pre-World War I Johnstown was accomplishing things that needed to be done. The city's downtown flooded every several years, but the continual filling and encroachment along the three rivers by corporations and individuals (like the B&O and the Fearls) still eluded correction. The initiative to create a new county failed. Except for Joseph Johns's legacy at the Point and the garden-type Central Park downtown, the city had no parks or playgrounds. The streams and rivers were open sewers that stank in dry periods and probably contributed to disease outbreaks. Only a few streets were paved each year, and the ones chosen were decided by political dickering. Once paved, they typically fell apart due to poor construction and utility butchering. Refuse collection and disposal became another fiasco after 1903 when Johnstown entered a multi-year contract with a company owned by present and former city officials. The police department was considered political and ineffective.[222]

Population Growth

The city's population almost doubled between 1900 and 1920, and the suburbs and the county were gaining rapidly. The table below depicts these trends:

Population Changes, 1900–20

	1900	1910	1920
City of Johnstown	35,936	55,482	67,327
Johnstown urban area (city plus nearby boroughs and townships)	50,546	81,155	99,687
Cambria County	104,837	166,131	197,839
Somerset County	49,461	67,717	82,112

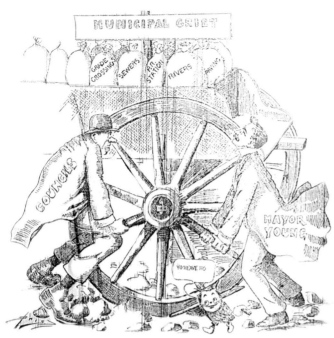

If They Would Only Pull Together.

Tribune cartoon of April 4, 1907, satirizing the gridlocked city government.

Police Chief John T. Harris, who served under Mayor John Pendry from 1902 to 1905. The comment "Make Hay while the sun shines" is probably a wordplay on William "Billy" Sunshine, an anti-temperance Republican political leader and city councilman. The cartoon is from the *Weekly Democrat* of December 2, 1904.

The Mayors

Johnstown's turn-of-the-century mayors were good men caught up in an unworkable municipal system.

- George Wagoner (1896–99), a well-known surgeon, was a Democrat. Wagoner lived on Franklin Street in Kernville.
- Lucian Woodruff (1899–02), a Democrat, was an editor with the *Johnstown Democrat*. Woodruff lived on Water (Somerset) Street in Kernville.
- John Pendry (1902–05) was an undertaker whose establishment and home was on Main Street near city hall. A Republican, he had once been city controller.
- Charles Young (1905–08) was a Democrat and a druggist. His pharmacy was across from the U.S. National Bank on Franklin Street.
- Alexander Wilson (1908–11) was a Republican and a partner in a coal dealership near his home on Fairfield Avenue in Morrellville.

Wagoner, Woodruff, Pendry, Young and Wilson were caring, seemingly honorable men. Serving a three-year term as mayor was a part-time civic duty. Being mayor meant holding a "dead-end" job politically speaking. No Johnstown mayor went on to a more powerful, prestigious or lucrative public office. It would have been nearly impossible to isolate and lay blame upon any of the forty-two councilpersons for the city's failures. The mayor—the personification of the municipality—was an ideal scapegoat. A known name and a recognized face, his term would be over. There would be another.

Consequences of Chaos: Johnstown Fires

In the early morning of October 31, 1903, a fire broke out in the city's largest theater, the Johnstown Opera House. The underinsured building was totally destroyed. Firemen complained of a defective fire hose. The property owners, the Ellis family, announced that the theater would be replaced with a new commercial building.[223]

Five weeks later, Mayor John Pendry received a critique and recommendations for Johnstown firefighting from the National Board of Fire Underwriters, based on an inspection done before the fire. The multicompany volunteer arrangement was judged unreliable; a paid, professional department was recommended.[224]

On January 19, 1904, Pendry included the recommendation in his annual message. Nothing happened. The councils were unwilling to face the public expense and political backlash from volunteer firemen.[225] Ironically, the recommendation began gathering support following the Baltimore fire (February 7, 1904), which destroyed much of that city's downtown.

A year after the opera house fire, the Cobaugh Building in Kernville burned, as did ex-Mayor Lucian Woodruff's home on Water Street.[226] Woodruff's daughter, Jessie Octavia, was married to Anderson Walters, head of the *Tribune*. Both newspapers initiated editorial and cartoon support for a paid fire department.

The Penn Traffic building burned on August 28 and 29, 1905, the largest single-building fire in Johnstown's history. The loss was $500,000. A temporary store was opened, but 328 people were idled. Rebuilding was quickly decided.

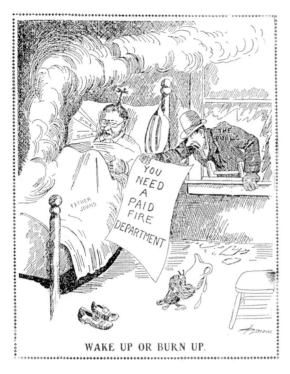

WAKE UP OR BURN UP.

Tribune cartoon of March 29, 1906, urging the establishment of a paid professional fire department.

Possibly the worst fire in Johnstown's history occurred the night and morning of March 27 and 28, 1906. The Swank Hardware building at Main and Bedford burned. Upper Main Street did not halt the flames. The Wild and Fisher buildings at Main and Clinton were destroyed, and the fire advanced along Clinton Street damaging the Geis Furniture and Carpet Store. It moved up Main Street on the Clinton side, destroying the Henderson Furniture Company and Louis Geis's residence. Seven buildings were totally destroyed and others were damaged.

There was near anarchy at the fire. An editorial pointed out that several of the "firemen became so drunk...that a police officer suggested...he be permitted to take charge of them."[227]

A Paid Professional Department

The March 1906 fire was the last straw. Mayor Charles Young, newly elected, pressed for a paid professional department. On April 24, 1906, Special Ordinance No. 707 was enacted. Johnstown would finally get a paid fire department. The department would be under a nonpartisan, five-member commission appointed by the mayor, to isolate the membership from politics.[228]

Needing impartial expertise at the beginning, the commission hired Thomas Freel, formerly a fire official from New York City, to serve as a consultant-organizer. Freel helped hire the firefighters, recommended procedures, equipment and alarm system changes, and participated in fire emergencies.

By October 1906, Freel's work was finished. The commission hired Frederick Murphy, as chief. Murphy soon left and was replaced by Logan Keller, a volunteer fireman. Keller served until 1922.

In October 1907, it was announced that as fire insurance policies in Johnstown expired, new premium rates would drop thanks to the paid fire department, its management and the many new hydrants.[229] On May 19, 1913, an unusual new vehicle was unloaded from a PRR freight car: a motorized fire engine made by the American LaFrance Company. The public was invited to the lake at Luna (Roxbury) Park to watch motorized pumping. The truck was test driven up Prospect Hill, a difficult feat for the horse teams.

Year by year, horse-drawn equipment was replaced by motorized units. In time, the impressive fire horses were no more. The transition was completed in early August 1922, about the time Chief Keller retired.[230]

II. MUNICIPAL REFORM

The Commission Concept

Everyone soon began boasting about the city fire department—paid professionals, well-managed and well-equipped since 1906—and the public health program with its Municipal Hospital. Both the fire and health departments were under a nonpartisan board, a commission. By 1910, "commission"—denoting effectiveness, integrity and the absence of political nonsense—was becoming a term of favor in civic circles. The Johnstown public began contrasting the fire department under a commission with the dual city councils, powerless mayor and the maligned police department, steeped in politics.

Galveston—September 8, 1900

Meanwhile, following a devastating hurricane in 1900, Galveston, Texas, began using a temporary commission to operate the crisis-torn city. Each commissioner was made responsible for specific programs. The several of them were making policy and enacting ordinances. The crisis had necessitated quick decision-making, effective action, unity and zeal—traits totally lacking in Galveston's pre-hurricane government.

After the emergency, public opinion would not permit the city to revert to the way things had been. The commission plan of municipal government became legally authorized in Galveston, and the concept spread from city to city in the early twentieth century. Being new and a contrast with the ineffective bi-cameral systems, the commission plan worked well—at first.[231]

Charles Price Speaks

A month after Charles Price became president of Cambria Steel, he began a crusade to reform the city's government. The initiative got started at a banquet held in his honor

on April 12, 1910, an event attended by 140 Johnstown leaders. The atmosphere was upbeat. Price would not be moving away to become president. He had brought Cambria's headquarters to Johnstown. There were speeches, songs and merriment.

After Price stood to acknowledge the warm acclaim, he spoke seriously: Johnstown was still growing. The population would soon reach one hundred thousand. Price then described the weak, perpetually lame-duck mayor and the forty-two councilmen. If such a system governed any corporation, he advised, that business would fail. There was little wonder the rivers were both putrefied and a flood menace.

Price next contrasted the politically infected police department with the effective fire force shielded from factional manipulation by a no-nonsense commission. Price's solution was simple: A small, nonpartisan commission should run Johnstown.

After the banquet, the Civic Improvement Committee, an ad hoc city elite group, was appointed. Price was chairman.[232] At the group's first meeting, Mayor Alexander Wilson reminded everyone that Johnstown's government was established by state law. Commission government could happen only through state legislation. The Civic Improvement Committee made recommendations about a wide range of matters, but its leading proposal was for commission government in Johnstown. Everyone in town began supporting it.[233]

The Commission Plan Comes to Johnstown

In 1913, most Pennsylvania cities were mandated to operate under the commission plan by the Clark Act, which amended the Third Class City Code.[234] Thanks to the new law, Mayor Joe Cauffiel would remain in office until early 1916. The term of the other four council members was only two years at first. After 1916 the mayor would be independently elected. The four council candidates with the most votes were winners. Officials were all elected citywide—not by wards as before.

Also a voting member of council, the mayor was a "first among the five." As director of the Department of Public Affairs, he was the city's chief executive or CEO. There was no longer a veto. The other four council members each headed a municipal program division.[235]

In an organizational meeting, after taking office following every municipal election, the council (including the mayor) would determine which member got which position. There was nothing nonpartisan in the Clark Act. Local elections remained partisan in Johnstown.

The commission plan went into effect on the first of December 1913. Joe Cauffiel, inaugurated in January 1912, remained mayor. The bicameral councils were no more. The city treasurer at first was an appointed officer. The controller continued to be elected.

III. "Fighting Joe" Cauffiel

In 1912, a Republican real estate broker and coal producer, Joe Cauffiel, became mayor. Repeatedly being sued for alleged contract breaches, Cauffiel usually prevailed. Although a

prohibitionist, the Johnstown establishment viewed him skeptically. In the primary, Cauffiel had defeated George Moses, a former state legislator. Unlike Cauffiel, Moses was considered a "safe" candidate. Cauffiel had beaten ex-Mayor Charles Young in the runoff.

Before seeking office, Cauffiel had "declared war" on several councilmen for an alleged impropriety—granting the city's street-lighting contract to the Citizens' Light, Heat and Power Company. Cauffiel had filed quo warranto actions against the councilmen claiming there was a conflict of interest in their voting.[236] Rather than question the legality of the contract itself, he challenged the men's incumbency by claiming their conflict-of-interest voting caused them to vacate their office. While unsuccessful, Cauffiel's frivolous action was shrewd politics.[237] While campaigning, Cauffiel had spoken to the issues as he saw them:

> *The city government is for the people…The city should own and operate the water company. Other public utilities should have franchises to expire on a given future date…I know something of the deals and dickers that have loaded the people of Johnstown with some millions of dollars of watered stock; paying interest on it. We haven't the stock, but are expected to pay the interest.*

Cauffiel ran large ads in the local press with his picture and somewhat populist ideas. An automobile enthusiast, he constantly bemoaned utility cuts made into newly paved streets. He also advocated eliminating all at-grade intersections of rail lines with city streets.

JOHNSTOWN, PA., SATURDAY MORNING, NOVEMBER 18, 1911.

Great Expectations

The *Johnstown Weekly Democrat* pokes fun at "Fighting Joe" Cauffiel just after his November 1911 victory in the mayoral election. The cartoon appeared on November 18, 1911.

Seeing Johnstown

Another *Democrat* cartoon about Mayor-elect Cauffiel. During his campaign, Cauffiel had berated the utility companies for digging into the streets.

Both the *Tribune* and the *Democrat* viewed Cauffiel's election as unexpected:

> *The special interests were caught napping at the primaries. Had they considered him seriously at that time, they would have beaten him…at any cost.*

Joseph Cauffiel had acquired the epithet "Fighting Joe." He was feisty, brash and unpredictable.[238]

The Lorain Steel Confrontation

Two and a half months after Cauffiel had become mayor, he was battling the Lorain Company (U.S. Steel). Its railroad, the Johnstown and Stony Creek (J&SC), was installing tracks over the Ferndale Bridge at the end of Bridge Street. Cauffiel went into action. A confrontation occurred between policemen and city workers against employees and officials of Lorain Steel. Ironically, the presidents of both the select and common councils sided with Lorain Steel.

"If they don't remove the obstruction," announced the mayor, "we'll blow it off the street with dynamite!" Carroll Burton, assistant to the president of the Lorain Steel Company, and three workers were arrested .

Percy Allen Rose, attorney for the J&SC, sought an injunction against the city. There were legal complexities having to do with the city's restricting usage of a part of the Valley Pike Turnpike Company, then undergoing condemnation. Cauffiel claimed the J&SC had no franchise rights from the city enabling it to use the bridge for its tracks.[239]

Unlike former mayors, Cauffiel was battling a giant corporation accustomed to doing as it pleased. Things were not the same. When the city councils enacted an ordinance granting the J&SC a franchise to use the bridge, Cauffiel vetoed the bill and described lucrative coal hauling done by the railroad. He also argued the tracks should be elevated to separate freight trains from vehicular traffic. The councils, however, passed the bill over Cauffiel's veto.[240]

The fight was still not over. Cauffiel staged a mass rally to protest what the councils had done. Some six hundred people packed the meeting chambers. When Cauffiel spoke, he reminded everyone of his platform: "I oppose any free and perpetual grants…" he went on in a spellbinding speech. There were cheers. When Percy Allen Rose stood up to address the group in behalf of the J&SC, he faced jeers and people yelling, "Sit down!" Rose, however, did speak.

The rally was a resounding success for Cauffiel. He had lost the franchise issue but had won the "people's war."[241]

The Crest of the Wave

Cauffiel created a "vice commission" to close down saloons on Sundays and holidays and to fight gambling. "My idea is to have an investigation and report that cannot be alleged as biased from the policeman's standpoint," he announced.[242]

Cauffiel was becoming a threat to the Johnstown professional and commercial elite whose influence extended in uncharted ways to different coalitions of city councilmen. Someone got an idea that a way to cage the mayor was to remove the line-item appropriation for his secretary from the budget. Cauffiel announced that if his secretary had to go, so would all city hall secretaries.

He constructed a wall out into the Stony Creek River and dared the Pennsylvania State Water Commission to remove it. The mayor's action baited a clever legal-precedent trap. If his wall had to come down, what was the legal status of all the other walls and illegal filling in the rivers?

Opposition to George Wertz

At the height of his popularity, Joseph Cauffiel in 1912 successfully supported Jacob Stineman of South Fork, another Republican, against reelecting State Senator George Wertz. Wertz, amiable and well connected, had been on Charles Price's Civic Improvement Committee. A "wet" Republican aligned with U.S. Senator Bose Penrose, Wertz was often

described as a "political boss" in Cambria County. Stineman, who had beaten Wertz with Cauffiel's help, died in 1913.

Ex-Senator Wertz, naturally bitter toward Cauffiel, was also the principal owner of the third most widely read newspaper in Johnstown, the *Leader*. In October 1914, the paper charged that liquor had been ordered for an unnamed stenographer employed by the mayor. Cauffiel issued a statement: "I will make a standing offer of $500 if they (the *Leader*) can prove their editorial." Attached were affidavits denying the charge, signed by Gladys Potter, the mayor's stenographer, and Kate Arthur, stenographer for Cauffiel Brothers. Cauffiel referred to the *Leader* as the "Penrose-Cambria County Liquor Sheet."[243]

Commission Form of Government

After the Clark Act amendments took effect in December 1913, the dual councils were gone. Joining Cauffiel were four new councilmen. Together they comprised the commission form of government. The new members were Nathan Miller, superintendent of finance and accounts, head of a real estate agency; Enoch James, superintendent of public safety and a partner in a construction company; H.H. Grazier, superintendent of streets and public improvements and an engineer with the Lorain Steel Company; and John Berg, superintendent of parks and public property, also a partner in Berg and Hoover, a notions wholesaler.[244]

Things got off to a comparatively good start. Progress was made with the PRR grade separations for streets leading into Morrellville. Negotiations were underway to acquire the Johnstown Water Company.[245]

Based on a recommendation of both the Civic Club and the chamber of commerce, the city council in June 1914 created a planning commission and appointed its first members: Edmund Overdorff, chairman, a contractor from Morrellville; Peter Carpenter, vice-chairman, proprietor of the Capital Hotel; S.G. Fetterman, a civil and mining engineer; David Ott, a planing mill owner; and Harry Miltenberger, a realtor.

The Honeymoon Ends

By April 1914 there were serious frictions between the mayor and the four councilmen. The Clark Act had vested in the mayor some vague power to oversee all the departments, meaning an independently elected official was supervising the work of others similarly elected, a source of friction and an organizational defect.[246]

By January 1915, after the new commission form of government was a year old, a major rift had set in between Cauffiel and the other four members, who had been meeting in private without him. John Berg made a motion to create a clerk position to aid city assessors. Cauffiel objected, saying that Berg should handle the duties himself. He even stated that Berg's doing the clerk's work would mean he would be earning a salary because Berg did not have enough to do.

Cauffiel's remark provoked Berg to stand and wave his arms. After Cauffiel had criticized the "star chamber" proceedings, H.H. Glazier stood and said calmly, "Mr. Mayor, if you

don't like our star chamber proceedings…you may stay away. We'll get along without you." Already the mayor was being isolated and the defects inherent in commission government had surfaced.

Throughout 1915, relations among and between the five men had become a disgrace. In the early part of the year, a fistfight almost erupted between Cauffiel and Nathan Miller. A week later the council voted to remove the police department from the mayor's supervision. The council voted to hire a Frank Horner as a policeman. Cauffiel refused to swear him in. The councilmen sought a mandamus to force Cauffiel to administer the oath. Cauffiel had Horner remove his shoes and pointed out that he was too short to meet the job requirements.

Cauffiel had had enough. He decided to run for county controller but was badly beaten. Only Berg got reelected. The new mayor taking office in 1916 was Louis Franke.

IV. LOUIS FRANKE'S TERMS AS MAYOR

On Monday, January 3, 1916, inauguration day for the new city administration, Mayor Joseph Cauffiel, donning a black suit and top hat and sporting a gold-handle cane, entered the city hall, presided over police court and discharged all prisoners in jail. During the inauguration ceremony a short while later, Cauffiel administered the oath to all the incoming officials. He then announced that he had no bitterness toward anyone.[247] Joseph Cauffiel would return as mayor again from 1920 through all of 1923 and again from 1928 until he went to jail in late December 1929.

Louis Franke was a Hornerstown druggist with a quiet demeanor and the skills of a diplomat. His first term as mayor was taken up with America being in the war, the influenza epidemic of 1918 and 1919 and the serious steel strike of 1919.[248] There was some municipal progress during these years, but things were not as dynamic as they would become later in the 1920s, especially during Franke's second term (1924–27).

Louis Franke's Second Term, 1924–27

It shall be my endeavor as Mayor…to labor for a program commensurate with this progressive age, coupled with economy and efficiency through the cooperation of our citizens.

With these words in his inaugural address, Louis Franke set the tone for his second four-year term as mayor. To more serious-minded Johnstowners, Franke's return signaled a relief from his predecessor—the quixotic, showy, prohibitionist Joe Cauffiel—who, during his second term (1920–23), had been part entertainer, part preacher, part demon, never predictable and a foil to the quieter, more deliberate Louis Franke.[249]

Franke continued with a solid program: a businesslike, no-nonsense administration, a bond issue to complete the partially finished sanitary sewer system, building more and better bridges, continued progress in hard-surfacing streets and alleys, and traffic and

parking improvements. Franke favored a new public safety building. Unlike Joe Cauffiel, a real estate broker, Franke favored zoning and guided its successful enactment.[250]

Franke's terms were comparatively harmonious. The chamber of commerce and other civic groups were welcome at city hall, and their members served on many ad hoc committees.

Franke's second term became one of the most progressive in Johnstown's history. On January 2, 1928, the day Cauffiel was sworn in for his third term, Louis Franke departed from his customary modesty and released a report detailing what had been accomplished during his own second term: fifteen miles of dirt streets and nearly seven miles of alleys had been hard-surfaced; twenty-one miles of sanitary sewers and sub-mains were installed, doubling the footage of sewers in the ground; a new Point Stadium and the Public Safety Building had been built. Already signed was the agreement with Bethlehem Steel Company for abandoning Iron Street through old Millville after the Hillside (later Roosevelt) Boulevard was completed. Great progress had been made toward achieving the boulevard—construction of retaining walls was underway, and the Point and Johns Street Bridges were under construction. The new Napoleon-Carr Street Bridge and the replacements for the Coopersdale and First Street (Swank Court) Bridges were finished. A traffic bureau had been established and traffic signals had been installed for the first time in Johnstown. The zoning ordinance had been enacted and enforcement had begun. The property tax rate had been reduced slightly. Police were working an eight-hour day. Municipal garbage collection was in effect.

Perhaps best of all to civic leaders, although not mentioned by Franke, there had been no nationwide embarrassments such as had occurred in 1923 with Cauffiel's expelling blacks from Johnstown or his nationally publicized non-enforcement of Prohibition. Another matter Franke rarely discussed was his "Boy's Court" to deal with youthful offenders, quietly and away from publicity. Juveniles found guilty in Boy's Court attended Saturday morning sessions with the mayor himself. Here Franke listened to their problems, talked with them and provided wise counsel.

Franke had given up his Hornerstown drugstore at the beginning of his second term. After serving as mayor, he went into the insurance business, retiring in 1968 at the age of ninety. Franke died in April 1975.[251]

V. Suburban Growth and Development

Johnstown's urban expansion could not be confined to its corporate limits. Almost anything in the way of land development had to overcome steep topography, rivers and railroad tracks. A successful developer usually had to obtain new roads, trolley extensions, utility services and occasionally bridges.

The Suburban Outmigration

In the 1898 to 1920 era, the leaders of Johnstown generally lived downtown (in the first four wards), in Kernville (wards Five and Six, also called the "South Side"), in Moxham

(the Seventeenth Ward), and at "the Rocks" (the general area between Osborne Street and Valley Pike and the B&O tracks and Central Avenue). A few Johnstown leaders, often Cambria Steel officials, lived in Westmont.

To avoid crowding and congestion, the continuing commercial development of downtown, dirty air (the prevailing winds were from the west), river-sewage odors and intermittent flooding, the upper classes began leaving the city itself.

Evan Du Pont had left Ferndale around 1913. James Thomas, the general superintendent of the Haws Brick Company who had constructed his Somerset Street mansion in 1905 (today's YWCA), purchased a large lot at Bliss Street and Weaver Court, and built his new home there in 1916. John Walters, a lumber and builders' supply executive, sold his Napoleon Street home and moved to Southmont.[252] There were many others. The trend would continue. A few developments discussed below represent brief case histories in the Johnstown region.

Southmont

Shortly after the turn of the century, a shrewd real estate broker, Frank Otto, foresaw a need for residential areas to house a growing population. Looking generally to the west, he had determined that much of this space existed around the vast Westmont plateau.

Otto knew good trolley service was essential for any major development to work. The topography, however, was such that the only feasible grade for a track into Westmont was through Hochstein's Hollow, formed by Cheney Run, a stream that flowed into Johnstown's Eighth Ward near the bottom of Whisky Springs Hill.

At Young's slaughterhouse on Franklin Street, there was a rough buggy trail called Hochstein Road leading generally west through the valley. Otto's firm, the Cambria Land and Improvement Company, purchased the 127-acre Hochstein Farm and in 1906 began installing streets, water mains and sewer lines, and started laying out lots. Otto's development was named "Southmont," and the lower part of Hochstein Road was renamed Southmont Boulevard.

Most land developers in the Johnstown area were trying to talk the Johnstown Passenger Railroad Company into installing tracks to provide trolley service to their enterprises. Otto's approach was more original. Westmonters wanted trolley service in general, but always on nearby streets other than their own. Since trolley service was politically controversial (and topographically challenging in Westmont), Otto began an "auto car line," an early type of bus to make scheduled runs. Local governments had no way to regulate his service. Otto gave the Johnstown Passenger Railway Company an opportunity to be a participating partner, greasing the way for the trolley service he really wanted. Four sixty-horsepower motorbuses were acquired and went into usage in October 1909.[253]

The Johnstown Passenger Railway Company was intent upon extending a trolley line throughout Southmont and into Westmont in cooperation with Otto. The July 15, 1908 trolley accident and its financial aftermath delayed service more than three years, however, and doubtless prompted Otto to pursue his small-bus plan.[254]

The Cambria Land and Improvement Company carefully designed one of its main streets, Diamond Boulevard, for trolley access to Westmont. Work began on the Southmont line in June 1911 and service was initiated on July 11, 1912.[255]

Woodvale Heights

In 1903, two officials of the Penn Traffic Company, Albert Custer and Al Berry, secured undefined property rights on a plateau area above Woodvale between East Conemaugh and Prospect and proceeded to develop the area as "Woodvale Heights."[256]

Viewmont

Elmer Davis, an ex-sheriff, and W.S. Stutzman, an ex-county commissioner and farmer, began developing Viewmont, behind Westmont, sometime in late 1905. Once part of the Stutzman farm, Viewmont was west of present-day Goucher Street along today's Menoher Highway. The developers provided one-acre lots on broad streets and boasted "well water no more than thirty feet down," electricity, cool summers and pure air. Some wealthy families had city homes but moved to Viewmont in the summer.[257]

Highland-Arbutus Park

By 1909, the Suburban Realty Company was fast at work trying to sell lots from land, much of which had been owned by George Wertz, homesites doubtless aided by the perpetually maligned Constable Hollow Road.[258] The general area was often referred to as the Highland Area and the development was Arbutus Park.[259]

Ferndale

In 1910, Ferndale Borough's population was 514. Despite a war and the influenza epidemic, the area's population had almost tripled in ten years, reaching 1,450 by 1920.

After Evan Du Pont moved to Johnstown in 1898, he acquired a home on Vickroy Avenue in Ferndale, a borough incorporated in 1896. He also bought adjacent acreage in the borough's upper and western parts that came to be called "Du Pont's Woods."

Around 1913, Du Pont joined the exodus of wealthy Johnstowners and moved to the Southmont area where he built a large mansion. Du Pont's Woods was offered for sale to the city but the councils never voted on it. Du Pont subdivided the site into narrow streets and small lots that sold briskly. The woods were timbered.[260]

VI. MUNICIPAL ANNEXATION, CONSOLIDATION AND FRAGMENTATION

In the dual-council era, the Third Class City Code limited Pennsylvania cities to twenty-one wards. After Coopersdale's annexation (1898) as the Twenty-first Ward, other annexed areas had to be placed into existing wards. Roxbury, a case in point, was assigned to the Eighth Ward.

Since every ward elected, respectively, three of its eligible citizens—one to each city council and a third to the board of school controllers—the statutory limitation deterred annexation, there being no way to guarantee an area joining the city that any of its citizens would sit on the councils or school board. No problem had arisen with Cambria City, Minersville, Grubbtown, Prospect, Conemaugh Borough, Morrellville, Woodvale or Coopersdale. Each had joined the city as one or more wards.

By the same token, adding a sizeable population to a ward might change its politics, a source of intra-city opposition to new annexations.[261]

East Conemaugh

In November 1905, a group of citizens in East Conemaugh Borough began urging annexation to Johnstown. The reasons for wanting to join the city were schools, police protection, better postal delivery and lower taxes. This advocacy never materialized due to strong opposition.[262]

Constable Hollow and Walnut Grove

In September 1909, a petition for annexation was presented for both Walnut Grove and Constable Hollow in Stonycreek Township. The city councils had ninety days to enact the necessary ordinance. The matter was not acted upon by the common council, either because of carelessness or deliberate inaction.[263]

The Greater Johnstown Initiative

Mayor Alexander Wilson (1908–11) launched a campaign in 1910 to encourage surrounding boroughs and urbanized township sections to come into Johnstown. To avoid another fiasco like the Walnut Grove-Constable Hollow petitions, he got both councils to pass resolutions of support to a Greater Johnstown movement. A committee of the mayor, city solicitor, city engineer, and the presidents of both councils was established, and the group set about to meet with area leaders to persuade their localities to join Johnstown.[264]

Wilson's program encountered opposition almost everywhere. Lower Yoder's citizens feared higher taxes.[265] A burgess, John Fyock, and a justice of the peace, Thomas Trimbath, announced they had polled Franklin and found overwhelming opposition because the borough had a huge tax base thanks to Cambria Steel's Franklin Works. Few would share it with a larger population.

In East Conemaugh William Crum, also a burgess, stated there was no support for annexation.[266] The committee effort had stimulated a lot of publicity and editorial support, but suburban opposition also prevailed in Ferndale.[267]

The citizens of Walnut Grove, however, were receptive. After a vote of 158 to 133 in favor, Walnut Grove was annexed on December 13, 1911. There was some untraceable politics over its ward placement. Fourth Ward citizens hired Percy Allen Rose to keep Walnut Grove out of their ward. Judge Francis O'Connor put Walnut Grove in the Seventeenth Ward, which then ceased to be totally "dry."[268]

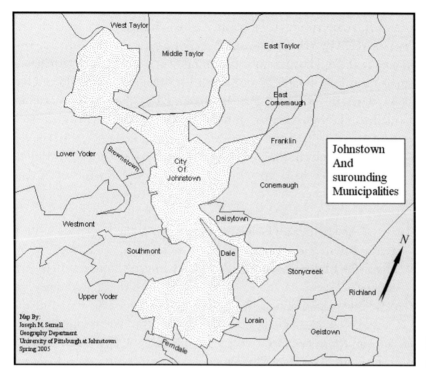

Map of Johnstown and suburban municipalities.

Westmont

In 1913, a serious movement got underway in Westmont for annexation into Johnstown. A burgess, Charles Rush, also a Cambria Steel official, announced that he was circulating a petition and was convinced enough signatures would be gotten. Rush's drive stimulated a similar movement in Brownstown. The movement in Westmont fizzled. No petition was submitted to the city and with the enactment of the Clark Act, opponents were taking a "wait and see" attitude about commission government.[269]

Mayor Louis Franke on Annexation/Consolidation

Louis Franke strongly believed in a unified Greater Johnstown and argued that with size and unity, the area's economy, prestige and influence would be enhanced.

Meanwhile, there had been three developments affecting the local government scene:

> 1. The Constable Hollow section of Stonycreek Township was incorporated as Lorain Borough on November 3, 1915.[270]
> 2. Oakhurst Borough was created in 1913. Seemingly, the borough was seeking to be taken into Johnstown City from the beginning.
> 3. The Cambria Steel Company had begun in 1915–16 buying up most of Rosedale Borough and moving its residents to homes elsewhere.[271]

In 1916, Mayor Franke created a "Committee to Work for Greater Johnstown," a joint city–chamber of commerce pursuit. The motto was: "100,000 population by 1920."[272]

The committee was to coordinate meetings and develop a systematic plan addressed at bringing Westmont, Daisytown, Brownstown, Dale, Franklin, East Conemaugh, Rosedale, Lorain, Oakhurst, Ferndale and similar areas into the city. The initiative had broad civic and newspaper support.[273]

Although the 1916–17 Greater Johnstown crusade waned during the war, Rosedale Borough joined the city on August 6, 1918. Oakhurst Borough was annexed in late February 1919.[274]

The Dale Case

When the committee approached Dale Borough, its officials told them to annex Oakhurst and return. In 1919, petitions were circulated in Dale Borough and its backers claimed the necessary signatures had been obtained. Challenging the petitions, Dale officials refused to enact the ordinance. A mandamus was sought to compel enactment. The mandamus was granted, but the decision was appealed to the state supreme court, which ruled that the statute on which the actions were based was illegal because the legislature had not worded the bill's title with sufficient clarity to describe its content, a constitutional mandate. Dale remained a borough.[275]

Opposition Reasoning and Tactics

The posture of the opposition did not lend itself to civic policy deliberation or communal ethics arguments. The discussion was typically focused on what was best for some individual situation at the moment—typically which scenario, borough continuation or city annexation, would result in lower tax rates or similar near-term concerns. School considerations were paramount.

The leading tactic of opposition was to delay rather than to combat an annexation initiative. The basic attitude was, "Why rush? Let's wait and see how things turn out."[276]

The Civic Goal Remains

Civic leaders and city officials continued to talk about the need for a single municipality to serve what was one city in an economic, social and physical sense. The argument was repeatedly made that the true Johnstown community had a population of more than 100,000, while that of the city alone was only 67,327. Annexation remained a civic goal, but by 1924 the suburban outreach sessions had ceased.

Small, piecemeal annexations brought in a few properties near Roxbury Park. After Rosedale in 1918 and Oakhurst in 1919, no more boroughs were added.[277]

VII. STREETS, BRIDGES AND CROSSINGS

Bridges and Grade Separation

There were two high-hazard railroad grade-level crossings: Station Street, which led up Prospect Hill becoming the Ebensburg Road; and Fairfield Avenue, where people going to Morrellville by trolley had to exit their streetcars, cross the tracks and mount another trolley.

The Station Street–Prospect crossing had been the subject of extensive negotiations with the PRR. Because of design limitations, high costs and unsettled plans for the new passenger station, achievement of what was to become the Prospect Viaduct seemed endless. An agreement between the city and the PRR was signed in January 1906, but there were delays, contract changes and extensions.[278]

In his final message to the councils (January 1911), Mayor Wilson was happy to report the viaduct had been "turned over to the use of the public."[279] Father Bronislaus Dembinski of St. Casimir's produced a petition signed by some ten thousand people seeking a bridge over the Conemaugh between Cambria City and Minersville. Cambria Steel donated land for the approaches. Estimated to cost $63,000, the bridge was completed in late 1910.[280]

Replacement of the Haynes Street footbridge between downtown and Kernville with a vehicular bridge was finally authorized in 1913 and financed by a city bond issue plus a county appropriation. Delayed by the war, the Haynes Street Bridge was finished in 1922.[281]

After extensive discussions with city officials and a multi-year process of elevating its mainline tracks in parts of town, the PRR submitted drawings, an agreement and a draft city ordinance bill to lower Fairfield, Delaware and Laurel Avenues beneath its tracks and to abandon the crossings over the tracks. The railroad in turn would construct bridges and abutments and build the new streets and sidewalks. While costly, eliminating the serious liability risks and the ongoing costs of crossing gates, safety lights and other hardware justified the costs to the PRR.[282] By 1915, all three underpasses were completed.

Mayor Joe Cauffiel was constantly seeking to remove all grade-level crossings in Johnstown. A tough challenge to his goal was the Somerset and Cambria's Rockwood Line (part of B&O). An extensive fill to elevate the B&O and related sidings was never seriously considered.[283]

The other target was the smaller Johnstown and Stony Creek Railroad (J&SC), a subsidiary of the U.S. Steel Corporation serving primarily its Lorain Steel Plant. Eliminating the grade-level crossing would present a difficult and costly challenge for the proposed new bridge over the Stony Creek between Moxham and the Eighth Ward near the Osborne–Central Avenue intersection. The city planning commission studied the idea of a major span to extend over both the river and the J&SC tracks, but the proposal was judged infeasible. In late 1916, a more modest new Moxham Bridge of concrete was authorized.[284]

The J&SC crossing at Horner Street presented no problem until the Horner Street Bridge was finished, because with no bridge in place, the southern end of Hornerstown had been a "dead end." When the new bridge opened and heavy traffic began moving between Hornerstown and the Eighth Ward–Moxham area, the crossing became a problem. Trains

caused major bottlenecks. There was no feasible way, however, for the J&SC to serve the steel mill and be elevated sufficiently to separate the railroad from Horner Street and Central Avenue.[285]

Johnstown Bridge Crisis

Johnstown got a serious wake-up call in March 1916 when the Maple Avenue Bridge collapsed under the weight of six trolley cars. For a brief time the calamity isolated Franklin and East Conemaugh from most of Johnstown. A temporary wooden structure served as a substitute bridge.[286]

As the city was located at the confluence of two rivers and served as a major rail center, the right combination of bridge failures could have devastated Johnstown. Entering downtown often meant using one of two bridges, the Kernville (Franklin Street) Bridge or the Walnut Street Bridge.[287] Should either collapse or be destroyed by flood or ice jam, the city would have been virtually cut in two. There was no convenient way to go between Coopersdale, Morrellville, Oakhurst, Minersville, Prospect or Cambria City on the one hand and downtown, Woodvale, Old Conemaugh Borough, Hornerstown, Kernville, Moxham or the Eighth Ward on the other, without making use of the Walnut Street Bridge.

Since the city's older bridges were made of steel and were dated from just after the 1889 flood, there was concern that other failures were inevitable. In each case the choice was whether to replace an old span or to recondition it. The latter was cheaper, quicker and less disruptive. The former, once accomplished, provided a more permanent solution.

A World War-era Bridge Program

The city had retained an expert bridge inspector, Bruce Veloy, in the European War era. Both he and the city engineer, J.R. Crissey, reported the Cambria City and the Walnut Street Bridges had to be improved immediately.[288] A decision was made to construct a totally new Walnut Street Bridge and to renovate the Cambria City Bridge. Both were indispensable, although the latter would not be as essential after the city abandoned Iron Street. Reconditioning the First Street Bridge (Swank Court) between Old Conemaugh Borough and Woodvale was also essential. It was overhauled in 1917.[289]

The Walnut Street Bridge project in 1917 and 1918 created a public relations nightmare. During construction, people had to cross the Little Conemaugh either using a temporary wooden footbridge or a makeshift "wagon" bridge placed near the Point. Trolleys could not cross; patrons had to walk over the footbridge and change streetcars. To make matters worse, the contractor doing both the Walnut Street and Moxham Bridges became insolvent. In early 1918, the city had to finish both projects.[290]

On February 12, a combination of flooding and ice jams not only threatened the Walnut Street Bridge as it neared completion, but also severely damaged both the temporary footbridge and the wagon bridge. The waters finally receded after the debris and ice slabs went away.[291]

Almost two weeks earlier, the Franklin to East Conemaugh Bridge, spanning both the river and the Pennsylvania Railroad tracks, collapsed, creating another traffic crisis near

Johnstown. Two men were killed, and a severe wartime blockage on the PRR mainline occurred.[292] The Franklin–East Conemaugh Bridge was not a Johnstown municipal problem, but city merchants had to use freight cars over the railroad for deliveries in Franklin and East Conemaugh Boroughs.

On November 1, 1924, a three-year project culminated with the opening of a new, $585,000 bridge connecting East Conemaugh and Franklin. The new 900-foot span eliminated what had become another grade-level crossing on the PRR mainline.[293]

Post-World War One Bridge Construction

In 1923, three major bridge projects were bid and contracted: a new bridge on Napoleon Street over the Stony Creek, the complete replacement of the Coopersdale Bridge and a new First Street Bridge (modern Swank Court) at Woodvale.

The Napoleon Street Bridge was a major addition, part of an alternative traffic-flow pattern to Cambria City and the West End areas. Its completion meant that traffic could reach the western parts of downtown without contributing to the congestion around the Franklin Street Bridge.[294] The construction of this new span bothered no one. The official opening took place on July 29, 1925. The Napoleon Street Bridge dramatically increased traffic flow on Market Street between Main and the Stony Creek River, triggering public pressure to relocate the city market, which for years had been situated on the east side of Market Street between Main and Vine Streets.

By June 1924, work replacing the First Street Bridge (Swank Court Bridge) between Woodvale and the Old Conemaugh Borough was underway. Built by the Independent Bridge Company, the new span was opened in early December 1924.[295]

Actual replacement of the Coopersdale Bridge encountered endless difficulties. In November 1923, a temporary structure was built for pedestrian use but a spring flood washed it away. Other delays were blamed on the city's not incorporating completion language into the construction contract. On July 31, 1924, Dr. Bertha Caldwell, a well-known physician, fell through an opening in the old bridge and died ten days later. The permanent new Coopersdale Bridge went into general use in early July 1925.

The Maple Avenue Bridge

A new bridge to connect the city and Franklin Borough was a major expenditure item. After Bethlehem took over Cambria Steel, the project of choice was a bridge on Maple Avenue over both the Little Conemaugh and a branch PRR line. Such a plan was important to Bethlehem in that the main entrances to the Gautier plants, the railcar shop and the Franklin Works were all along Maple Avenue, served by the Franklin trolley line.

Although the city engineer had estimated the bridge would cost over $500,000, everyone assumed many parties would share the cost: the city, Bethlehem Steel, PRR, Cambria County and the Pennsylvania Highway Department.

On June 22, 1926, the city council instructed its solicitor, Tillman Saylor, to petition the Public Service Commission to order the grade-level railroad crossing eliminated and to

apportion the costs among interested parties. The PSC conducted a hearing in late March 1927, but its July ruling was a terrible one for Johnstown.

The city was ordered to have the new span completed by December 31, 1928. The cost sharing was in percentage allocations: City of Johnstown—55 percent; the PRR—20 percent; Franklin Borough—10 percent; Cambria County—15 percent. Neither Bethlehem Steel nor the Pennsylvania Department of Highways was to contribute at all. Johnstown officials began seeking delays and different cost allocations. Having initiated the petition in the first place, the city was in the awkward position of delaying a project everyone wanted. In September 1932, the PSC rescinded its order, an action forced by the Great Depression.[296]

Although the crossing was a severe traffic bottleneck, the new Maple Avenue Bridge was not finished until 1957. It cost $2.1 million.[297]

The Ferndale Bridge

The bridge connecting the city's Moxham section to Ferndale at Bridge Street was an antiquated remnant of the old Valley Turnpike. Lacking sidewalks, pedestrians often used the trolley bridge at the end of Central Avenue rather than risking the Ferndale Bridge in heavy traffic. City officials wanted the new bridge not only to cross the river but to also pass above both the B&O and the J&SC tracks, a concept that would have required a costly structure at a new location. The PSC held a hearing and ruled that crossing the river and two sets of tracks did not justify the $750,000 cost. Washed away in the 1936 flood, the Ferndale Bridge was replaced in the same location.[298]

The B&O Station Relocation and the Widening of Washington Street

The B&O's passenger and freight stations were adjacent to one another on the northern side of Washington Street, generally across from the intersections with Franklin and Clinton Streets. Griffith-Custer Steel also sat next to the depots.

There were traffic jams at the freight depot when trucks were backed against the railroad platform for loading or unloading, and Washington Street, already narrow and busy, became nearly impassable. For years the city had been seeking to widen it between Franklin and Clinton. Through a 1916 contract with the city, the railroad had earlier agreed to move both stations to Baumer Street near Bedford but the work was halted during the war. Other delays stemmed from the Stony Creek's width issue.

With the huge Bethlehem investments in the Gautier Mills, both the Griffith-Custer Steel plant and the B&O stations were needed for a railroad yard and a CBL-B&O interchange. Griffith Custer's facilities were acquired. The firm moved to Woodvale.

With Louis Franke's second term ending, the city council in July 1927 ordered the station platforms removed for the Washington Street widening. One week later, a city steam shovel ripped them away. A protesting railway employee was arrested. The altercation strained relations between the city and B&O. Nothing except closed-door negotiations happened for two years.

The Pennsylvania Water and Power Resources Board accepted the city's revision of the Stony Creek River channel lines in July 1929 allowing station construction on Baumer Street in exchange for excavations on the Kernville side of the river to achieve the river width. By March 1930, everything was in place. The B&O began spending $365,000 for new passenger and freight stations and a rail siding on Baumer Street. Washington Street was widened.[299]

VIII. THE ABANDONMENT OF IRON STREET

By the spring of 1924, Johnstown City and Bethlehem Steel officials were negotiating an agreement to bring about major changes both parties wanted—a new boulevard from the Point to Cambria City. On the opposite or eastern side of the rivers, Iron Street would be abandoned through the Lower Works.

On April 5, Bethlehem submitted a draft agreement that would give to the city the right-of-way along the western riverfront plus an eighty-seven-acre hillside park. The city in turn would construct two new bridges near the Point plus the boulevard itself, and would abandon to Bethlehem Steel all of Iron Street from the Cambria City Bridge at McConaughy Street to Johns Street. It would also deed the bridge to Bethlehem Steel.

City officials unanimously rejected Bethlehem's proposal and extensive negotiations resumed. Meanwhile, reasoning that it soon would cease being a public way, the city stopped maintaining Iron Street—one of the most important routes in Johnstown. It also began ignoring the Cambria City Bridge, a vital link between two major sections of the community and a span that had been repeatedly patched up to prevent collapse.

Through new negotiations, the city secured from Bethlehem properties for better approaches to four bridges: Swank Court (First Street), Coopersdale, the proposed Johns Street Bridge and the Prospect Viaduct. Also to be ceded was the eighty-seven-acre Hillside Park, the entire right-of-way for the boulevard itself and $85,000 in cash payable when Iron Street and the Cambria City Bridge were deeded to Bethlehem.[300]

The county agreed to contribute $327,000 toward the Point and the Johns Street Bridges.[301]

Bridges and Walls

In late June 1927, bids for the two bridges were opened. The Ferris Engineering Company of Pittsburgh was chosen to construct the two spans based on its $466,000 bid.[302] The Johns Street Bridge was opened to limited public use in July 1928. Until the boulevard was opened, completion of the Point Bridge was not an issue.

The next major component of the Hillside Boulevard project was the construction of about 1,500 feet of massive retaining and river walls to hold up the hillside around the Point Bridge and to secure nearby riverbanks. The Ferris Company was again the low bidder at about $223,000 and was awarded the contract.[303]

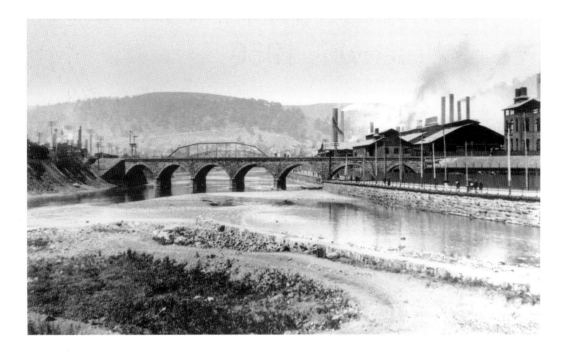

The "Old Stone Bridge," as seen from the Point around 1910. Iron Street, which passed through the first arch to the right of the Conemaugh River, was a major street in Johnstown until its abandonment to the Bethlehem Steel Corporation in 1930. To the left of the river were the Haws Refractories Company and the rail line connecting the Lower Works with the Rolling Mill Mine.

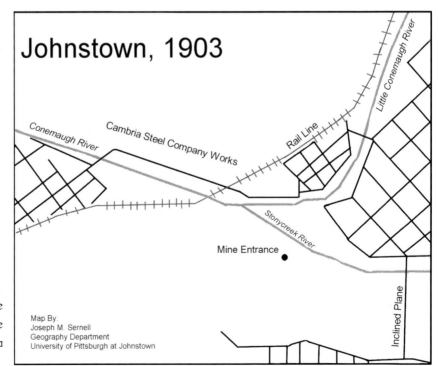

Map showing the area between the Point and Cambria City around 1903.

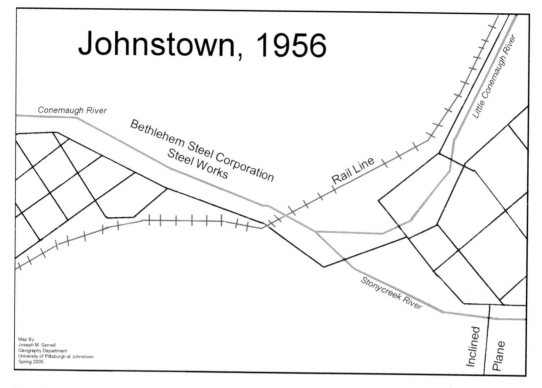

Map showing the same area after Iron Street had been abandoned and the Riverside Boulevard (later Roosevelt Boulevard) had been built.

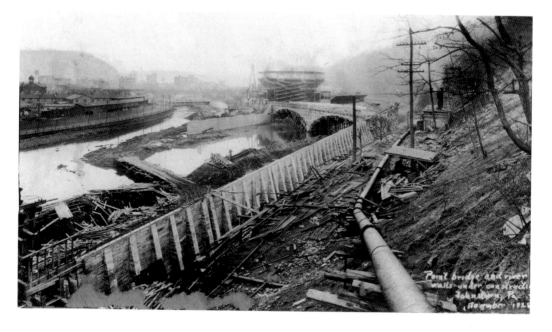

November 1928 view of the Point Bridge under construction. The Riverside (Roosevelt) Boulevard would connect the Point Bridge with Cambria City, thereby enabling the city to abandon Iron Street.

The Underpass

As construction for the two new bridges and the retaining walls got underway, arrangements had to be made for the boulevard to pass beneath the mainline of the PRR. The underpass had to be constructed through the fill on the western side of the Old Stone Bridge. In June 1928, city officials began formal negotiations with the railroad. The Pennsylvania Railroad Company also redesigned its track layout near the Old Stone Bridge.

Meanwhile the need for retaining walls between the Old Stone Bridge and the Point became apparent. In late August 1929, the T.J. Foley Construction Company of Pittsburgh won the wall contract and was chosen to construct the underpass itself.[304]

By late 1929 and throughout much of 1930, the public watched the configuration of projects reach fruition. The new route was officially designated the Hillside Boulevard but later would be renamed the Roosevelt Boulevard. Iron Street between Johns and McConaughy Streets and the Cambria City Bridge were abandoned and transferred to the Bethlehem Steel Corporation. On October 30, 1930, traffic began using the boulevard. The face of Johnstown had been changed drastically.[305]

IX. TRAFFIC CONGESTION AND SAFETY CONCERNS

Johnstown's street system was developed to handle horse and buggy traffic. Trolleys were added later, usually on the busiest streets. Already commonplace by 1915, automobiles increased throughout the 1920s.

The city's downtown in the post-World War era was intensely congested. Trolleys were evermore in the way of other vehicles. Their stopping usually halted everything behind them and interfered with vehicular turn movements.

Parking

In late June 1924, the Bethlehem Steel Corporation, spending millions of dollars on capital additions to its Gautier Works, notified Johnstown officials that it needed to take back a five-hundred-car parking lot, the "Auto Park," situated near the B&O Stations. The city had been leasing the space to furnish free downtown parking.

There were no parking meters. Free time-limited parking was allowed on most streets. Enforcement was lax.[306]

Traffic Signals

In June 1924, Johnstown's first traffic signal was installed at Main and Franklin, a curb-corner signal. Although hard to see, the public got accustomed to it.

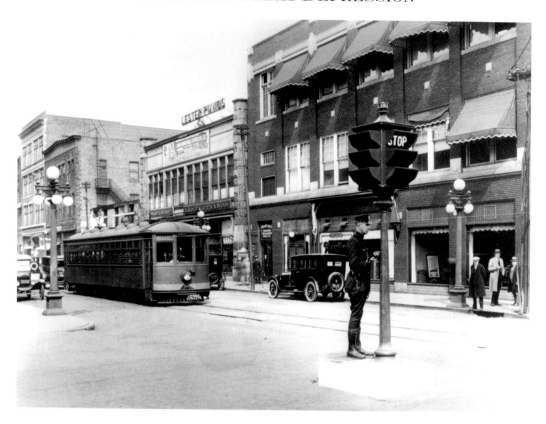

New traffic signal at Franklin and Vine. This traffic signal, the second in Johnstown, was installed on April 17, 1925. The trolley is destined for Jerome in Somerset County. The brick building is Dan Shields's then-new Capitol Building.

By April 1925, traffic signals were being installed at Vine and Franklin (near the congested Franklin Street Bridge), at Main and Clinton, and at Market and Main Streets. By July 1929, there were five traffic signals on Main Street alone, all operated by one master controller timed for better traffic flow.[307]

Traffic Safety

The advent of the automobile brought serious hazards. Cars ran into each other; trolleys ran into cars; and children, accustomed to playing and sleigh riding in the streets in comparative safety during the horse-and-buggy era, were often victims of serious injury and death by automobiles.

In 1924 alone, 40 people were killed in automobile accidents in and near Johnstown. Another 65 were injured so seriously they required hospitalization. In 1925, 51 were killed in the Johnstown area, 20 happening inside the city limits. In 1926, 9 were killed in Johnstown and 289 were injured. Vehicle-related deaths inside the city for 1927 and 1928 were respectively 10 and 13. More traffic fatalities were happening inside Johnstown in a typical 1920s year than occurred in any ten-year timeframe late in the twentieth century.[308]

The Uniform Traffic Code

Through the Pennsylvania League of Cities, mayors and other city officials in 1926 began advocating a statewide motor-vehicle code so that citizens would not have to learn new traffic regulations each time they visited another city. Mayor Louis Franke, a proponent, became chairman of a committee of local leaders to draft such a code. The group's work, a synthesis of local ordinances and state laws, was completed early in 1927. Governor John Fisher signed it into law on May 11.[309]

X. SEWERAGE SYSTEMS

Disease and Stench

No trunk sewers went through the city before 1915. Sewers, ditches and culverts were all made to flow to nearby streams. Household sewage and storm runoff were combined. Before the Quemahoning Reservoir went into early usage, the steel companies had been taking almost all the water that flowed through the rivers during dry spells. Two large mains captured the Stony Creek at the Border Dam upstream of Bens Creek. When the river was low, as it often was, nothing flowed from above the Border Dam through the river

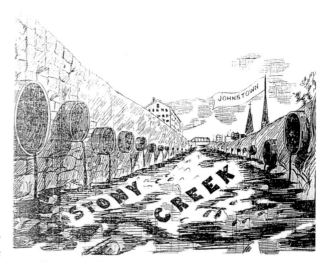

JOHNSTOWN'S MAIN SEWER.

Will "Those Benefited" Pay the Price of Scattering Contagion and Disease?

A *Johnstown Tribune* cartoon of July 17, 1906, urging a modern sanitary sewerage system for Johnstown.

THE DAILY TRIBUNE—JOHNSTOWN, FRIDAY EVENING, AUGUST 21, 1908.

Trying to Block the Sewer

Through this cartoon of August 21, 1908, the *Johnstown Tribune* is taking a shot at its rival newspaper, the *Johnstown Weekly Democrat*. W.W. Bailey, its publisher, is depicted as blocking the city's sewerage system project (ie. by not supporting it).

below it. Two large pipes also took water from the Little Conemaugh into the mills for use in desperate circumstances. During dry spells, almost nothing flowed through Johnstown's streams except raw, untreated sewage.

Despite the pleas of doctors, the unspeakable stench, the begging of civic leaders and press cartoons and editorials urging a modern sewerage system, nothing was done. The state health board had the power to mandate sewerage system installation at the city's cost and had to approve all proposed plans.[310] The powers were used to enhance persuasion, however, not for legal action.

Cauffiel's Plan

In early January 1914, the city commissioners voted to create an "office of sanitary engineering" to design a sewerage system for Johnstown. An omen of problems ahead surfaced with Joe Cauffiel's opposition vote. The mayor supported neighborhood collector sewers but opposed trunk lines through the city and a treatment plant. Cauffiel favored large upstream dams to impound water for flood prevention and to flush out the smelly streams during dry spells.[311]

In January 1914, the city hired Clark Collins as its sanitary engineer and W. S. Baver as his assistant. Collins concluded immediately that most of the existing sewer lines had to be replaced to separate storm water from household sewage.[312]

By early 1915, Collins's plan for a system to cost over one million dollars was finished and submitted to the state. Approval was obtained in late April.[313] A referendum was held in May 1915 seeking voter approval for bonds to pay for the system. The chamber of

commerce and both newspapers urged passage. Cauffiel fought the measure. Opponents prevailed 2,493 to 328.

The Sewer Program During Louis Franke's First Term

Louis Franke became mayor seven months after the bond defeat. His policy was to extend sewer laterals and lines as part of street construction and always prior to paving and repaving to avoid cutting the streets later. Nothing was done on the trunk and interceptor lines, however, until 1917.

In his second annual message to the city council, Franke referred to the sanitary sewer system as a "necessary evil." Guided by Mayor Franke, the council voted a $200,000 bond issue for a large trunk line through Coopersdale toward the proposed treatment plant site.[314] To continue the work, Franke sought smaller, more modest bond issues that usually went uncontested by the general public.

By the end of 1917, almost nine miles of total sanitary lines had been installed. The city's goal was now one of constructing in increments a complete sanitary sewerage system. Work almost stopped during the war. Afterward there was slow, steady progress.

The 1924 Bond Issue

When Louis Franke began his second term as mayor (1924–27), he reported that the entire sewer system was about two-thirds finished, excluding the treatment plant. In February 1924, he reported that to finish the system, an expenditure of $2,819,750 would be necessary.[315] Franke, however, continued his more modest approach and won referendum approval of a $500,000 bond issue. From 1924 through 1928, about five miles of sewer mains were added each year.[316]

In a report issued November 1, 1928, the city's Bureau of Engineering informed the council that 47 miles of total sewers were in place; however, 1.8 miles of trunk mains, 3.25 miles of sub-mains ("feeder" mains), 45.8 miles of service laterals and the treatment plant itself were still needed.

Mandatory Connection Ordinance

On November 12, 1929, shortly after the stock market crash, the city council enacted a mandatory hook-up ordinance, a policy the state health officials had been urging. Every building owner was required to connect when a sewer line was available.

XI. Parks, Playgrounds and Recreation

The only early provision for Johnstown's future park needs was done by its founder, Joseph Johns, in his 1800 village plan. Johns had set aside the Point area for park purposes, a county courthouse site that has been used as Central Park, four tiny garden parklets at Main and Market Streets, and Union Park, which would become the site for the War Memorial Arena.

As the community grew from a village to small city, there was no apparent need for parks or playgrounds other than those furnished through Johns's farsighted legacy. As Johnstown exploded into a medium-size city (1890–1920), its elected and civic leadership, preoccupied with business and personal materialism and entangled in an atrocious local government, did little to provide public parks.

At the turn of the century, a burgeoning population was being squeezed onto the land whether suitable for development or not. Space for homes, businesses and industry took precedence over park or playground usage. The beautiful Von Lunen's Grove, extending from Park to Linden Avenues and from Ohio Street to Sam's Run in Moxham, for example, was developed into streets and residential lots by 1903.

Roxbury Park—Luna Park

There was also a continuing likelihood that Roxbury Park, a fenced-off amusement area, would be subdivided into residential lots. The threat became all the more ominous when Frank Cresswell, a former engineer and Johnstown's leading stockbroker, took possession of the property from the Tri-County Driving Park Association in 1904 after the $40,000 in bonds he owned defaulted.[317]

John Pender, the city's top liveryman and easily the best-informed person in Johnstown about horse racing, had been leasing the Roxbury Park racetrack for some time. Every year he had provided an eagerly awaited racing season.

Once in control of the property, Cresswell sought to quadruple the rent. Pender promptly moved his popular events to the Westmont Racetrack through a five-year lease beginning with the 1904 racing season. The 1904 Roxbury Park season then became such a disaster, Cresswell tried in vain to get Pender back.

That very September, Cresswell leased Roxbury Park to a new association of approximately one hundred community leaders headed by Charles Young, the city's next mayor (1905). Their goal was for Roxbury to remain an amusement park.

The association contracted for some $50,000 in facilities including a roller coaster, merry-go-round, "upside-down house," laughing gallery, crystal maze, lake enlargement, more boats, a two-thousand-seat grandstand and a vaudeville theater.

Before the park had its grand opening over the 1905 Memorial Day weekend, it was renamed "Luna Park" after a similar place in Pittsburgh. That September, Luna Park was used for the Inter-State Fair, an agricultural exposition that attracted some 25,000 people.[318]

The Panic of 1907, a serious recession that lasted into 1908, affected Luna Park negatively. The 1908 fair was called off.[319] Luna Park proved unprofitable for Young's association. A new group headed by Ernest Emmerling of the Emmerling Brewing Company, took over the lease, keeping the park in Johnstown hands.[320]

Greater Valley Park—Island Park

A weak rival to the Luna amusement facility, the Greater Valley Park, got underway around 1904 near Riverside. It was located in the floodplain area adjacent the Stony Creek just

Horseracing at Luna Park, c. 1915.

upstream of the big river bend—the flat area generally west of the B&O tunnel. The Windber trolley line had opened the area for public use in 1902.

The place was renamed Island Park in January 1906 after a new group acquired the property and promised many new facilities. Island Park featured a small hotel, Ferris wheel, children's miniature railroad, dancing pavilion and other facilities. There were plans for footbridges to connect the small islands in the Stony Creek River, a roller coaster and river swimming, among other features. A marginal enterprise, Island Park faded away before World War One.[321]

Ideal Park

Another private amusement area, Ideal Park, was developed in Somerset County along Bens Creek about one-half mile upstream from the Stony Creek River. Begun prior to the war, Ideal Park by the 1920s had become a popular site for family reunions, church and group picnics and general recreation.[322] There were picnic pavilions, a large athletic field, outdoor meeting facilities and a small hotel. An immense swimming pool (800 by 200 feet in size) with a sand-covered bottom was installed in August 1921.

Crystal Beach—Lorain Park

In 1922, about twenty acres in the Bens Creek area near the intersection of Valley Pike (Ferndale Avenue) and Tire Hill Road (Route 403) were made into a recreation area by a group of people active with the Johnstown Baseball Club.[323] A swimming pool, picnic

facilities and a large ball field area were installed, and the place quickly became a popular warm-season area known as "Crystal Beach." Lorain Steel got an option on the property and exercised it in 1930.

Lorain Steel also owned a nearby flat area immediately across Bens Creek that came to be known as "Lorain Park," the site of many organized picnics. After 1930, Crystal Beach and Lorain Park were jointly managed. The once popular recreation complex deteriorated during the Depression and was shut down after the 1941 season.[324]

The Schoenfeld Report

In 1912 the Civic Club hired one of its ex-members, Miss Julia Schoenfeld, a staff consultant with the Playground and Recreation Association of New York City, to prepare a Johnstown recreation survey. Schoenfeld's full report was printed in the *Tribune*.[325]

Using calculations based on the population of children, factored with her professional association's playground needs standards, Schoenfeld demonstrated an extreme imbalance. For all practical purposes, there were no playgrounds in Johnstown. Young children were playing in streets, schoolyards, vacant lots and especially in alleys. Schoenfeld had counted twenty-five children, one only three years old, playing in Cambria City's Bradley Alley. At another alley in Kernville, she counted twenty. When asked why they were playing in alleys, they answered that the police had stopped their playing in the streets and there was nowhere else. The very few play areas were too small. Both the Luna and Island Parks were fenced off. Children had nowhere else to play.

Tom Nokes

The *Tribune's* first sportswriter was Tom Nokes (1888–1981), who had the support of the paper's publisher, Anderson Walters. Nokes had been keenly interested in recreation, and in 1908 the paper's sporting department had organized a Boy's Baseball League. A year later, Nokes created a small advisory committee to help promote and pay for his paper's fledgling league.

Nokes's group grew to some twenty-five members, and by 1913 its scope covered a much broader recreational focus. As league president, Nokes established an honorary membership category, which included the mayor and many community boosters—his boss, Anderson Walters, George Wertz, David Barry (chamber of commerce president and a leading banker), and others. Soon the group, calling itself the "Amateur Recreation Commission," was organizing leagues and scheduling basketball, track and field, soccer and similar events. Press coverage was continuous.[326]

With Anderson Walters's encouragement, Nokes began an outpouring of publicity and editorials favoring park and playground acquisition, an initiative of the Civic Club. An unofficial "Park Board" also got created with Peter Carpenter and Anderson Walters as members. The "board" lobbied for playgrounds staffed with supervisors, and it encouraged after-hours playground use of schoolyards.[327] Nokes's groups functioned as if they were official bodies, although they were not city agencies.

When the commission form of government started in late 1913, the park and recreation commissions faced a risk of becoming inoperative because by law all activities had to be

concentrated in the new five-member council. Councilman John Berg, now superintendent of parks and public property and a novice in government, supported the creation of a Park and Playground Board of Johnstown, an idea likely planted by Nokes. The seven-member group first met in January 1914, and chose Peter Carpenter chairman. Nokes was secretary.

Now legally in charge of them, Berg announced he was delegating to the board the full authority to operate the city's parks and playgrounds. "I will back you to the limit," he said.[328]

Amateur Program

Amateur athletics in Johnstown had been put on a firm footing, largely organized through Nokes and his commission, but both the programs and organizations were continually changing. The whole thing gave Nokes materials to write about in the *Tribune*, and the paper in turn supported park acquisition and most organized athletics. Nokes, who often wrote about himself in the third person, drafted many of the editorials on park and recreation matters in the period before the war.

Park Plans

In early 1914, Peter Carpenter took an extended trip abroad and purposely visited many great European parks. Upon returning, he announced a $1,000 contribution toward the purchase of a park site in Constable Hollow, a fifty-acre tract of land owned by George Wertz near what would soon become Lorain Borough. Carpenter's idea was to attract thirty or more similar donors, but others would not commit.[329]

Mayor Joe Cauffiel announced his opposition to the Constable Hollow land acquisition, ostensibly because of unspecified mineral-right questions, but probably it reflected his animosity toward George Wertz, the "wet-faction" Republican boss soon to be named county controller.

Editorials of support appeared, and all indications were that the Constable Hollow land acquisition would materialize. The purchase, however, was not undertaken. Rifts within the commission government were surfacing, and the park acquisition issue simply faded away.

Meanwhile the *Tribune* continued to urge general park purchases. Elk Run Park (later Stackhouse) and Luna Park were both mentioned.[330] The city did get one new park. In late June 1915, Peter Carpenter donated Yoder Falls in northern Somerset County, his forty-acre retreat near the Windber line. It was promptly renamed "Carpenter Park."[331]

Later, with Cauffiel gone, the chamber of commerce began urging the Constable Hollow acquisition, an even larger tract than the 50 acres owned by Wertz. An offer of more than 188 acres had been made for $50,000, payable over ten years. On January 2, 1917, the city fathers took up the question and voted "no" by a three to two vote. The action took place during a time of anti-chamber sentiment in political circles. Berg announced in classic Johnstown double-talk that he wanted the purchase, "but not at this time." Others favored buying Luna Park.[332]

The Comprehensive Plan

With Peter Carpenter serving as vice-chairman of the city planning commission, the Johnstown Comprehensive Plan (1917–18) addressed a need for more park space. The plan

proposed public ownership of the steep hillsides around the city: the Westmont hillside, hillsides west of Oakhurst, a hillside in Ferndale near Ogle Street and Green Hill near Daisytown. The plan advocated the acquisition of both Constable Hollow and Luna Park.[333] In 1918, over forty-eight acres of steep and wooded hillsides were donated to the city by Mrs. Anna Von Lunen Hager, Mrs. Minnie Von Lunen Roberts and Mr. Rudolf Sann. The acreage, "Highland Park," is at the edge of Moxham.[334]

Acquisition of Luna Park

In his inaugural address at the beginning of his second mayoral term (January 1920), Joe Cauffiel urged the purchase of Luna Park, an on-and-off proposal for years. Civic groups and community leaders were favorable. No opposition surfaced.[335]

Negotiations with the Frank Cresswell heirs were successful. The price was to be $210,469. Settlement had to await a special "bond issue for parks." The measure to raise $350,000 was uncontested. On July 18, 1922, the council appropriated $366,618 for park acquisition and development purposes. The funds bought Luna Park plus some nearby land in Upper Yoder Township known as the Berkley Plot. It also financed a park plan plus some development costs including fence removal.

Swimming

In earlier times, Johnstowners enjoyed swimming in rivers, especially the Stony Creek near the Point and at "the Rocks" below Osborne Street. As the city grew, the rivers became polluted and bathing in them was forbidden.

Prior to 1920 there were no outdoor swimming pools in Johnstown. Although the site was difficult to reach, people flocked to the Border Dam on the Stony Creek, several miles upstream, where the water was cleaner. On July 28, 1919, Mayor Franke likened the spot to Atlantic City on a busy day. Of the estimated one thousand people he saw, most were from Johnstown.[336]

The first public-type outdoor swimming pool in Johnstown was constructed by the Lorain Steel Company in 1920 on the western side of Central Avenue north of the Ohio Street intersection. It was officially opened on June 18, 1921.[337]

The next year, the city's recreation commission constructed an outdoor pool in Morrellville on land owned by the school district behind what was to become the new junior high school. Oval in shape, Fichtner Pool was 250 by 165 feet in size and was shallow around its perimeter and deeper near the middle.[338]

Point Stadium Development

In April 1924, City Engineer Lee Wilson inspected the old Point Stadium and submitted a report to the city council. He found that the grandstand and bleachers were beyond repair and might collapse. Wilson recommended everything be demolished.

A new stadium was a popular cause during the mid-1920s. The chamber of commerce took a special interest and joined the recreation commission and city council as advocates.

The Greiner Company was retained as architect-engineers. The firm designed a steel and concrete facility to seat fifteen thousand. The curved grandstand had two levels.

The only way the city could finance the new stadium was through a bond issue requiring a referendum. In November 1925, voters gave approval. Fred Zipf and Sons, a Johnstown contractor, was awarded the concrete work, and Engstrom and Company of Wheeling was chosen to erect the steel. The two bids totaled $215,735.

Work progressed throughout the spring of 1926. The first event in the new stadium, a double header between the Johnnies and Clarksburg, occurred on July 5, when the stadium was still being finished. The first major sporting event was on Saturday, October 16, 1926, when Washington and Jefferson College defeated Carnegie Tech, the first college football game ever played in Johnstown. Some nineteen thousand people attended.[339]

XII. JOHNSTOWN SCHOOLS

Johnstown's Board of School Controllers, a twenty-one-member board, faced the challenge of educating a growing and diverse school population. The board was responsible for providing new schools plus additions to existing ones, adding faculty and staff and making timely curriculum changes.

From 1900 until the First World War, the school population was growing by about 210 pupils annually. There were complicating trends and new developments that were shattering school administration estimates based on calculated progression. An ever-rising percentage of pupils was continuing on to high school rather than dropping out after the eighth grade, a new trend altering a longstanding Johnstown working-family practice. Parochial schools were also attracting growing numbers of students. The Panic of 1907 precipitated an absolute decline in the high school enrollment for 1908, the only glitch in an otherwise steady growth pattern. From 1901 to 1916, the total pupils in Johnstown's public schools went up by more than half (51.3%), with the numbers of students attending its only high school increasing over five times.

The following table represents information, generally consistent but approximate only, derived from a variety of sources, chiefly Johnstown newspapers:

Enrollment City Schools—1900–World War I [340]

Year	Total Attendance	In High School	School Age Population	Percentage
1900–01	5,273	214	N/A	N/A
1901–02	6,148	250 (approx.)	N/A	N/A
1904–05	6,501	282	N/A	N/A
1907–08	6,697 (est.)	404	7,460	89.8 %
1908–09	6,891	365	8,154	84.5 %
1909–10	6,989	524	8,327	83.9 %
1910–11	6,622	578	8,500	77.9 %

Year	Total Attendance	In High School	School Age Population	Percentage
1911–12	6,814	703	8,912	76.5 %
1912–13	7,261	720	9,492	76.5 %
1913–14	7,502	788	9,659	77.6 %
1914–15	7,767	976	10,724	72.4 %
1915–16	8,600	1,154	11,712	73.4 %
1916–17	9,300	1,189	12,700	73.2 %
1917–18	8,847	1,306	N/A	N/A
1918–19	9,023	1,270	N/A	N/A

The High School Issue

The upward flow of pupils from all the elementary schools (twenty-three in 1912) was directly into Johnstown High School on Market Street downtown. Superintendent James Muir and A.E. Kraybill, the high school principal (1904–11), could easily chart the groundswell of pupils passing through the lower grades and continuing to high school. To Muir and Kraybill, the handwriting was on the wall—already crowded, the high school would soon be overrun with students.

In June 1910, just after the summer recess had begun, Kraybill reported to the school board that the high school had opened in September 1909 with 578 pupils, having closed the previous June with 512. For the next school year he was estimating an enrollment of 645. Kraybill recommended two new high schools—one a technical and the other a commercial institution.

Regardless of the superintendent's support, Kraybill's proposals were ignored. Both men were fired for political reasons, but the high school issues were partly to blame. In 1914, two major additions—one at each end—plus a separate gymnasium—were added to Johnstown High School.[341] Classes were also being taught in the basement, and an extra period had been added to each school day at the high school.

In 1915 the Johnstown School Board opened the second junior high school in Pennsylvania—Garfield—on Garfield Street between Chandler and Butler Streets. (When the new Garfield Junior High School opened in 1927, the earlier junior high became "Chandler," an elementary school.) The first Garfield School was experimental, leading to a time when there would be three junior high schools and one senior high school in Johnstown.[342]

Elementary School Additions and Enlargements

New elementary school buildings and additions to older ones also had to be constructed to accommodate the swelling population. To help deal with Moxham's growth, the Cypress Avenue School was erected in 1900 and received a major addition in 1906. In 1908 a new school at Village Street was constructed. In 1905 the Bheam School was built to serve Morrellville. In 1908 Roxbury School was constructed at Franklin and Sell Streets, and by 1913 a new wing almost as large as the original structure was added. In 1909 a new Washington School was built in the Prospect section, and in 1913 a new Meadowvale School was constructed to

serve Hornerstown. The twenty-one-ward system (each having an elected school controller) contributed to the scattering of numerous small schools about Johnstown.

The twenty-three elementary school buildings serving Johnstown in 1912 are listed below with their 1912 beginning enrollment, numbers of teachers and locations:[343]

School	Location	Number of Teachers	Pupils
Adams Street	Main at Adams	4	137
Benshoff Street	Minersville	6	226
Bheam School	Faifield Avenue at "J"	10	314
Chestnut Street	Cambria City	5	174
Coopersdale	Boyer Street	6	184
Cypress Avenue	Moxham	8	279
"D" Street	Morrellville	8	314
Dibert Street	Kernville	8	299
Garfield	Morrellville	6	201
Horner Street	Hornerstown	8	131
Meadowvale	Wood Street—Hornerstown	15	567
Osborne	Osborne Street—8th Ward	8	275
Park Avenue	Moxham	8	264
Peelor Street	Prospect	4	149
Roxbury	Franklin at Sell Street	7	286
Somerset Street	Kernville	16	575
Twelfth Ward	(Washington) Prospect	8	254
Union Street	Downtown	9	341
Village Street	Moxham	7	324
Walnut Grove	Walnut Grove	7	278
Woodvale	Maple	7	267
Totals	23	172	6,480

The School Reform Act of 1911

By 1908, proposals were underway to eliminate ward representation on the local school boards. At the November 1908 meeting, the Johnstown board voted nine to seven in favor of a resolution supporting a reform measure pending in Harrisburg for smaller boards elected at large. An expression of board sentiment, the straw vote had no effect.

One of the opponents was a youthful member from the Fourteenth Ward, Daniel J. Shields (1886–1961), who had been elected school controller in 1907 at the age of twenty-one. In propounding his reasoning, Shields argued, "This is the age of graft and the country is rotten with it. Why then wouldn't it be easier to buy a board of seven or nine members than one of twenty-one?" Shields also rejected an argument that the quality of school board members would be improved by there being a smaller body elected at large.[344]

Reform was inevitable. On May 18, 1911, Governor John Tener signed Act 191 into law. The Johnstown Board of School Controllers became the School District of Johnstown, a second-class district. In November 1911, city voters chose a nine-member board with staggered terms: three for two, three for four, and three for six years. Elected at large rather than by wards, the new members took office December 7, 1911.

President Daniel Shields and the Decapitation Crisis

At a special meeting of the Johnstown Board of School Controllers held after the regular February 28, 1911 session had adjourned, Shields, only twenty-four years old, was nominated for school board president in a run-off with the existing president, Dr. A.S. Fichtner from Morrellville. Shields won. His victory was a rebuke to Dr. Fichtner for allowing a delegation of citizens to butt-in and take part in an investigation. Fichtner's not having "showed the citizens the door," prompted the change. Shields had engineered the coup.[345]

Three months later, the school scene was astir with intrigue. Miss Ada Wertz, daughter of Senator George Wertz, was being promoted to chair the high school English department, and the head of the department, Miss Gertrude Wray, was to become high school principal. A.E. Kraybill, the current principal, was fired. James Muir, the protesting school superintendent, was also fired. While no evidence linked Senator Wertz to the personnel changes, the *Johnstown Democrat* aggressively condemned him. Its June 21 headline began: "School Board Obeys the Boss."

Exactly how intrigue of this sort worked is not known. Daniel Shields's cousin, John Minahan, a bricklayer from Cambria City, supported him by voting for the personnel changes. The leading newspapers condemned the intrusion of politics into school matters. Some of the actions were probably intended to bring about changes before the new school code, just signed into law on May 18, would oust the sitting board members.

The June 1911 crisis alerted the citizenry about politics infecting the school board. There was a mass meeting, calls for a grand jury investigation and a debate over whether a woman should be a high school principal. Ironically none of the members, including Shields, who had voted to promote Ada Wertz and Gertrude Wray and to dismiss Muir and Kraybill, sought reelection. Of the nine new members elected after the school reform legislation took effect, six had voted to support Muir and Kraybill.

Shields was elected to the city's common council in 1911 (before the Clark Act took effect), again representing the Fourteenth Ward. Shortly after his school board career had ended, he opened Shields Bar and Café on Clinton Street and became executive director of the Cambria Retail Liquor Dealers' Association.[346]

The Gary Plan

In the late spring of 1917, the school board and administration began exploring the educational program in Gary, Indiana, a new community built around a modern steel mill developed by the U.S. Steel Corporation. Gary was a planned community with modern streets, parks, sewers and other urban infrastructure. It had also started an innovative

educational system featuring new "work, study, play" school buildings for all-year, around-the-clock use by students and the general public. There was also specialized teaching in the elementary grades, a radical departure from Johnstown's practice of each elementary teacher instructing pupils in everything from reading and writing to mathematics, science and art.

The Johnstown school superintendent, J.N. Adee, appointed a committee to study the plan. Two members visited Gary, while others reviewed written materials. In June 1917, the committee produced a report to the school board describing the school facility concepts: around-the-clock and all-year building use by pupils and the general public, specialized teachers using team-teaching concepts and joint school-recreation programs. There was even a swimming pool in every school and extensive early and advanced vocational education facilities and instruction. Education in Gary was a lifelong pursuit.

The report, realistic in that it did not recommend Johnstown scrap its program or two dozen small elementary buildings, did contribute to the development of much larger and more rounded high school buildings and instructional programming. The experimental use of Garfield Junior High School (at Butler and Chandler) and the more comprehensive design philosophy of the new junior and senior high school buildings owed much to the Gary Plan evaluation and inquiry. Herbert Stockton, the next superintendent, had been a member of the Gary Plan committee.[347]

Johnstown Public School Developments After World War I

> *I propose to pursue the same policy in my conduct of the affairs of the superintendency as I have in my conduct of the affairs of the principalship of the high school…I am opposed to politics in the public schools either on the part of the school board, superintendent, or any subordinate. I shall not submit to any dictation from any quarter.*

This public statement was issued in April 1918 by Professor H.J. Stockton, who had just been named school superintendent after serving six years as principal of Johnstown High School.[348] He and his predecessor, J.N. Adee, had wrestled with growing enrollments, the leading problem of the school system. The war had halted new building activity and the effects of peacetime were unpredictable.[349]

Stockton knew the key problems of the school system would be rampant growth and progressively higher percentages of pupils going to high school. To Stockton, the only solution was ambitious and costly: construction of one new central high school and two new specially designed junior high buildings—the first (Cochran) in the Eighth Ward near Moxham and Hornerstown; the second in Morrellville near Oakhurst Borough, then undergoing annexation. The pupil mix would be the modern 6-3-3 plan: the first through the sixth grades were elementary, the seventh through the ninth were junior high, and the tenth through the twelfth constituted the senior high school grades.

There was still a need for more elementary schools, and Stockton, a pioneer advocate of vocational education, sought an "industrial building" in the central part of the city. Stockton outlined his vision one month after the armistice.[350]

The school board proposed a $2 million bond issue for a November 1919 referendum. The tense atmosphere of the steel strike caused a wise postponement. The bonds were approved in May 1920, and the building program soon got underway. At the beginning of the 1921–22 school year, crowding was at its worst. The opening of the new Cochran Junior High School was a year in the future and the district management was forced to move pupils from one school to another. Classroom space was leased at the Zion Lutheran Church, and portable classroom buildings were used.

Stockton had strongly advocated one large central high school.[351] Three new elementary schools were opened in 1922—Chestnut in Cambria City, Maple Park in Walnut Grove, and Coopersdale. Cochran Junior High opened for use in 1922 although work was still underway. The Johnstown High School, located near the center of town, was completed and opened in September 1926. Garfield Junior High School was completed for the 1927 fall semester.

In April 1922, rumors were rampant in Johnstown that Stockton's contract would not be renewed. Apparently school board members sought personally to choose the textbooks to be used in the city schools. Stockton would have none of this. Despite wide and influential community backing, his contract was not renewed. Stockton went into the insurance business, but soon got elected to the school board.[352] On April 11, 1922, Dr. Samuel Slawson became superintendent.

Changing School Dynamics in the Mid-1920s

With the construction and opening of the massive Central High School, the conversion of the former high school into Joseph Johns Junior High, the completion of Garfield Junior High School, the reversion of the former Garfield Junior High School back into an elementary school and the opening of Cochran Junior High School, the continuum of crises about classroom space was over before the 1920s decade had ended.

Johnstown School District Enrollment Data, 1920–30* [353]

Year	Total Enrollment	Central High School	Junior High School
1919–20	9,523	1,367	505
1920–21	9,889	1,410	586
1921–22	10,835	1,330	1,744
1922–23	10,804	1,378	1,723
1923–24	11,081	N/A	N/A
1924–25	11,933	1,158	1,895
1925–26	12,335	1,163	2,088
1926–27	13,000	1,200	2,695
1927–28	13,560	985	3,341
1928–29	13,748	1,060	3,657
1929–30	13,033	930	3,459

* The above data is approximate only. It comes from a variety of sources. The figures changed almost daily.

Johnstown's Parochial Schools

Many of Johnstown's churches offered "church schools," almost all taught by Sisters of a particular order. Until 1922, there was no parochial high school and information about the church schools is scattered.[354] The numbers of pupils and grade levels has not been found, and in some cases the instruction was probably a religious supplement to public schooling:

School	Location	Order
Immaculate Conception	Cambria City	Sisters of Divine Providence
Sacred Heart	East Conemaugh	Ursulines
St. Anthony's (Italian)	Woodvale	Sisters of St. Joseph
St. Benedict's	Geistown	Sisters of St. Francis
St. Casimir's (Polish)	Cambria City	Sisters of St. Francis
St. Columbia's	Cambria City	Sisters of Mercy
St. John's Catholic	Old Conemaugh	Sisters of St. Joseph
St. Joseph's (German)	Old Conemaugh	Sisters of St. Francis' Mary
Greek Catholic	Cambria City	Not known
St. Patrick's	Moxham	Sisters of St. Joseph
St. Paul's German Lutheran	Morrellville	N/A
St. Rochus (Croatian)	Cambria City	Sisters of the Precious Blood
St. Stephens (Slovak)	Cambria City	Sisters of St. Francis of Mary Immaculate

Johnstown Catholic High School (Later "Bishop Mccort")

When Bishop Eugene Garvey died in October 1920, John Joseph McCort, coadjutor bishop of the Altoona Diocese, succeeded him. Having served as an instructor at St. Charles Seminary, McCort favored Catholic education. In January 1922, presiding over a call meeting in Johnstown, he announced two parallel but mildly competitive fund drives—one in Altoona, the other in Johnstown. Each community was to raise $100,000 to build its own Catholic high school. The bishop organized a three-week campaign. Every family was to pledge a minimum of $25 and the wealthy were encouraged to donate more. The two fund drives were successful, and on June 25, 1922, a cornerstone was set for the Johnstown Catholic High School Building on Osborne Street.

The building was finished in six months. A new freshman class would begin each year until all four high school classes were functioning. Meanwhile, prior to the building's completion, 170 pupils had already registered and were attending classes at local churches.

The arrival of Johnstown Catholic High School onto the educational scene had a noticeable effect on public high school enrollment. In the 1923–24 school year, about 300 pupils were attending the new school.[355]

XIII. MISCELLANEOUS PUBLIC FACILITIES AND ISSUES

The Public Safety Building

Until the mid-1920s, the Number One Fire Station, headquarters and central fire-alarm equipment were all crowded together in the old Assistance Fire Station at Washington and Market Streets, a building owned by Bethlehem Steel. Offices in city hall were jam-packed, and there had been discussions but no action in the city council about a new public building.

A propensity to delay was quickly changed with the realization that more fire-alarm-boxes could not be added until there was greater floor area to house additional components. Since there were plans to add alarm boxes all over town and to expand the police call-box system, additional space was essential.[356]

In August 1923, the city reached an agreement to purchase the fire station and headquarters for $15,000. By early October, it was seeking proposals from architects to design the Public Safety Building.[357] By August 1924, Hirsch and Schollar, an Altoona firm, had designed a five-story building. The proposed structure would house the police and fire departments, their communications equipment, health and laboratory facilities and the Number One Fire Station. The cost estimate was $250,000, to be financed through a bond issue already authorized in 1924. Berkebile Brothers of Johnstown was contractor.

Work progressed throughout most of 1925 and well into 1926. September 20, 1926, was "moving day." The building was dedicated on December 16, 1926, followed by open-house visits for several days.[358]

XIV. POLITICS IN THE 1920s

The Parties and the Factions

The Republican Party, the dominant political organization in Cambria County throughout most of the 1920s, was split almost every way divisions might occur—wet and dry, northern and southern, Catholic and Protestant and so forth. Anderson Walters (1862–1927), publisher of the *Tribune* and Pennsylvania congressman-at-large during the Sixty-third (1913–15), Sixty-sixth (1919–21), and Sixty-seventh (1921–23) Congresses, was generally considered the "dry," pro-Prohibition faction leader in the World War I–early 1920s era. George Wertz (1865–1928), a former sheriff, county controller, state senator, part owner and publisher of the *Johnstown Leader*, real estate developer in the Richland-Geistown area and the district congressman during the Sixty-eighth Congress (1923–25), was a rival party leader and a "wet."

For the Democratic Party leadership in Johnstown and Cambria County, one would look to W.W. Bailey (1855–1928), principal owner and publisher of the *Johnstown Democrat*. Bailey was a free trader, supported "free silver" and advocated Henry George's "single tax." Bailey's close friendship with William Jennings Bryan explains Bryan's many visits and speeches in Johnstown. Bailey had also served in congress for two terms (from 1913 through 1917).

In November 1924, both Bailey and Walters were running for district congressman. The Republican numerical advantage should have given Walters a sure win, but the results were close. There were hints of irregularities, a recount, and a charge of fraud in a Westmont precinct. The matter went to the county court, which concluded that one hundred of Walters's votes were forged, and that Bailey had won the cliffhanger by fourteen votes. The county election board, however, refused to certify Bailey as winner, claiming that the ballot box had been improperly reopened. Bailey appealed the inaction to the Pennsylvania Supreme Court but was unsuccessful. He next petitioned the U.S. Supreme Court, which declined to review the case. Meanwhile in March 1925, Walters was seated.

The final decision point was with the House Committee on Elections, which declared that Walters had won by fifty-one votes.[359]

Ku Klux Klan Influence in Mid-1920s

George E. Wolfe (1876–1939) from the Hornerstown section was a Democrat, a Catholic and a well-known lawyer. In 1923, Wolfe saw an opening to win the election for district attorney. Just before the election, Wolfe received an unsigned letter from the Ku Klux Klan with a leaflet enclosed. The letter read, "You will never hold the office. You might as well quit now."[360]

For whatever reason, Wolfe's vote tally was well below what most Democrats typically got precinct-by-precinct. Two months after the Rosedale Incident,[361] the Klan's newly awakened, anti-Catholic posturing had taken its toll. Wolfe felt betrayed by Democratic loyalists, but his low vote totals are best explained by the momentary strength of the KKK.

Gus M. Gleason

In 1923, a shrewd and well-connected Republican from Clearfield County, Gus Gleason (1881–1941), and his family moved to Johnstown just after he had been named secretary of the Central Pennsylvania Manufacturers' Association and manager of its casualty insurance company's local office. The association handled workmen's compensation insurance for many major corporations. Its parent organization, the Pennsylvania Manufacturers' Association, was becoming a political force in the state.

When one of Gleason's relatives from DuBois had died, John L. Lewis and other labor leaders attended the funeral. Gleason's sister was married to I.C. Mishler, the theater impresario. Gleason had been active in Republican politics and his reputation preceded his arrival.

Shortly after moving to Johnstown, Anderson Walters asked Gleason to stop by the

Tribune for a visit. He arrived on time but was made to wait inordinately. Noticing staff people going in and out of Walters's office, Gleason informed a secretary that he had other things to do and left.[362]

By the time of Anderson Walters's death in 1927, Gleason and his close friend, Stephen Pohe, a senior vice president of Penelec, had taken control of the Republican Party from what little leadership there had been at the time, an unusual feat for any newcomer to Cambria County.

Gleason's rise to leadership can be credited to his friendship with and very effective political support given to John Fisher from Indiana County in the 1926 gubernatorial election. Thanks to Gleason's organizing and voter-turnout efforts, Fisher carried the county by more than 5,200 votes. As governor, Fisher delegated patronage appointments to Gleason, who began developing a unified organization.

Changes were happening when the bonding effects of Prohibition were breaking down and old-guard Republican leaders were losing control. Anderson Walters, aging and ill, died in December 1927. George Wertz died in November 1928. Temperance was history.

HIGHWAYS AND TRANSIT DEVELOPMENTS FROM 1900 UNTIL THE GREAT DEPRESSION

I. REGIONAL ROADS AND TURNPIKES

At the start of the twentieth century, one took the train to reach places away from Johnstown. The stagecoach era was over. With its demise, many turnpikes the stages had used fell into disrepair, and were either unusable or had gotten taken over by township or county governments that usually were neither able nor willing to maintain them. Township roads in general were said to have been deplorable.

Farm-access roads webbed their ways throughout rural areas. Their locations had been established by timeworn usage. The more dominant routes were the established township-to-township roads and busier turnpikes. Pennsylvania townships were authorized to levy a "head" tax dedicated to road maintenance. Those who did not pay had to "work out" the road tax, a practice from earlier times. "Men and boys putter and loaf around a couple of days," Judge Francis O'Connor once lamented, "This they call working out the road tax."[363]

The Pennsylvania Legislature had outlawed the "working-out" concept but left intact a local-option provision to permit townships to continue it. Many did so. Most townships had neither the funds nor substitute labor to maintain good roads. Road conditions discouraged trips to destinations more than a few miles from Johnstown in a horse-drawn vehicle. Such travel was slow, uncomfortable and risky.[364]

The Automobile

In the years between 1900 and 1910, the automobile in Johnstown was a rich man's showpiece. Often shipped to the city in a railcar, each new arrival prompted a short newspaper article. While Henry Ford's Model T was first manufactured in 1908, assembly-line mass production (making cars affordable to many people) began in 1913.

The Automobile Club of Johnstown was founded in 1905 with twenty-six start-up members: Jacob Murdock, a lumberman, was the president. George Swank, Harry Swank and Arthur Cresswell were, respectively, vice president, treasurer and secretary. The club had several purposes: social pleasure driving, vehicle racing, promoting laws for convenience and safety and advocating quality roads and streets.

By May 1904, a new state law required automobiles and trucks to be registered through the counties. Every operator needed an annual driving permit, which could be gotten from a city government for three dollars. Within Pennsylvania cities and boroughs the speed limit was eight miles an hour. Outside the city limits one could drive one mile in three minutes except at curves. The laws were enacted based on various auto club recommendations.

The councils in Johnstown also sought with difficulty to word an ordinance to keep automobiles from spooking horses, an impossible goal. Whatever was good for horses was usually bad for automobiles and vice versa.

In 1906, Jacob Murdock personally drove his twenty-four-horsepower Packard on a 243-mile trip to Philadelphia in thirteen hours and seventeen minutes. Murdock reported the roads were in good condition everywhere except near Johnstown. In May 1907, Joseph Love and Billy Sunshine set a new Johnstown-to-Somerset record—one hour and thirty minutes.

A few people were beginning to drive from Los Angeles to New York, each seeking to break the earlier speed record. In 1908, Jacob Murdock shipped his "Packard 30" to Los Angeles and on April 24 he and seven others set out for New York City. On May 22 they reached Johnstown and spent a night at home. When they arrived in New York, the entire trip had taken thirty-two days, five hours and twenty-five minutes . Murdock's actual running time had been just over twenty-five days, another new record.

In June 1910, Murdock and his family returned from a two-month automobile touring vacation in Europe. Murdock described the fine roads in other countries and reported that those in France were the best anywhere.

The well-publicized excursions and speed trips brought on a dawning realization: a motorist could use an automobile to reach distant places. If one could get to Philadelphia from Johnstown in thirteen hours over bumpy, stream-fording roads, what would the future bring if there were quality highways to distant destinations?[365]

The 1905 Legislation

The Good Roads Act of 1905 assigned new duties and funding to the two-year-old Pennsylvania Highway Department. The statute sought to address a key problem: how to decide which bumpy, mud-filled roads to improve. Cambria County was typical of the state; its twenty-eight townships had over 1,500 miles of roads, most being in deplorable condition—bad enough for horse-drawn vehicles but impossible for the automobile.

The program that evolved from the 1905 legislation had three features: engineering assistance to county and township road commissioners; rudimentary design standards for macadam roads; and finally a cost-sharing program in which the townships, working

through the county, would seek state aid. The townships and county would choose and prioritize roads for improvement and estimate the costs. The state commissioner of highways had the ultimate approval authority.

The 1905 legislation also failed to do certain things. Cities like Johnstown were ignored, and even their prominent through streets received no state assistance. Even more important, there was no provision for planning and building a totally new highway where a road did not already exist. The focus was upon prioritizing and improving the many existing roads winding around all over the place.[366]

The hopes and promises of the 1905 legislation did not measure up. There was too much to be done. Macadamized roads were superior to dirt roads but they were far from perfect. Drag brakes, together with the effects of freezing and thawing, tore them up. Eventually potholes replaced mud bogs and hard-soil bumps. Worst of all, road improvement in Cambria County was uneven. As was true with the streets of Johnstown, there was a patchwork of improved roads. The perceived injustice made complaints and finger pointing inevitable. Developing the first two-year program had been irksome.

Cambria County's first application for assistance was sufficient to improve only 47 miles of township and borough roads, leaving 1,450 miles untouched. At such a pace, fixing the roads would have required a generation. Meanwhile automobiles were multiplying and some improved roads had to be rebuilt.[367]

The Turnpikes

Everyone wanted to get rid of turnpikes and their tollgates—the only road-related subject over which there was no dispute. The problem was determining what government unit would care for the road with the tollgate gone. Petitions were filed in 1906 to eliminate tolls from the Valley Pike. While undergoing review in 1908, Judge Francis O'Connor inexplicably exempted the Moxham and Ferndale Bridges, causing future legal problems. Later in 1908, the Johnstown and Scalp Level Turnpike (Scalp Avenue) from Walnut Grove to Scalp Level was acquired by condemnation, an action triggered by the company's not maintaining the road. When completed, it was announced that the Scalp Level Turnpike had been the last Johnstown area toll road. The Cramer Pike, however, remained a toll road until taken over by the Pennsylvania Highway Department in 1920.[368]

The Jungle Road

In 1908, a mini-scandal surfaced that would affect Johnstown-area road building and improvement for a decade—the Constable Hollow Road, a proposal made by Charles Leventry, a Republican county commissioner, and his Moxham colleague and neighbor, George Wertz, a candidate for and later a Republican state senator (1909–13). Leventry was part owner of and an officer in the Highland Coal Company with a mine in Stonycreek Township above Moxham. Wertz owned land throughout Constable Hollow (the valley of Sam's Run, east of Moxham) over to the Walnut Grove area. The two allegedly used their

THE TOLL GATE

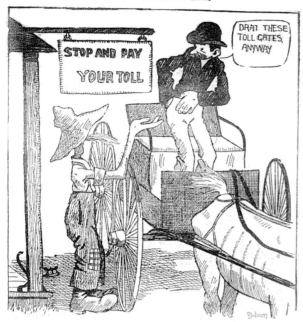

A Thing That Should be Abolished

Everyone hated toll roads. The cartoon is from the *Weekly Democrat*, September 8, 1905.

influence to get the state to improve the extension of Ohio Street up past the coal mine. In short, the Constable Hollow Road benefited properties both men were developing through their Suburban Realty Company.[369]

At that time (1908), contemporary Geistown did not exist, and today's more built-up sections of Richland Township were rural farmlands and woodlands. The Constable Hollow Road was described as a road to nowhere and was soon being called the "Jungle Road" or "Wertz Road." In an era when highway improvements were badly needed all over, the project smelled of political greed. In addition, Wertz was a "wet" in the period before Prohibition and was becoming a rival to Anderson Walters (a dry) in an ongoing battle for leadership of the Republican Party.

O'Connor's Grand Jury Scheme

Dissatisfaction about roads being rife, and his own reelection contest less than two years away, Judge Francis O'Connor, a Democrat, was "smelling blood." In June 1909, he decided to get into the road dissatisfaction fray through an unorthodox but original ploy. He sicked the grand jury on to everybody having anything to do with roads in Cambria County, including Mayor Alexander Wilson of Johnstown. O'Connor opened by addressing his grand jurors:

> *Gentlemen, we direct your attention to the fact that as grand jurors and under your oath, you are bound to report any unprosecuted crime in the county of which you have knowledge. The*

general character of these crimes…is violations of the liquor laws, the presence of…houses of ill fame, and the neglect of their duty by public officials—notably road supervisors…If this neglect is such that it renders a highway a nuisance, then it is a public crime and the grand jury has it in its power to take cognizance of it…If the grand jury is cognizant of cases in which the supervisors are neglecting their duties, it should take immediate action.

The grand jury soon found itself in the road-project development business. The 1909 program done under the Good Roads Law had incorporated an additional step not spelled out in the 1905 statute and one far outside the judge's charge—plan approval by the grand jury.

By early September, late in any year to accomplish roadwork, the 1909 program had finally taken shape. The commissioners agreed to about one hundred miles "of good roads through Cambria County." The grand jury, charged with investigating neglect-of-duty situations in township and county road building and maintenance matters, turned down the program, suggesting that it be voted on by the people. "There are many people who object strenuously," one juror was quoted as having said, "and these objectors would all put the blame for the whole thing on our shoulders."[370]

Judge Francis O'Connor's grand-jury stratagem had gone awry. Instead of helping to get things done, it had become part of the problem.

Other Causes of Indecisiveness

It also seems that the indecisiveness and inaction by township supervisors during this era were rooted in issues between the "haves" and "have-nots"—those who lived on farms and did not own automobiles or trucks and the very few "city slickers" who did own them. As late as October 1911, there were only 375 automobiles registered in Johnstown City, about one car for every twenty-nine families.

Township supervisors and commissioners doubtless resented the pressures to spend money and labor on roads to benefit wealthy outsiders who could be seen with their ladies driving by in noisy contraptions that kicked up dust, frightened farm animals and got chased by dogs.

Township authorities had another reason to be indecisive—the emerging delineation between state roads and local roads was not clear. The state had ultimate approval authority under the Good Roads Act and seemed to be favoring through-roads that went from community to community. Rumors were circulating that the state highway department soon would announce a program to finance and build these roads at state expense. Township officials were logically reluctant to commit local money to fund them. A result was that the roads most desired by urban automobile owners were the very ones township supervisors were least likely to include in their programs.

The Cambria Road Improvement Association

Less than two weeks following the grand jury's handwashing inaction, Johnstown leaders were busy creating another organization—the Cambria Road Improvement

Association. Some thirty people chose Charles S. Price, Anderson Walters and Harry Mainhart, respectively president, vice president and treasurer. Its executive committee was equally blue ribbon. After its September 22 founding, the group proceeded to meet with township supervisors. For a while, there was an abundance of editorials championing the importance of roads to farmers, the general economy and other components of the public good. The state highway department continued to be hammered by everyone, and the Wertz Road through Constable Hollow was an increasingly discussed scandal. Nothing seemed right with Cambria County road building and maintenance or with the state highway program.[371]

The Sproul Act

The "bottoms up" approach to road matters (townships and boroughs acting through the counties to the state) had resulted in an uneven patchwork of roads that made little sense to the serious motorists who were seeking good road connections to desired destinations.

In 1911, Governor John Tener and Senator W.C. Sproul began advocating legislation for a new approach—a system of state roads connecting key locations. They would be planned, constructed and maintained by the Commonwealth at state expense. In February, the Sproul Bill was introduced in the Pennsylvania Senate. Its first draft had incorporated about two hundred route systems. The basic philosophy was to connect each county seat to all adjacent county seats, including those in bordering states. When the first draft of the bill became public, Johnstowners were alarmed. Their city, not a county seat, was almost not mentioned at all. Charles Price, president of the Johnstown Automobile Club and a spokesman for the Cambria Road Improvement Association, took immediate action. Together with D.J. Berwind of the Berwind-White Coal Company, they caused a Bedford to Blairsville link (modern Route 56) to be added to the bill. Johnstown was part of the route.

Sproul's bill underwent extensive revision in April and May of 1911, primarily because it was route specific and spelled out communities between the county-seat destinations. When finally enacted, there were 296 designated routes sequentially numbered. Johnstown was mentioned in only three routes and always as part of other county-seat linkages.

Having created hope, anticipation and a lot of fully state-funded roads all over Pennsylvania, there was an obvious need for big money. The 1911 and 1913 state legislative sessions authorized a referendum to amend the constitution for a $50 million bond issue. Meanwhile another 118 more route designations had been added to the state system through amendments to the Sproul Act. Promises were flowing like spring rains as inducements for a favorable statewide vote.

In November 1913, the statewide bond issue was defeated. Cambria County had voted against it. Newspaper editorials in Johnstown had urged people to vote "no." The argument was that a $50 million program would result in scandals and waste. The Jungle Road was cited as what would be repeated with a big state program.

The defeat of the $50 million bond issue authorization left the state with an enormous road construction authorization—10,200 miles with no way to pay for it. In 1915, Governor

Martin Brumbaugh managed to get a two-year appropriation of $8.4 million for the highway department, a minimal amount that would have to last until World War I.

Meanwhile the assembly-line revolution of Ford production was underway. Automobiles were becoming increasingly plentiful, less costly and more widely used. By November 30, 1916, licenses had been issued for 1,860 vehicles in and near Johnstown—roughly one car per ten families. RFD addresses were beginning to appear on the owner lists. The automobile was here to stay.[372]

Highway Associations

Whenever public needs greatly exceed available resources, a strong incentive exists for pressure groups to organize to lobby their interests. The Cambria Road Improvement Association was made up largely of the same people as the Johnstown Automobile Club. In time, the former faded away and its agenda was assumed by the latter organization. After the Johnstown Chamber of Commerce got underway in 1910, road advocacy became one of its initiatives.

An early nationwide organization, the Lincoln Highway Association, was founded in 1912 by a consortium of automobile manufacturing interests. It sought to promote a highway from New York City to San Francisco. In Pennsylvania a linear corridor from Easton to Pittsburgh was forged by linking a line of county-seat to county-seat routes already spelled out in the Sproul Act.

There had apparently been no lobbying from Johnstown. Use was made of the Bedford to Greensburg link—Route 119 in the Sproul Act. Selection by the Lincoln Highway Association raised the state priority for funding along the Lincoln Highway.

Melville James, an Ebensburg newspaperman and a former *Johnstown Democrat* reporter, sought to use the Lincoln Highway Association strategy on a more modest, statewide scale. In March 1916, he founded the William Penn Highway Association and persuaded many civic organizations and automobile groups to join. Members included the Johnstown Chamber of Commerce and several community leaders.

James and his William Penn Highway Association also sought to link Pittsburgh and Philadelphia with a modern highway composed of Sproul Act routes. The corridor through Cambria County would connect Hollidaysburg, Ebensburg and Blairsville. Johnstown interests were appeased by including a Johnstown to Mundy's Corner link also named the William Penn Highway. The first Johnstown connection was through East Conemaugh, but it was later routed through Prospect.

James was politically astute. He gained the early support of Governor Martin Brumbaugh, who wanted a quality east-west road to pass through his own Huntingdon County. The William Penn accomplished this.[373]

Johnstown Priorities

In terms of east-west highways, Johnstown was left out. The Lincoln Highway was to its south and the William Penn Highway was to the north. Many highway needs were advocated in

Johnstown's civic circles, but the highest priority was to access Ebensburg and the William Penn. A high priority was to develop Sproul Act Route 52 from Johnstown to Mundy's Corner.

Aside from the William Penn and Ebensburg initiatives, the pre-World War I highway priorities are difficult to judge some ninety years later. Indeed they were not always clear to contemporaries: one group sought a good road to Westmont and agitated for brick-paving the twisting Mill Creek Road through Kernville. There were spokespersons for a road from Westmont over Laurel Mountain to Ligonier. Some favored improving the Main Line Highway (Frankstown Road) from Johnstown to South Fork, Summerhill, Wilmore, Portage and Cresson. An effort got underway to improve access from Johnstown to the Lincoln Highway and eventually to Somerset.

Johnstown's regional highway development had always been impeded by steep topography, streams and complications caused by railroad rights-of-way. In addition, the city's not being a county seat lowered its standing for Sproul Act projects.

Johnstown Area Road Developments

When the United States entered the war, there was only one all-weather road connecting Johnstown with the outside world, a stem of the William Penn Highway between the city and Mundy's Corner. Everything else leading into Johnstown was subject to ruts, mud and dust.

The William Penn Highway had been recently improved eastward from Mundy's Corner to Philadelphia. Upgrading its western continuation that passed over Chicory Mountain was to face future delays.

Jacob Murdock, the automobile enthusiast, was Johnstown's good-roads hawk. He was persistently involved in highway advocacy and was both a founder of and often served as president of the Cambria County Good Roads Association.

Just as the nation was adjusting to the war, Murdock stated Johnstown's top priority:

> for Johnstown to reach the Lincoln Highway over a road that will be passable the year round without wallowing through mud holes a foot deep.

The war, however, deferred building roads. Labor and materials were unavailable.

Postwar Priorities

Six days before the armistice in November 1918, Cambria County voters, by a five to two margin, voted favorably for a successful constitutional amendment allowing the Commonwealth to sell up to $50 million in bonds to construct roads in Pennsylvania.

In February 1919, about forty prominent Johnstown and Cambria County citizens visited Lewis Sadler, state highway commissioner. The meeting was upbeat. The county's favorable vote greased the delegation's mission. With the room full of welcomed good-roads enthusiasts, Sadler dictated several commitments including:

1. Route 317, from Johnstown to Jenner's Cross Road (giving Johnstown access to the Lincoln Highway), would have the top priority.

2. Route 314, from Mundy's Corner to Armaugh, was to be financed by the state (meaning no local contribution). This road would be deferred briefly due to a higher priority being given to Route 317.

This flip-flop in priorities did mean the William Penn would be delayed in its construction upgrade westward into Indiana County, doubtless causing problems for the well-organized William Penn Highway Association.

When the happy road enthusiasts returned on their special railroad car to Johnstown, a meeting of the Cambria County Good Roads Association was called to order. Jacob Murdock, just back from France, was named president. A.M. Custer was treasurer. A membership drive would be initiated at once.[374]

Murdock stated his views on road policy: Concentrate on the big through highways and eliminate the little roads that go nowhere. Within one year of the armistice, some forty miles of new roadwork were under contract in Cambria County near Johnstown.[375]

The Menoher Highway

Just before Christmas in 1919, a new proposal originated in Johnstown that was known to have been controversial in Ebensburg and Somerset—the Menoher Highway. This special road was to begin at General Charles Menoher's Johnstown birthplace near Franklin Street and Valley Pike, extend up through Southmont and Westmont, cross over Laurel Mountain to Waterford and end at Ligonier.

There was broad support for the road both in Johnstown and in Westmoreland County.[376] Proposing to dedicate the highway to a popular Johnstown war hero was a shrewd ploy—opposing the plan might be construed as insulting the general. Endorsement petitions were circulated and quickly signed by hundreds.[377] While it took many years to build, the Menoher Highway was eventually accomplished.

After several years of waiting, the William Penn Highway was finally completed through the county west of Mundy's Corner, a delay caused by the priority change and high cost of crossing Chicory Mountain. On October 1, 1925, during a Blairsville historical commemoration, completion of the William Penn Highway was also celebrated.[378]

The County's Bond Issue

In the spring of 1920, the Cambria County Commissioners proposed a $5 million bond issue to finance county roads and bridges and to match both state and township funds to leverage more projects. Backed by both the Cambria County Good Roads Association and the Johnstown Chamber of Commerce, the referendum was successful.[379]

A final and controversial issue in the early 1920s, supported cooperatively by Johnstown good-roads advocates, involved an extension of the Frankstown Road and its tie-in with the Clapboard Run Road (from Franklin Borough) to South Fork, Summerhill, Wilmore, Portage and eventually to Cresson. Here it would join the William Penn Highway. The project was accomplished, having been financed jointly using county bond issue, state and township sources.[380]

Overview of Postwar Progress

In his 1926 *History of Cambria County*, John Gable had estimated that at the end of the First World War, Cambria County had almost twenty miles of "improved roads," not including city or borough streets. By the end of 1924, the county road engineer estimated that a total of 201.58 miles—a ten-fold increase—were in place. Pennsylvania was said to have been one of the three leading states nationwide in road construction, and Cambria County in turn was among the top four counties in the Commonwealth.[381]

II. TROLLEY AND REGIONAL PASSENGER RAILROADS

As Johnstown's population and prosperity grew, so did the usage of the trolleys owned and operated by the Johnstown Passenger Railway Company. In the era before the automobile was commonplace, trolley service was essential both to business firms that catered to heavy customer traffic as well as those with one or more sites having heavy employment.

Each time a new line was installed, a single-track line double tracked, or some other major change was implemented, either a new city franchise or a franchise modification had to be issued. Both were done by the enactment of a city ordinance, a procedure that generated controversy because it revived the issues of perpetual versus time-limited franchises and franchise fees. A lot of wheeling and dealing preceded council action on most franchise ordinances, and a veto by the mayor meant the whole thing would be taken up again.

In the public eye, trolley service was a constant source of complaint. The cars were too cold in winter, too crowded, too jerky, too bumpy and on and on. Like a lot of public services when things were well done, no one paid attention; but when service was bad or inadequate, everyone complained.

"Coley" and "Ev"

The president of the Johnstown Passenger Railway Company was T. Coleman "Coley" Du Pont (1863–1930), by 1900 an ex-Johnstowner living in Wilmington, Delaware. He had managed the local Lorain Steel Company operation from 1894 to 1899, after Arthur Moxham had moved on to Lorain, Ohio. Later, in 1902, he had become president of the Du Pont Company. Charming, witty and outgoing, Coleman Du Pont had been a popular civic leader during his Johnstown years. He also returned often.

The Johnstown Passenger Railroad could do no right. Everyone beat up on the company, complaining that the cars were too cold, too hot, too jerky and too crowded. The cartoon is from the *Johnstown Tribune,* December 16, 1905.

Puzzle---Get the Lady in the Street Car

Coleman Du Pont was in poor health. Some said he suffered from pancreatitis. Others said he had the "social disease." He occasionally confided to friends that his health problems were rooted in his excesses—"too much good food, too much good drink, and too many bad women."[382] Coleman Du Pont's career was carefully followed in the Johnstown newspapers through articles that dealt with his leadership at Du Pont, his activities in politics as a U.S. senator and his unsuccessful bid for the Republican presidential nomination in 1916, and his several trips to the Mayo Clinic.

The man who ran the Johnstown Passenger Railway Company was Coleman's unobtrusive younger brother, Evan (1872–1941), who had followed his older brother to Johnstown in 1898. Soon afterward, Evan Du Pont married a local beauty, Helen Quinn, from the Quinn Dry Goods Store family.

"Ev" Du Pont was a contrast to his more flamboyant brother. He said little. Sometimes when he was expected to attend a business meeting about the trolley company, he failed to show up. He might have been found with a shovel, personally working on trolley tracks. From time to time a special trolley would be used to carry VIPs and their wives on a civic tour about town. "Ev" Du Pont, donning a dressy conductor's uniform, often operated the streetcar himself. Repeatedly, when there were meetings of this or that committee he served on, he never chaired the meeting. He was sports-minded and especially fond of baseball. He was known for giving out small Hershey candies and trolley passes to children. It was said that Evan Du Pont could lose money almost as quickly as his brother, Coleman, could make it.[383]

From 1903 to 1921, Luna Park was situated on a trolley turnaround terminus, meaning the approach was double-tracked. Island Park, a struggling competing amusement area,

had one stop on the single-track Windber line. Special events at Luna Park received extra streetcar service. Island Park was apparently not so fortunate, and its manager claimed his park was being slighted.

"I have an appointment to see T.C. Du Pont in Wilmington," announced a frustrated J.T. Flournoy, Island Park's 1906 manager. "Not alone are the Island Park interests affected, but the farmers along the route, and the residents of Scalp Level and Windber too." One is forced to conclude Flournoy had tried to work through Evan Du Pont, but of this there is no mention. Flournoy began threatening "legal action."[384]

On August 21, 1906, a high-level conference of directors was held with T.C. Du Pont and Percy Allen Rose, a director and counsel for the company. After the meeting, Coleman Du Pont issued a statement:

> *The Johnstown Passenger Railway Company will better its service in every way possible…*
> *There will be no change in the officers of the company.*

When a journalist sought more clarification from the other directors, none would comment.

The reporter next talked to Evan Du Pont who told him he was not a director and had not attended the meeting. As such the reporter stated, "He would not care to enter into a discussion." One surmises Evan Du Pont had been under siege for service complaints and his own public relations problems. The directors had met without him, and the urbane Coleman Du Pont had supported his brother.[385]

Pressures for New Service

A group of developers from the Highland area in and around Geistown had met with T.C. Du Pont in August 1907 in an effort to secure a commitment for a trolley line to Geistown. Du Pont informed them that that if a satisfactory right-of-way could be had at no cost to the company, a Geistown line and service would be forthcoming. While Du Pont's statement sounded promising, the developers' task became a heavy one. There were severe grade limitations that restricted the options as to where tracks might go.[386]

After many delays and difficult franchise obstacles, trolley service was initiated in Morrellville on December 1, 1908. The route through the Eighteenth, Nineteenth and Twentieth Wards was separated from the other system by the grade-level crossing of the PRR mainline tracks at Fairfield Avenue. Patrons had to leave the trolley near Broad Street, walk across the tracks and board another trolley on the other side. When the underpass at Fairfield Avenue was finished in 1915, trolleys could pass beneath the tracks.[387]

A Tragedy

On July 15, 1908, a Windber-line trolley carrying almost one hundred passengers collided with a railroad engine pulling a car loaded with bark at the B&O grade crossing in Ferndale. One man, Ernest Gianetta, was killed and forty people were injured.

The costly accident drastically strained the finances of the Johnstown Passenger Railway Company. Proposed line extensions and improvement commitments were deferred indefinitely. A major reorganization was essential. In December 1909, Coleman Du Pont sold his controlling interest in the company to the American Railways Company, 25,000 of the 40,000 total shares outstanding. Du Pont's offer was conditional that all other shareholders would be extended the same tender offer. American was a Philadelphia holding company that owned a number of local trolley systems and electric generation plants including several major ones in Pennsylvania.[388]

In February 1910, the Johnstown Traction Company was chartered. The new company would lease the former Johnstown Passenger Railway Company from its new owners and would manage and operate it. Evan Du Pont, the leading stockholder, served as president.[389]

Trolley Trials and Tribulations

In January 1917 a delegation of citizens from Coopersdale appeared before the city council complaining about poor trolley service in general and for Coopersdale in particular. The cars were said to be filthy, cold in winter and were being spat upon by passengers and conductors alike.[390] By December 1917, complaints were being filed with the Public Service Commission from other parts of the greater community—Bens Creek, the Eighth Ward and elsewhere. The company was not financially able to expand, to modernize or to upgrade service by adding more and new trolley cars.

In May 1919, the company sought a six-cent fare, an increase of one penny per ride but with "free transfers." The city fathers appointed a committee to decide what posture the municipality should take before the Public Service Commission. The company owed the city $30,000, its share of the new bridges at Walnut Street and in Moxham. The city decided to oppose the fare increase and refused to withdraw its opposition until overdue bridge payments were made.[391]

In 1920, Johnstown Traction bought six used trolley cars previously servicing a defense plant in New Jersey that had been shut down after the war. Desperate to save money, the company petitioned the city council in May 1923 to rescind an ordinance requiring two-man crews on each trolley car. Mayor Joe Cauffiel initially announced, "I will fight against it to my last breath." He changed his mind, however, citing that the company had been operating at a loss and was transporting children to school.[392]

The Southern Cambria Railway Company

The chief trolley development affecting Johnstown outside the Johnstown Traction Company was the Southern Cambria Railway Company. Its mission was to furnish trolley service between Johnstown and Ebensburg. The company had become chartered in 1902 but floundered until Judge Francis O'Connor's brother-in-law, P.J. Little, an Ebensburg attorney and former county chairman of the Democratic Party, became president; and George Wertz, the Republican politician, became vice president. Work was well underway by 1909, but there were difficult elevation and bridge problems throughout the system.

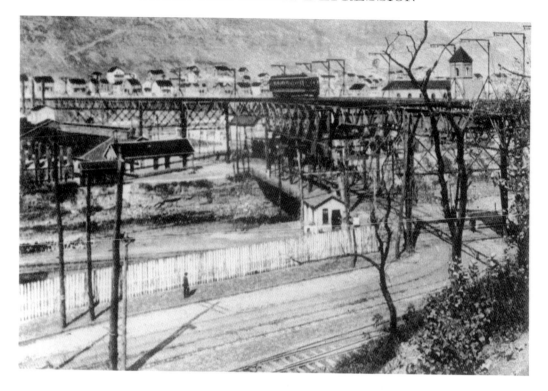

The Southern Cambria Railroad Trestle over the PRR mainline, the Conemaugh and Blacklick tracks, Maple Avenue and the Conemaugh River. The view is from the American House looking toward upper Woodvale around 1911.

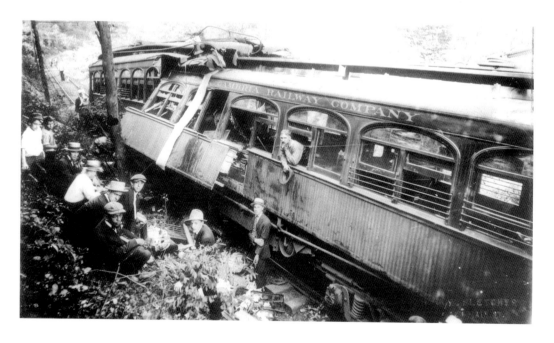

The wreck of the Southern Cambria Railroad. On August 12, 1916, two of its trams collided, killing twenty-one people and injuring another forty.

The line used Johnstown's downtown loop and Clinton Street into Old Conemaugh Borough. The trolley next climbed the Railroad Street hill in front of the American House. It then turned onto a very lengthy trestle that crossed several linear barriers: the Conemaugh and Blacklick Railroad, the Conemaugh River, Maple Avenue and the PRR tracks. The span itself ended at Woodvale Avenue, which the line followed into East Conemaugh Borough, then twisted onward to South Fork, eventually reaching Ebensburg.

The Southern Cambria fostered big plans. A sister company, the South Fork and Portage Railway, began extending a branch line to Wilmore and Portage.[393] On January 10, 1910, the Southern Cambria conducted a trial run for one hundred guests. The demonstration trip went only as far as South Fork, a run that was started for the general public later in 1910.[394] Service between Johnstown and Ebensburg commenced on January 19, 1912. In late May, it was extended to the center of Ebensburg. The trip from Johnstown to the county seat took about one hour each way.[395]

On August 12, 1916, disaster struck. Two Southern Cambria cars collided head on. Over forty people were injured and twenty-one were killed. The Southern Cambria Railway Company was immediately thrust into a major financial crisis. It managed to stay in business until 1928, when operations ceased.[396]

THE WRATH OF GRAPES

TEMPERANCE, MORALITY, PROHIBITION AND CRIME

I. THE SLIPPERY SLOPE OF PARADISE

The Brooks High License Law of 1887

As part of the judicial system in each Pennsylvania county from 1887 until after 1920, there was a "license court." Every existing or hoped-for business in the manufacture, warehousing, shipping or sale—whether retail or wholesale; through stores, bars, saloons or restaurants—of spirits including beer or wine, had to receive an annual license from the court. The license court also had to approve any transfer of a license from one owner or proprietor to another prospective one. Each applicant was required to appear before the court in person, supply detailed personal and business information and present a petition signed by twelve persons vouching for the applicant's good character and the need for the establishment.

The judge presiding had total discretion. For any or no reason, he could approve or disapprove an application. The judge was free summarily to reject every application in the entire county, as once happened in Greene County. He could quiz the potential licensee and could listen to opponents. A family business of long standing might encounter a license renewal denial. Failure to receive a renewal was not a condemnation or "taking" of private property, and there would have been no compensation. The judge of the license court was supremely powerful. There were no standards to guide a judge's discretion other than vague wording that licensees should be persons of good character.[397]

From its inception there had been constant efforts to repeal the Brooks Act. They failed. The statute remained in effect until vitiated by the Eighteenth Amendment. Even then the license courts continued functioning, with little or nothing to do, in hopes of Prohibition's repeal.

Newspapers often used the term "liquor-license trust." *Trust* being pejorative in the era, the expression referred to an informal alliance among those in the liquor trade, certain

The Ideal and the Real Cambria Democracy.

A pro-temperance cartoon from the *Tribune* of April 26, 1905, depicting the "liquor trust." Pennypacker, on the right, was Pennsylvania's governor. "Trust" was a term of derision in Johnstown at the start of the twentieth century.

political and party faction leaders, and the several lawyers who seemingly knew the tricks and had the contacts to assure that their license-seeking clients were successful.

When A.V. Barker, a Republican, was judge, the lawyers advocating for licensees were Republicans. When Francis O'Connor became judge in 1901, they were usually Democrats, and with Marlin Stephens, applicants started using Republican attorneys once again.[398]

In 1915 (about one year after Billy Sunday's Johnstown revival sessions), the license court was accused of putting pressure on those seeking new or renewed licenses to join the Retail Liquor Dealers' Association, a group ostensibly trying to elevate the ethical standards of its membership. The judge's encouragement was seen as inappropriate. The "clean-up" campaigns of the Retail Liquor Dealers' Association were motivated to eliminate situations that might lead to hard-line temperance finger pointing and bad publicity. The association also had a hand in lobbying and passing out political campaign money.[399]

In Cambria County, the Brooks Act had the practical effect of destabilizing the judiciary. As the temperance-Prohibition movements grew in influence, the license court judge was increasingly "between a rock and a hard place." Judge A.V. Barker had been defeated in 1901 in his bid for reelection by Francis J. O'Connor. O'Connor in turn was beaten in 1911 by Marlin Stephens. In both cases, seasoned political observers ascribed the defeats to license court issues.

A simple illustration of the twisted environment caused by the license court is revealed in an editorial of the *Johnstown Democrat* in defense of Judge Francis O'Connor, a Democrat:[400]

The judge declared that if he were furnished with evidence that any person had declared that they had "pull" with the court, he would see that the person bringing him such evidence was protected and that the person making the claim was fittingly dealt with.

The editorial suggests some people were boasting they had influence with the court and were preying on license applicants. The court in turn was bothered by the implied attack on its judicial integrity.

Remonstrance

In addition to applicants for licenses, whether new or renewed, there was a format for remonstrance, a protest filed with the court against a specific license or against all license applications within a defined area. Any given remonstrance might be motivated by an unusual combination of temperance advocacy, greed and politics. The all-powerful judge could hear and consider or refuse to consider any or all of them.

Moxham had been a dry village from its inception and one of its developers, Albert Johnson (Tom Johnson's brother), had restricted all Moxham deeds to prohibit liquor outlets.

In 1907, the license court received a license application from a David Costlow seeking to open a bar in the Seventeenth Ward. More than one thousand people signed a petition opposing the request. The application was denied.[401]

One concludes that the license court was a bottomless pit of intrigue—potential licensees deftly seeking approval of their own applications and sometimes plotting against competitors or opposing factions. The judiciary got pulled into these squabbles in an atmosphere of incomprehensible politics.[402]

Temperance Organizations

There were three mainstream temperance organizations in and about Johnstown: The Women's Christian Temperance Union (WCTU), the Prohibition Party and the Anti-Saloon League.

The WCTU was a women's organization with a number of branches or "unions" coordinated by a Cambria County WCTU organization. Its local unions were rooted in neighborhoods, smaller communities and occasionally in parishes. They met periodically and were social clubs with pro-temperance and anti-vice missions. Women could not yet vote, so the WCTU was not powerful in and of itself. The organization did influence other groups, the clergy and community leaders.

The Prohibition Party was a single-issue political party with negligible influence in and around Johnstown. The Anti-Saloon League had been founded at Oberlin, Ohio, in 1893. There was a national office by 1895. In March 1907, a Cambria County branch was established. The local organizing group was the Johnstown Ministerial Association, a Protestant group. A constitution was adopted and the new league sought to include two members from each temperance organization in Cambria County. Its first president was Calvin Hays, pastor of the First Presbyterian Church. Hayes had become a crusading temperance leader.[403] The Anti-

Saloon League in Johnstown was very effective, especially after it had begun mobilizing its members politically.

The Local-Option Initiative

The first serious activity of the Cambria Branch of the Anti-Saloon League coalition was a local-option initiative, a statewide effort to modify the Brooks Act to permit a locality to vote whether to outlaw the production and sale of alcohol within its boundaries. "Locality" meant a borough, township or city ward.

While the local option idea had been debated for years, a concerted effort for enactment began to crystallize in 1908 throughout Pennsylvania. The Cambria Branch was an active participant. By February 1909, a bill, the Fair Local Option Act, had been introduced in the legislature by Willis Fair of Westmoreland County. The Johnstown Ministerial Association circulated petitions of support.[404]

The bill underwent legislative committee hearings on February 24. People, for and against, flocked to Harrisburg. About twenty women from Western Pennsylvania WCTU unions went about singing "Pennsylvania Shall Be Free." A delegation from the Cambria County Retail Liquor Dealers' Association also went to Harrisburg in opposition. Fair's bill was defeated.

Reverend Hays immediately began to organize for the 1911 legislative session. Cooperating through the Anti-Saloon League, Protestant churches began raising campaign funds and picking candidates for public office.[405] Although introduced in every legislative session up until Prohibition, local option was never enacted.

Billy Sunday

When the Johnstown Ministerial Association met in November 1910, its speaker was Rev. Scott Hershey. He spoke about the ex-baseball player Billy Sunday and the evangelistic revival work he had done in New Castle. Hershey described the many conversions Sunday had brought about.[406]

By early January 1911, both the select and common councils had been petitioned by forty-six churches in Johnstown favoring a Billy Sunday revival series. Specifically they were seeking the Point Park as a temporary site for a large wooden tabernacle to house Sunday's meetings.

Henry Raab, a Second Ward councilman, began lobbying both councils against the revival series. Also a wholesale liquor dealer, Raab had gone to Harrisburg in March 1909 to fight local option and knew what Calvin Hays and the clergy were seeking. Raab claimed his constituents were against "a lot of noise at the Point," and added, "Sunday has...a variety show, and it shouldn't be foisted upon the people of the Second Ward."

The capable attorney Henry Storey gave an eloquent speech in support of the tabernacle. Although passed by the common council, the resolution was defeated in Raab's select council by ten nays to nine yeas, a single-vote defeat.[407]

Public pressures were reenergized following a trip by Storey and Hays to meet with Sunday at Toledo in May. Sunday told the two men that his schedule would not permit him to do a revival in Johnstown prior to the autumn of 1912. He also advised them he was coming to Johnstown regardless of the councils' votes.[408]

Already the citizenry had been worked up by the councils' refusal. At a mass protest rally in mid-April, speakers were voicing, "If the councils won't give Billy...the Point, we'll get rid of the councils! We'll get a commission form of government!" By the summer of 1911, petitions addressed to the Reverend Billy Sunday were being circulated among local churches begging for a Johnstown revival.

Meanwhile the statewide Anti-Saloon League continued its abortive campaign for local option.[409] In early 1913, the league had picked a new state chairman, Calvin Hays. By June 1913, city council members were aware that their tenures were being cut short. The legislature had passed the Clark Act and commission government would begin on December 1. The councils were also being outdone time and again by an aggressive mayor, Joe Cauffiel, then at the peak of his roller-coaster popularity.

On June 3, 1913, Cauffiel wrote the recreation commission:

> *I hereby notify you that the city will reserve enough ground at the Point for the Evangelistic Committee to erect a tabernacle for Billy Sunday.*[410]

A very young Tom Nokes, commission president, knew Cauffiel had exceeded his authority. Nokes would also be running for city council later in the year. Too astute to battle a tidal wave of Sunday support, he raised no objection.

Construction of a large wooden barn-like building with a sawdust floor got underway at the Point near Main Street. Sunday insisted that the local committee install such a structure to his specifications. The tabernacle would be dismantled later and its lumber used to construct homes for the poor.

Sunday's Revival Crusade

Billy Sunday arrived in Johnstown on Saturday, November 1, 1913. His revival series began the next day and ended in mid-December.[411] The *Daily Tribune* gave front-page, upper-right-corner coverage to Sunday throughout the crusade. Attendance and collection totals were reported daily. The texts of Sunday's copyrighted sermons were also printed.

On Sunday, November 2, the attendance and collections were given as:

	Attendance	Collections
Morning	8,000	$437.91
Afternoon	7,500	$218.94
Night	9,000	$355.20
Total	24,500	$1,095.64

People remarked, "Billy came, Billy saw, and Billy conquered."

Sunday did not hold forth on Mondays, his day of rest. By Tuesday, also election day for choosing council members in the new commission government, he was going strong again in Johnstown.

By the end of Sunday's first week, it was reported:

One week of Billy Sunday and the old town has been turned topsy-turvy in the matter of opinions about the famous baseball evangelist…One man, it is said, after hearing the sermon of "the Home"…cleared the cellar…of its store of liquors.[412]

Near the end of the second week, Sunday began asking for people "to stand four-square before mankind for God." Audience members so inclined would go forward and shake Billy's hand, a feature of each evening session. On Thursday, November 13, there were 174 conversions. On Friday, there were 193 more.

Sunday's preaching style was well known before his arrival. He would "wrestle" with the devil and make all sorts of energetic gestures. Whether revival histrionics or a near accident, he once almost fell off the platform. Sunday's teachings were based on rural and small-town values blended with evangelical, fundamentalist, Protestant Christianity. He was later seen as a spokesman for simpler virtues in an increasingly complicated era. Through Sunday, urbanizing America was searching for its lost innocence.

In Billy Sunday's credo, Satan is everywhere and uses many false gods and clever devices to lead men astray, away from the salvation of God. These include card playing, gambling, vice, love of money, dancing, the theater (including movies and vaudeville), false teachings such as evolution, modernist theology, biblical criticism and anarchy. Liquor was especially a source of evil. Baseball, however, was an exception. It could even be played on Sundays.

One needed to repent, accept Jesus Christ as Savior, follow the ways of God and avoid the many devices of the devil. On December 5, Sunday held two services for women only. Attendance totaled 15,300 and 333 converts had "hit the trail." Before the afternoon meeting, a parade led by Billy Sunday and his wife took place downtown with 10,000 people in the procession.[413] When Joe Cauffiel "hit the sawdust trail" and went forward to shake Sunday's hand on December 7, the audience exploded into wild pandemonium.[414]

December 15 was Sunday's last day in Johnstown. The collection for the evangelist and his organization exceeded $16,000. The Cambria Steel Company gave $1,000. The trolley company had given $500. Other businesses and individuals made sizable contributions. Total attendance had exceeded 557,000. There were 12,320 conversions.[415]

Theaters continued to operate while Sunday was in Johnstown. Harry Scherer, the city's leading theater manager, sent Sunday a special invitation to see the religious drama, *Ben Hur*. Sunday politely declined. Something of a showdown was almost promoted when Eva Tanguay, the great comedienne, decided to attend a Billy Sunday meeting in late November. Sunday assured her she would be treated courteously.[416]

An interesting contest that went unnoticed occurred on Saturday evening, November 22. Anna Pavlowa, the great Russian ballerina (many critics maintained she was then the greatest woman dancer in the world) performed at the Cambria Theater while Billy Sunday (to his followers the greatest preacher in the world and a man who viewed all dance as a device of Satan) held forth simultaneously, only a few short blocks away.

Advertisements for both Goenner Beer and the Cambria Theater's features were often placed on page one of the *Tribune* just under the Billy Sunday news items. Whether theater attendance fell while Sunday was in town is not known. Hotel business thrived.[417]

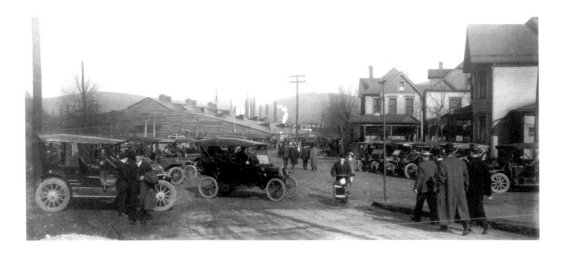

View of the Billy Sunday Tabernacle at the Point in November 1913.

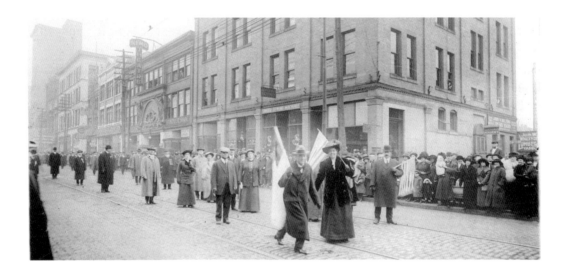

Billy Sunday and his wife lead a parade in Johnstown on December 5, 1913.

The Sunday Legacy

Early in the morning of December 15, 1913, the day Sunday left Johnstown, a railcar with forty tons of extremely hot steel got bumped and rolled down into the Conemaugh River, causing an enormous explosion. Windows were shattered for blocks and people were injured. Some thought Judgment Day had arrived in keeping with Sunday's prophecies.[418]

Sunday's next crusade was Pittsburgh. Many Johnstowners took trains to attend the sessions. Temperance backers had received a boost. A Sunday Anti-Liquor League was founded by Jacob Murdock, who became president. Such prominent citizens as Edwin Slick,

Dr. W.E. Matthews and H.M. Davies became members.[419] The group went to work filing remonstrance petitions. On January 26, 1914, seven baskets of them were presented. By early March, however, 265 licenses had been granted by the court. Others were pending.

II. CAUFFIEL'S REPUBLIC OF VIRTUE IN HIS CITY OF THE PLAIN

Mayor Joe Cauffiel, a prohibitionist who had "hit Sunday's sawdust trail" had just been sworn-in to his second four-year term (1920–23) as Johnstown's mayor. His top priority was set: Johnstown's problems would be solved by a deep-pit burial of John Barleycorn. "Prohibition will begin tonight at midnight," the triumphant mayor announced at police court early on January 16, 1920. "And it is expected of the officers that they bring in all who are found with liquor on their persons. Such prisoners will come under the Prohibition enactment and will be sent to jail as bootleggers."[420]

The next day, Jacob Meyers, an elderly greenhouse worker, became the city's first Prohibition trophy. Cauffiel jailed him for "one day less than a year."[421] The absence of similar sentences over the next few weeks suggests Meyers's fate had warned others. More likely the distribution channels of illegal spirits had not yet become established.

Prohibition seemed to be working at first. The police court had light dockets. Crime was actually down.

An Imperfect World

In early April, Prentiss Herring, a black Franklin bunkhouse resident, died at Conemaugh Hospital from chemical poisoning. Another black resident, John Robinson, also a hospital patient, informed Coroner Mathew Swabb that bunkhouse residents were buying "pyro," a poisonous product, and mixing it with sodas. Pyro was found to have caused Herring's death and those of four others.[422]

A few days later, federal agents seized a three-still moonshine operation in Cambria City. By early May, alcoholic drinks and "real" beer were flowing again. Before a quality pipeline had gotten established, the beverage of choice seemed to have been "Jamaican ginger," an over-the-counter medicine containing alcohol. Jamaican ginger reputedly gave its imbibers a "hefty kick."

In May 1920, a nameless official told an inquiring newspaper reporter, "Yes, I have it from very good authority that good beer and whiskey are being sold right over the counter in Johnstown. There seems to be no great effort to enforce the federal law. Why this is I do not know unless the Democratic Administration is laying down on the job." Indications were that both moonshine and bonded whiskey had become readily available by mid-spring. A one-ounce shot cost fifty cents.[423]

Reports of extreme illness and death from illegal alcohol were common and created unusual litigation. In August, a distraught father appeared in the mayor's court telling

of his son's buying two drinks at Marcella's Bar. The whiskey had made the boy so insane he had to be admitted to an asylum The Marcella case exposed a vortex of legal complexities that the aggressive mayor was not equipped to handle properly. Cauffiel's bumbling in police court often provided evidentiary and procedural defects for later judicial appeals.[424]

Cauffiel seemingly used the police court as a pulpit for pronouncements against alcohol. A recurring frustration was proving the true alcoholic content of seized substances. Cauffiel sentenced many "drunks" to jail terms. What he really wanted was to stop the manufacture and sale of alcohol, also the responsibility of federal agents. Cauffiel repeatedly instructed the police to round up the dealers selling spirits.

Gathering evidence was tricky. Both federal officers and the city made use of George Ridley. Ridley would go into a bar, buy a shot, gulp but not swallow it, leave the premises and spit the liquid into a two-ounce bottle for evidence. He once got confused and could not identify which bartenders had sold him various samples. One such proprietor was Daniel Shields.[425]

A Whiskey Ring

In late August 1920, it was reported that federal agents had seized seventy barrels of good-grade whiskey and eleven barrels of 190-proof grain alcohol from the Johnstown Drug Manufacturing Company.[426] The feds unmasked a large-scale liquor production operation disguised as drug manufacture.

On October 27, federal enforcement agents conducted coordinated raids on fourteen local hotels. Buys were made in Cambria City, on Iron Street near the railroad station and in Old Conemaugh Borough.[427] Investigation strengthened the belief of there being a "whiskey ring." While there was no certain proof, rumors persisted. U.S. Commissioner Ray Patton Smith stated he did not believe a ring existed but said if there were one, it did not have "pull" to delay or prevent raids or to get early warnings about them.[428]

The *Johnstown Tribune*, on November 29, asserted that a large quantity, 105 barrels of spirits, had arrived in Johnstown after shipment over the PRR. The piece stated that the local whiskey ring was stocking up for the holidays. It continued:

> That whiskey is easy to obtain is evident. It is possible to buy all that the pocketbook can afford and with little or no trouble. In fact "runners" for various "big fellows" are peddling the stuff openly, soliciting trade and offering well-known brands for sale.[429]

The Tippling House Ordinance

Cauffiel resurrected an old "Tippling House Ordinance," developed by the late W. Horace Rose after the 1889 flood when he, an attorney, had been the new city's first mayor. The Tippling House Ordinance went after the liquor dealers rather than their intoxicated or "hung over" customers.[430]

On December 15, following his police court, Cauffiel issued another lengthy public statement:

> The sale of liquor in the City of Johnstown must cease. The examination of samples taken from the various places show from thirty-one to as high as forty-five percent alcohol...There is one great mystery in my mind that the Federal agents in this locality seem to find no evidence leading to the violation of this law. They have been told and retold at various times of cargoes, truckloads, and carloads but they turn a shut eye and deaf ear.

Cauffiel then issued a call for fifty "good and able-bodied citizens" to take an oath and serve as special officers to suppress liquor violations.[431]

Just before Christmas, a Thomas Clise from Hollsopple bought liquor at Shields' Café, became intoxicated, was arrested and later cooperated with police. Daniel Shields was arrested for maintaining a tippling house. His lawyer was his neighbor and friend, Percy Allen Rose, who ironically was challenging the very ordinance sponsored and probably drafted by his father. Shields did not appear in court at first but showed up after the mayor insisted he be present. Shields claimed he did not know the meaning of "tippling house," but chose to pay a fine rather than go to jail, the first skirmish in Cauffiel's war with Dan Shields.[432]

Cauffiel later sent three new "sleuths" into a bar on Railroad Street. The men flashed their badges and searched but found nothing illegal. The proprietor treated them all to a free drink of whiskey from his private stock—a gift, not a sale.[433] After Christmas, Cauffiel put into service two new "sleuths" who made buys of illegal liquor in six hotels. Each proprietor paid a $100 fine and resumed business.

The mayor next began a new strategy: after a few successful raids, Cauffiel posted a traffic sergeant in front of Shields' Café and another at Charles Kist's Barroom. When Shields's case came before the mayor, Cauffiel began by asking him how many times he had been arrested, tried and "forfeited."

"You ought to know," Shields fired back. "You are the fellow who framed it every time... My conduct in life has been more lawful than yours. You have been in the courts more than I have...I'd like to tell you what I think. Meet me out in the woods and I will tell you!"

Cauffiel answered that he would be told nothing.

Shields then shouted, "A thousand dollars, I can. Why single me out, then? You've got a personal grudge against me!"

After the mayor denied any personal feelings in his liquor campaign, he ordered that Shields' Café be closed. There would be others.[434]

Next, Cauffiel hired Walter Miles, another of his special policemen. Miles went about investigating, got drunk, was arrested and had to appear before Cauffiel in police court.[435] After Cauffiel's judgments were entered, the county court system seemingly went out of its way to overrule him on legal technicalities, which the hapless mayor provided in abundance. The cafés and hotels that he sought to close got injunctions against his tactics. The mayor then issued a new proclamation expressing both anger at the courts and maintaining that

his actions to close the places were legal. Cauffiel was then advised that denouncing the injunctions might result in his being held in contempt of court.[436]

In September 1921, several clergymen were invited to police court for a view of Prohibition in action. Men were presented and charged with having been drunk. When asked where they had gotten the liquor, the typical answer was from a nameless friend in Seward or some other place. Cauffiel remarked facetiously, "We have no saloons in Cambria County, yet whiskey is being sold and sold in quantity."[437]

Cauffiel even hired special "detectives" to check up on the loyalty of his own police force. One such agent, a former police officer, told the mayor that his police chief, Charles Briney, had taken a drink at a social affair a year earlier. Cauffiel suspended the chief for ten days. Following an investigation and a hearing, Briney was restored to duty by the vote of all five councilmen including the mayor.[438]

In February 1922, two of the mayor's special police or "sleuths" accused a city policeman, Dewitt Schenck, of having "taken a drink." Schenck was immediately suspended by the mayor. A short time later his two accusers were arrested by county detectives for violations of the Volstead Act and were charged with "having intoxicating liquors on their persons."[439]

In August, Cauffiel staged another coup. Probably exasperated that alcoholic spirits continued to be manufactured and sold apparently in greater quantity than before Prohibition, the mayor called a special meeting of a large group of hotel proprietors and saloonkeepers—the regulars—at his office. Cauffiel then advised them he was through. If they would make and sell "good beer," discontinue the sale of moonshine and liquor and help him fight bootleggers, they could sell all the "good beer" they were able to sell insofar as the city was concerned.

Cauffiel was addressing two sore points at once. First, he was calling attention to the inadequate federal effort to enforce Prohibition. Second, by saying, "Good beer is better than bad water," he was attacking the Johnstown Water Company, another favorite target. Not only was the water supply being called inadequate—there had been a severe drought at the time—but according to Cauffiel the water was also contaminated.

The Cauffiel announcement got national publicity. Federal officers were put on the defensive. O.R. Stiffler, a federal district supervisor, was removed from the Johnstown area. In Washington, an assistant federal Prohibition commissioner stated to the United Press, "The sale of real beer, whether Johnstown's water is bad or not, is a violation of the Volstead Act and will not be countenanced. The mayor of a town cannot set aside the Constitution of the United States."

Cauffiel's ploy did nothing to change the sale or flow of beer. Around town it was seen as a publicity stunt that had taken place between the May primary in which George Wertz, a "wet," only a few weeks earlier had beaten Anderson Walters, a "dry," for the Republican nomination for congress. Wertz was a shoe-in and Cauffiel had assumed the seating of the politically connected new congressman would result in lax enforcement of Prohibition in and around Johnstown no matter what he did through the city government.

Cauffiel got front-page attention all over the United States. Anderson Walters editorialized in his *Tribune* about the far-flung publicity: "Everywhere but in one city—Johnstown." The *Tribune* had put the "Good beer is O.K." news on the back page.[440]

Prohibition enforcement went on. Every indication was that liquor and "good beer" could be had in Johnstown almost as if there were no Prohibition. The idea of a "whiskey ring" persisted.

The same names popped up from time to time. There were strong beliefs in payoffs, political strings and an invisible web of officials and political insiders who protected the liquor trade.

Convictions brought forth motions for new trials, reversals on appeal and clever legal maneuvers quite often resulting in guilty rulings being overturned. The accused hired the best lawyers. Impaneling a jury of temperance supporters was difficult in Cambria County where an unknown but very large percentage of the citizens were opposed to the Eighteenth Amendment and the Volstead Act that implemented it.

III. PROHIBITION ENFORCEMENT

The Walters-Wertz Feud Continues

Although they mixed in the same social and civic circles, Walters and Wertz were enemies of long-standing. In 1922, they had opposed one another for the Republican nomination for Congress. Wertz had won and served a two-year term.

Anderson Walters, incensed over his defeat, had uncovered another gem: the relocated federal Prohibition agent, O.R. Stiffler, had made a pilgrimage to George Wertz, presumably seeking Wertz's help in getting back his old job. Walters used this information (or fiction) to reheat a recurring editorial theme—politics is the enemy of Prohibition enforcement.[441]

In 1924, the two were at each other again, both seeking the GOP nomination. Wertz tried an interesting tactic: to siphon away some of Anderson Walters's hard-core temperance support, he accused the publisher of failing to report the news of raids and arrests against one of Wertz's well-known Republican affiliates, Daniel Shields. He also reported that Walters and Shields had met one another overseas when they had both been in Europe at the same time.

Since just about any informed Johnstowner would have assumed—right or wrong—that whatever trips Shields might have taken to Europe would have been in connection with importing alcoholic spirits, Wertz sought to plant the notion ever so cleverly that Walters and Shields, who lived across from one another downtown, were up to no good.

Walters fired back in a large political ad in the *Tribune* of April 18, 1924. The item was entitled: "Merely Throwing Dust." The ad represented Wertz as being in a desperate situation. Walters wrote he had never met Shields in Europe—indeed it was stated they had never been together in the same city. The item went on to revive the old stories of Shields's place in the "Wertz-Sunshine Gang" which had been "running" the Republican Party's wet faction.

In early May of 1924, Shields was arraigned before a U.S. commissioner at Baltimore on charges of conspiracy to violate the National Prohibition Act, part of his first serious encounter with federal enforcement.[442]

Three weeks later, while Shields was still under indictment, a large crowd of Johnstowners attended the grand opening of the new Capitol Building at Franklin and Vine. The Capitol was a multi-purpose facility that housed a diverse array of separate business activities—a banquet and dance hall, a bowling alley and a street-level cafeteria and Dodge showroom. Mayor Louis Franke was a guest of honor.

The Capitol Building was owned and operated by the Capitol Real Estate Corporation, reportedly capitalized at $500,000. Its president was Daniel Shields. Other officers were J. L. Simler, Herman Widman and a John Gastman. Gastman's brother, James, managed Shields' Café.

"Uncle Dan"

Daniel Shields made friends easily. In Washington he had developed a wide range of contacts including senators and, according to his close friend Perry Nesbitt, with Franklin Roosevelt while FDR was assistant secretary of the navy. Shields reputedly could walk through the U.S. Capitol Building and greet people right and left.

These contacts helped him with a business venture exporting picks, shovels and hand tools to Russia, probably during its New Economic policy phase.[443] Shields apparently encountered difficulty getting paid, possibly after Stalin's take over. At any rate, Shields's export career soon ended.

In the spring of 1923, Shields made the acquaintance of a Miss Dell Hayes, an unmarried clerk with the IRS in Washington. Miss Hayes handled Prohibition enforcement information regarding Pennsylvania breweries and also had access to records about licensed alcohol manufacturers.[444] Shields was seeking detailed information about distilleries lawfully producing alcohol for medicinal and industrial purposes.

When Shields had discovered that Miss Hayes had free access to this kind of information, he quickly arranged an introduction. Boxes of candy, telephone calls and both theater and dinner dates followed. The information he was seeking began flowing his way around April 1923. By April 1924, Miss Dell Hayes had been paid about $2,100.

In connection with other investigations, Prohibition agents raided Shields's Johnstown offices and learned of his espionage arrangement with the friendly IRS clerk. Miss Dell Hayes was now in hot water. Federal prosecuting attorneys needed her cooperation without giving Shields's legal defense team an argument that she would be testifying against him to avoid her own prosecution.

Meanwhile, Miss Dell Hayes had become Mrs. Dell Evans, and in 1926 had given birth to a baby girl. Shields sent an unsolicited gift of $100 to the baby. A "Dear Uncle Dan" letter followed, thanking him for the money. It had been ghostwritten by the mother for her thirteen-week-old child. Shields's attorney had introduced this letter as evidence—part of the defense strategy.

The trial in Washington, D.C., went on for several days. After being cloistered all night, a jury found Shields guilty on two counts of bribery. Shields's petition for a new trial was denied. He was fined $900 and on November 6, 1928, began serving a two-year sentence at Lorton, Virginia. Shields's term was shortened for good behavior and he was released on June 14, 1930.

Shielding Shields

While Shields was being tried for bribery, other legal battles were headed his way. The former Emmerling Brewery on Baumer Street in Hornerstown was apparently a site for

brewing illegal beer and distilling whiskey. In April 1925, E.C. Emmerling and Victor Schuller were charged with violating the National Prohibition Act. It was reported that they had in their possession almost 29,000 gallons of "real" beer, 440 gallons of whiskey, various brew kettles, distilling paraphernalia, tanks and vats. They were also charged with transporting and selling illegal beer and whiskey.[445]

The case moved slowly in federal district court, a delay probably caused by an expanding investigation with more defendants and charges being added. By February 1926, ten people had been indicted and were being tried for alleged violations and conspiracy. Among them was Daniel Shields. Testimony was given alleging that Shields had received $80,515 in "protection money." Shields denied the charge but testified that as a real estate broker he had sold the brewery and received a commission. One of those charged, Julius Rodstein, who had acquired the brewery, testified he had bought both beer and "protection" from Shields. Shields in turn denied having owned the brewery in the first place and having ever operated it.

On February 15, at the end of a complicated "he-said finger pointing" trial that had produced a lot of hearsay about police payoffs, three men—E.W. Hardison, J.L. Simler and I.E. Hunter—were found guilty on three counts each: possession and manufacture of liquor, possession of the material and implements for manufacture, and conspiracy. Herman Widman, J.M. Gastman and Daniel Shields were found guilty of conspiracy. The president, vice president, secretary and treasurer of the Capitol Real Estate Corporation had been judged guilty of a felony by the U.S. District Court at Pittsburgh. All six sought a new trial.

Interestingly, the case made it on appeal to the U.S. Supreme Court. On April 11, 1927, Chief Justice William Howard Taft (U.S. president from 1908 to 1912) ruled that the district court judge had erred when he sent messages to the jury insisting it reach a verdict. Shields and the others were not exonerated. They had to undergo a new trial in Pittsburgh.

In the second trial in mid-May 1928, Shields was found guilty. His petition for a new trial was denied. He was sentenced to one year in the Cambria County Jail and fined $2,000. By this time, however, Shields had been convicted of bribery and was serving a two-year sentence in the Washington, D.C. jail at Lorton, Virginia.[446]

President Herbert Hoover commuted his sentence in the Emmerling Brewery case on June 12, 1930. The $2,000 fine, reduced to $1,000 by the president, was paid in July. Shields never served time in the Cambria County Jail.[447]

IV. RIFE LAWLESSNESS

Around 3:00 a.m. on Wednesday, March 15, 1922, an explosion shook the Woodvale neighborhood. Dynamite had been placed at the entrance to the Antonio Gallucci and Sons Grocery Store next to Saint Anthony's Church. When it exploded, every window in Gallucci's building was broken. None of the Gallucci family or other tenants were killed, although many were thrown from their beds. A police investigation got underway.

Six weeks later, Jim Nicoletti met with Antonio Gallucci. Nicoletti informed him that many people were jealous of his success and prosperity. Gallucci was advised that he could

live in peaceful comfort and enjoy Nicoletti's renewed friendship by giving him $1,500. Gallucci was warned he must say nothing to anyone about the matter. He was also told that failure to give Nicoletti the $1,500 would result in Gallucci receiving the same treatment as had happened to Nicoletti's own brother-in-law who had been murdered.

A day later, Carmelo Esposito visited Gallucci's store and told him that for $1,000 he would tell him who was responsible for the dynamiting. Esposito then departed but returned telling Gallucci that if he did not pay the $1,000, "they"—the gang—were going to bomb him again. Promising to pay more later, Gallucci gave Esposito $125, and later told his troubles to his priest. The priest apparently talked Esposito, a member of the same church, into returning the $125.

Meanwhile, Nicoletti persisted with his demands. On a September 8 visit to collect from Gallucci, an incriminating conversation was overheard by police officers hidden in an adjacent room. Nicoletti was arrested. Esposito's arrest soon followed.

The investigation led to the arrests of three other people believed to be involved in the extortion racket. The men retained Charles Margiotti, a skillful attorney from Punxsutawney and a future state attorney general. Following a trial that took eight days, Jim Nicoletti and Carmelo Esposito were both found guilty of "blackmail" and "demanding money by menace and force." Three other alleged gang members were found "not guilty."[448]

On October 7, 1925, Reverend G.K. Hetrick, a crusading anti-liquor pastor of the Conemaugh Evangelical Church, discovered twenty-two sticks of dynamite encased in a galvanized bucket placed under the porch where he slept. The makeshift bomb's fuse had somehow stopped burning. Hetrick had been receiving threats warning him to halt his anti-liquor crusades.[449]

In the early morning hours of April 9, 1926, an explosion caused extensive damage to Angelo Salvatore's barbershop at 313½ Broad Street in Cambria City. A heavy concussion shook buildings and shattered glass. No one was injured or killed. Amazingly, at that same time the same night, a bomb was exploded at Mike Lapaglia's Riverside home. No one was present. Family members refused to discuss the matter with investigators.[450]

That same week, Frank Rizzo, who operated a small store at his Prospect home, was murdered. Rizzo had been knifed a few years earlier and a later attempt had been made to bomb his business. Around nine o'clock on the night of April 12, 1926, Rizzo was called to come into the street. Two shots were fired. Rizzo died instantly.[451] About one hour later that same April evening, Frank Muro, a twenty-five-year-old coal miner, was found shot to death on the Bedford Road near Elton. Mrs. Rizzo, unaware of Muro's death, identified him as the man who had summoned her late husband into the street.

On January 17, 1927, Sam Ippolito was murdered. According to his brother, Joe Ippolito, he (Joe) had started receiving visits from Tony Arena, Andrew Gruttadano and others who told him he had to pay his brother's "bill" plus $500 to avoid being killed himself. The implication was that his brother, Sam, had refused to pay an extortion demand and was murdered as punishment.

Joe Ippolito, a Coopersdale barber, armed himself with a loaded two-barrel shotgun he kept at his shop. On March 23, Arena and Gruttadano visited the barbershop, presumably

to collect. Ippolito got his rifle and killed them both. Ippolito was tried and judged guilty of manslaughter. The verdict was overturned on appeal.[452]

On October 30, 1928, George Cupp, a prominent Johnstown grocer and Harry Cupp's brother and former partner, was shot to death. Among his last words were, "I am shot. The gang got me." Testimony revealed that Cupp began fearing for his life in late May. Tony Lima and James Siciliano were charged with the murder. Lima had an alibi and was found innocent and the case against Siciliano was dropped. New evidence surfaced. Lima was again indicted but in March 1930, he was found "not guilty."[453]

These random reports of bombings, murders and threats reveal the existence of extortion racketeering in and around Johnstown during the mid- to late 1920s. Elderly Johnstowners still talk of earlier "banana wars" involving crime and extortion. What is not known is the degree to which people paid up and were left alone.

The Grand Jury Investigation

In 1929, the county judges established a special grand jury to explore crime and to evaluate the integrity of public officials, including the police. In a report made public on July 31, the grand jury did not reveal any official corruption but concluded with:

> It is felt that disrespect for the liquor laws has produced disrespect for all law…The more grave criminal offenses have been observed to have sprung out of an environment connected with the illicit liquor business.[454]

V. THE DECLINE AND FALL OF "FIGHTING JOE" CAUFFIEL

On January 14, 1929, Mayor Joseph Cauffiel and Jonathan Rager were both charged with "conspiracy to do certain illegal acts." Rager had connections with several Johnstown gambling places, including one he operated in Morrellville. Rager claimed that in 1928 he had been bribing the mayor to leave his illegal operations alone. He testified later that Cauffiel had asked him to arrange with Jack Gastman, a Shields associate, a share of the gambling operation in the Capitol Building. Rager claimed Cauffiel was seeking a kickback, especially from the baseball pool operating there.[455]

Rager also claimed he had contributed money to Cauffiel's campaign for mayor. Since Rager's donation had not been reported as a campaign contribution, he concluded Cauffiel had pocketed the money. Rager was pleading guilty.[456]

Protesting his innocence, Cauffiel fought the charges. His public and private family posture was that a cabal of political, liquor, police faction and personal enemies were framing him. Cauffiel's personal public relations image was at a low state. He had been in one lawsuit after another over a stock deal involving a western mining company, which was

at worst a scam or at best a fizzle. Cauffiel had been sued repeatedly by investors whose stock values had vaporized. Time and time again in these lawsuits, Cauffiel had lost and was forced to pay damages.[457]

Cauffiel Brothers Realty, Inc., had also conducted a land sales scheme. His son, Meade, vice-president of the firm, headed up a unit that had subdivided some steep hillside acreage above Moxham into lots, "on paper." There were "deeds," but the land itself was unimproved. A customer would make small monthly installment payments and in time was supposed to become the owner of his or her lot in the Buena Vista Land Development. From time to time a customer might ask to be shown his or her lot, but no one was able to point out on the ground what belonged to whom or exactly where it was. Cauffiel was cited in a 1929 grand jury report with highly questionable practices, inasmuch as there were strong indications that people appearing before him in police court got favorable treatment if they were Buena Vista customers. While the grand jury report was issued after Cauffiel's conviction, knowledge of his land sales scheme and the alleged improprieties associated with it was widespread.

Cauffiel also had another public relations problem. He had been defeated in the Republican primary by Herbert Stockton, former school superintendent, but having cross-filed to run as an "independent," Cauffiel nonetheless had become a candidate in the November "run-off" election. Cauffiel had won by a razor-thin majority. Whether true or not, lots of people believed his claim to the mayor's chair was tainted. Nonetheless he was sworn-in on January 2, 1928.

Throughout the trial, which went from March 12 through 16, there was conflicting evidence. Policemen testified that Cauffiel would call off raids they had planned. Jack Gastman swore there was nothing to Rager's claim that Capitol Building gambling was being protected by the mayor. Cauffiel maintained total innocence. Rager, in turn, had given detailed evidence against him.

After deliberating for fifteen hours, the jury found Cauffiel guilty on several counts—extortion, perjury, conspiracy and keeping a gambling house.[458] Cauffiel's attorney, Percy Allen Rose, petitioned for a new trial, citing twenty-five reasons. The three county judges *en banc* refused the motion. The case was appealed to the Pennsylvania Superior Court, which sustained Cauffiel's conviction. Two weeks later, the Pennsylvania Supreme Court declined to review the case. There were no more remedies.[459]

At 3:30 p.m. on Monday, December 30, 1929, Joe Cauffiel reported to the Cambria County Jail to begin a two-year sentence. Many people urged him to resign being mayor. He refused. By law, his conviction vacated the office.

Johnstown Civic Organizations

1900 to 1930

The Johnstown Board of Trade had folded by 1900. Men like Coleman Du Pont were not emerging as community leaders. When a civic undertaking was needed, a special committee was usually organized, as had happened with the centennial and the new county initiative. Once their mission was accomplished, the groupings dissolved.

I. The Chamber of Commerce

Retail Merchants

In February 1904, Johnstown retailers met to hear J.W. Rittenhouse, representing the Pennsylvania Retail Merchants' Protective Association. Retailers in Pennsylvania cities had been organizing to protect themselves against the "professional beat" or "deadbeat," a person behind in paying bills who continued incurring debt.

A week later some forty merchants had joined a "Johnstown Retail Merchants' Protective Association." George Swank was president. The word "protective" was dropped, and the group became "the Merchants' Association of Johnstown."

The Chamber's Founding

On May 21, 1910, an ad hoc committee of Johnstown retail and wholesale businessmen organized the "Business Men's Exchange." Its first undertaking was a county automobile trade tour, a three-day promotion covering two hundred miles. Each participating firm had an automobile with name signs describing the business. The group sought new customers by going from town to town, greeting the public and passing out gifts and leaflets.

The tour got underway on July 14 with thirty-eight cars. Whole towns and villages turned out. The vehicle parade, a spectacle in rural crossroads and villages, was an exciting local event. The promotion proved a success.[460]

Earlier, on May 25, a similar group from the Pittsburgh Chamber of Commerce had visited Johnstown. Its president was F.R. Babcock whose lumber company had a large sawmill in Somerset County. A dinner was held at the Crystal Café attended by over three hundred people. After a good-will exchange, the Pittsburghers continued their tour that went as far as Altoona and Tyrone.

Merchants, other businessmen and professional leaders were increasingly interacting in more formal ways. When the visitors from Pittsburgh had come as the Pittsburgh Chamber of Commerce, the idea of a formal organization for addressing civic concerns was rekindled. The Johnstown Chamber of Commerce became official on December 5, 1910—the date the charter application was recorded, although on November 16, 1910, the chamber had filed a protest with the Pennsylvania Railroad Commission opposing a Bell Company long-distance offering. It had been signed by W.L. Stewart, secretary of the Johnstown Chamber of Commerce.[461]

A Banquet at the Elks Club

The first chamber banquet was held at the Elks Club on December 6, 1910. There were many speakers, including Charles Fels of Philadelphia and London; Charles Price of Cambria Steel; George Wertz, a state senator; John Waters, president of National Radiator; and Dr. George Wagoner, a former mayor. The speakers emphasized a need to address broad community issues—the trolley line to Ebensburg, modernizing the municipal government, parks and recreational development and similar big-thinking initiatives.

The nucleus of what had begun as a merchants' protective association, and had become a business exchange group for joint promotions, was now being influenced by the likes of Charles Price, Anderson Walters and even P.J. Little, an attorney and a Democratic politician from Ebensburg who was president of the Southern Cambria Railroad Company, then installing a Johnstown to Ebensburg trolley.

From the perspective of the merchants whose attention was focused on shops and department stores, their mutual self-help organization was being captured by people with agendas other than their own. George Wertz, charming and shrewd, was a political boss tied to the liquor interests when an Armageddon was shaping up between wets and drys. Others were placing a key focus on northern Cambria County, where coal mining was booming. The bigger thinkers were urging Johnstown to reach to the north.

A Broad Program

The new chamber organized an industrial committee whose focus was trolley extensions to Ebensburg and beyond, a trolley line to Geistown, a project to acquire park acreage in Constable Hollow and a program to aid promising industrial prospects.[462]

An important feature of the chamber's work remained its "credit information department," a vestige of the protective association. By 1912, the chamber had credit information on

twenty thousand people, and had even become a collection agency for past-due accounts owed to member merchants.[463]

In 1912, the chamber launched a major membership drive. The sales pitch was that the organization benefited all businesses by discouraging solicitations, sharing credit information, preventing "wildcat" advertising schemes and merchandise donations and providing a forum for businessmen to discuss common concerns.

The chamber itself, however, was stuck in the cement of its work devoted to servicing the agendas of merchants and professional persons. The rote work of maintaining credit reports, collecting delinquent accounts and deterring solicitations was functionally inconsistent with community betterment, municipal policy and creative industrial development. W.L. Stewart, the chamber's first secretary, was good at the former but complained in vain that more staff and other resources were needed:

> *We have no industrial department, no expert who can take the time and effort to ascertain what these firms and people want to know, giving them facts in concrete shape, and…ascertaining exactly what the firm…has to offer Johnstown.*

Stewart pointed out that the chamber did not even have expense money to entertain industrial prospects, and he advocated a financial assistance program for carefully screened firms seeking to locate in Johnstown.[464]

While there is no record of internal disunity, one concludes there must have been a rift between the merchant service advocates and those favoring a broader community focus and an industrial development program.[465] A committee to make plans for "broadening the scope of the chamber of commerce" was created. Its members were H.J. Hills (YMCA secretary), Ludwig Henning and W.L. Stewart, the chamber secretary.

In March 1914, the chamber's board of directors unanimously voted to hire the American City Bureau to do an on-site review and recommend a work scope and reorganization. American City's principals, Lucius and Samuel Wilson, were to be in Johnstown for three months. Based on their preliminary report, the chamber board would decide if the firm would complete the full work program, which was expected to take another three months.

The work statement was as broad as could be imagined and the model being pursued was based on the chamber in Syracuse, New York. Everything going on in Johnstown was expected to fit within the proposed work scope—document translation addressing Johnstown's multi-lingual population, police matters, a farm committee for a rural outreach program, all phases of municipal government and industrial development.

In July 1914, Samuel Wilson was named permanent secretary of the Johnstown chamber.[466] Its program would include housing, a modern sewerage system, better streets, sidewalks and other community infrastructure, cleanliness and the removal of eyesores, promoting a better taxation system and a focus on transportation. The chamber would even create a farm bureau, and in November 1914, it began publishing a magazine, *Doings*.[467] After several issues, *Doings* was replaced by a newsletter.

The chamber continued to maintain a retail trade committee to deal with holiday closings, special events and store hours. Its industrial committee began functioning in late

May 1915.[468] The 1915 chamber was debating whether to back individual candidates for public office. Fred Krebs, president at the time, felt strongly that the group should be on record for or against policies and projects, but should never endorse or oppose "any individual or set of men."[469]

In April 1917, right about the time the United States entered the war, a new-member drive almost doubled the group's size. Once again, the chamber began to redefine its mission. The *Johnstown Tribune* consistently supported the chamber. An editorial on April 16, 1917, gave some insight into internal discord and criticisms being leveled at the organization:

> *Its purposes were misrepresented by a few largely for personal political benefit. It is a fact... that candidates for political office went out of their way to have it made known they were not a part of or affiliated with, or in sympathy with the chamber of commerce...prejudice has been raised...against the chamber on the ground that it was a...debt-collecting concern.*

Early in 1917, the chamber's board arranged to bring in Roland Woodward, secretary of the Rochester Chamber of Commerce, to prepare another assessment and program of work hopefully to rejuvenate the organization.

Woodward's report suggested Johnstown was too lucky: "There is a danger to a community in too easy prosperity, for it may center the minds of the people on payrolls and smokestacks as the sole desideratum." Woodward stated the community should focus on housing, trolley line extensions and industrial diversification. He stated that Johnstown was too conservative. The chamber and its members, he urged, should "be bold."[470]

The Chamber of Commerce During and After World War I

The chamber's basic course during the war had been to debate Woodward's report and to expand its board to twenty members.[471]

In February 1918, the chamber decided to develop its own dining room for members and guests on the top floor of the Fort Stanwix Hotel. The chamber's new secretary, G. Wray Lemon, announced the idea was a huge success.[472]

More Discord

By May 1921, the chamber again was redefining itself. The bylaws were being changed to prevent board members from succeeding themselves. Six new directors would be chosen each year. There was also ballot reform within the organization. Members had to vote in person, not by mail.

In 1920, William Lunk, the former YMCA secretary, served briefly as chamber secretary. Harry Hesselbein, an editor for the *Tribune*, held the position briefly in 1921. John Gable, an editor with the *Johnstown Democrat*, became secretary in 1921 and served until late September 1923. Gable's political activity allegedly forced him to leave. During this time the chamber's offices were moved from the Fort Stanwix Hotel to the Swank Building, and the dining

PULLING TOGETHER

Tribune cartoon of May 30, 1919, supporting the
Johnstown Chamber of Commerce.

A Chamber of Commerce Cartoon That Has Occasioned Much Comment.

room was closed. In 1924, Harry Hesselbein returned to the organization as secretary, a position he would hold until 1933.[473]

Chamber of Commerce Industrial Development Initiatives

While the community's civic and commercial leadership did take comfort in Charles Schwab's capital improvement investments, the steel industry was having ups and downs throughout the 1920s, and the coal business was also undergoing problems.

In 1925, the chamber of commerce once again began to address the question of an industrial development program for Johnstown, the most significant chamber initiative for the next several years. After tabulating a detailed questionnaire addressed to all Johnstown industries, the chamber's directors devised an approach modeled after what was being done in Portland, Oregon. The thrust involved creating a for-profit subsidiary corporation, the Johnstown Industries Financing Service, or JIFS. JIFS would raise money through donations to be used to buy stock or corporate bonds in worthy industries—ones that showed interest and promise in expanding in Johnstown. The JIFS board would make the decision based on its perception of a firm's viability, growth potential and profitability, plus a general idea of what was good for the community.[474]

On January 24, 1927, at the chamber's annual dinner at the Sunnehanna Country Club, the need for industrial diversification was stressed by D.M.S. McFeaters, treasurer of the Johnstown Trust Company. Harry Hesselbein, the chamber's secretary, next outlined the

Johnstown Industrial Financing Service, Inc.—what it was and how it would operate. The JIFS plan would help small, local firms expand as well as attract new firms into Johnstown.[475]

The chamber was seeking to raise $200,000 to put JIFS on a sound footing. A five-day fund drive got underway on Monday, May 16, 1927. By Friday the solicitation teams had generated $57,360—a long stretch from the $200,000 originally sought, but enough to launch the initiative.[476] In May 1928, the chamber began a second-year effort, a four-day fund drive to raise $30,000—$12,000 to operate the organization and $18,000 "for industrial development and diversification."

One presumes the fund drive failed because there was no further mention of it in the press.[477] In July 1928, a new approach was announced—a sale of stock in JIFS. One also concludes this tactic was unsuccessful because the news topic vaporized again through non-coverage.[478]

The Johnstown Chamber of Commerce and its JIFS subsidiary boasted their industrial promotion successes—the Associated Button Company's move from Newark, New Jersey, to Ferndale (seventy employees); bringing the Brooklyn Hospital Equipment Company to Woodvale (sixty employees); aiding the expansion of the Friendly City Box Company on Railroad Street (twenty employees); and relocating the Standard Chocolate Company from Irvin, Pennsylvania, to Woodvale and aiding its expansion. The chamber also had a role in attracting and growing the Penn Cigar Company in Cambria City (maximum 110 employees); assisting a small ceramics unit in Hornerstown and merging two lesser Johnstown firms to form the Brown-Fayro Company.[479]

The chamber's newly chosen president was W.W. Krebs, who had become publisher of the Johnstown *Tribune* in 1928. Krebs had a lifelong interest in industrial development. In 1929, the chamber's Industrial Development Committee undertook a detailed survey of the Johnstown area. The study documented and quantified everything from minerals in the ground to utilities, transportation facilities and schedules, firms, employment, products, demography and similar information. Released on July 27, the major findings were published in the *Tribune* in installments that ended in early August.[480] Ten weeks later, the stock market crashed.

II. OTHER CIVIC AND COMMUNITY ORGANIZATIONS

The Civic Club

In December 1904, a group of Johnstown women became interested in establishing a juvenile court and related programs for youthful offenders. They sought to prevent juveniles from mingling with adult criminals. On December 12, a meeting was held with Judge Francis O'Connor and District Attorney Marlin Stephens. Both men were supportive.

By January 16, 1905, the group, then twenty-five women, set about to adopt the program-focused "constitution" covering many concerns—city and county government, education, recreation, art and other pursuits. Named the "Civic Club of Cambria County," it had a broad objective of "promoting by education and organized effort a higher public spirit and

better social order." The organizers were upper- and middle-class women that included Mrs. Marshall Moore, Dr. Bertha Caldwell, Mrs. J.C. Sheridan, Miss Florence Dibert and Miss Julia Schoenfeld.

The group succeeded in raising over $2,000 to pay for a juvenile probation officer and to fund the establishment of a facility where "poor women can place their children during the day while out earning a livelihood." Membership in the Civic Club grew rapidly.

On June 20, 1907, the Civic Club put on an outing at Luna Park to raise money for vacation schools for poor children. Johnstown society ladies worked tirelessly: Mrs. Anderson Walters, Mrs. Fred Krebs, Mrs. Evan Du Pont, Mrs. N.B. Swank, Miss Florence Dibert, Mrs. E.B. Entwisle and Mrs. W.K. Murdock, to name a few. A huge success, the event would be repeated for years to come.

The *Johnstown Tribune* actively supported the Civic Club and gave the group excellent media coverage, favorable editorials and positive cartoons. In May 1909, Florence Dibert, the club's president, reported on the accomplishments and goals of the club: solid performance in juvenile court matters and a successful vacation school for less fortunate children. By 1910, the club had raised money for four handsome drinking fountains placed downtown "for man and beast."[481]

By 1913, the Civic Club was studying the Johnstown local government and was even taking positions on garbage disposal matters. The club also recommended the creation of a planning commission, a proposal that materialized. There seemed to have been no ongoing conflicts or rifts within the group.

A June 19, 1909 *Tribune* cartoon backing the Civic Club, an effective women's organization dedicated to community improvement throughout Johnstown and Cambria County. The wife of *Tribune* publisher Anderson Walters was active in the group.

It Looks As Though That Boulevard Might Materialize NOW

Associated Charities

A few days after Christmas in 1913, representatives from civic organizations met to go over recent Christmas charitable activities. The need for central information and a coordinating organization was discussed. Charity recipients were reportedly going from one organization to another gaining excessive assistance.

The group funded a survey to assess the problem and propose solutions. In February 1914, the same group sought help from several civic leaders who in turn proceeded to organize Associated Charities, a forerunner of the United Way. Its purpose was to coordinate charitable fund raising and service delivery. The organizing president was Charles Price, recently retired. Associated Charities struggled throughout the 1920s. In 1925, for example, it only raised $12,800 toward a goal of $17,500.[482]

The Ad Press Club

A professional association of people from the advertising and newspaper worlds of Johnstown got organized in 1913. In addition to addressing members' professional concerns and contacts, the Ad Press Club arranged a speakers' forum every year.

Each November or December, some two hundred upper- and middle-class Johnstowners would come together at a banquet. Afterward they listened to a number of speakers discuss community problems and proposals. The speakers were political leaders, public officials, businessmen, lawyers, reporters and editorial writers. Tom Nokes seemed to have been the club's founder. Ludwig Henning, manager of the Valley Engraving Company, was the first president. Support came from Anderson Walters and W.W. Bailey, newspaper publishers.

Ground rules enabled each speaker to talk freely without press bashing. News accounts were always positive about the club.[483]

The Johnstown Country Club

With the encouragement of the Cambria Steel Corporation, the Johnstown Country Club was founded in 1903. The site was the company farm near Grandview Cemetery below the Westmont racetrack. The founding officers were: president, Thomas Murphy, an attorney; vice-president, Charles Price; secretary, Charles Longenecker; and treasurer, Fred Krebs. Cambria officials and their wives ran the club. Plans were underway for golf and tennis facilities. The original membership was limited to one hundred.[484]

In 1910, a clubhouse designed by Henry Rogers replaced the more modest house first used. The building, later the Bethlehem Management Club, houses a restaurant as of this publication.

Sunnehanna Country Club

In late February 1921, Johnstown Country Club was moved from its Southmont location to a larger tract offered by the Cambria Steel Company at "Cambria Farms" in what was still

Upper Yoder Township. The new site, initially 132 acres, was big enough for the eighteen-hole golf course the club officers were seeking.

The tract was leased for twenty-five years for one dollar per year plus all property taxes. H.A. Tillinghast of Philadelphia planned the golf course, and Henry Rogers designed the clubhouse. The Sunnehanna Country Club was officially opened with a dinner dance on September 3, 1923.[485]

Johnstown Motor Club

In September 1923, several prominent citizens founded the Johnstown Motor Club to promote route markers and directional signs along highways approaching the city.[486] The club also sought to furnish its members with the best routes between communities and to provide current highway condition information. The club also supported good roads.

Tom Nokes, always in the civic picture but rarely the front man, was the first secretary. His successor, Rudolph Kirschman, developed a full-time staff and opened an office in the Fort Stanwix Hotel. In October 1923, the club became an affiliate of the American Automobile Association (AAA).[487]

LEAKS IN THE ROOF OF PARADISE

THE JOHNSTOWN BLACK COMMUNITY

I. THE JOHNSTOWN BLACK COMMUNITY 1903–1930

In 1903, a perceptive article appeared in the *Johnstown Democrat*: "Johnstown's Colored Population—It Numbers About 500 and it Includes Many Who Are Thrifty and Progressive." The writer, Nelson Raynor, was a white journalist.[488]

Raynor began by expressing an opinion shared by many at the time: it is impossible for colored people and whites to coexist in the same land. Raynor described the scene in Johnstown. There were five hundred black citizens, many of whom had never lived in the South, plus ex-slaves from Maryland and Virginia. Some had fought valiantly for the Union during the Civil War.

Raynor had interviewed a black man who described other black men who had done well, including a barber with his own shop and a successful contractor. These men worked hard and were honest. The spokesman next expressed his own credo, an attitude probably welcomed by paternalistic whites:

> *The colored man must remember his position and must not think he is better than the white man…*
> *his ancestors for centuries were slaves and he cannot catch up with the others. He has a place of his*
> *own, and so long as he stays in his place and attends to his business he will succeed in his work.*

Raynor had also interviewed two prominent educators about black children in the schools. He was told there were sixty to seventy colored pupils. "They are not discriminated against," stated one of the educators.

> *The black children do not seem to be any different from the white ones intellectually when*
> *they are in the lower and medium grades; and there are cases where they have reached high*

school, and as long as they remained they proved studious and intelligent. But most of them leave when they get in the middle grades, either going to work or quitting for some other reason…As soon as they reach the higher grades and their numbers have become depleted…they are alone.

Jim Crow Migrates North

There were subtle indications that the peaceful coexistence between the races that seemingly prevailed in turn-of-the-century Johnstown was breaking down. The growth in animosity probably reflected a nationwide transformation wherein Northern whites were becoming sympathetic to Southern whites, gradually taking on some of their racial hostility.

In November 1906, black leaders sought to prevent Thomas Dixon's play, *The Clansman* from showing at the Cambria Theater. The group petitioned Mayor Charles Young, citing the drama's glorification of mob vengeance and lynching. The play did show in Johnstown and was such a success, it returned to the city in April 1908.[489] When the movie version, D.W. Griffith's *Birth of a Nation*, came to Johnstown in November 1915, and again in March 1917, it was hailed locally as a film masterpiece and the Ku Klux Klan scenes were described as "especially thrilling."[490]

An editorial, "The Negro Problem," appearing in the *Weekly Democrat* on March 8, 1907, described the change besetting the North. Its author believed the changes were also happening slowly in Johnstown:

Ten years ago, the "Jim Crow" cars were unknown in the North. Now they are multiplying in the states of Indiana and Illinois, especially on those railroads which have outlets from the South…Within recent years, Negro lynchings have occurred with…frequency in the highest centers of northern civilization.

While the author did not define exactly what he meant by the "Negro problem," he implied hostility between the races, especially white attitudes toward blacks.

II. THE MASS IMPORTATION OF BLACKS INTO JOHNSTOWN

After the Great War erupted in Europe, immigrant workers stopped coming to the United States. To meet a mounting labor shortage, recruitment of Southern black workers got underway. Prior to his 1912 retirement, Charles Price made arrangements for his horseman and servant, "Jack" Johnson, a black man, to work in the Cambria Steel office building downtown. Well known to company officials, Johnson soon managed the corporate dining room.

Faced with a labor shortage prior to United States' entry into the war, the company sent Johnson to Southern states to recruit workers. Johnson "checked in" with police authorities

everywhere he went. Those enrolled, about fifty at a time, were seated on railway coaches destined for Johnstown.

The recruits were typically single black males. Their migration cannot be quantified, inasmuch as there were returns home, secondary migrations and blacks who arrived on their own initiative. From before 1917 until the end of the war, labor was at a premium in Johnstown, and "colored families…came by rail and bus and…a few on foot."[491]

From the individual interviews and testimony given in 1920 to the Interchurch World Movement's Commission of Inquiry in regards to the 1919 steel strike, the Cambria Steel Company was reportedly continuing black worker importation after the strike.[492] At this time the recruitment would have been done to replace foreign workers who were returning to Europe after the war. The following table summarizes the Johnstown black population using census data:

Selected Black Population Data, 1900 to 1920

	City of Johnstown	Cambria County	Franklin/E. Conemaugh
1900	314	519	N/A
1910	442	640	N/A
1920	1,650	2,492	445

Between 1910 and 1920 there was little net increase in the number of blacks in Cambria County, other than those in and around Johnstown.

Settlement Conditions

Once black workers had arrived in Johnstown, they were usually housed in company-built bunkhouses in Rosedale above the Lower Works, and in both Franklin and East Conemaugh Boroughs near the Franklin Works.

The fewer, earlier resident blacks generally lived in Kernville, Old Conemaugh Borough, Prospect and downtown. According to the 1920 census, these sections were home to 560 blacks—361 males and 199 females. In the Fourteenth Ward, however, which included Rosedale after its 1918 annexation, there were 767 blacks—646 males and 121 females, a ratio of more than five to one. While comparable data is not available for Franklin and East Conemaugh, the imbalance would have been like Rosedale's. Meanwhile Rosedale itself was being used for coke ovens and a new sintering plant. There were no efforts to establish a wholesome residential environment.[493]

In the spring of 1923, Dean Kelly Miller from Howard University visited Johnstown bunkhouses and described their conditions as deplorable. He claimed never to have seen "such pitiable conditions as prevailed in Johnstown." Miller wrote that the black men were "poor, untutored newcomers from the South." There were no wholesome places of amusement and little for them to do in their spare time. They would have been avoided by whites, both foreign and American, and were probably shunned by Johnstown's established black community. Young male newcomers with neither family nor community support systems were logically prone to vice, gambling, Prohibition-era alcohol, drugs and violence.[494]

Labor's Attitudes

There are no indications that blacks were being recruited to Johnstown in 1919 specifically as strikebreakers. Unlike other
steel centers, the Cambria Steel Company's planned strategy was to close its mills completely in the event of a strike. Nonetheless, in August 1919 (just before the strike), labor leaders met with Mayor Franke after "the arrival of a number of Negroes in the city." Franke was urged "to take action to prevent the importation of 'undesirables.'"[495]

During the individual Johnstown steelworker interviews undertaken by Interchurch World Movement staff in 1919, there was frequent mention of black workers still being recruited by Cambria Steel. The typical comment was decidedly negative. White steelworkers stated that recent black arrivals were lazy and unproductive.

Social Disintegration

With the United States' entry into the war, crime increased in Johnstown and the numbers of arrests per average day were breaking previous records. From April 1 through April 15, 1917, there were 350 arrests—almost 25 per day. A police spokesman explained:

> *Hundreds of men are being brought every month by the industrial concerns of this city. The laborers imported include many men of questionable habits and inclinations, and the police are kept busy during all hours.*[496]

By July 1917, the city council was preparing for race riots, including contingency plans for deputizing citizens as policemen. Councilman George Hershberger was the proponent. "All over the country we hear of unrest among the Negroes coming up from the South," he noted. "Our police department is not…equipped to handle a big riot."[497]

Johnstown newspapers published a stream of accounts describing altercations involving black arrivals, often those living in company bunkhouses. In early December 1918, a bunkhouse supervisor, Charles Stanton, awakened Joe Boston, a "giant Negro" from Texas. Boston got violent, saying he had been awakened too early. A fight ensued and the police were summoned. Boston beat up both Stanton and Patrick Coyle, a Franklin policeman. Boston was shot by Franklin's police chief, Dan Wirick. Although wounded, Boston continued fighting until he died.

In August 1920, two blacks attacked and robbed Edwin Lane, a shoemaker and repairman located on Haynes Street. Lane had been beaten in the head. One assailant was caught. In May 1921 two blacks were severely wounded in a Rosedale bunkhouse shooting that had erupted during a poker game. Later that November, a dispute broke out between two black men, Frank Hodge and Seymour Johnson, at a Rosedale dance. Hodge followed Johnson home. Johnson got a gun and killed his assailant, "in self-defense," he pleaded.[498]

III. THE KU KLUX KLAN

On Freedom Day, September 22, 1921, a resolution was passed at the AME Zion Church urging Johnstown's two congressmen, Anderson Walters and John Rose, "to use their influence in any way whatever, and to vote for a measure for a thorough investigation of this infamous [Ku Klux] Klan."[499]

Nothing indicates Johnstown's black citizens were aware of there being a local Klan organization. There had been news accounts of chapters being formed in Ohio and other parts of Pennsylvania. Sensing the community's growing animosity toward the newcomers, which would affect all blacks and, recalling Johnstown's affection for *The Clansman* and *The Birth of a Nation*, Johnstown's established blacks had reason for concern.

In late January 1922, the *Johnstown Tribune* reported that "a large class of prominent men" had been initiated into a local organization of the Ku Klux Klan. A ceremony had taken place "under the light of the fiery cross." Everything and everyone was shrouded with secrecy. Whoever wrote the article concluded with, "it has been announced that the work of the Ku Klux Klan throughout this section is progressing most satisfactorily."[500] In April, a second initiation and cross burning took place. The news article referred to the initiates as "prominent men," but no names were given.

To be a member, one had to be of "good moral character," a native-born American and a firm believer in the Christian religion. While not mentioned, native-born blacks, Catholics, Orthodox Christians and Jews were ineligible. Ostensibly, the Klan favored Prohibition. Klan organizations were also being formed in Somerset, Bellwood, Barnesboro and other places.

After dark on August 25, 1922, Johnstown was exposed to a strange, somewhat frightening spectacle. High on Green Hill near downtown, a tall cross blazed in flames. Many Johnstowners sought to get closer but were denied access. Stationed all around the burning cross were hooded Klansmen dressed in white robes. One man, also hooded, was dressed in black. He was the master of ceremonies and head of the Klan in the Cambria district. The cross burning was reported not to have been an initiation. The occasion was not given. It was said that thousands of people flocked downtown to get a good view.[501]

On September 22, a brief but unusual ceremony occurred at the YWCA on Somerset Street. YWCA officials had announced in advance there would be a surprise. After most attendees had arrived, a number of automobiles pulled up in front of the building. In single file, an uncounted number of hooded Klansmen paraded up the front walk and into the lobby. Saying nothing, one of them presented an envelope containing seventy-five dollars in cash and a pamphlet describing the purposes of the KKK. Without pausing for thanks or ceremony, the group immediately filed out. The *Tribune* referred to the incident as "enjoyable."[502]

Something similar occurred at an evening service at the Beulah United Evangelical Church in Dale Borough on March 11, 1923. Fifteen hooded Klansmen entered the church in the middle of a service and presented the pastor with an envelope containing fifty dollars for the church's building fund, an apology for the interruption and a pamphlet describing the Klan and its purposes. The group departed immediately.[503]

Johnstown Ku Klux Klansmen on Bedford Street in Dale Borough in the mid-1920s.

The local Klan was obviously seeking to boost its image and win public favor. At that time there had been an investigation (with a finding of no fault) into the group by Congress, and recent violence had broken out in Ohio between the Klan and another group organized to counter it. Even in Johnstown and Cambria County, Anderson Walters, smarting over his May 1922 Republican primary defeat by George Wertz for congressman-at-large, had blamed the KKK for opposing him politically. An editorial scuffle erupted between the *Tribune* and the *Democrat*. A *Tribune* editorial went on to say that the newspaper had obtained much information about two Klan groups. Never, however, did either newspaper publish the names of any KKK organizers, officers, members or affiliated organizations.[504]

Phillip Jenkins, in a study of extremist groups in Pennsylvania and using state police information, stated that the Johnstown klavern (No. 89) had approximately 1,775 members in 1925. Statewide, the Klan had peaked at about 250,000 members in the 1920s. Considering the membership restrictions detailed above, the figures represent a significant percentage of the eligible.[505]

In the late afternoon of June 19, 1923, a fifteen-year-old-girl was allegedly attacked by an unknown black man in a wooded area between Conemaugh and Headricks Cemetery. On Tuesday, June 20, hooded KKK members went into the black settlement in nearby East Conemaugh and burned a cross. Borough police said the cross burning was a "warning."[506]

IV. ROSEDALE

In the summer of 1923, the rash of thefts and violent crimes in and around Rosedale was escalating. Almost always, blacks were victims of blacks. John Scott was charged by William Richardson for shooting at him. Two Rosedale black women got into a fight and one chased

the other with a razor. Two men were charged on July 23 with fighting. In mid-August, John Knox was shot and killed in a Rosedale barbershop. Frank Williams, another black and the alleged murderer, was said to have been hidden by six other black men, all of whom were either charged with accessory to the fact or "of suspicion."[507]

The Rosedale Incident

Just before midnight, August 30, 1923, Joseph Grachen, a city patrolman, was sent to investigate a domestic disturbance between Robert Young and his live-in girlfriend on Rosedale Street. Grachen concluded things had calmed down and resumed patrolling.

Shortly after midnight, he came upon an automobile accident in which two blacks, Levi Samuel and a companion named "Dad," had hit a pole near Young's residence. One of the pair was bleeding. As Grachen dealt with the accident, Robert Young (who may have been in the vehicle earlier) came over in a drunken, drug-crazed condition and pointed a gun at the patrolman. A fight ensued, and Grachen was shot in his right lung. Grachen fired a few rounds and managed to get to a nearby bunkhouse where a man named Myers called police headquarters. Shortly after 12:30 a.m., two cars bearing seven police officers arrived. One in the group, Joseph Abrahams, was immediately struck in the heart with a bullet. Abrahams was pronounced dead when his body reached the hospital. Another detective, Otto Nukem, was hit as he left the same car, but the wound was not serious. County Detective John James was shot and killed as he entered the building where Young was hiding. Lieutenant William Bender and Captain Otto Fink were also seriously wounded as they pursued Young within the building. Detective John Yoder finally reached Young and shot and killed him.

There had been confusion amidst the tense excitement. Some of the wounded policemen later reported having seen multiple scattered gun flashes in the darkness, reports that gave rise to news accounts that many blacks were battling police officers.

Police Chief Charles Briney talked to his police officers, rounded up and interrogated about twenty blacks from the area and conducted a thorough investigation. Briney concluded that Robert Young had been the sole gunman. In truth, with the exception of seeing Joseph Abrahams being hit, no surviving policeman witnessed the actual fatal shooting of any other policeman.

Briney's conclusion was significant. Had there been a widespread belief that the killing of two and wounding of four police officers was a result of a black mob riot, broad-scale violence might have erupted.[508]

After dark on September 1, the Klan burned a large cross on Benshoff Hill. Klansmen had come from afar to Johnstown. Tensions were high. Mayor Joe Cauffiel kept telling people that blacks should leave town for their own safety. Meanwhile Rosedale remained heavily patrolled. The state police had sent in six troopers to help maintain order. More were dispatched later.

Mayor Cauffiel

The "silly season" of Johnstown politics usually begins Labor Day, and Joe Cauffiel was seeking renomination in some of the primaries, then being held in mid-September. On

Monday, September 3, eight blacks were arrested in Minersville for being "disorderly" and "on suspicion." They were charged with having made threatening remarks against Johnstown policemen during the Rosedale crisis early August 31. In police court, Cauffiel fined them various amounts and sentenced them to jail. He then used their incarcerated predicament to pressure them to leave Johnstown.

Two days later the mayor fined Levi Samuels, H.R. Samuels and "Dad" Hall for gambling. Samuels and Hall had been in the wrecked automobile in Rosedale investigated by Patrolman Joseph Grachen early August 31. Following the shooting, the three had been confined to the city jail "on suspicion." Cauffiel imposed fines and ordered them to leave town. They agreed to depart.[509]

Cauffiel had earlier been blamed with treating blacks in demeaning ways. In late 1920, the AME Zion Church's new pastor, G.W. Kincaide, became vocal in asserting the rights of Johnstown's blacks. In March 1921, the congregation had passed a resolution attacking both Cauffiel's "horse play" toward them in police court and his practice of jailing blacks "on suspicion."

On January 17, 1923, Cauffiel had made a public statement denouncing the importation of "undesirables." His words were probably intended for the new corporate officialdom, as Cambria's acquisition by Bethlehem was being finalized at that time.[510]

The Expulsion

Seven days after the Rosedale Incident, on the evening of September 6, 1923, Joe Cauffiel issued a public order, which came out in the *Johnstown Democrat* through an interview with Ray Krim, a reporter:

> *I want every Negro who has lived here less than seven years to pack up his belongings and get out.*[511]

Cauffiel's "newspaper" order had other features: future importation of Negro and Mexican workers into Johnstown were banned. Black visitors invited as guests of Johnstown's entrenched citizens must register with the mayor or chief of police. Until further notice, except church services, all black gatherings such as dances, picnics and similar functions were forbidden.

Cauffiel praised the city's established blacks who had already undergone his seven-year investiture. He even predicted their cooperation:

> *They want to do what is right. I am convinced they are as ashamed of the Rosedale occurrence as anybody can be...My mind is made up: Negroes must go back from where they came. They are not wanted in Johnstown.*[512]

Cauffiel also ordered the police to search the homes of Johnstown blacks for weapons, guns, hammers and kitchen knives.[513]

There is no reliable information on how many blacks departed Johnstown following the Rosedale Incident. Cauffiel stated that many had left before his expulsion announcement,

"for their own safety." Florence Hornback, having interviewed many blacks eighteen years later, reported:

> *Frightened, penniless and not knowing what else to do, Negro families of men, women, children and old folk gathered up a few belongings and set out on the highway.*[514]

As had been true with his "good beer will be allowed" announcement a year earlier, Cauffiel generated national publicity, but his expulsion was widely condemned in both the North and South. The *Johnstown Democrat*, which had served as Cauffiel's mouthpiece, attacked his action as a politically motivated publicity stunt—totally illegal, immoral and unworkable.[515] The *Johnstown Tribune* neither reported Cauffiel's edict nor editorialized for or against it. The evening of the day following Cauffiel's expulsion announcement, the KKK ignited twelve crosses in and around Johnstown, visible for miles.[516]

A telegram was sent from James Weldon Johnson, secretary of the NAACP, to Governor Gifford Pinchot, asking him "to protect the colored citizens of Johnstown against the Ku Klux Klan methods of Mayor Cauffiel."

The Mexican Embassy and its consul at Philadelphia each complained to both Cauffiel and the governor about the treatment of Mexicans in Johnstown. Pinchot cabled Cauffiel asking for a complete statement of the facts, and on September 18 Cauffiel answered him by letter.[517]

The governor decided to let the matter blow over. Cauffiel's term was soon ending. Proving Cauffiel a liar might have triggered further riots. Pinchot did, however, send Cauffiel a polite but firm letter dated October 2, 1923.

Cauffiel had not sought the Republican nomination for mayor. Candidates could cross-file, and although nominated by the Prohibition Party, he withdrew before the general election.

V. THE LILLY RIOT

In late March of 1924, an outbreak of mob violence took place in Lilly, Pennsylvania, resulting in three deaths and many serious injuries. A large number of Johnstown Ku Klux Klan members were involved.

In early 1924, tensions had been developing between Catholics, especially Italians, and Protestants in and around Lilly, a small borough situated between Portage and Gallitzin in Cambria County. As part of its mission to champion Protestant and American values—seen by the KKK as virtuous—and to fight foreign and Catholic influences—equated by the Klan as "evil"—Klansmen were beginning to view Lilly as the site of a miniature Armageddon in the making. The ethnic and Catholic residents of Lilly were also believed by KKK members to have been a source of recent extortion racketeering surfacing in Johnstown.

Pursuing their notions of virtue, Klansmen from Johnstown and outlying areas had begun making trips to Lilly on Saturday nights, both to recruit members and intimidate ethnic Catholics.

In February 1924, someone had fired shots into the Lutheran Church parsonage at Lilly. Pastor E.S. Brown's wife was almost hit. A similar attack was repeated a few nights later and again on March 21. The day following the final shooting, two men—Dominick Naples and Amedeo Tranquillo—were arrested.

Both men insisted they had not fired the shots but were being blamed for actions perpetrated by their accusers, Klansmen guarding the parsonage. The two Italians claimed the shots were fired to attract hordes of Klansmen to Lilly to agitate against Catholic foreigners.

Lilly's tensions soon reached a fever pitch. Local leaders sought help from the Pennsylvania State Police. A department spokesman assured them that a detail of troopers, capable of handling any potential trouble, was being sent to Lilly.[518]

The Klan Special

Shortly after 7:00 p.m. on Saturday, April 5, 1924, a chartered train from Johnstown carrying more than four hundred Klansmen arrived in Lilly. Donning white robes and hoods, most of the group marched four abreast through Lilly's streets toward Piper Hill.

As they moved forward, Lilly townspeople along the route began jeering and insulting them. Youngsters driving two automobiles attempted to break up the marching columns. The town was then plunged into near-total darkness by someone who had pulled a switch at an electrical substation.

Despite these annoyances, the marchers reached Piper Hill, where they conducted a ritual ceremony and burned two crosses. Next, parading in orderly fashion, the Klansmen began returning to their train. Meanwhile, a group of townspeople told the train crew that dynamite under the "Klan Special" would soon explode and urged the crew to get the train out of Lilly at once.

A railroad detective ordered the train moved a short distance so the tracks and the railcars could be examined. The warning had been a hoax, a failed attempt to leave the more than four hundred Klansmen stranded at Lilly.

As Klansmen filed back through Lilly, someone got a fire hose and began directing heavy streams of water at the marchers. Fights broke out and shots were fired. Two innocent bystanders were killed instantly and a third person, Frank Miasco, one of the men operating the hose, was mortally wounded. Twenty other people were severely injured, many needing hospitalization.

Finally the train was boarded. With some passengers bleeding, the "Klan Special" began chugging toward Johnstown.[519]

The Arrests

Sheriff Logan Keller and a few state troopers conducted an investigation into the events at Lilly. As each Klansman departed the train at Johnstown, he was searched. While it was reported that many abandoned revolvers were found, those who still had weapons were singled out for arrest unless they could prove non-involvement in the riot.

Twenty-seven Klansmen and thirteen people from Lilly were initially arrested and incarcerated in the county jail at Ebensburg. All were denied bail.[520]

Sympathy Demonstrations and Counter Demonstrations

The arrests of the Klansmen prompted an outpouring of protests from other klavern units, especially in Western Pennsylvania. Crosses were burned and speeches charging abuse and loss of liberty were common. In Beaverdale, Sheriff Logan Keller and state troopers quelled a near riot. Klansmen were also being countered by a Catholic group, the Flaming Circle, an organization seeking to outdo the Klan's crosses by igniting large circular designs that blazed at night on prominent hillsides.[521]

The Martyrdom of Owen Poorbaugh

An arrested Klan member, Owen Poorbaugh, contracted pneumonia while jailed at Ebensburg. He died at Memorial Hospital on April 25, 1924. The death prompted renewed criticism of the bail denial and precipitated charges of poor treatment at the county jail.

Poorbaugh's funeral and burial became a well-publicized martyrdom ceremony. On April 27, Klansmen and their families and friends, said to have come from nine counties, packed into Johnstown for three services: the first at Poorbaugh's Roxbury home, the funeral itself in the brand new Beulah Evangelical Church in Dale Borough and the burial itself in Grandview Cemetery. An estimated two thousand people wearing KKK robes paraded about in linear columns. While crowd sizes are often exaggerated, the *Johnstown Tribune* estimated there were "between 20,000 and 25,000 persons gathered in Grandview Cemetery to witness the KKK burial of Owen Poorbaugh."[522] The spectacle and publicity surrounding Poorbaugh's funeral turned out to have been such a triumph, the Klan was eager for more.

In early July, while her husband, Reuben, was serving a two-year term for involvement in the Lilly episode, Josephine Miller suffered severe burns while incinerating rubbish at her home. She died on July 6. On an impressive but smaller scale than the Poorbaugh spectacle, Josephine Miller was also accorded a Klan burial, which her husband, Reuben, was released to attend. Robed Klansmen lined the Dale streets between the Miller residence and the Evangelical Church. After the funeral, a large procession of robed Klansmen paraded down Bedford Street, crossed the Haynes Street Bridge and went up to Grandview Cemetery for the Klan burial rites. Traffic was tied up for twenty minutes.[523]

A Klan monument to Owen Poorbaugh was also dedicated in Grandview Cemetery on October 13. An estimated ten thousand Klansmen attended.[524]

The Trial

By the trial date, forty-four people had been charged with carrying concealed weapons and inciting and participating in a riot that had resulted in deaths. With two opposing sets of defendants being charged for the same offense, the nature of the trial was an unusual and difficult one. Percy Allen Rose, the lead attorney for the Klansmen, petitioned for a

separate trial for each of those he represented. He stated there were "two antagonistic factions here represented—the Ku Klux Klan and the Catholic Church." Rose argued that because of the clash of interests, there was no way to seat an impartial jury. Rose's motion was overruled and a jury was impaneled through the firm hand of a special judge, Thomas Finletter from Philadelphia.

The next test occurred the afternoon of Tuesday, June 10, at about three o'clock. When a witness testified proudly that he was indeed a member of the Ku Klux Klan, an outpouring of cheers and approving applause exploded in the packed courtroom. Judge Finletter used the outburst as an excuse to clear the courtroom. Afterward the trial was lightly attended, and the courtroom atmosphere became calmer and more relaxed.[525]

Over four days, the story of the Lilly episode was probed in detail. Fifteen Lilly residents gave testimony for defendants and provided them with alibis. On Thursday, the defense rested. Judge Finletter immediately dismissed cases against thirteen of the forty-four. No evidence had been presented against them.

The next day the jury reached a verdict. All thirty-one men were found guilty of "affray and unlawful assemblage." The riot charges were dropped. Petitions for a new trial were rejected, and twenty-eight of the thirty-one people—eighteen Klansmen, including Klansman Samuel Evans, who had shot Frank Miasco during the fight over the hose, and ten Lilly residents— were all sentenced to two years in the county jail. Although found guilty, the other three were not sentenced.

VI. THE JOHNSTOWN KLAN FADES AWAY

Following the Lilly incident and the trials, the Klan peaked in membership and for a time was able to mount ostentatious cross burnings and mass gatherings. When the new Beulah Evangelical Church was completed in Dale Borough, its former church building, located farther east on Bedford Street, was sold for a Klan recreation center and headquarters.

The day after Josephine Miller's (July 10) funeral, a cross was burned at the edge of Evan Du Pont's estate in Viewmont. Whether Du Pont was an intimidation target is not known.[526]

Two weeks later, three hundred new members were initiated at a cross-burning on Berkley Hill above Roxbury Park. It was reported that four thousand members from Cambria, Somerset and Westmoreland Counties had attended.[527]

In early August, a new Klan organization, the Junior Ku Klux Klan, held its organizational ceremony near Walnut Grove. With adult supervision, young boys ignited a cross visible over much of Johnstown.[528] Ten days later, on August 14, 1924, "Klan Day," a well-organized picnic with games and sporting competitions, was celebrated at Ideal Park. Approximately fourteen thousand people including many from other counties attended. Klan Day ended with the burning of a cross said to have been sixty-five feet high—perhaps a Klan record. A huge crowd sang "America" and "The Old Rugged Cross."[529]

The Decline

After its post-Lilly, Poorbaugh-martyrdom peak, the Johnstown Klan seemingly declined. Its appeal was wearing thin. The enormous manpower effort to burn crosses was getting fewer volunteers. The hero status of the eighteen Klansmen doing time in the county jail gradually faded, especially after many of them were released through appeals or for good behavior.[530]

The Klan had developed a reputation for donating funds to help churches construct new buildings. Ironically, the Mount Olive Baptist Church, the second oldest black congregation in Johnstown (c. 1876), was relocating to a new site at Main and Adams Streets, and its pastor, R.B. Birchmore, actually requested a contribution from the KKK. In late October 1924, the Klan made a $100 donation.[531]

How such a contribution matches the Klan's white supremacy tenets is hard to fathom. The Mount Olive Church was identified with blacks who had decades-old roots in Johnstown and who perhaps did not welcome the floods of arrivals from the Deep South. The Rosedale Incident, which had prompted Cauffiel's expulsions, had occurred just over one year earlier. At its best, the Klan may have been religiously generous. At its worst, it may have been seeking to divide an already fragmented black community.

From 1925 to 1927, cross burnings became less frequent. Their mystery, novelty and excitement had eroded. The Klan itself suffered losses in esteem due to KKK violence elsewhere. There was a scandal and a lawsuit over national dues in 1927.[532] While its decline is not easily explained, by 1929 Johnstown's klavern (No. 89) was becoming moribund.

OVER HERE FOR OVER THERE

JOHNSTOWN DURING THE FIRST WORLD WAR

The Guns of August 1914

By late July 1914, the crisis in Europe had reached a stage where stepped-up diplomacy to avert war had clearly failed. Mobilization was underway, and detailed battle plans were going into execution.

War halted the flow of immigrant workers to Johnstown. It also created civic anxiety that local immigrants whose homelands were fighting one another might become bellicose. Austrian and Hungarian males between twenty-one and twenty-eight years old were ordered home. An unknown number of Johnstown immigrants were supposed to have been mobilized during the First (1912) and Second (1913) Balkan Wars, but indications are that there had been little obedience to these orders. Calls in 1914 for Johnstown's Austro-Hungarian men to report stressed that any previous deserter would receive full amnesty when reporting for duty.[533]

Many Johnstowners were in Europe in varying situations at the outbreak of the war. Morris Woolfe, for example, had been in Germany. He managed to get back to Paris and then home. Harry Silverstone was attending a family reunion in East Prussia. Morris Nathan and his wife were in Frankfurt, Germany, and had great difficulty getting to Holland for their return. Conversely, Henri Franke, first cousin of Herman Cron, superintendent of the Goenner Brewing Company, had been visiting the United States. A lieutenant in the Austrian army, he had spent over three weeks trying to arrange passage to Austria. During the delay, he visited his relative in Johnstown.[534]

Johnstown's immigrants frequently had gone back to their homelands to visit family, especially in the summers. In 1914, many such visitors were forced into their countries' armed services. Austro-Hungarian subjects in Johnstown were in a quandary over what they should do. Swindlers were trying to coax them into selling their homes and personal property at absurdly low prices. Others were tempted to accept dubious offers being made by some to do "substitute military service" for a fee.

Rev. John Ratz, a Hungarian Roman Catholic priest, and Rev. Ernest Porzsolt, a Hungarian Lutheran, conducted a mass meeting at the Cambria City Fire Hall attended by an estimated five hundred people. Everyone was urged not to sell out to speculators or enter into any military service substitution contract. The amnesty being granted to former deserters was explained. Individual situations were being evaluated by Baron Hauser, an imperial consul from Pittsburgh. Transportation money for those returning to fight was arranged.[535]

Unusual Loyalties

The very next day, Johnstown's "Slavs" had a mass meeting of their own in Cambria City's Croatian Hall—this one a support rally, not a "what-to-do" session. At the rally, pro-Russian and Pan-Slav feelings were stronger than national ties. The Croatians, Slovaks and Slovenians whose provinces were part of the Austro-Hungarian Empire were siding with the Serbs and Russians.[536]

On August 9, the German-Americans of Johnstown assembled at the Turnverein (then anglicized into "Turners"). The group established a fund for German war relief. Resolutions were also passed urging the American press not to get hoodwinked by French, English and Russian propaganda either as to the course of the war or other "false reports and misrepresentations," the latter referring to alleged German atrocities in Belgium.[537] Another resolution urged there be no demonstrations in Johnstown by any nationalist groups in behalf of one or more belligerent countries.

The Magyar Hungarians met again on August 15 at the Nemo Theater to hear a delegation from Hungary: Dr. Bela Barabas, Buza Barna and Lehel Hedervary. The message was: "We will fight with Austria now. After the war, we have been promised full and separate independence." Austria had needed to make concessions to greater Hungarian autonomy to sustain Magyar loyalty during the war. The speeches brought cheers from the Hungarians.

There are no statistics available as to how many of what nationalities did go back to fight. Indications are that in Johnstown, with the exception of the Serbians, there were comparatively few fighting for either the Allies or the Central Powers. After Italy entered the war in late May 1915, many Italians returned for military service.[538]

Tensions and Riots

S. Holzman and Son, steamship agents and bankers in Cambria City, frequently posted letters, news items and pictures in the windows of their Broad Street office. In late July 1914, they began posting photographs of war mobilization and enthusiastic crowds. The pictures upset some Serbs, Austrians and Hungarians. Fearing violence, the displays were taken down and discontinued.[539]

The first known riot in Johnstown triggered by war-induced animosities was a melee between Poles and Russians that occurred in Ferndale on Saturday, August 1. There were ten arrests and seven fines. A more serious incident broke out in Cambria City on October 11, 1914. An estimated twenty-five were implicated. The explanation given in the mayor's court was:

All these fellows are Poles, understand. But some of them are Russian, some…are Austrian and some are Prussian…So they got talking about the war…and then the fight started.

Fearful that another incident might erupt into a major disturbance, Mayor Joseph Cauffiel imposed stiff fines.[540]

Johnstown's Germans had their own weekly newspaper, the *Johnstown Freie Presse*, printed in German since 1878. In mid-August 1914, an editorial appeared and was repeated in German (with no English translation) in the *Johnstown Tribune*. The editorial stated that the world would marvel at the German-Austrian war machine, which could not be beaten by the English, French and Russians. The mood of the American people would change when they came to understand the power and organization of Germany.[541]

As the war raged on, sentiments gradually shifted more toward sympathy for the English, French, Serbians and Russians, rather than to the Germans and Austro-Hungarians. Johnstown relatives of soldiers and sailors on either side furnished local newspapers with pictures of cousins and nephews taken in the trenches. Local societies raised funds for war relief and bandages. No fine lines were drawn as to which side Johnstown humanitarian efforts were helping until 1917.[542]

Johnstown Goes to War

America officially declared war with Germany on April 6, 1917. While diplomatic relations were severed two days later, war was not declared against the Austro-Hungarian Empire until December 7, 1917, a significant delay in Johnstown because of its ethnic population.

Rapture

Even before April 6, 1917, an enthusiastic excitement was sweeping over the community. Portraits featuring a stern-looking Woodrow Wilson could be found in window displays and on bulletin boards. Attorney Percy Allen Rose, reviving a patrician practice at the onset of the Civil War, wrote to Governor Martin Brumbaugh and offered to raise a cavalry regiment. Patriotic rallies were commonplace. Editorials urged "America First!"

There is one positive and inescapable duty of every American man, woman, and child. That duty is unhesitating and unyielding loyalty.

Mayor Louis Franke asked people to display the Stars and Stripes, and on April 5, several thousand citizens participated in another of Johnstown's "biggest-ever" parades. The parade formed at the Point and proceeded up Main Street. Civil War veterans rode in cars, and those from the Spanish-American War marched with Johnstown's "boys who had served on the Mexican border last summer." Even the Austrian band participated. A rainfall failed to diminish the crowd or cool its jubilation.[543]

By April 12, over two hundred Johnstown High School boys had volunteered to be drilled at the Point by the Pennsylvania National Guard. Stepped-up military recruitment

got underway with notable success. It was reported that the enlistment drive in Johnstown in relation to population was the most successful of any Pennsylvania city.[544]

Johnstown was draped in red, white and blue. A committee of veterans and community leaders collected enough money to install a giant steel flagpole in Central Park. One month after the war's declaration, a flag-raising ceremony was attended by some twenty thousand people packed into the park.

Everyone was striving to make ostentatious displays of patriotism and loyalty. Like other American communities, Johnstown had no experience in what to do or how to go to war in a massive conflict. The Civil War had ended a half century in the past, and the Spanish-American War had caused no community deprivations.

The war's early April beginning was timely for spring planting. A national food shortage was feared, and a war-garden movement immediately got underway in Johnstown.[545] Mayor Franke issued a proclamation urging all suitable land be used for gardens. A local gardening commission was appointed to help people acquire garden sites, to give out information about planting and even to distribute seeds that were in short supply.

Recruitment and the Draft

Voluntary enlistment was steady. Some better-educated young men volunteered for officers' training leading to commissions, and on May 10, 1917, four such Johnstown men received orders to report: George Foster, an attorney and son of the late merchant Andrew Foster; Warren Schumacher (who was beginning to spell his name "Shoemaker"); Carl Glock, a Harvard student and son of the Swank Hardware manager; and Paul Barton from Patton. Schumacher and Barton had been working for the city engineer on the sanitary sewerage system.[546]

Three weeks later Johnstown's Army Ambulance Corps, all college students, posed for a group photograph at the Trinity United Evangelical Church. The forty-eight men, recently recruited by George Wagoner Jr., son of the doctor and ex-mayor, were all scheduled for immediate service in France.[547]

By early May, planning for the military draft had gotten underway so that by the time the Selective Service Act became law on May 18, the machinery for its administration was already in place. All men from twenty-one to thirty years in age were required to register at their voting place. Johnstown City was divided into two zones. On June 5, 7,533 men registered. Of these, exactly one-third (2,511) were "alien"—not United States citizens—and another 26 were "enemy alien," meaning German. Neither alien category was subject to the draft, but the former group had to fulfill their national service requirements, provided their home countries were allied with the United States.

Each county and city was assigned a quota of men to be drafted based on a special population estimate done by the U.S. Census Bureau. Johnstown's population was estimated at 82,290, a grotesquely excessive figure. (The 1920 census count was 67,327. The city government and its planning commission had been using a current estimate of 70,000 people.) There were no adjustments in the census bureau's estimate for "aliens." In a word, Johnstown had to furnish more of its eligible men through the draft because of an overly inflated population estimate, plus the fact that just over one-third of the draftee

pool comprised ineligible aliens. In addition, the city got no offsetting credit for its earlier volunteer enlistments.

On July 25, Mayor Louis Franke filed written objections with the War Department both about the draft policy and the flawed population estimate. He also sought an offsetting credit for Johnstown's earlier volunteers. Franke pointed out that Johnstown's labor shortage was already affecting its coal and steel industries, both vital to the war effort.

The mayor's appeal was summarily rejected. The War Department was in no mood to consider protests and special situations. In the first draft call, Cambria County's quota was 1,655 men. Of these, 505 were to come from the City of Johnstown. They would be called up in increments of just over 200 men.[548]

The Send-Off

Ever since the Civil War, Johnstown had a tradition of furnishing each of its departing warriors with a "comfort kit"—a small canvas bag containing needles and thread, buttons, stamps and stamped post cards, talcum powder and similar items. The Red Cross arranged for volunteers through its Women's Relief Corps to assemble, fill and distribute the kits.

The Ad Press Club launched a project to furnish "smokes for the boys." The idea was to provision Johnstown's soldiers and sailors with cigarettes and other tobacco. Non-smokers were given chewing gum.

The *Johnstown Tribune* sought to establish itself as an information bureau for all Johnstown area servicemen. The newspaper collected and made available the men's service addresses to people wishing to write them. As an inducement to sending names and military mailing addresses, Johnstown servicemen would receive the *Tribune* daily newspapers free for the duration.[549]

Another custom initiated early in the war and followed in most cases was the farewell banquets at the Fort Stanwix Hotel. Groups of soldiers boarding departing trains went first to the main dining room at the Fort Stanwix for an elegant meal hosted by a veterans' and citizens' committee. The dining room was draped with flags and banners, and the nervous recruits and draftees were expected to listen politely to patriotic exhortations, prayers and reminders that Johnstown was behind them.

The armed services were segregated at that time, and on October 27, a group of Johnstown's "colored boys" were also given the farewell banquet at the Fort Stanwix. Since "boy" was also used with young white soldiers and sailors, no racial slur was intended. The AME Zion and Mt. Olive Baptist Churches arranged to give every black recruit a Bible.

On Labor Day, September 3, the "largest crowd that had ever poured into the city streets" viewed a parade again described as "the greatest." Flags and pennants were everywhere. The cloud-filled skies reflected the glare from Cambria's furnaces. The parade was honoring the first contingent of draftees going on active duty. On September 7, more draftees destined for Camp Lee, Virginia, were accorded the Fort Stanwix banquet and railroad station farewell.[550]

A similar farewell on October 8 almost resulted in a major tragedy. The weight of a mass of people standing on the Johns Street footbridge caused its approach span to collapse. Many were injured. There were no deaths.

The Fund Drives: Liberty Bonds

The United States government pursued four separate liberty bond drives to help finance the war. The first got underway in May 1917, with a goal of $2 billion nationwide. Johnstown's share of a countywide quota was set at $500,000. The sales drive was supported by the banks, which sold the bonds, the chamber of commerce, employers and public officials. There was a speakers' bureau of "four-minute men"—civic leaders known for good speechmaking, always eager to speak briefly at public gatherings to promote bond sales. Short talks could be expected at most meetings. George Wolfe, the noted attorney, was the first "four-minute man" chairman. Percy Allen Rose succeeded him.

By mid-June, Johnstown had subscribed to $1,875,000 in liberty bonds, almost four times its quota. For days, every article and editorial in the *Johnstown Tribune* ended with **"BUY LIBERTY BONDS!"** in bold print. Throughout the war, both the Johnstown and Cambria County quotas were exceeded in all four liberty bond campaigns.[551]

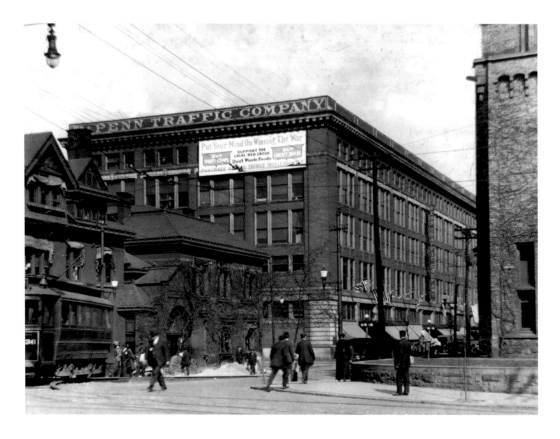

The Penn Traffic building during World War One.

Red Cross

Ever since its well-known relief effort following the 1889 flood, the Red Cross had been looked upon with favor by the citizens of Johnstown. With major roles in the war, the organization needed operating funds and undertook two drives to increase membership and raise money.

The first sought $100 million nationwide. Cambria County, including Johnstown, exceeded its $150,000 share by mid-July 1917, but the fundraising was an ongoing activity. Ex-President Theodore Roosevelt spoke to a crowd of ten thousand at Luna Park on September 30, urging generous support for the Red Cross.

On May 25, 1918, during the second fund drive, Edgar Munson, Pennsylvania's Red Cross fund chairman, informed W.R. Lunk, YMCA secretary and local Red Cross coordinator, that Johnstown had raised more money per capita than any place in Pennsylvania. William Thomas, president of the Johnstown Trust Company, announced that his bank was donating another $1,000. "Let's increase our lead way past the others!" he urged.[552]

Wartime Shortages

Like other American communities, Johnstown experienced shortages, especially of many food items, energy sources and manpower. Making do with less was a patriotic duty, and there was little protest. Rationing was not imposed.

President Woodrow Wilson appointed Herbert Hoover to serve as food administrator. Hoover in turn established an organization of local "food administrators" nationwide, all unpaid volunteers. Dr. H.A. Garfield, Wilson's fuel administrator, dubbed pejoratively the "coal dictator" by those who disliked his policies, was also responsible for naming local "fuels administrators."

The approach taken by these officials locally was to gather by questionnaires and other sources massive data about demand and supply of materials. They would then issue orders encouraging restrictions of one kind or another, which, if obeyed on a widespread basis, were intended to free up supplies for wartime purposes. The prime enforcement mechanisms were the news media and public opinion. There were occasional fines.

By mid-1917, Cambria County had its own food administrator, Joseph Hinchman, a retired wholesale grocer and confectioner. Hinchman did little with the position and soon resigned. Just after Christmas, Peter Carpenter, proprietor of the Capital Hotel, took the job. He worked diligently to balance local food needs with resources, all leading toward the tough objective of assuring that Cambria County would be adequately fed while its food supply was being offset by diversions to the military and overseas relief.

The position was nightmarish and full of challenges. Carpenter might order a meatless day only to find it led to meat spoilage and grocers' complaints. He wrestled with problems such as whether to kill more chickens for poultry meat or to have more eggs. Johnstown went through "meatless," "wheatless," "sweetless" and "heatless," days and had its share of "victory bread"—bread either made with flour derived from grains other than wheat or with reduced wheat content.

Electric refrigerators were not yet widely used. Ice was another essential product in short supply because the ammonia needed to produce it was being diverted to explosives and fertilizer manufacture. In addition, home delivery of ice was unreliable because there were fewer trucks, ice wagons and drivers. Carpenter urged people to pick it up themselves at designated "ice stations." The complaining public, especially the "drys," observed ice wagons making frequent deliveries to bars and saloons, but not to peoples' homes.

After eight difficult months, Carpenter announced his resignation in a revealing letter:

> *War conditions have brought such a state of affairs that I am compelled to give up the extensive and strenuous duties of food administrator…I have given up all my porters for war work, my clerk was drafted…I must retire as Food Administrator or give up my hotel business entirely.*

He was succeeded by George Glenn, an ex-grocer and one of Carpenter's assistants.[553]

Electric power was also conserved but on a voluntary basis, enforced once again by patriotic public opinion. Prior to the United States' entry into the war, Johnstown city officials had made arrangements for a new "white-way" street lighting system for downtown. When the new lights were turned on in April 1918, an awkward public relations problem surfaced and Johnstown officials agreed in July to install 100-candlepower instead of the original 200-candlepower globes in the fixtures.

Store merchants were also being pressured to stay dark, creating a greedy temptation to keep the lights on while adjacent competitors stayed dark—a sort of advertising one-upmanship. The encouraged standard was for all retail night lighting to be turned off after 6:30. In the summer months the downtown stores closed earlier by mutual agreement.

There were occasional "heatless" or "fuelless" days ordered by the controversial Dr. H.A. Garfield, the U.S. fuels administrator who had gotten off to a rocky beginning by trying to cap coal prices at two dollars per ton, a move that caused many operators to halt coal mining altogether. The "fuelless" days seemed absurd to Johnstown's citizens, since coal was being mined throughout the area, even inside the city limits.

Beginning in August 1917 and lasting until after the war, Johnstown merchants cooperated in a campaign to lessen delivery services. The slogan was "Carry your parcels home." Shortages of all kinds made home delivery more difficult.

Manpower Shortages and Women at Work

With the serious shortage of men, women were being hired to fill their places in the workforce. Johnstowners may have been surprised in early February 1918 to have seen a newspaper photograph of seven women shoveling snow for the Pennsylvania Railroad. The beleaguered Johnstown Traction Company had lost twenty male employees to military duty. As was being done in other cities, the company explored hiring women conductors.[554]

Trained nurses were in enormous demand. A special recruiting office was established in Johnstown both to recruit trained nurses and to urge women to study nursing.

The fire on Franklin Street near Vine Street, Saint Patrick's Day, 1918. The First Lutheran Church is near the center of the picture.

The Germans

When the Great War broke out in August 1914, there was little support for either side in Johnstown. As time passed and sentiment shifted in favor of England, France, Italy, Serbia and Russia, citizens of German background, many of whom had relatives serving in the German and Austrian armies, felt alienated.

The following letter to the *Tribune* was written by Herman Cron, the general manager of the Goenner brewery and a recently naturalized citizen, when the United States declared war against Germany. It reveals the duress experienced by people of German background.[555]

> *Sir: The statements which have been circulated in regards to my conduct are all falsehoods…I have always lived right, whether in this country or in the land of my nativity…I will, if the demand comes, prove myself as good an American citizen as the rest of you. But going to war against one's mother country is not a thing to be lightly regarded. My mother, my father, and my sisters still live in the old country, as well as scores…of relatives.*
>
> *Herman Cron*

Wartime Johnstown was unpleasant for persons of German origin. The distrust and dislike of people and things German had started before April 1917. By mid-April, enemy aliens were required to surrender firearms, explosives or explosive devices, cipher equipment and

code books to the chief of police. Annual Deutsche Tag festivities were either discontinued or done in secret.

In December 1917, it was announced that all German language classes at Johnstown High were being discontinued because only two students had signed up for them. The next month, students at Garfield Junior High School "went on strike" and refused to study German. Later the county superintendent recommended that all German language study be discontinued. The textbooks were said to be enemy propaganda.

On January 22, 1918, fearing sabotage and espionage, signs were posted to warn all enemy aliens (Austrians and Germans) not to go near Cambria Steel properties. Dr. Carl Nickolaw, a German alien, was arrested on February 22, "on suspicion." In April 1918, John Ordronko, an Austrian, when drinking in a Johnstown hotel, was heard to shout, "Hurray for the Kaiser!" He was thrown out of the hotel, arrested and fined $100. Two weeks later, a small fund drive got underway to purchase a large American flag for the borough building in East Conemaugh. About eighteen foreigners, mostly Austrians who had refused to contribute, were attacked by a mob and were covered with tar and feathers.

On April 17, two prominent Johnstown ladies, Mrs. Bruce Campbell and Mrs. Charles Suppes, were selling war bonds in the post office when J.W. Hantz, a local baker, announced to them that he would not subscribe to anything that would "destroy wealth." An argument ensued, and Mrs. Campbell reminded him, "Our boys who are over there fighting for democracy have to be fed and clothed." Hantz was reported to have said, "It doesn't make much difference who buys bonds. I know who is going to win the war." He then announced he wouldn't give five cents for a fifty-dollar liberty bond. Mrs. Suppes next followed Hantz to his Bedford Street bakery, got his name and reported the incident to the police. Hantz was arrested.[556]

Even the Central Park monument dedicated to the city's founder, Joseph Johns (originally Shantz) was not left alone. Johns had German (through Switzerland) roots and the monument, dedicated to him in June 1913 bore an inscription, written in German. It was covered to keep it from being read.[557]

Serbians and Croatians—Johnstown's Yugoslav Initiative

Johnstown's Croatian and Slovenian (whose native lands were in the Austro-Hungarian Empire) people's support for the Serbian-Russian cause in the very early days of the Great War, prior to any hint of future United States involvement, was unusual. The joint statement was a precursor to proto-Yugoslav thinking, almost three years before the Corfu Pact (June 1917) and the Corfu Declaration (July 20, 1917).[558]

On June 28, 1917, the very anniversaries of the Battle of Kosovo (1389, by Western calendars) and the assassination of Archduke Francis Ferdinand and his wife at Sarajevo (1914), some seven hundred Serbian and Croatian soldiers stopped off in Johnstown on this significant date in Serbian history for a battle-flag blessing ceremony. Serbian soldiers from other cities in the United States were on their way to southern Europe to do battle against the enemies of Serbia and to bring about the new nation of Yugoslavia. Reverend

John Krajnovich, the presiding priest, was rector of the Saint Nicholas Serbian Orthodox Church in Cambria City. The fact that these men would come to Johnstown for a battle-blessing ceremony on an important date in Serbian history just after the Corfu Pact had been developed but before its July 20 declaration was an indication of Johnstown's importance among the proto-Yugoslav ethnic populations in the United States.

Johnstown's Serbians also fought in the war, serving with the Serbian army mostly in France because there was no easy way for them to get to Serbia. Whether any went to Corfu is not known. By August 1917, 120 of Johnstown's Serbians had already joined the Serbian army. In September, 20 more were added. Their departures were marked by religious services and patriotic rallies in Cambria City.

Americanization

The term "Americanization" was used throughout the war. Never precisely defined, it had to do with a total acceptance of American ways, ostentatious patriotism, aliens becoming U.S. citizens, use of English instead of foreign languages, wearing American clothes rather than native garb and other manifestations of conformity to American normative culture.

Foreigners who resisted were ostracized. Johnstown's chief of police, Matthew Swabb, seemed to sense treasonable behavior in town and was continually waxing forth to promote Americanization and seeking greater policing powers to deal with the many enemies he felt were all over Johnstown.[559]

The Slackers

"Slacker" was a loosely defined term of derision during the war. It meant a draft-dodger, but was also used to describe a person who did little or no work, especially when local war industries had labor shortages. Slackers were arrested from time to time.

Later in the war, when the labor shortage became so acute it interfered with steel and other military production, deferments could be sought for workers in key wartime industries. Fearing people would label them slackers, most Johnstown employees resisted management persuasions to seek their draft deferments.

Leaders and Heroes

Johnstown boasted two towering personalities active in the war: Charles T. Menoher, a major general; and J. Leonard Replogle, the "steel czar."[560]

Menoher was born in 1862 in old Grubbtown, an area that had come into the city as the Eighth Ward following the 1889 flood. After graduating from West Point in 1886, Menoher became a career army officer. In France, Menoher commanded the Forty-second, the Rainbow Division. Menoher's war record and that of the Forty-second Division were both outstanding. On November 10, 1918, the day before the armistice was signed, Menoher was reassigned and was succeeded by his deputy, Brigadier General Douglas MacArthur, a man whose career he had helped to promote.

General Menoher's widowed mother, Mrs. Sarah Menoher, lived in Moxham. She was honored as "Johnstown's mother" several times during the war. After the war, General Menoher was placed in charge of the Army Air Corps.

The peripatetic Jacob Murdock, president of the chamber of commerce, arrived in France with the YMCA Motor Transportation Corps in September 1918 and was assigned to the Rainbow Division. Murdock took the opportunity to invite General Menoher to visit Johnstown after the war to give several speeches and be honored by the community. Menoher's return took place on February 5, 6 and 7, 1919.

After leaving the Cambria Steel Company in 1916, J. Leonard Replogle moved on to New York City where he founded Replogle Steel and Vanadium Steel and had a key role with Wharton Steel. Replogle and Charles Schwab were close friends.[561]

By April 1917, Replogle had become a leading personality in the American steel industry. In August 1917, he was chosen to be the steel administrator with the War Industries Board, first under Daniel Willard and later under Bernard Baruch. Replogle was given enormous power to determine which corporation got what orders, and he had a hand in setting steel prices. His authority also extended over purchases by Allied nations from American steel corporations. Replogle's responsibilities, however, did not extend to ordnance manufacture. He had to keep up with plant capacities and capabilities, backlogs, problems and cost structures all over the United States.

Replogle bought liberty bonds through local institutions and made donations to Johnstown charities. He delivered an important address to the Johnstown Rotary Club on August 21, 1918.

Charles Schwab, raised in Loretto, also visited Johnstown often. In mid-April 1918, the nation was faced with a crisis in shipping brought on by the need to transport a large army of men and materiel to Europe. There had been heavy shipping losses to submarines. New vessels had to be built and launched on a rush basis. Charles Schwab was set to turn down the position of director general of the U.S. Emergency Fleet Corporation when President Wilson personally described how critical the situation was and why he, Charles Schwab, was the man for the job. Schwab accepted, moved to Philadelphia, a shipbuilding center, and spent most of his time traveling from shipyard to shipyard expediting construction to a fever pitch.

The first American soldiers began landing in France in June 1917, and some were in trenches by October. In February 1918, Johnstowners were informed that Herbert Seigh had been the first American soldier to kill a German soldier in trench warfare. Seigh, from Hornerstown, was a sharpshooter who had been in the army for seven years.[562] Nick Dalanoudis, a native of Athens, Greece, was another local battlefield hero. He had moved to Johnstown in 1913 and joined the army in October 1917. Dalanoudis was later sent to France and fought in Belgium and at Verdun. He came across sixty-five German soldiers in a dugout and started firing at them. They all surrendered. Dalanoudis was awarded the Distinguished Service Cross. After his April 1919 discharge, Dalanoudis worked for the Linderman Candy Store on Main Street.[563]

Major General Charles T. Menoher being honored by his hometown on February 5, 1919. He is saluting as he passes a reviewing stand at city hall. At this point in his career, General Menoher, a non-aviator, was commandant of the U.S. Army Air Corps. His deputy was Brigadier General 'Billy' Mitchell.

HOME AT LAST

General Menoher's career history as revealed by mementos affixed to his suitcase. The cartoon was in the *Johnstown Tribune* on February 5, 1919.

Peace

Johnstown was eager to celebrate the nation's victory and the coming of peace. Despite a raging flu epidemic, parades, speeches and frivolities got underway on November 7, 1918. An announcement made by Admiral Henry Wilson was premature—an understandable error based on Austria-Hungary's withdrawal from the conflict and the repeated reports of widespread chaos within Germany itself.

When the November 11 armistice was signed and officially announced, Johnstown's second celebration was even more enthusiastic than the first. The mills and mines shut

down, church bells rang forth and the downtown streets quickly filled with crowds that had to be pushed to the curbs to make way for impromptu band formations and chaotic marching units—all in an ambiance of good cheer and frivolity.

Various wartime measures were quickly relaxed. Wheat could be used without limitation in baking bread. Elevator restrictions were discontinued. With no war to motivate patriotism, tough measures were unenforceable. Everyone wanted to forget the war and return to peacetime.

There was a postwar effort to raise funds for a "Liberty Temple," a monument to the men and women who had served on active duty and a memorial for those killed. Victor Rigamont, the city's former resident planner, proposed a tall building that would straddle the Stony Creek River at the lower end of Main Street to serve as a new city hall. An architectural sketch prepared by George Wild appeared in local newspapers on December 9. The Liberty Temple idea never caught on and the funds for a monument were not raised.

A Lost Generation

Unlike in other communities in the United States, there is no complete World War One list of servicemen who had used either Johnstown or Cambria County as their home-of-record. In addition, there is no numerical data about other categories such as branches of service, nurse corps, ambulance corps or similar groupings.

An accurate compilation of Johnstown's fighting men and nurses would have been difficult to prepare—Johnstowners were serving with the Serbian, Italian, English and American armed forces. Some had also fought for the Central Powers, chiefly with the Austro-Hungarian armies.[564]

Casualties

James Brannigan, a sailor from Johnstown's Woodvale section, was the city's first casualty. His ship, the *Jacob Jones*, was a destroyer torpedoed by a submarine in late November 1917.

Other reports of casualties would continue until several years after the war. Some servicemen perished with the influenza epidemic of late 1918 and early 1919. Others died from war wounds, especially the long-term effects of poisonous gas.

As of September 18, 1919, 101 servicemen from Johnstown and vicinity had died as a result of the war. The vast majority were casualties of the last three months. Twenty-eight had died from disease.[565]

THE STEEL STRIKE OF 1919

General Background

The Cambria Steel Company's pre-World War I policy toward unionization was one of ruthless suppression of any effort to organize its mill and mine workers. A suspected labor organizer or vocal sympathizer faced dismissal.

Following the late 1890s decision for the Cambria Steel Company to remain in Johnstown, its corporate challenge was to compete as an independent against the major steel trusts, meaning Federal Steel initially and later U.S. Steel. Soon after its April 1901 beginning, U.S. Steel controlled three-fifths of the steel making in the United States.

In time, the U.S. Steel Corporation began to achieve a policy of open shops and a form of industrial paternalism. While his mechanisms were not precisely worked out, Judge Elbert Gary, chairman-CEO, instructed his subsidiary managements that workers should be shown, "that it is for their interests in every respect to be in your employ."[566] U.S. Steel was encouraging employee stock purchase plans and other policies to give its workers a sense they belonged to one happy family.

When America entered World War I, closed-shop unionism in the steel industry was non-existent. Smaller independent companies, Cambria Steel included, logically feared that if their mills were organized, they could never compete with the steel trust.

The war brought several changes to the steel industry: a labor shortage, higher steel prices, huge corporate profits and a federal role regulating the operations and policies of the corporations then doing record business. Fearing work stoppages or slowdowns in wartime, the Wilson administration became friendly to labor. In an effort to maintain wartime employment levels, President Wilson established the War Labor Board (WLB) shortly after America's entry into the war to prevent strikes or lockouts that would affect the war effort. Platitudinous policies were promulgated that sounded good but which were almost meaningless in specific situations:

- *Strikes and lockouts were to be avoided.*
- *Workers were free to organize.*
- *Workers could not be disciplined for union activities.*
- *Where union shops existed, they would remain; where open shops existed they would remain.*
- *All workers would receive a living wage.*

The WLB would settle disputes. Lacking statutory authority, its powers were supported by patriotic opinion, government persuasion and the purchase leveraging through the War Industries Board and other wartime agencies.[567] The War Labor Policies Board, chaired by Felix Frankfurter, was created in May 1918 to promulgate uniform federal policies in labor matters.

Midvale Steel and Ordinance Company Policies

The Midvale Steel and Ordinance Company, which had acquired Cambria Steel in 1916, came to be run by many of Andrew Carnegie's former managers. William Carey became president of the U.S. Steel Corporation following Charles Schwab's 1903 resignation. By early 1911, Carey had resigned. He helped create the Midvale Steel and Ordinance Company, becoming chairman. Alvah Dinkey, president of Carnegie Steel and Schwab's brother-in-law, became Midvale's first president. William Dickson, previously a senior vice-president at U.S. Steel, became a Midvale vice-president responsible for personnel matters.

Dickson's philosophy of management is difficult to follow, largely because of his strong dislikes: he abhorred Henry Frick's ruthless anti-union tactics, yet Dickson had distaste for non-company labor unions; he disliked Elbert Gary's "cooperation in competition" intended to stabilize steel prices. Dickson favored enlightened management policies toward workers and disliked the twelve-hour, seven-day shifts. He favored "industrial democracy," which he defined as an internal corporate matter presided over by a well-meaning, informed management promoting fair worker elections and representation leading to "collective bargaining."[568]

The Background

In April 1918, the International Association of Machinists (IAM) began organizing Midvale's Nicetown Plant at Philadelphia. Six hundred men who were on strike were terminated. Strikebreakers were hired. A government mediator was told there was nothing to mediate. The matter eventually got to the WLB, and some discharged workers were rehired.

Midvale's military business orchestrated by the War Industries Board necessitated the company's staying in the good graces of the government, a situation giving Dickson an opportunity to solidify his misty employee relations ideas through a Midvale variation on shop-committee proposals being encouraged by the WLB.

The Midvale relations plan was Dickson's brainstorm. It got a rubber-stamp OK from Carey and a hasty approval by the Midvale board. On September 23, 1918, a notice was

posted and circulated throughout all units of the Midvale Corporation including Cambria at Johnstown.[569] Among other things, it stated:

> We recognize the right of wage-earners to bargain collectively with their employers and we hereby invite all employees to meet with the officers…for the purpose of…adopting a plan of representation by the employees.

What was developed was a plan calling for one representative to be elected annually for each three hundred employees in every plant. They, in turn, would choose one man for each three thousand employees to serve on a company-wide committee. Representatives would meet with corporate officers four times a year. Cambria had fifty-six men on the larger committee.

While the Midvale Employee Representation Plan (ERP) was challenged on many points, it was eventually sanctioned by the WLB in February 1919. Meanwhile, the IAM continued raising objections with Midvale officers about its Nicetown problems, matters the union communicated with the Labor Department and the WLB.

The war was over, however, and the makeshift wartime agencies were disbanding and becoming toothless. President Wilson was fully engrossed with the Paris peace conference. Midvale managers also faced uncertainty over the future profitability of the steel industry in general and their corporation in particular. War orders were history. The peacetime demand for steel was unknown, as were the capabilities of the competition.

The National Scene

William Z. Foster had been an important union leader in a successful drive to organize the Chicago stockyards. At an April 1918 Chicago Federation of Labor meeting, he introduced a resolution to organize the American steel industry. It was approved and sent to the American Federation of Labor (AFL) in Washington. Taken up at the AFL convention in June 1918, the resolution was passed by the members.

On August 1, thirty union leaders met with Samuel Gompers and established the National Committee for Organizing Iron and Steelworkers. Its secretary-treasurer was William Z. Foster.

Dynamic and captivating, Foster was spellbinding before an audience. Born poor in Massachusetts and raised by Irish parents in Philadelphia, he had worked in a wide variety of jobs—a background perhaps deliberately obscured and exaggerated to promote the mystique of a working-man folk hero.[570]

In early September 1918, committee organizers began to sign up new members in steel centers around Chicago, including Indiana. The lead affiliate was the Amalgamated Association of Iron, Steel and Tin Workers of North America. The drive was highly successful. Workers flocked to meetings to sign union cards. Wartime conditions motivated the signatures—wages trailed cost-of-living increases. Labor shortages had restored twelve-hour shifts and seven-day workweeks where they had been eliminated during the war. Workers also knew federal government agencies in general and the WLB in particular were sympathetic. "Brothers, when jobs are begging for men, and the U.S. government is with us,

we cannot let this opportunity go by," an enthusiastic Cleveland union man wrote.[571] The many immigrant steelworkers who harbored plans to return home after saving a wartime nest egg were more militant, especially with the flow of foreign-worker recruits cut off. Workers were eager to sign union cards whereas before the war, fearing replacement by other workers, they were reluctant.

On October 1, 1918, the undaunted National Committee for Organizing Iron and Steelworkers opened a Pittsburgh office to focus on Pennsylvania and Ohio. This was happening exactly one week after the Cambria Steel Company had announced and posted notices about the Midvale Employee Representation Plan. Also on October 1, Elbert Gary's eight-hour day took effect at all U.S. Steel plants. It had been announced during the September unionization drives.

Foster charged that Gary's action was "union busting." On October 8, inspired by Gary's announcement, J.C. Ogden, Cambria's general superintendent, posted eight-hour-day notices at all Johnstown plants.[572]

In November, the first quarterly meeting of the employee representatives met with the corporation's management at the Bellevue-Stratford Hotel in Philadelphia. Some two hundred people attended. William Dickson wrote favorably about the sessions in his diary. The steelworkers, however, were unenthusiastic.[573]

Johnstown Organization Drive

The Pittsburgh office of the National Committee for Organizing Iron and Steelworkers had begun functioning in October, even before the first Midvale employee plan meeting in Philadelphia. The influenza epidemic was raging everywhere, schools were intermittently closed and meetings of any kind were being discouraged. In other steel communities in the Greater Pittsburgh Region and in eastern Ohio, community leaders and steel executives started mounting anti-union campaigns.

The *Johnstown Tribune* (the only local newspaper whose issues from this time have survived) simply did not mention the AFL unionization drive at all until its successes were well known around town. The first such revelation occurred on March 17, 1919, in an article describing a committee of workers going from plant to plant telling employees that the Midvale "collective bargaining plan" was a better one than that being proposed by AFL organizers.[574]

The national committee's Johnstown coordinator was Thomas Conboy, a staff organizer for the AFL. The Conboy-led drive had been far more successful than Cambria's officials would acknowledge. Many employee plan representatives had signed up with the AFL team and were seeking the federation's assistance with the company plan. According to William Foster, testifying in 1920 before the Commission of Inquiry of the Interchurch World Movement, the Employee Representation Plan being pushed by Midvale's management had the effect of driving the workforce into the AFL:

> *We started in to organize Johnstown at the invitation of the men; and one of the prime factors moving those men…was the announcement by the company that they were going to establish*

a company union. So…we went in and started out our campaign of organization. As the company union became established, the trade union became established on the outside. The company used every effort…to destroy the trade union, discharging thousands of our men—in the most cruel way.

By March 1919, the AFL committee was claiming a 40 to 50 percent sign up in Johnstown. Cambria officials put the union success at approximately 10 percent.

E.E. Slick had been working for Carnegie Steel for about twenty-two years when, in 1912, he became general superintendent of Cambria Steel.[575] He had experienced the Homestead Strike of 1892 and, being a Donner man, would have looked to Henry Frick's ruthlessness as the appropriate response to the AFL Johnstown initiatives. Disdainful of the Midvale Employee Plan, Slick believed it would promote outside unionism.

Under Slick, Cambria had begun using detectives to keep tabs on its employees. Slick was summarily firing people who had signed union cards, especially Midvale ERP delegates. He had gotten about a thousand employees he could trust "sworn in" as deputy sheriffs and was allegedly amassing a store of rifles. The AFL committee had complained to the Labor Department about Cambria's suppression tactics. The department in turn reported these matters to William Dickson.

Dickson visited Johnstown in late March for a firsthand inspection. With William Carey's approval, Dickson reversed Slick's efforts: the cadre of deputy sheriffs was disbanded, and the weapons were eliminated. "Slick is making a great mess of the whole situation including the collective bargaining [ERP] scheme," Dickson wrote in his diary.[576]

When Dickson conferred with William Corey and Alvah Dinkey following his Johnstown trip, he urged that Slick resign "for the good of the service." On April 3, 1919, the *Tribune* reported Edwin Slick's sudden departure from Midvale with no reason given, and his future uncertain. The startling revelation came one day after Slick had announced that in the event of a strike, Cambria's mills and other operations would simply close.[577]

Slick's replacement happened so quickly everyone sensed an orchestrated script. On April 5, Alfred "Fred" Corey Jr. was named president of Cambria Steel. Being William Corey's brother and until then serving as general superintendent of Carnegie Steel's Homestead Works, Fred Corey was assumed by Midvale's higher management to be up-to-speed with whatever anti-AFL strategies were planned by Elbert Gary. And, being William Corey's brother, he could speak for the Midvale Company.

Cambria's new president sent a somewhat equivocal letter to union officials in Johnstown. He would "deal with employees" through the existing Employee Representation Plan or "through any other accredited committee elected by the men in any way."[578] Corey did add that the company "would not deal with any outside organization or committee on…relations between the company and its employees." This begged the true situation: Corey's posture toward an internal employee representation committee that had linked with the AFL.

The chamber of commerce seized upon Corey's arrival as an occasion to put on a Johnstown banquet with speeches and give-away flowers. The May 1 event would also showcase the chamber's new offices and dining room atop the Fort Stanwix Hotel. At the

reception, some two hundred Johnstown business and community leaders met Fred Corey for the first time. He came across as youthful, articulate and sincere.

Jacob Murdock, the outgoing chamber president, recently back from France, whispered to him, "Don't pay any attention to anything that might happen." Banker David Barry, Charles Schwab's brothers-in-law, was toastmaster.

The affair began with several loud pops and bangs. Explosions scattered carnations over those at the head table including Murdock, Barry, Fred Corey and Judges Francis O'Connor and Marlin Stephens. The explosions were taken to represent the violence of a steel strike.

Next, the black waiters staged a skit—they "went on strike" refusing to bring forth the banquet meal. Abe Cohen, a retired merchant, was appointed "arbitrator." Finally, dressed in bandages with patches of corn plaster, the servants limped their way back and served dinner. The affair featured mysterious messages broadcast by a loudspeaker system.

In his short speech acknowledging the honor accorded him, Corey made it known to all that he was "Fred" and concluded by saying, "I don't know what is going to happen, but I assure you we will all be together when it happens."

Whether Fred Corey had wanted it or not, the banquet had broadcast a not-so-subtle message to the Cambria workforce: the business leaders of Johnstown support management; violence is expected; management will prevail. The "striking" waiters had served the meal in the end.[579]

Strike Sentiment

In the spring and early summer of 1919, impatient union steelworkers throughout the nation began urging action. Workers were being fired. Production had been cut back due to declines in orders, and the Cambria Steel Company was using the lull to dismiss union sympathizers. The Johnstown Allied Mill Workers Council telegraphed William Foster in mid-July that if a strike was not soon authorized, "we will be compelled to go on strike alone here." Nervous impatience was leading some members to withhold union dues.[580]

On July 20, the National Committee for Organizing Iron and Steelworkers met at Pittsburgh to initiate a strike vote, a union-by-union process that took a month to accomplish. At the meeting the committee developed a list of twelve demands to be used in later negotiations. These included a right of collective bargaining, reinstatement of those discharged for union activities, the eight-hour day, one day's rest in seven, a living wage, union dues check off and the abolition of company unions.[581]

By August 20, various unions had polled their members so that the committee could make its final tabulation—98 percent favored striking if the companies refused "higher wages, shorter hours and better working conditions."

The committee tried to meet with Judge Elbert Gary on August 26, but he refused. A group led by Samuel Gompers next met with President Wilson on August 29 seeking his help in arranging a meeting with Judge Gary. This failed. Gary told Wilson's emissary, Bernard Baruch, he would not meet with outsiders who did not represent the workforce.

When Johnstown's strike committee sought a meeting with Fred Corey, he took a cue from his former chairman and refused to meet or discuss any of the twelve demands and suggested that the matters be addressed through the company union.[582]

Having exhausted all avenues for negotiation, the national committee voted on September 10, 1919 to strike, beginning Monday, September 22. President Wilson urged a delay for three weeks until after a major industrial conference to address postwar labor problems. The situations in the steel centers were too far awry. Gompers, himself, favored the delay but September 22 remained firm.

Using committee records, Foster reported that 11,846 workers in Johnstown had signed union cards. While most of them were from the Cambria Steel Company, there were also employees from Lorain Steel and the National and Union Radiator Companies.

Steelmaking operations had begun to shut down even before September 22. Cambria Steel hired striking workers as guards and fire fighters and for plant shut-down preparation.[583]

Mayor Louis Franke issued a public statement on September 22 urging all parties to be calm and to obey the law. The city would not be taking sides but would rigorously enforce the law to prevent violence, intimidation and property destruction.

The Strike in Johnstown

On Wednesday, September 24, 1919, Thomas Conboy reported eighteen thousand workers were on strike throughout the Johnstown area. Included were about two thousand miners supplying Cambria's coke ovens. Pickets were stationed at all mill entrances. Conboy urged everyone to obey the law. Lorain Steel at Moxham continued to operate but with fewer workers. Conboy confided that Johnstown was law abiding, a sharp contrast with the ruthless suppression underway around Pittsburgh, especially at McKeesport and Clairton.[584]

Workers in Johnstown were free to attend public meetings, a situation quite different from elsewhere. For the first several weeks, the strike scene in Johnstown was uneventful. Nearly one month into the strike, the *Tribune* undertook a review of the overall situation in Johnstown. While the newspaper had a pro-management bias, the survey sought to be objective and was probably accurate. The article cited:

> 1. Cambria Steel was closed "by order of the company."
> 2. Lorain Steel was said to be in full operation.
> 3. National Radiator and Union Radiator were operating on a full-time basis.
> 4. Haws Refractory mines were operating at seventy-five percent of normal production.

The comparative tranquility at Johnstown was because Cambria Steel had shut down. Without taking sides, Mayor Louis Franke simply enforced the law.

Syndicalism

On April 3, 1919, six months before the strike, the *Tribune* had published an editorial: "The Foster Case." Its writer had information that William Z. Foster had once been "affiliated and in sympathy with the I.W.W." The editorial continued:

It seems to us that there is due from Mr. Foster specific personal denial of his alleged sympathies with the I.W.W. and specific renunciation of the sentiment he avowed.[585]

On Monday, April 7, the Central Labor Council of Johnstown had conducted an inquiry into the Foster case using a recent article written in *Labor World* about Foster and his syndicalist past. In attendance, Foster blasted the publication as anti-union. After a heated discussion, the group backed Foster.[586]

A few months later, in early September, a reporter for *Iron Age* magazine obtained a copy of "Syndicalism," jointly authored in 1911 by Foster and E.C. Ford. The story broke in the September 18 issue of the *Tribune* under a lead: "TO PERMIT THE STRIKES OF WORKERS…AS PROPOSED BY A SMALL BAND OF AGITATORS WOULD BE A CRIME."

The pamphlet, reprinted without union label, began being circulated in steel-center communities just as the strike was getting underway. An extract read:

If society is even to be perpetuated—to say nothing of being organized upon an equitable basis—the wage system must be abolished. The thieves at present in control of the industries must be stripped of their booty and so reorganized that every individual shall have free access to the social means of production. This social reorganization will be a revolution. Only after such a revolution will the great inequalities of modern society disappear.[587]

Gompers dismissed the pamphlet as youthful immaturity. Foster himself avoided reporters and made "no comment" replies when they managed to reach him.

Reverend C.C. Hays, the pastor of the First Presbyterian Church downtown, was Johnstown's leading Protestant preacher. On the first Sunday after the strike began, Hays referred to Foster's "Syndicalism" in his sermon:

Having read the book, I would be a coward and a criminal myself if I did not stand up and expose it…What the Syndicalist proposes, he says, is the overthrow of capitalism and the reorganization of society.

Hayes went on to suggest that Foster was cleverly using the strikers to achieve his sinister purposes.

The following Sunday, October 5, Bishop Eugene Garvey of the Johnstown-Altoona Diocese delivered a sermon against the strike. "Increase production, save your money, spend reasonably," he urged.

Father Bronislaus Dembinski of Saint Casimir's Catholic Church, a legendary Cambria City parish priest, spoke unrelentingly against the strike, which he said was German and Bolshevik propaganda. Thomas Conboy was especially disdainful of "the Polish priest," and told strikers that Dembinski personally owned stock in Cambria Steel and was organizing churchmen to promote strikers returning to work.[588]

In early October, the Senate Labor Committee began hearings in Washington on the steel strike. The committee explored Foster's IWW-syndicalist past and sought Foster's rejection

of his 1911 views. Foster's response was that he was working within the AFL organization and had never strayed from its principles. He never, however, recanted "Syndicalism."

The whole business of Foster's earlier ties to radical causes and ideologies was front-page material in Johnstown newspapers. Foster was a "lightning rod."

Cracks in the Crystal

Cambria Steel's strategy during the strike was to close down, wait it out and resume steelmaking when enough workers to justify feasible operations decided to return. The scene was peaceful. There were no strikebreakers or picketing confrontations.

There were indications that the strike effort in Johnstown was falling apart by the middle of October. Strikers were denied the benefits they were seeking. A few strikers protested by tearing up their union cards. The Moulder Union decided to pay benefits to its members. Conboy objected. Since there were inadequate funds to pay benefits to all strikers, the Moulder action was creating morale problems and dissention.[589]

In addition, workers at U.S. Steel's Lorain plant at Moxham and the two nearby radiator companies were working despite continuing efforts by Conboy to shut them down. Conboy was exhorting union members at the Labor Temple to "stand firm," because good things would come out of the Washington conference that had started October 6. Everyone knew Judge Gary was opposed to arbitration, however, and with Woodrow Wilson recuperating from a stroke, the conference seemed unpromising.

Rumors began to circulate among the strikers that an inside organization was forming to arrange a special settlement with Cambria Steel. Conboy emphatically denied a rumor that men were returning to work.

On October 24 it was announced that the company was opening an employment office to sign up men to resume work. Notices were being posted at mill gates and other places telling of the office location and hours and announcing that operations would begin when sufficient workers had enrolled.[590]

On Tuesday, October 28, William Z. Foster told the overall strike committee at a Pittsburgh meeting that the critical need to keep the strike alive was money. "It's a joke the way the internationals are responding to demands for money." Foster expressed concern that his free-food commissaries would dry up without big money.[591]

The Citizens' Committee of Johnstown

Sensing the time was right, a number of business and professional Johnstowners sponsored and signed a full-page advertisement appearing in city newspapers on October 30 and November 1, 1919. Addressed to "You Men of Mills and Mines," it was signed by 259 individuals. The Johnstown Chamber of Commerce had coordinated the effort, although its name was not on the notice.

Each ad contained three blank "coupons" for workers to sign stating they wanted to work. They could be mailed without postage. Since there was no address given, it seems clear that postal authorities were siding with the committee and the steel company.

The *Johnstown Democrat* reported that people were eagerly filling in the coupons at the Labor Temple immediately upon publication, a statement probably true because the *Democrat*'s strike reporting generally comports to pro-labor accounts.

On November 1, the general strike committee published a counter advertisement of its own addressed to the "Citizens' Committee and to the Public." It stated that "recognition of the right of individuals to affiliate with any organization they may see fit is the prime issue." The ad took exception to the statement of the citizens' committee that local industries favor the open shop. The ad stated, "Hundreds of workers lost their jobs simply because they joined trade unions." The statement was made that Cambria Steel sought shops "closed to union men."

On November 2, about six hundred Cambria steelworkers attended a controlled rally at the Cambria Theater. Admission was by ticket, and the tickets were carefully distributed to prevent agitators from entering and disrupting the meeting. The principal speaker was Rev. A.F. Campbell, a Methodist clergyman from Connecticut who stated he was once a Moulder Union member. The organizer and chairman of the meeting was W.R. Lunk. Lunk claimed he had been asked to arrange the meeting by steelworkers seeking to work.[592] There was an underlying assumption at the meeting, neither proved nor disproved, that a large majority of the striking workers did want to work but strike leaders were intimidating them.

How Dr. Campbell was chosen to keynote the rally is not known. He began his remarks with a statement that if three hundred men marched to work, the strike would be over. He could see a "return-to-work" spirit on the faces of those assembled. "Coming down to the test, the workers need only one man to help them—the mayor." Campbell suggested that the mayor and the police "escort certain undesirables to the edge of town. Then let Fred Corey blow his whistles and everybody go to work."

Mayor Louis Franke was in attendance. His posture was neutrality toward the strike but he repeated what he had said before, "Individuals' right to work if they wished to do so, would be maintained in Johnstown."

It was said there were many wishing to attend the Cambria Theater meeting who could not get inside. Some were probably strike supporters. No pro-strike statements or demonstrations were made at the meeting.

The Foster Expulsion

Strike organizers were now on the defensive. On Friday, November 7, the *Johnstown Tribune* wrote of strike leaders urging their followers to "stick it out until they gain their demands." The article included an earlier announcement that William Foster would be in Johnstown to make a three o'clock speech and continue to New York for a fundraising rally.[593]

When Foster arrived that afternoon, he gave no speech. He was forced to leave town instead. Exactly how this happened may never be known. Foster's version was that during his stopover in Johnstown, while walking to the Labor Temple, two reporters told him he was in danger and should leave town because a "citizens' committee" and company officials were conspiring to expel all organizers from Johnstown. Next,

detectives stopped him on the street. Foster stated he was told, "It would be at the risk of my life to take a step nearer the meeting place. I demanded protection, but it was not forthcoming." Later Foster wrote:

> In the meantime, Secretary Conboy arriving upon the scene, the two of us started to the Mayor's Office to protest, when suddenly in broad daylight, at a main street corner…a mob of about forty men rushed us. Shouldering me away from Mr. Conboy, they stuck guns against my ribs and took me to the depot…Later I was put on an eastbound train.[594]

The account in the *Tribune* on November 8 was more subdued: Foster had arrived at 2:04 p.m. Friday to give a 3:00 p.m. talk at the Labor Temple. He was told that a "body of citizens had reached the conclusion that Johnstown men could handle their own affairs without assistance." Foster was said to have "lunched at a restaurant…and a few minutes later was escorted to the depot."[595]

On Monday, November 10, the *Johnstown Democrat* described Foster's Madison Square Garden rally. Correctly or incorrectly, the article referred to Foster's telling of his forced eviction from Johnstown as an "embellishment," but stated that the episode had given him what he needed to raise huge sums of money. After telling his story, Foster shouted, "What are you going to do about it?" The article stated, "Basins were spilling over [with money] and derby hats were rushed into the breach." Foster was reported to have collected $103,000 in cash and $315,000 in pledges.[596]

Thomas Conboy remained in Johnstown, "in hiding." He wrote messages from "somewhere in Johnstown" to the strikers urging them to stay loyal to the strike cause, but not to break the law "as the citizens' committee had done."[597]

In addition to William Lunk, Conboy expressed special disdain for three other members of the citizens' committee—Harry Tredennick, Phillip Price and George Robinson.[598]

On November 11, a petition signed by the local strike committee was sent to the Johnstown City Council. The "whereas clauses" told that the citizens' committee had been practicing mob rule and the mayor and chief of police were not protecting the public against violence. The petition sought the city council to direct the mayor and chief of police to enforce the law and protect the rights of all citizens, including strike organizers.

Work Resumes

The very next day, Cambria Steel officials announced that enough workers had agreed to return to work for the company to resume operations on Monday, November 17. According to a company spokesman, on one day alone—November 12—about one thousand men had signed up.[599]

From out of nowhere a unit of the Pennsylvania Constabulary, a horse-mounted cadre of the Pennsylvania State Police especially trained in crowd control, appeared in Johnstown as it had done at critical times in other striking cities. Strikers dubbed the constabulary "Cossacks." Its ranks could be brutal but effective. Mayor Franke announced publicly that the city government had not sought them.

Late Sunday afternoon, November 16, a "street demonstration" in Cambria City turned violent. The constabulary rushed in. A reporter chronicled, "The well-trained horses gave exhibitions of how to break up groups of men." Michael Bosko, suffering a head wound needing stitches, was arrested. Bricks were thrown from the Fifth Street Bridge. Crowds were told to go home.[600]

The next day, the whistles sounded and work resumed. The *Johnstown Tribune* reported, "Approximately 8,000 are back on their jobs today and others are awaiting calls from their foremen." It was said that the returning workers were unmolested, and there were few reports of returning men being threatened. The police presence was strong. About twenty armed pickets and loiterers were arrested.

Johnstown press accounts would lead their readers to believe the strike was over. In addition to the *Tribune* and the *Democrat*, the *Johnstown Leader* announced on November 18, "The strike is broken."[601] A researcher for the Interchurch World Movement disputed the claim. With no documentation, he reported the company had attracted only one-tenth the usual workforce and had not made a successful start.

As the week passed, workers increasingly reported. While there were loyal holdouts, the Johnstown strike was over. The strike collapsed in other locations about the same time as it was failing in Johnstown. On Monday, November 24, the National Committee for Organizing Iron and Steelworkers reviewed the situations in each community. While the committee agreed to continue, it wanted a face-saving way out. The members decided to ask the Interchurch World Movement, already doing a study of the strike, to mediate. Its leaders agreed.

On December 5, Bishop Francis J. McConnell, Dr. Daniel Poling and Dr. John McDowell met for over two hours with Judge Elbert Gary, chairman of U.S. Steel. Nothing was accomplished. Gary concluded with, "There is absolutely no issue."

On January 8, 1920, a telegram went out from the National Strike Committee: "All steelworkers are now at liberty to return to work pending preparations for the next big organization movement."

Johnstown Insights

The 1919 steel strike has been written about extensively both nationally and in Johnstown. During the strike itself, an evaluation got underway by the Commission of Inquiry of the Interchurch World Movement. The study was biased in favor of the AFL strike effort. Some staff members were close personal friends with William Z. Foster, for example. Reviewing steelworker interview statements from Johnstown, the staff rejected anti-strike sentiments and focused on pro-AFL union statements.

A researcher named Marshall Olds and the accounting firm of Haskins and Sells critiqued the work of the Interchurch World Movement and successfully destroyed it analytically. Marshall Olds, however, offered nothing in its place. There is also no explanation of what prompted Olds's analysis or how it was financed. One suspects Elbert Gary.[602]

The Johnstown experiences during the strike were different from those of other steel centers in several respects:

- The Cambria Steel Company closed down. The work stoppage was a strike and a lockout. No one crossed picket lines. There were no strikebreakers.
- Steelworkers and labor leaders were free to assemble at the Labor Temple and other places, a contrast with other strike locations, especially in and around Pittsburgh.
- Mayor Louis Franke took a posture of neutrality and vowed to protect the rights and safety of everyone.
- Johnstown business and professional leaders and some clergy organized a pro-corporation, anti-strike citizens' committee, which violated the legal rights of labor organizers. The degree to which there were excesses cannot be proven unless one accepts the version of William Z. Foster as unexaggerated truth.
- In Johnstown, the senior and skilled workers were inclined to return to work, whereas the less skilled and the foreigners were more likely to remain on strike.
- Black strikebreakers were not used in Johnstown.

Foster

The most fascinating personality in the strike was William Z. Foster, its key initiator. Foster visited Johnstown several times both during and after the strike. He was helping to form the American Communist Party from disparate radical groups in late 1919 even during the strike itself, although in its latter phases. He visited Moscow in 1920, met with Lenin and Trotsky, and returned to the United States even more convinced that Communism was in the future and that he personally would have a major leadership role.

William Foster ran for president of the United States on the Communist ticket in 1924, 1928 and 1932. He remained a loyal Communist through many events that caused more idealistic members to defect—the purges, the Trotsky murder, the Nazi-Soviet Pact, the Russo-Finnish War and the 1956 Soviet repression in Hungary and Czechoslovakia. Foster died in Moscow on September 1, 1961, at the age of eighty-one. Nikita Khrushchev visited him before his death.[603]

THE GREAT DEPRESSION

I. THINGS AIN'T LIKE THEY USED TO BE

Stock values plummeted on October 3, 1929, a drop followed by choppy sessions, more down than up. On October 29, frightened investors dumped over sixteen million shares in a selling frenzy. The market had crashed.

Bethlehem's Charles Schwab and James Farrell, chairman of U.S. Steel, both made optimistic statements. Throughout 1929, steel markets had been strong and Bethlehem had a $60 million order backlog.

The *Johnstown Tribune*, upbeat and civic, editorialized that there need be no panic or recession:

> *But we still believe that those billions were represented by paper profits...The crash will in the long run prove a help to general business. The mills are still working.*[604]

In January 1930, the *Tribune* published another bullish editorial stating that the nation's steel industry was operating at 67 percent, double the 30 percent of late 1929.[605] It concluded, "In every likelihood these upward trends in business will be continued. The business depression appears to be behind."In early 1930, increased production in Bethlehem's mills boosted Johnstown's economy and optimism. The corporation had almost $60 million in orders by June 30, slightly more than in mid-1929. In early 1930, no relief measures were proposed in Johnstown. Pessimism was considered a deterrent to an eagerly awaited upturn. Optimism was stoked by steel industry good news.[606]

In March it was announced that the part of the Johnstown municipal tax base derived from assessments on the value of occupations had dropped significantly. Many men were seeking work elsewhere. Fewer women were working in local shops.[607]

A Changed Posture

The stock market continued sagging throughout 1930. Unemployment, business slowdown and attendant ills moved into Johnstown like an enveloping fog. The community's earlier reaction had been avoidance and negation. Good news had been emphasized and exaggerated. Bad news was shunned.

Then, and almost at once—around the fall of 1930—almost everyone readily acknowledged that Johnstown was in the midst of a grave depression, one deeper and more serious than the Panic of 1907 or the postwar recession of 1921.

The community's attitude and approach quickly changed. A new posture of problem acknowledgement and civic mitigation took root. The community reformed itself by developing new organizations and programs to replace an inadequate institutional framework. People readily acknowledged that prices had hit new lows. Car sales had nearly ceased. Shortly after the summer recess, the school district undertook a survey to determine how many parents of public and parochial pupils were unemployed. The count, 648, was believed to be well below the true number.

"None of our employees will become public charges," an unnamed Lorain official announced. An employee family organization, the Good Fellowship Club, assumed responsibility for Lorain's employee relief in Johnstown. There was similar paternalism at Bethlehem's Cambria Works. The personnel department surveyed the general condition and needs of fourteen thousand workers and their families. Having just taken over Iron Street through the Lower Works, the management announced that any employee needing firewood could take it from the fence that had separated the street from the mill itself. In less than two hours the fence had vanished. Bethlehem then devised four firewood distribution sites for employees and families.

A Bethlehem Relief Committee made up of five superintendents and five workmen was formed to identify and mitigate case situations, whether the solution called for more work, moratoriums on payments for company-owned housing, or similar help. Like Lorain Steel, Bethlehem altered its personnel assignments so that at least one employee in each family was working.

Mayor O. Webster Saylor, appointed to complete Joe Cauffiel's term,[608] established an Emergency Relief Committee for the city and, as things turned out, for suburban areas as well. The mayor served as honorary chairman but the working chairman was Reverend W.K. Anderson. The executive committee included business, media and civic leaders such as Nelson Elsasser, Harry Cramer, Harry Hesselbein, Hiram Andrews and David Glosser. The committee sought to coordinate relief activities in and around the city and to work against fraudulent charities.

The group first met on Friday, November 21, 1930, and again the next Monday, when the staffs of social welfare agencies joined them. Plans were developed for a unified application form for all relief requests. Relief programs were to function smoothly among several organizations—the Associated Charities concept revived.[609]

The relief committee's office was on the fifth floor of the Public Safety Building. The client files of the Social Services Exchange, a central clearinghouse, had been moved to the new office. By its December 3 opening, the Emergency Relief Committee had raised

$1,200, mostly from employee contributions. On its first day there were 156 applications for help. By January 12, there were 1,154. The contributions given to the committee began slowing down as payments for relief were increasing. The committee's needs exceeded its funds, and first-time recipients were returning for more aid.

Councilman George Griffith, responsible for streets and public improvements, suggested that able-bodied relief recipients with families work on both a seven-hundred-foot section of sanitary sewer in Moxham, and on the reconstruction of Osborne Street, so that public dollars could pay for crisis relief.

It was soon evident that the Emergency Relief Committee's program had been evolving from emergency handouts into a relief program. The former was marginally useful. The latter, beyond its resources, triggered a program conflict with the Cambria County Poor Board, responsible for on-going charity including work relief. Despite an effort to establish a coordinated program between the committee and the poor board, the committee effort was becoming ineffective.[610]

Reds and Radicals

In February 1931, a small group of radicals led by Tom Rogers from Portage staged a demonstration outside city hall. Police ordered them to move. They refused. Fifteen were arrested for disorderly conduct. Fearing mob violence, a large number of policemen were on duty.

Two weeks later, William Z. Foster returned to Johnstown to speak at a rally scheduled at Point Stadium by the Council of Unemployed of Johnstown, of which Tom Rogers was a "section organizer." Having left the AFL, Foster was serving as executive secretary of the Trade Union Unity League, an affiliate of the Russian Communist Party. A crowd of five hundred heard Foster claim that Soviet Communism was the future.[611]

Work Relief

In early 1931, the relief focus sought to boost employment. An employment committee was organized to work with the Emergency Relief Committee. The general idea was to create work often through public projects but also to encourage employers to share what work there was among more workers.

By late January some men were actually working on the Moxham sewer job, improving Osborne Street and constructing the channel walls along Sams Run in Moxham.

The Canning Kitchen

An affiliated activity of the Emergency Relief Committee was the "canning kitchen," sponsored by the Food Committee for the Needy headed by Mrs. Johnson Symons. There were many volunteers, as well as technical and equipment help from Dale McMaster with the vocational department at Johnstown High School, and the off-hour use of the facilities of the Ferguson Packing Company in Cambria City. Farmers donated surplus food. Two tons of sugar were also donated, along with thousands of cans and bottles.

Mrs. Symons and her volunteer helpers canned and otherwise preserved thousands of units of sauerkraut, apple butter, beets and other foods. The rations were distributed to the needy during the 1931–32 winter. The canning kitchen was continued the next year.[612]

The Community Chest

In addition to various efforts, Mayor Saylor's Emergency Relief Committee members were the civic leaders who, in July 1931, founded the Community Chest, the culmination of an idea long advocated by the chamber of commerce. The Community Chest would conduct one single fund drive per year to finance several charities. Once organized and functioning, the new organization was intended to supplant but continue the Emergency Relief Committee's work. This role transfer occurred formally on November 1.

Meanwhile, the new organization launched its first fund drive, an effort to raise $250,000. Being a new activity in uncertain times, its leaders had no history to guide a realistic goal. Despite media support, a large volunteer committee and a lead-off contribution of $6,000 from John Waters, the drive fell short. By late November, however, 8,800 people had pledged $181,000, a massive sum for Depression-era Johnstown.[613]

Pinchot's Rural Road Program

Gifford Pinchot's second administration as governor began in January 1931. One of his campaign promises had been rural road building—"to get the farmers out of the mud." Pinchot was also seeking a subsistence wage for thousands of otherwise unemployed workers.

In Cambria County, the state highway department organized many destitute workmen into three shifts, each with two ten-hour days per week. Over six working days, three different sets of men each worked twenty hours. At forty cents an hour, each man earned eight dollars a week.[614]

There was little engineering involved in the road buliding. The narrow roads were made from nearby stones and simple materials. Employment was through patronage and relief-agency referral. The numbers of people subsisting on this proto-WPA program were enormous. It was said that there were more people working on the Pinchot rural road program in Cambria County than had worked for Bethlehem's Johnstown mills during flush times.

II. CHALLENGE TO THE OLD ORDER

No one can understand how awful it [the Great Depression] *was unless he had been there and had seen and felt it. The whole thing was horrible—beyond description.*
Andrew Gleason Sr.—Attorney, Johnstown, Pennsylvania

When anxiety, fear and hopelessness sweep through a social order, the institutional framework and leadership is often undermined, and its constituency may become incapable of facing reality. Anger and hatred, by-products of fear and hopelessness, may consume the group.

A rebellious personality often emerges who defies those in authority with sensational accusations, offbeat proposals and exaggeration. Such a challenger directs societal hostility against civic institutions and their leadership.

The Great Depression produced a number of spellbinding personalities who fit the mold of anger exploitation, rebellion and belligerency. Like a new artistic style, cult movement, fashion or dance craze, demagoguery was rampant during the Depression.

"Red"

Edward John "Eddie" McCloskey, the one-of-a kind personality who became mayor in 1932, fits the mold of a Depression-age demagogue. Born in 1890 to Irish parents in the Prospect section of Johnstown, McCloskey dropped out of school at an early age to work in the Cambria mills. He became a machinist. The circumstances of his leaving Cambria Steel are not known, but he harbored a lifelong bitterness toward the corporation.

By 1910, McCloskey had become a prizefighter, a bantamweight fighting as "Red" McCloskey. He was well known in Johnstown, other Pennsylvania cities especially Pittsburgh, and even at Windsor, Ontario. In 1911, during a trip to the Detroit area, he worked as a machinist in an automobile plant and road-tested Packards.

When home for Christmas in 1912, McCloskey signed up to fight a promising local boxer named "Kid" Macher. In what became his last bout, McCloskey won by knockout and gained a prize of $1,300. With this money, plus other savings, he bought a three-car taxicab company from Wess Hostermann. McCloskey and his brother, Hugh, were the usual drivers. In addition to conventional taxicab service, McCloskey sought to evolve his business into a chauffeur–car pool and serve a number of prominent downtown individuals.

In 1914, McCloskey decided the taxicab business was not profitable. He sold out to launch the McCloskey Company, a laundry and dry cleaning establishment located at the family homestead in Prospect. In April 1920, another outlet was started on Market Street downtown. McCloskey and his wife, Irene, operated the company until 1935.

Possibly looking ahead to a mayoral campaign, McCloskey started a sensationalist, anti-establishment newspaper in 1929 called the *Derby*." Ostensibly a monthly publication, indications are that it came out on no predictable timetable. McCloskey assumed the printing costs personally. Young boys who distributed it were allowed to keep the five cents charged for each copy. Unemployed people were offered the *Derby* free. From the few surviving copies plus news items and other sources, a general idea of Eddie McCloskey's credo can be constructed. McCloskey saw Johnstown as a town dominated by Bethlehem (Cambria) Steel, and that the city's business elite would readily subordinate itself to the wishes and needs of the Bethlehem Company. He felt that the city government (most but not all city officials), the two daily newspapers, the chamber of commerce (called by McCloskey the "chamber of comics" and "chamber of come worse") each played roles in this steel-mill, business-elite complex.

According to McCloskey, the Johnstown business elite trampled on the rights of laboring classes and the poor and helpless in pursuit of power and greed. Public utilities were seen as especially greedy—the Public Service Commission was being controlled by the utilities it should be regulating; the Johnstown Water Company was seen as an appendage of the

Bethlehem Steel Company; and the gas company pumped gas that is "half air." McCloskey also believed that city police were being paid off to protect liquor, gambling and vice.

In McCloskey's view, Walter Krebs, owner-publisher of the *Tribune*, conspired with Hiram Andrews, managing editor of the *Johnstown Democrat*, to "steal" the *Democrat* from the heirs the late W.W. Bailey (principally Mrs. Georgia Bailey).[615] After the Krebs "takeover," McCloskey saw no difference between the *Democrat* and the *Tribune*.

And finally, one of McCloskey's guiding principles: "Franklin Roosevelt is a great man. He will be a great president."

Eddie McCloskey depicted himself as the people's man; a fighter willing to expose evil and stick up for the weak and powerless against a greedy, powerful, elitist cabal. He also stated that he might be assassinated. To his credit, there were traces of truth in much of what he said and wrote.[616]

From Candidate to Mayor

On March 13, 1931, the Pennsylvania Legislature's Utility Investigating Committee began exploring utility regulation reform. Eddie McCloskey showed up and began talking about Johnstown's being under the Bethlehem Steel Company's yoke. This was judged relevant to the committee agenda because of Bethlehem's control of the Johnstown Water Company.

As the discussion proceeded, McCloskey boasted that ex-Mayor Joseph Cauffiel's arrest and conviction resulted from his (McCloskey's) work and urged the committee to send an investigator to Johnstown to work with him. At this same hearing, Father James Cox, a social-activist priest from Pittsburgh, was attending—the first time Cox and McCloskey met one another.[617]

In the November election for mayor, Eddie McCloskey, a Democrat, defeated the incumbent Webster Saylor by 8,162 to 6,770, a hefty majority given the Republican registration advantage in Johnstown. McCloskey's campaign had been free from newspaper ads. He was well known and popular. He had also promised to clean up vice and gambling by firing Police Chief Charles Briney. While not a prohibitionist, everyone knew that McCloskey never touched beer or alcohol.

Cauffiel's Farewell Performance

On December 30, 1931, five days before McCloskey was to take office, and precisely two years after he had first begun serving his two-year sentence, Joseph Cauffiel was finally given the pardon he had been seeking from Governor Gifford Pinchot. He had been paroled several months earlier, partly for good behavior but chiefly because he was gravely ill with cancer.

When he got the pardon, Cauffiel went to city hall with an attorney and began a fruitless effort to be reinstated as mayor. He announced that Briney was no longer police chief and that all vouchers needed his (Cauffiel's) signature to be valid. Cauffiel was bluffing that Pinchot's pardon had somehow restored his incumbency for the remainder of what had once been the term.

Knowing Cauffiel's claim was specious and there was insufficient time to adjudicate a case, even if the ex-mayor could find an avenue to generate one, the lame duck council instructed everyone to ignore Cauffiel.

There was, however, some commotion at McCloskey's January 4 inauguration, specifically the traditional "turning over city hall keys" from the outgoing mayor to the new one. Arrangements had been made for this to take place at the Market Street entrance to city hall. For whatever reason, Webster Saylor was not around. Cauffiel brashly intruded into the ceremony. Announcing, "I never really gave these up," he handed some keys to McCloskey in a gesture that ended one flamboyant career at the beginning of another.[618]

The Hunger March

A few days before their inauguration, McCloskey and James McKee, the city treasurer-elect, went to Pittsburgh for a meeting with Father James Cox about a forthcoming hunger march Cox was organizing. McCloskey wanted the Washington-bound marchers to pass through Johnstown for a local rally and to afford Johnstowners a way to join.

The day following McCloskey's inauguration and ball, trucks and cars by the hundreds began jamming through Johnstown. A rally was held at Point Stadium. Cox and McCloskey both spoke. Cox's message was that there existed "plenty of money" in the country but it was in the wrong hands. "President Hoover is still trying to give money to the bankers, but none to the people," he bemoaned, referring to the Reconstruction Finance Corporation. "The government sent Al Capone to jail for cheating it of $100,000, yet John Rockefeller is giving $4 million to his son to escape the inheritance tax." Cox's speech, a restatement of Huey Long's "share the wealth" themes, included praise for Mayor McCloskey.

The hunger march not only created a traffic jam in Johnstown, it also exhausted the Salvation Army's food fund, inasmuch as the group felt an obligation to feed the out of towners. Helen Price, the late Charles Price's daughter, reimbursed the Salvation Army for its generosity. McCloskey's bringing countless marchers to town, however, unnerved local citizens.[619]

Mayor

As soon as McCloskey took office, tensions began mounting between the mayor and the other four councilmen. From the outset, McCloskey had insisted upon Police Chief Briney's immediate demotion. The council refused, claiming Briney first must have a hearing.

McCloskey countered that his mayoral platform had emphasized dismissing Briney, and his own election majority had made Briney's demotion a mandate. The council refused, and McCloskey announced he would not consider anything else—even budgets—until Briney was no longer chief. "I will not look at your budgets…until we settle the matter about the chief of police."

Refusing to sign Briney's pay warrant, McCloskey suspended him for ten days. When the suspension was over, Briney was suspended for ten more days, a violation of law. By early February, Briney was seeking a mandamus to compel McCloskey to sign his pay warrant. At the hearing, McCloskey began arguing with Judge John McCann, who threatened the

mayor with contempt. Eventually the judge ordered his tipstaff to remove McCloskey from the courtroom.[620]

McCloskey insisted everything be done in open sessions, and the chamber was repeatedly packed with hordes of supporters. Council meetings were becoming unruly mob gatherings. On one occasion, after the mayor had been arguing with a councilman, someone offered to the mayor that if he said so, "We'll take 'em out for a ride and they won't come back." On a similar occasion, McCloskey offered some advice, "Go easy. Those cops out there are just waiting to bust you over the head. Wait 'til we can get rid of them."

McCloskey attracted attention and letters from all over the nation with his sidewalk-construction plan, a public works program to hire unemployed persons building sidewalks.

If there were a redeeming side to McCloskey, especially during his early weeks as mayor, it was not reported in the local press. Hiram Andrews, editor of the *Democrat*, had some good words to say about the mayor at the beginning of his administration, but a rift soon developed between them. The *Tribune* repeatedly depicted McCloskey as an irresponsible rabble rouser. McCloskey, in turn, often disparaged "Doobey" Krebs.

Addressing the previous day's city council meeting, the *Tribune* on February 10, 1932, editorialized:

> *Council...accomplished just exactly nothing...There were a number of important things to be taken up including authorization for the sale of $200,000 worth of bonds for work on the sanitary system...to give employment to...men who are now idle.*

On February 23, things hit a new low. The council session consumed seven hours: two in the morning and five that afternoon. McCloskey had sought to hire a John Pernau to serve both as marketmaster and a sort of "secretary watchdog" for him. Other councilmen were opposed. Nothing was accomplished all day.

While one might easily accuse the *Tribune* of exaggeration to blemish McCloskey and his claque, the May 5 editorial speaks for itself:

> *Government by vituperation seems to be the newest order...in city affairs. The mayor's exhibition yesterday at, and following the council meeting violated all common decencies. Cursing, the use of gutter epithets, vilification in unprintable language, attacks on members of council and members of the courts of Cambria County in the jargon of the alleys, appeals to the mob spirit which came close to inciting to riot.*[621]

McCloskey had developed another bizarre practice—midnight rides to release prisoners from jail. Early the morning of May 18, 1932, three runaway Pittsburgh boys were being held at the Public Safety Building. Pittsburgh police had requested Chief Briney hold them until Jewish Big Brother Club members retrieved them.

At about one o'clock that morning, McCloskey ordered the youths driven out onto the Menoher Highway and dropped off. He personally was in the vehicle. McCloskey's explanation was that the boys had hitchhiked to Johnstown. He was merely taking them to a spot where they might hitchhike back.[622]

Further inquiry uncovered an ongoing practice of McCloskey's ordering certain prisoners to be released from jail after midnight. They were then driven to remote spots and let go. In most cases the prisoners had been drunks or vagrants. Some got taken almost to Ligonier. On May 13, in the early darkness, ten men were removed from their jail cells and were let go, one by one, at locations along the Somerset Pike.

III. THE BONUS EXPEDITIONARY FORCE'S SOJOURN IN JOHNSTOWN

Early in 1932, a group of unemployed war veterans got solidly behind a bill pending in Congress that would have authorized an earlier payment of a bonus to war veterans than the 1945 date established by law. Enactment would help impoverished veterans cope with unemployment. A group of them organized as the Bonus Expeditionary Force (BEF) and began planning a "march on Washington" to support passage of the bill. The movement caught on nationwide. One of the founders, ex-Sergeant W.W. Waters, was chosen commander of the BEF.

By May thousands of veterans and their families, plus a number of radical infiltrators, had arrived in Washington, vowing to remain until their demand was met. Every state was represented. While many members departed before the group's eventual dispersal, most remained. Many fashioned makeshift shelters in Anacostia Flats in southeast Washington, while others moved into otherwise empty buildings on Pennsylvania Avenue. Waters's staff developed an unduplicated count of 22,574 BEF and family members present in Washington on July 16, 1932.

Congressman Wright Patman's bill (supported by the BEF) was defeated in the Senate on June 17. President Herbert Hoover next managed to get an appropriation of $100,000 to pay for the group's return to their homes. Most remained in Washington in hopes of a reversal of the decision.

In time, many BEF members had been forcibly evicted from the once-vacant buildings on Pennsylvania Avenue. Later, General Douglas MacArthur, army chief of staff, and two upcoming officers—Dwight Eisenhower and George Patton—undertook a harsh eviction from Anacostia Flats. MacArthur went beyond the more circumscribed orders of President Hoover and used tanks, tear gas and flames to destroy BEF shanties and personal belongings. Hapless and embittered, the remaining BEF members began to regroup, locate what they could of their meager possessions and move on. The forced eviction occurred on July 28, 1932.

Camp McCloskey

Many BEF members wanted to stick together to renew their demand for the earlier bonus payment. If they could not remain in Washington, there was a general plan to regroup elsewhere for another demonstration. Although he had never served in the military, Eddie McCloskey had a special interest in the BEF.

In his book, *BEF: The Whole Story of the Bonus Army*, its commander W.W. Waters stated:

> *Among the many ambitious gentlemen attracted by the potential power and publicity value*
> *latent in the BEF ranks was Mayor Eddie McCloskey of Johnstown, PA. A week or so*
> *before the eviction, he had come to Washington and had made a fiery speech about the Bonus*
> *and patriotism to the men of the BEF. In an unguarded moment, he had inadvertently said:*
> *"If ever you are driven out of Washington, there will be a place for you in Johnstown."*

Waters stated that he directed a telephone call to the mayor to make certain the Johnstown proposal still stood. McCloskey reaffirmed his offer. Soon BEF members were en route to Johnstown. Their destination was well known. The governors of the states through which BEF members were moving hastened their through-passage into the next state—preventing their turning back, and denying any stopping within that state. Pennsylvania Governor Pinchot instructed the state police to keep the BEF in motion and to stop any treks toward Johnstown. Police command posts were easily outmaneuvered. BEF members arrived between July 29 and August 1, 1932.[623]

It did not take long for the news of McCloskey's invitation and the BEF's acceptance to reach the citizens of Johnstown. A negative reaction was instantaneous. People were asking: Where will these people be placed? Who will feed them? When they get sick, which physicians or hospitals will care for them? Johnstown's citizens were already being visited by hobos begging for food, clothes and odd jobs. McCloskey was blamed for attracting masses of them.

Confronted with solid hostility, McCloskey announced he had not really invited the BEF and their families—only its leaders. Regardless of whether McCloskey's invitation had been misunderstood or his explanation was face-saving fiction, the marchers were soon pouring into Ideal Park, where someone had arranged to establish a camp.

A BEF camp staff was quickly established. Spaces for tents and vehicles were assigned in orderly fashion. The BEF had its own military-police unit. Campers were promised that tents and blankets, said to have been gifts from generous Maryland supporters, were on their way by truck. As it turned out, this materiel was actually National Guard property shipped, unauthorized, by supporting guardsmen.

The *Tribune*, intransigently hostile to McCloskey, began an editorial attack:

> *An invitation, official or otherwise, to the Bonus Expeditionary Force now encamped at*
> *Washington, to make this city its headquarters is unfair to the unemployed of Johnstown, to*
> *the welfare agencies, to the Poor Board, to the taxpayers, and to the thousands who are making*
> *contributions to local relief.*

The next day, Saturday, the *Tribune* published two more editorials.

> *The issue is squarely up to the Mayor. Because of his action…the city is faced with a most*
> *serious burden, a burden entirely unjustified and unwelcome to the entire community.*

When news of the BEF's sojourn first became known, neighborhood civic clubs around town began convening, drafting protests against McCloskey and "Uncle Dan" Schnabel, the amiable automobile dealer and city councilman who had visited the Anacostia Flats site voicing support for the BEF's cause. Neighborhood clubs in Minersville, Prospect, Oakhurst and Coopersdale began expressing a need for a local militia, while rebuking the mayor. A special meeting of city council was held on Saturday, July 30. Councilmen had doubts whether there were adequate policemen available to handle the encampment.[624]

McCloskey's posture was, "We don't need any policemen for these fellows, but for those cops of ours…It's my department and I'll handle it." McCloskey then publicly rebuked the police department for failing to enforce the liquor laws.

Meanwhile, a *Tribune* reporter visited Ideal Park and reported a "happy scene." People were sleeping in cars and on picnic tables and bleachers. Children were enjoying the merry-go-round and other amusements. BEF officers were described as well organized and managing the camp efficiently.

A young Malcolm Cowley, a Belsano native and at the time a leftist reporter for the *New Republic*, also visited the encampment. He found bitter men and women talking revolution and violence. "Give me a gun and I'll go back to Washington," he quoted someone as saying. Cowley wrote that another person had shouted, "Hoover must die."[625]

Interestingly, the BEF had its own ways of addressing internal problems. Twelve alleged Communists, having refused to swear allegiance to the American flag and the Constitution, were expelled from Ideal Park on July 31. "We want no Communists or 'reds' in our organization. They started the trouble in Washington," someone told a reporter.

Father James Cox showed up to speak for his Jobless Party but was booed down.

On Sunday, July 31, W.W. Waters flew to Johnstown in a BEF airplane for a firsthand inspection. This was also a time when the group desperately needed to decide its future. Waters found McCloskey uneasy and eager for the Bonus Army to leave. The mayor was described as promising everything anyone wanted, especially food. Waters wrote, "McCloskey was speaking at every given chance," and quoted him as saying, "God sent you to Johnstown! There will be a day when a million men will march on Washington to take over the government!" Waters wrote that BEF campers had become numb to exhortations and promises. People were yelling at McCloskey, "When do we eat?" Some of his talks were being greeted with boos, a stinging rebuke to a crowd-swaying mayor. Ideal Park was also being called "Camp McCloskey."

The Exodus

Even before his trip to Johnstown on Sunday, Waters knew he was heading a movement that was falling apart. The BEF faithful had limited food, no money, no jobs and little hope. He discovered that Doak Carter, his own chief of staff, was holding up in the comfort of a Johnstown hotel. The community, unable to feed and care for the BEF, wanted them gone.

Johnstown's establishment leadership was understandably focused on two major concerns: preventing ills to the community—disease, crime and disorder—and getting the BEF campers (known as "khaki shirts") to leave peacefully and quickly.

Dr. George Hay, president of the Cambria County Medical Society, had organized a group of ex-military doctors to stand shifts at Ideal Park for medical care and disease prevention. Several members of the BEF, still suffering from tear gas in Washington, were hospitalized. There was one confirmed typhoid case.

The problem of providing food was also a major issue. The population at Ideal Park continued increasing through August 1. Adequate rations were not on hand. Ironically, if sufficient food were available, the BEF might have had no departure incentive. There had been food donations to the BEF when they were situated in Washington, which had come from National Guard stocks as well as from sympathetic food suppliers. BEF staff at Ideal Park did receive a few truckloads of "bags of beans, onions, cabbage, canned goods, bread, and the like." Some well-meaning person or group set about distributing sandwiches at a refreshment stand. Two children developed ptomaine poisoning and were taken to Mercy Hospital.

Whatever the food situation, the crowd estimate had reached five thousand by Monday, August 1. Food stocks were dwindling and BEF members and their families were said to be getting "half rations," a term not defined. Waters had been banking on accepting an offer for a permanent BEF settlement at Catonsville outside Baltimore. Once he realized that the proposal was unworkable, he instructed the BEF staff to "advise the army members to return to its respective communities until we are enabled to make definite plans to carry on."

With Waters's order for the BEF to go home, Johnstown leaders raised money and worked out a plan with both the B&O and the PRR to transport people to their home communities. Funds for the exodus were donated by Johnstown businesses, public and private agencies and civic leaders. Both the City of Johnstown and Cambria County made appropriations. The chamber of commerce supplied food parcels.

On August 3 there was a mass meeting, a "demobilization assembly," at the camp. The details of Waters's order and Johnstown's civic assistance were explained. The crowd had mixed reactions. With Waters not present, William Waite, the camp commander, explained the necessity for disbanding. McCloskey spoke openly against Doak Carter and the few leaders resisting Waters's order. At one point the mayor hinted of violence if BEF members refused to depart.

The next day, August 4, the encampment at Ideal Park began an orderly break up. Those leaving in cars were given gasoline, token money and food packages. The others marched in orderly fashion to the B&O tracks nearby. BEF members had lined up in formations that corresponded with their train departures. State health department workers began an immediate clean up. By August 6, 1932, the BEF had departed.[626]

IV. THE FURY IN THE SOUND— McCLOSKEY'S JOHNSTOWN

Prior to the BEF sojourn, Eddie McCloskey had been in the limelight day after day. Now he was like a beaten boxer in need of a comeback. Without excuse or apology, he continued to talk and write of his helping poor veterans get what should have been theirs.[627]

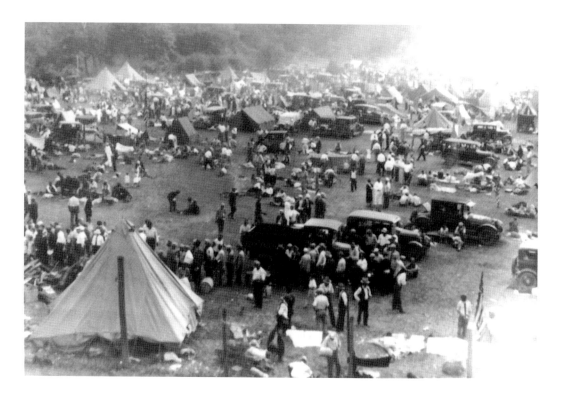

The Bonus Army at Ideal Park in late July or very early August 1932.

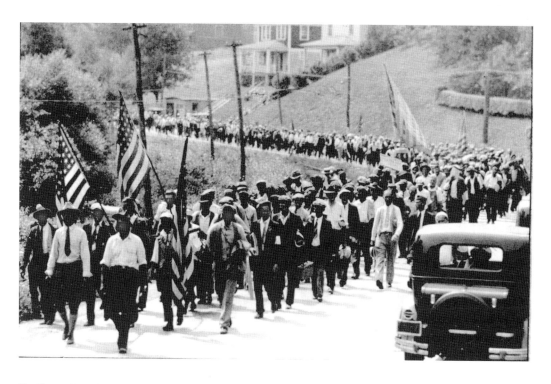

The Bonus Army leaves Johnstown. Its ranks departed on August 5, 6 and 7 of 1932.

The details of city government were boring to the redheaded mayor. McCloskey thought of himself as a big-picture man. He once told a newspaper reporter it took about two hours a week to be mayor. Laws, orderly procedures, sound engineering applications and numbers that had to add up by funny categories did not interest him. McCloskey wanted to help the little guy. The big people were stepping on the little people. He wanted to stop it.

McCloskey was fiercely anti-Communist. In addition to his Catholicism, he had probably sharpened his aversion from his friend and mentor, Father Cox of Pittsburgh, who was constantly battling Red agitators seeking to worm their way into his crusades.

In January 1935, McCloskey wrote to several people he seemed to admire: Huey Long, Father Charles Coughlin of Detroit, Upton Sinclair of California, William McNair (Pittsburgh's controversial mayor) and Father Cox. In the letter he expounded some of his latest thinking: there should be a national tax on vacant land; there should be no taxes on owner-occupied housing, but dwellings for rent should be taxed. This would promote home ownership. The governments themselves, not private business firms, should manufacture all armaments. By taking the profit motive out of weapons manufacture, wars would be less likely. Finally, McCloskey felt the U.S. government should stand behind and pay off all deposits lost in any national bank that had failed. The state governments should do the same in the cases of failed state banks.[628]

The Worst of Times

Johnstown was suffering in 1932. By May, 27.5 percent of the workforce was unemployed in Cambria County. By October, it was 30 percent. In March 1933, the unemployment rate was 35.6 percent. Modern distinctions about underemployment were not relevant. Families were breaking up. Hobos were knocking on doors asking for food. Unable to care for their families, husbands became depressed and wandered off.

The Bethlehem Steel Company lost $5.5 million in its third quarter, even more than the $4,671,000 it had lost in the second quarter of 1932.

In May of 1932, the city itself was running out of cash. There was also a persistent belief of there being waste and inefficiency in Johnstown's city government. Eddie McCloskey shared the attitude and had an intuitive sense that the problem stemmed from the long-term political "baggage" at city hall. McCloskey wanted to clean things out and save money. He, the mayor, was viewed as being in charge but, even had he known what to do, he lacked the powers to effectuate meaningful change

Goodrich

Bethlehem Steel officials approached the city with a suggestion: Johnstown should hire Ernest Goodrich, an efficiency expert, to develop recommendations to cut costs. Goodrich was an engineer who had been in charge of the New York City Bureau of Municipal Research. He had also worked on various local government projects throughout the United States and in other countries. The Bethlehem Steel Company volunteered to pay half of Goodrich's $12,600 fee.

After a cursory review of city operations, Goodrich claimed his work could save from $150,000 to $200,000 per year. McCloskey eagerly supported the proposal. Other councilmen were not enthusiastic, but the measure passed by a three to two vote. The more detailed work began in late June. Goodrich was to be finished by November 1932. Goodrich's opening strategy was to furlough all city employees in stages for thirty days without pay. With differing groupings of the workforce gone, he could see how things functioned in their absence and would then decide which workers to terminate.

Given the commission form of government with respective staffs being appointed and supervised by individual councilmen, Goodrich's approach involved opening a Pandora's box of office politics and vicious backbiting, especially during the Depression, when one in three local people was unemployed. Anxious city policemen decided to work the month without pay rather than be absent. In time, all city employees made the same offer. While it saved money in the short term, the practical effect was to reduce everyone's salaries by one month's compensation in 1932—not develop long-term cost savings. Goodrich next recommended the library be closed permanently and the recreation program be eliminated. The council balked. Such measures would give the idle even less to do during their idleness.

In time, Goodrich's role had begun to change somewhat. Council began referring petty operating decisions for his recommendation. Even the request for $1,000 to help the BEF's departure was sent to Goodrich for approval. One of Goodrich's staff, I.C. Moller, undertook a special study of the police department. His findings pleased McCloskey. Moller found there were two distinct factions with long-standing political origins. Each feared the other. Moller reported that some off-duty policemen were visiting bars and gambling joints with questionable women. Moller also reported that the jail had become a welfare and social club. Prisoners were being recycled—in, out and back in again. Behind bars they were fed. Many participated in an endless card game. Moller recommended that repeat prisoners be isolated from one another and all sporting at the jail be terminated.

Moller's lead recommendation was for Chief Briney to be given a six-month leave of absence with half pay and General Pelham Glassford, the recently resigned police superintendent in Washington, D.C., be named "civilian police superintendent" for one year. At the end of six months, Briney would return to serve under Glassford for the remaining six months. McCloskey supported Moller's recommendation, but Glassford declined the offer.

In lieu of Glassford, the mayor picked Arthur Mahan from a list of candidates recommended by the state police superintendent. Mahan had once been a prizefighter. A month after Goodrich and his staff had finished their work, and during the very negotiations for a civilian police superintendent, Charles Briney died.

Soon Mahan and McCloskey were at each other's throats. Their disputes were rooted in the conflicting provisions of the Third Class City Code regarding the mayor's powers to oversee the police department. McCloskey suspended Mahan and began running the department himself.

Mahan got a temporary injunction restraining the mayor's action. Later, however, the court not only dissolved the injunction, but also ruled there had been no statutory authority

for Mahan's contract. In a word, the Goodrich-Moller recommendation calling for a civilian superintendent was illegal. McCloskey was now triumphant. The whole thing had served as a ruse to oust Briney who had obligingly died.

McCloskey next named Harry Klink as chief. The council, in mid-August 1933, approved the recommendation. Before long, however, Klink began having one dispute after another with McCloskey.[629]

Irksome Eddie

When McCloskey disliked a measure approved by the council but which required his signature, he refused to sign the instrument. Bethlehem Steel, for example, had given both Stackhouse and Hillside Parks to the city, which had accepted them. Certain conditions in the Stackhouse deed had not been met. Bethlehem granted a three-year extension for the city to meet them, otherwise the land would revert. The council agreed. Opposed to the city owning Stackhouse Park in the first place, McCloskey refused to sign the time-extension agreement. As often happened, the council sought a mandamus to force his signature.[630]

A quorum of three or more councilmen had to be present to transact any business. Frustrated by having to listen to long speeches, name calling, profanity and threats, members frequently got up and walked out, leaving McCloskey and usually Dan Schnabel without a quorum.[631]

The Sixteenth Round

Knowing of McCloskey's efforts at urging the Cambria County Poor Board to aid Johnstown citizens, a large delegation from scattered locations met with him at city hall on June 5, 1933. McCloskey agreed to help them address problems they were having with the Poor Board.

The Poor Board's Johnstown office was in the welfare building on Washington Street. Although he had no appointment, McCloskey and a throng of seventy-five stormed over to the Poor Board office about two blocks away. After entering the building, the mayor and his followers began climbing the stairs, when a startled director, Leon Bennett, managed to utter, "Now Eddie!" and gave some minimal resistance to an apparent onslaught. Getting slugged, Bennett needed several days' recuperation at home.

He then filed charges against the mayor. McCloskey was found "not guilty." There had been so much conflicting evidence, the jury could not reach a guilty verdict.

The Shields-McCloskey Bout

In January 1934, Eddie McCloskey faced another challenger, one against whom his fistic ways had no effect. At the time, Daniel Shields was a businessman recently defeated in a bid for city council. He appeared before the city solons complaining about a lack of police protection. Given the mayor's shifting roles in a perpetual shake up of the police bureau, Shields was indirectly attacking McCloskey.

Shields reported that his Capitol Building had been robbed several times, its safe had been pilfered and damage had been done to some plastering. After catching a youth believed responsible, Shields took him to police headquarters. The lad posted a twenty-five-dollar bond and was released. Shields informed the council that the boy had been allowed to forfeit the bond rather than appear in police court. "The whole thing was a farce all the way," Shields announced to the council.

McCloskey spoke up, "In regard to the boy that was released, Shields bumped his head into the plastering and put a hole in the plaster."

"You're a liar!" Shields retorted.

"Nobody calls me a liar and gets away with it!" McCloskey shouted and charged forward to hit Shields.

Shields grabbed the mayor and got his right arm around McCloskey's neck. He then began slugging the mayor's face with his left fist. The police broke up the fight.

From this time forward, Shields maintained a crusade repeatedly charging McCloskey's police bureau with lax enforcement of the gambling laws. He began writing letters to the city council and to the press. Ironically, Shields was making the same accusations against McCloskey that McCloskey had made against Webster Saylor.[632]

Candidate McCloskey

In the spring primary in 1934, McCloskey cross-filed, seeking both the Republican and Democratic nominations for secretary of the Pennsylvania Department of Internal Affairs. He was badly beaten in both primaries.

Despite the defeats, McCloskey announced he would run for United States senator as an Independent, a race he never actually attempted. While there is no record about it, McCloskey was probably under pressure to give up the effort. Democrats would have feared that in the tight race, McCloskey might have siphoned enough votes away from Joseph Guffey, their candidate, to elect the Republican, David Reed. Guffey managed to win a close election.

Before George Earle, the governor-elect and a Democrat, took office in January 1935, the word was out that McCloskey would be named chairman of the state athletic commission by the governor, probably part of a deal to keep McCloskey out of the Senate race. The appointment made State Representative Hiram Andrews furious. He accused McCloskey of betraying the Democratic Party by uttering abuse against Harry Bender, a Democrat who had been narrowly beaten for assemblyman.

McCloskey was nonetheless appointed in January 1935 to the $5,500-per-year position. Also continuing to serve as mayor, McCloskey was earning $9,000 per year from the two positions. He closed the family laundry–dry cleaning business and forgave all debts owed his company.

Hiram Andrews introduced a bill intended to prevent anyone in Pennsylvania from holding two full-time public positions simultaneously. Dubbed "the McCloskey-ouster bill," it was defeated 102 to 71.

Earle soon regretted the appointment. On May 1, McCloskey was suspended for thirty days without pay and ordered to make a public retraction of a statement he had made

charging three sports editors with being on a wrestling promoter's payroll. In his reprimand letter the governor wrote McCloskey, "You have admitted these charges to have been absolutely without foundation."

County Commissioner

In 1935, while serving both as mayor and chairman of the state athletic commission, McCloskey ran as a Democrat for Cambria County commissioner. The *Johnstown Tribune* opposed him vigorously. After carefully examining McCloskey's recent property-tax record for 106–108 Market Street, the newspaper editorialized:

> *Candidate McCloskey owes his 1931, 1932, 1933, 1934 county taxes...Candidate McCloskey also owes his 1931, 1932, 1933, and 1934 city taxes...and his 1931, 1932, 1933, and 1934 school taxes...Candidate McCloskey owes county, city, and school taxes in the sum of $2734.50.*

The same editorial reminded its readers of McCloskey's $9,000 annual salaries from two public positions—the equivalent of approximately $120,000 per year in 2005. Despite the attacks, McCloskey was elected to the Cambria County Commission and took office in January 1936. McCloskey denied the *Tribune*'s assertions about his unpaid taxes in a later *Derby* issue.

V. THE JOHNSTOWN BANK CRISIS OF 1933 AND 1934

In 1929, 659 banks in the United States closed, about the annual average throughout the 1920s. The number jumped to 1,352 in 1931 and to 2,294 by 1932. Although failures were happening throughout Pennsylvania, Johnstown banks seemingly had no problems.

Johnstown's leading banker was David Barry, president of the First National, the largest and oldest bank in town. Stiff, serious, aloof and married to Charles Schwab's sister, Barry gave the First National an image of strength. Other banks in town were also considered "safe."

Signs of Trouble

Just before Roosevelt's inauguration on March 4, 1933, there had been a number of runs on big-city banks. Various governors began declaring bank holidays within their states. After Herbert Lehman announced the closing of all banks in New York State to extend through the end of March 6, Gifford Pinchot had no choice but to declare the same holiday throughout Pennsylvania. Had its banks remained open with the others closed, there would have been a drain on Pennsylvania's financial houses.[633]

The Federal Bank Holiday

One of Roosevelt's first actions as president was to proclaim a four-day bank holiday. His March 6 (1933) action was later extended to March 13. Inasmuch as the president's order was based on a questionable war statute, the Congress hastily enacted the Emergency Banking Relief Act, which sanctioned the holiday and provided a process whereby only strong banks could reopen on an unrestricted basis. National banks judged to be in shaky condition by the Comptroller of the Currency had to be operated by a "conservator."

Another new power had to do with making a sharp distinction between recent deposits and pre–bank holiday deposits. New deposits were liquid. Old deposits were subject to withdrawal restrictions, meaning they would be treated as "frozen" until the bank in question was judged solvent. Without this dual system for classifying customer balances, conventional deposits into restricted banks would have ceased and many more institutions would have failed.

Johnstown's Troubled Banking Scene

The Pennsylvania Legislature also passed an emergency statute to deal with state banks. The Sordoni Act was signed by the governor on March 8, 1933. Modeled after the federal legislation, it empowered the state secretary of banking to regulate state banks. The secretary could close institutions deemed to be insolvent. The segregation of deposits into the pre-holiday and post-holiday categories was also provided.

On Monday, March 13, Johnstown's banks did reopen, but only for two hours. Activities were limited to making change, receiving new deposits, receiving gold coin and gold certificates in exchange for currency, receiving interest and principal payments owed to the banks and accessing safety deposit boxes. The area's banks were only making change and receiving funds. They were not releasing any net new currency.

Business firms also began using certain practices to curtail currency release. They also had to exercise care that payments being made to them by check were drafts against liquid balances. At the Glosser Brothers department store, if any check were written for more than the amount of the purchases, the customer got a credit slip or company scrip for the difference—not cash. Penn Traffic had a purchase-card system. Customers could make many purchases throughout the store. Each would be recorded on the card. One check would be written to cover all transactions. No change was given back unless the customer had paid in cash.

The Bethlehem Steel Company resorted to a four-check-per-payday plan. Instead of a single paycheck (almost impossible to cash), the company would permit each employee to allocate the compensation over four separate checks. Vendors would honor the checks in exchange for purchases grouped to equal or nearly equal one of the checks.

On Wednesday, March 15, three banks in and near Johnstown were permitted to reopen on an unrestricted basis: the Johnstown Savings, the Moxham National and the Dale National Bank. All prior deposits held by the three houses were treated as liquid, and the

institutions resumed normal business. As for the other banks, Johnstowners had to adjust to the new reality of dealing with liquid and frozen deposits.[634]

A Johnstown Tragedy

On March 17, 1933, Johnstowners received a devastating jolt: The comptroller of the currency had determined that both the First National and the U.S. National Banks, many times over the largest financial institutions in Johnstown, each had to be managed by a "conservator." Both banks had "problems."

A conservator was a virtual dictator who reported to the Comptroller of the Currency, not to a bank's board. Francis Martin, U.S. National cashier, and David Barry, president of the First National, were named conservators of their respective banks. The conservators were limited to rigid loan-enforcement practices. They had no discretion to be flexible with problem loans. In addition, conservator-operated banks were unable to make new loans until they were operating on an unrestricted basis.[635]

By late June, the U.S. National had developed a plan generally acceptable to the Comptroller of the Currency. It called for depositors to agree to accept seventy-five cents on each pre-holiday deposit dollar as unrestricted, while twenty-five cents would remain frozen, meaning it would become available at some future time when the bank's finances improved. In addition, $800,000 in new common stock would be issued and subscribed to by existing shareholders, half financed by their frozen deposits and the other half paid for in cash.

In August, the bank's president, John Waters, with the city's mayor and other bank officials, visited Washington seeking plan approval. Waters had invested personal funds in restoring the bank to solvency. Stricken at the Washington meeting, he was rushed to a hospital. On August 14, Waters died.

By September 23, the plan received federal approval, and the U.S. National began operating on an unrestricted basis in keeping with the bank's plan. The new president was John Walters, a lumber and building-supply firm owner. Francis Martin reassumed his position as cashier. Soon after the resumption of normal operations, officials at the bank were happy to report that more deposits had been taken in than withdrawn.[636]

The Johnstown Bank and Trust Company

Meanwhile, William Gordon, Pennsylvania secretary of banking, had set about to salvage five state bank and trust companies in Johnstown, all in perilous condition. That October he assigned one of his representatives, W.R. Wirth, to work with George Rutledge and George Suppes of Johnstown to devise a plan to combine four of the banks into a single new institution: the Johnstown Bank and Trust Company. The fifth bank, the Title Trust and Guarantee Company, had been judged insolvent. The plan they developed called for 10 percent of each depositor's holdings in the four banks to be converted into shares of stock for the new bank at a subscription price of $15.50 per share. The stock would be distributed to the depositors. Each depositor would eventually have the unrestricted use of pre-holiday deposits limited as follows:

Johnstown Trust Company	30 cents per dollar
U.S. Savings and Trust Company of Conemaugh	20 cents per dollar
Morrellville State Deposit Bank	20 cents per dollar
Johnstown State Deposit Bank	25 cents per dollar

With the exception of secured and other special categories, the remaining deposits would be waived.

While the plan created tensions among customers and board members joining the new Johnstown Bank and Trust Company from former institutions, the arrangement was eventually approved by about 75 percent of the depositors.

The overall plan was approved in Harrisburg in January 1934. The board of directors of the new Johnstown Bank and Trust Company met for the first time on May 25 and selected George Suppes to be president and George Rutledge as secretary-treasurer. The other directors came from the four combining banks. There were internal tensions and disputes at the beginning.[637]

The Johnstown Bank and Trust Company opened for business on a normal basis on June 25, 1934. It has since evolved into a major multi-county bank holding company, operating in 2005 as the First National Bank of Pennsylvania.

The Title Trust and Guarantee Company Receivership

On November 5, 1933, a notice was posted on the entrance of the Title Trust and Guarantee Company at Main and Clinton Streets:

> *By virtue of the Department of Banking Code, I have taken possession of the business and property of Title Trust and Guarantee Company, Johnstown, PA, and I have become its receiver as of the close of business, November 29, 1933. William Gordon, Secretary of Banking*

The liquidation of Title Trust and Guarantee Company was traumatic in Johnstown. It represented the city's first Depression-era bank failure, a calamity no one would have anticipated. Its titular president had been the redoubtable David Barry.

On March 5, 1934, an appraisal of Title Trust was completed. The historic book value of its assets had been $2,810,000, while their current worth was fixed at $756,000—a little over one-fourth of the original value. Seven months later, on October 17, some $274,000 was distributed to Title Trust's disgruntled depositors—fifteen cents for each dollar of pre-holiday, unsecured deposits.[638]

An Abortive Effort to Salvage the First National

On October 31, 1933, David Barry, Mayor McCloskey, key officers of the First National and a few prominent community leaders went to Washington to meet with staff members of the comptroller's office. Barry, as conservator, had developed a plan for

the reorganization and reopening of his bank on an unrestricted basis. The likes of the mayor, Nelson Elsasser, David Glosser, Max London and A.M. Custer had been asked by Barry to help persuade federal officials to approve his proposal. Its details were never divulged. No decisions were made.

The real situation at that Washington conference was not made public, but on November 17, David Barry (then conservator), Jacob Murdock and Harry Swank (both vice-presidents of the bank), and Patrick McAneny (its cashier), were all indicted on various federal law violations: misapplication of funds and making false entries.

This earthshaking news item was buried in a small article near the bottom of page two of the *Tribune*. None of the principals' names or any Johnstown connection were mentioned in the headline, and the piece indicated a Pittsburgh origin. On November 21, even more indictments were directed at the four men—eleven counts charging misapplication and eight counts of false bookkeeping entries.

Immediately ousted as conservator, Barry was replaced on November 18 by a staff person, J. Allen Rhodes, from the Comptroller of the Currency. In late December, the earlier plan to reorganize the First National was abandoned as "completely unworkable." On February 6, 1934, an announcement was made that the First National Bank was in receivership and would be liquidated. J. Allen Rhodes had determined the bank was "unable to pay its just and legal debts." His assignment as conservator was terminated and a receiver, John Vallely, was appointed.

Bank customers with safety deposit boxes were instructed to give up the boxes. Those who had made deposits since March 6 of the previous year and had "liquid" deposits were instructed to withdraw them immediately. Vallely announced an inventory and appraisal of all assets and liabilities would be undertaken. At some unknown future point in time, people holding "frozen deposits" would receive "dividends" for whatever portion of them might be available after liquidation.

Anger and chaos were unleashed in the community. Businesses, professional citizens, churches and individuals had funds tied up. There was anger about the new receiver whose qualifications were questioned. It was pointed out that all costs of the conservators before and the receiver at present were being paid from the resources of the bank, meaning a bottom-line lessening of dividends. Ray Patton Smith, a prominent attorney and U.S. commissioner, complained that depositors' funds would be discounted when and if they got paid back, while anything owed the bank had to be paid in full with no flexibility, a system he believed both unfair and counterproductive.

Near the end of March in 1934, John Vallely unveiled another revelation when he sued officers of the First National for large and unpaid loans they had been making to themselves and to family members—loans whose interest and principal payments were in arrears! Jacob Murdock, a Johnstown civic leader for thirty years and bank vice-president, was not only bankrupt but also owed the First National $450,000. David Barry owed it just over $150,000 and Mrs. Barry owed $138,581. The First National had loaned Murdock's nephew $10,000, secured by a worthless note. Murdock was also charged with making a large withdrawal from his bank without adequate resources or solid collateral. Other officers had also been receiving loans from the bank, loans they were unable to pay off.

In March, an audit of the First National by Ernst and Ernst revealed that almost half of the total amount loaned out by the bank, nearly $6 million, had been to twenty families, meaning that since most of this $6 million was in default, the twenty thousand First National depositors had been contributing to the few through the doings of the bank.[639]

The lax loan policies of David Barry and the First National's board were not so much at issue in his criminal trial. Boss of the two failed banks, Barry had been charged with making false accounting entries between both institutions. He had been taking deposits from the First National and moving them to the Title Trust and Guarantee Company and making illegal book entries about the transactions.

On June 16, 1934, he was found guilty. Five days later, Barry was dead. Both Johnstown newspapers gave strangely detailed descriptions of a massive heart attack. There was a general but hushed-up understanding within the upper crust of Johnstown society that he had committed suicide.[640]

The First National's assistant cashier, Charles McGahan, had committed suicide on December 5, 1933. Jacob Murdock, severely injured in an automobile accident in December 1933, killed himself on July 10, 1934.

In addition to Barry, George Gartland, one-time vice-president of the Title Trust Guarantee Company, pleaded nolo contendere to a charge of making false entries. Being a subordinate to Barry, Gartland was placed on two-year probation. Harry Swank, a vice-president, and Patrick McAneny, the cashier at First National, were each found guilty of technical violations and were given probation.

In April 1934, John Vallely secured a loan to the First National of $4.2 million from the Reconstruction Finance Corporation (RFC). As the receiver made progress in collecting and foreclosing on outstanding obligations, dividends were paid out to depositors. On April 25, the initial distribution commenced, and depositors began receiving government checks amounting to twenty-five cents on each dollar of pre-holiday deposits.

In 1935, John Vallely died. He was succeeded first by Harold Collins and in 1936 by Herman Baumer, former state senator and a Democrat. Baumer managed to pay off the RFC loan by December 31, 1936. In September 1938, a second dividend of ten cents on the pre-holiday deposit dollar was paid out. During April and May of 1940, another ten cents was distributed.[641]

The Bank Crisis in Perspective

The bank crisis of 1933 and 1934 precipitated a reduction in the total number of Johnstown banks from ten down to five, all of which had become protected under the new Federal Deposit Insurance Corporation. Many prominent citizens, having used their positions to make loans for themselves and their family members that they were unable to repay, had been disgraced. Four bank leaders were indicted and were either judged guilty or had pleaded guilty or nolo contendere. Three prominent Johnstowners had committed suicide. Millions of dollars of local deposits were either lost altogether or were paid back at future points in time in fractional amounts of what had been deposited. The losses affected family finances, church treasuries, the capability of charities to help the needy, the fiscal viability of business firms, future educational opportunities and more.

VI. THE NEW DEAL IN JOHNSTOWN

The Great Depression ushered forth Franklin Roosevelt and the New Deal era. Roosevelt's strategy involved the aggressive use of government powers and resources to overcome the Depression and its problems.

Toward a Planned Economy—The NIRA

Becoming law in June 1933, the National Industrial Recovery Act (NIRA) sought to solve the nation's ills through economic planning. Industrial and business associations were to develop plans and trade agreements to halt overproduction and stabilize prices within industrial and commercial groupings. The plans were also to provide wage and working-condition requirements. Antitrust laws and regulations would be relaxed. Each plan was intended to interface harmoniously with other plans. Once completed, they were to be submitted to the president for approval, a task delegated to General Hugh Johnson, director of the National Relief Administration (NRA), a program created by the NIRA.

Industrial and commercial firms were being pressured to pledge that their corporate procedures and policies would conform to the tenets of whatever plan or plans governed their enterprise. Once a management had agreed to live by the principles within the appropriate plans, the firm could display a "blue eagle" emblem throughout the facility, on the company's stationery and in its advertising.

There was an underlying assumption that if all major business activity in the nation would comport to the appropriate plans and to the NIRA system, the troubled economy— like a capsized boat—would right itself and prosperity would return.[642]

This system produced enormous difficulties. Johnstown manufacturers such as the National Radiator Corporation had to pay a Pittsburgh steel price, including a transportation charge equal to the cost of getting steel from Pittsburgh (a "basing point") to Johnstown (not a "basing point"), to produce radiators even though the steel actually used was produced in Johnstown. The same firm in Pittsburgh would not have to pay a transportation charge.[643] These isolated situations seemed absurd and triggered constant appeals and challenges. Generally speaking, the big firms could weather the NRA plan requirements better than smaller ones.

There was no official licensing. The enforcement mechanism was rooted in public opinion and action. A massive effort got underway nationwide to encourage everyone (citizens and businesses alike) to do business only with firms displaying the blue eagle emblem that signified a firm's NRA conformity.

In Johnstown, the "voluntary enforcement" was overseen by an advisory committee consisting of city government members, the chamber of commerce and service-club and trade and professional association representatives. On August 8, 1933, the group chose Stephens Mayer, an attorney and war veteran, to serve as "general" in a military-rank-style

organization. Its mission was to encourage citizens and businesses to sign pledge cards vowing to do business only with blue eagle firms.

Everything from speeches to service clubs, radio addresses and door-to-door canvassing by women was undertaken. Visits were made to employers to urge compliance with labor requirements, including collective bargaining and eliminating forbidden child-labor practices.

Johnstown took the NRA effort seriously in the beginning but the initial enthusiasm quickly faded. On May 27, 1935, the U.S. Supreme Court declared the NIRA unconstitutional. The NRA system in Johnstown quickly disappeared.[644]

The Civilian Conservation Corps—CCC

The Civilian Conservation Corps Act, passed by Congress in March 1933, created a military-style work corps for unmarried male volunteers, ages eighteen to twenty-five, from families on relief. Older military veterans were also eligible. CCC members were assigned to work on forestry, parks and conservation projects at thirteen hundred camps being established nationwide. There was also classroom and vocational training. Most of the members' $30 monthly salaries got sent home to their families.

In October 1933, Nelson Elsasser took the initiative to establish a CCC camp at Johnstown. With Mayor Eddie McCloskey's help, Elsasser quickly submitted an application. The CCC sought to develop and reforest Stackhouse, Hillside, Roxbury, Carpenter and Highland Parks. After initial difficulties, the first application received a hasty approval in March 1934 for work to begin that April.[645]

A Bedford County camp staffed with war veterans was moved to Johnstown by truck and train and was reopened as the Joseph Johns State Park Camp Number Five. The barracks and headquarters were placed at Berkley Farm, an extension of Roxbury Park. The CCC program was administered in six-month projects, each having an application and budget. As the fourth increment neared its end, there were plans to terminate the Johnstown program (Camp 1397) in April 1936. Recovery efforts following the Saint Patrick's Day Flood, however, kept the program intact.

The CCC program was well received in Johnstown. There were no problems between the camp and community. The local camp roster was composed of persons not from Johnstown. It was a CCC policy for members to serve away from their home.

The CCC in Johnstown developed Stackhouse Park by constructing the through-road, many trails, shelters, picnic facilities and other features. An old garbage dump was completely cleaned out. Work was also done in Roxbury Park. Thousands of trees were planted, especially on Hillside Park.[646]

In 1937, the city was informed that CCC Camp 1397 would be terminated even though the work scheduled for Stackhouse Park had not been completed. The decision stemmed from a dispute between the CCC and the city over the upkeep of what had been done. City officials had agreed to provide ongoing maintenance, but Stackhouse Park upkeep was taking low priority after the 1936 flood.

Despite protests and visits to Washington, the CCC camp was removed in October 1937.[647]

Work Relief—Civil Works Administration

President Franklin Roosevelt created the Federal Civil Works Administration (CWA) in November 1933 by executive order. Administered by the Federal Emergency Relief Administration, the CWA was to pump money into the economy and to provide quick employment to people still out of work. In many ways, the CWA was a morale booster. Although a federal program, it was administered in Pennsylvania by the state government through the counties, each of which had its own "civil works administrator." In Cambria County, the first incumbent was Herbert Davies, a private accountant.

The City of Johnstown sought project approval for storm sewers, reconstruction of bridge abutments, cobbling of streets and other small jobs. By December, temporary employment had been created for eleven hundred men. Each was to work three days of a six-day workweek. Additional projects were approved in January, including improvements to the city airport at Westmont, work on Mill Creek Road, Hillside Park cleanup and other jobs.

The CWA program in Johnstown was chaotic. Putting over a thousand men to work on short notice with hand tools and work materials exceeded the city's capacity. There was always a rush to get work started and threats of project cancellation, even in bad weather. CWA workers were often seen standing around seemingly idle.

The CWA program was criticized widely (even by its top administrator, Harry Hopkins). It was said to have been abused by politicians creating patronage-fueled political machines. In Cambria County, Republicans, including Gus Gleason, were allegedly using the New Deal program to strengthen GOP roots. Complaints also arose because some people were hired while deserving others were not chosen. The CWA program was terminated at the end of March 1934.[648]

After the surge in temporary work-relief employment from late November 1933 until the CWA program demise, there was comparatively little work relief in Johnstown. The State Emergency Relief Board (SERB), which had administered the CWA, had been responsible for administering both federal relief as well as work relief. Despite Governor Pinchot's efforts, the agency was inadequately funded in Pennsylvania to take advantage of all the federal resources that might have become available.[649]

One success from the CWA program was a project to remodel, landscape and to make additions to the Municipal Isolation Hospital in Prospect.[650]

The Works Progress Administration (WPA)

The city had also submitted an application for funds to do extensive work on the sanitary sewer system through Harold Ickes' Public Works Administration. The application was still pending when the Emergency Relief Appropriation Act of 1935 was enacted and signed, creating the Works Progress Administration (WPA).

By July city officials were formulating a large program for over $3 million in projects to include dredging and cleaning the rivers, providing lights for Point Stadium, installing channel walls along tributary streams, creating the city golf course and improving the sanitary sewerage system.

By mid-August the proposed work program had been broken down into twenty project units. The city's matching requirements of $590,000 could either be in cash or in materials, manpower, equipment and other non-cash contributions. If the first application had been accepted with no changes, meaningful work for a thousand people would have been provided.

In August 1935, the city's river-dredging proposals were all rejected as "not-cost-effective."[651] Extensive channel-wall work, however, was approved on Sams, Cheney and Solomon Runs. Dredging was authorized for St. Clair Run.

By mid-September 1935, twenty-one WPA projects were approved in and around Johnstown, including many submitted by the city. Most school buildings in the area were also being improved through upgraded brickwork, minor repairs and interior painting. The whole program was expected to create 850 jobs.[652] Work got underway immediately.

The destruction caused by the Saint Patrick's Day Flood precipitated major changes in the WPA program. Workers were quickly reassigned for emergency cleanup and afterward for river and tributary dredging and for unclogging sewers. By early April 1936, there were 2,600 WPA workers assigned for clean-up in Johnstown alone. After a few busy days the number was reduced to 1,100 and by early May, there were only 300 doing cleanup work.[653]

Retaining Walls

WPA labor and funds were used to install massive retaining walls from the Point to Cambria City to protect the new Hillside (Roosevelt) Boulevard. The 1936 flood had raised a serious concern that without the walls the new road would eventually be eroded by the Conemaugh River. The job lasted more than two years and was finished in January 1939.

Another wall was constructed between 1936 and 1938 at the "Rocks," around the bend in the Stony Creek below Osborne Street. The two retaining-wall projects combined had a final cost of $614,000.[654]

Other WPA Projects

The WPA program was used to construct the city's nine-hole golf course at Berkley Hills, which opened in May 1938. From 1937 onward there was an ongoing sidewalk and curb construction program. Fronting property owners provided the materials, and WPA workers did the work under city supervision.

WPA funds and workers were also used to widen Franklin Street through Kernville and to improve the complicated Napoleon–Franklin Street intersection near the new Hickory Street Bridge. Many streets and alleys throughout the city were paved and repaved. WPA office workers reorganized city tax records and developed delinquency lists.[655] There was also a women's sewing project located in the old shirt factory on Wood Street. WPA workers also made renovations to the Incline Plane.

The WPA program to improve Sams Run, Cheney Run, Saint Clair Run and Solomon Run, halted by the 1936 flood, was resumed in 1937. A single project covering all four streams was authorized for $170,000.[656]

Among the final WPA projects was the large $67,700 band shell at Roxbury Park, a project pushed by a citizens' group led by Dr. Charles Colbert. Mayor Daniel Shields supported the project. Made of cut-stone and steel, the band shell was dedicated on June 17, 1940.[657]

VII. COMMUNITY ORGANIZATIONS

The Johnstown Chamber of Commerce struggled to maintain members and organizational effectiveness during the Depression. Difficulties with dues, a perceived irrelevance of mission during the Depression and the New Deal, and Eddie McCloskey's ridicule were contributing factors. Things were not the same. The chamber seemed unimportant to many citizens.

As he had done in 1921, Harry Hesselbein, the chamber's secretary since 1924, resigned in August 1933 to return to the *Tribune* as a full-time managing editor. For almost a year, there was no secretary (executive director), but on July 1, 1934, William Mason, a chamber professional from Hanover, assumed the post. In addition to Depression-era problems, Mason had arrived in the thick of the bank crisis, Eddie McCloskey's hostile term and a time when a rival organization was developing. If Mason or the chamber accomplished anything significant in 1934 and 1935, there is no record of it.[658]

The Citizens' Council of Greater Johnstown (CCGJ)

In April 1934, a new organization got underway—an umbrella or "group-of-groups" organization—the Citizens' Council of Greater Johnstown (CCGJ). The leading personality was Nelson Elsasser, former CEO of Nathan's department store. By February 1935, the CCGJ comprised sixty-seven affiliated organizations, including such disparate entities as the Johnstown Jewelers' Association, the American Legion, the German and Austrian World War Veterans, the Johnstown Chamber of Commerce itself and the Business and Professional Women's Club. Each organization was entitled to two representatives on a governing board. Any member of a participating organization could join the CCGJ.

In addition to Elsasser, some of the key CCGJ personalities were A.M. Custer, Leo Buettner and the organization's secretary, Lawrence "Larry" Campbell. Campbell was energetic and effective. A Johnstown native, he had been affiliated with his father, Amos, and a brother, Walter, in a small real estate, insurance and mortgage-loan business.[659]

The CCGJ's work agenda was all-encompassing. It included urging the community to take advantage of New Deal housing programs through the Home Owners' Loan Corporation. The CCGJ advocated three-lane highways on routes leading into Johnstown. It sought an expanded parks and recreation program and was endeavoring to make Point Stadium fiscally self-sufficient.

By February 1935, the CCGJ was assigning its sixty-seven-member organizations each to one of nineteen clusters. A board-member governor was designated to work with each grouping for interface purposes, an indication the CCGJ had become unwieldy and was seeking to forge a common agenda from diverse viewpoints.[660]

The CCGJ also undertook industrial development. It sought to gather data believed useful in attracting business firms and even to raise money for site acquisitions. CCGJ claimed a success in bringing the Milan Macaroni Factory to Hornerstown. After the firm opened, CCGJ began promoting macaroni recipes.[661]

A Stratagem

Behind the scenes, Johnstown community leaders addressed what they believed was a civic dual rivalry. Rather than allow a new, seemingly energetic organization to grow at the expense of a moribund chamber of commerce, a committee of about fifty civic and business leaders met on June 22, 1935, to form yet another organization, the Johnstown Board of Industry and Commerce. Ostensibly, the new group would focus solely on industrial development and economic growth, objectives no one dared oppose. In actuality, the new organization was a magnet to co-opt the CCGJ into the chamber of commerce, thereby aligning new faces and dynamism with old Johnstown—W.W. Krebs, Bethlehem Steel and the like.[662]

The "front man" in the new Board of Industry and Commerce was Samuel Heckman, president and general manager of Penn Traffic. Everything was prearranged at the organizational meeting. The board was announced: Hiram Andrews, A.M. Custer, C.C. Dovey, Nelson Elsasser, David Glosser, George Griffith, P.H. Harris, S.H. Heckman, W.A. Kennedy, W.W. Krebs, Charles Kunkle Sr., Francis Martin, Herman Wilhelm and B.F. Faunce.

The Johnstown Chamber of Commerce, Inc.

In the Johnstown of 1935, the Board of Industry and Commerce was a toothless shell, an idea with a long way to go, but nevertheless a form of "bait." In February 1936, the results of behind-the-scenes wheeling and dealing were announced. There would be a new chamber of commerce—Johnstown Chamber of Commerce, Inc. Like the CCGJ, it would be an umbrella-type group comprising four "somewhat autonomous" organizations: the original chamber of commerce, the Johnstown Board of Merchants, the Citizens' Council of Greater Johnstown and the Board of Industry and Commerce. Larry Campbell was managing director. William Mason departed.

VIII. THE JOHNSTOWN SCHOOL DISTRICT

The Depression changed almost everything involving public education. The city had stopped growing demographically. There had been no more annexations throughout the 1920s. In the early 1930s total school enrollment figures had begun to level off and in 1936 a gentle enrollment decline commenced. By 1940, the school population had dropped 11 percent from the 1930 level, a decline aided in part by the school board's eliminating the kindergarten program beginning with the 1939–40 school year, an action affecting about 750 children.

Johnstown City School District Enrollment, 1930–41[663]

School Year	High School	Junior High School	Total
1930–31	996	3,844	13,322
1931–32	1,302	4,190	13,885
1932–33	1,377	4,051	13,458
1933–34	1,588	4,261	13,928
1934–35	1,369	4,352	13,505
1935–36	1,461	4,483	13,689
1936–37	1,486	4,568	13,635
1937–38	1,561	4,425	13,199
1938–39	1,695	4,196	12,899
1939–40*	1,802	4,365	12,407
1940–41	1,725	4,230	11,796
1941–42	1,710	4094	11,245

* First year the kindergarten program was eliminated. (Resumed in 1951–52 school year.)

Tough Times and Hard Choices

Extreme unemployment, tax defaults and business and bank failures all hit the school system hard, forcing school authorities to make wrenching decisions. New building construction and additions ceased altogether. The school board agonized about closing three elementary schools, but its members actually gave up only one, the Benshoff School in Minersville. In 1930 the most important construction project of the Johnstown school district was covering the Cypress School's play area with asphalt.[664] In the decade to follow there would be simple maintenance and little else unless done with WPA labor and materials.

Worst of all, the creative energies of school policy thinking were focused upon no-win, controversial decisions—cutting costs and eliminating badly needed staff positions. In a word, the actions being taken were displeasing and invoked public anger. Issues of defining future needs and reforming education got lost in the Depression gloom.

The school board initiated a personnel policy of dismissing all female teachers who were married. When any new woman teacher was hired, it was explained clearly that if she got married, she would be dismissed immediately. The practice echoed a policy of a few businesses in Johnstown, and was a slight variation on a theme instigated by Bethlehem Steel to try and keep at least one member of a family working when a layoff was necessary. The practice, however, reveals the school district values in the Great Depression. An outstanding female teacher—exactly the sort everyone would want to instruct their children—would be terminated upon her marriage to make way for an unmarried woman or a man who might not have been as good a teacher. The goal of

offering the best education was subordinated to a philosophy that the purpose of public instruction was to provide school-related jobs.

In January 1932, the Taxpayers' Equity League made a report to the Johnstown School Board suggesting certain cost cuts and a sharply revised salary plan. In the end the school board decided to reduce everyone's salary by ten percent, a measure that was painful but easier to justify than explaining why one person, subject, grade, or school building was more important than another. Johnstown school board also cut the property tax rate from seventeen to sixteen mills for the 1932–33 school year.

At the beginning of the 1933–34 term, Superintendent James Killius reviewed various measures that had been taken to operate within limited finances. Among his list of retrenchments was the news that the teaching staff had been reduced from 535 to 462 over the previous five years while enrollment had risen slightly.[665]

There had even been some discussion of the school district aiding the hard-pressed parochial schools that were facing a shut down. If closed, their pupils would continue their education in the public schools at taxpayers' expense. Percy Allen Rose, the school board solicitor, ruled that the U.S. Constitution forbade such generosity.

<div align="right">11.</div>

THE RIVER STRIKES BACK

THE SAINT PATRICK'S DAY FLOOD OF 1936

I. THE 1936 JOHNSTOWN FLOOD

River Encroachment

In January 1903, word was received from the attorney general's office that the Commonwealth would not be an amicus curiae participant in city lawsuits against the Fearls and the Somerset and Cambria Railway (B&O), parties alleged to have encroached into the Stony Creek River.[666] The city's contention that the Stony Creek River was a "public highway" by an 1820 law would be less persuasive in court. The attorney general had probably been pressured to avoid the case by the most powerful interests in Pennsylvania.

The councils were incapable of grasping difficult legal issues involving sovereign waterway rights, property condemnation, setback lines and statute-of-limitations law—all having unknown costs and no-win political consequences.

Almost twenty-five years earlier (1879–1881), the B&O had been urged and financially assisted by the Cambria Iron Company and a cluster of puppet municipalities to construct the Somerset and Cambria Railroad from Rockwood to Johnstown. Its tracks crowded the Stony Creek River. The Cambria Iron Company had also encroached into the rivers. The PRR had built the Stone Bridge across the Conemaugh. The structure plus the silting it precipitated were believed to have worsened the city's floods.

Johnstown city officials had been looking for an easy way out of the encroachment–property rights issue. They wanted the courts to decide that the Stony Creek River had a natural right-of-way 225 feet wide, and anything that encroached on these limits should be removed at no cost to the city. Everyone acknowledged the city could condemn the river's right-of-way, move everything off of it and excavate and wall off the channel. No one, however, knew the cost or where the money would come from.

Another tactic was tried—to sue the encroachers for damages when flooding took place. They would then be motivated to vacate the river lest a serious claim arise in a future flood. In June 1903, the city sued the B&O seeking $50,000 in flood damages supposedly caused by the railroad's Stony Creek encroachment.

By December the case reached a jury. The railroad had indeed invaded the river. Its trespassing had caused damages—but only ten dollars' worth. A precedent, however, had been set. Damages might skyrocket next time.[667] Later, in 1905, the city got into another lawsuit with the Fearl family, who had been cutting a ditch across disputed river-bottom land.[668]

Floods

Floods continued plaguing the city. On July 11, 1904, Johnstown's streets were likened to Venetian Canals.[669] On June 7, 1906, waters rose quickly to $17\frac{1}{2}$ feet, as measured on a gauge where an 11-foot stage meant flooding. People who had ventured out could not get home. Trolley service was interrupted.[670]

On March 14, 1907, rain and melting snow flooded Johnstown again. An eighteen-foot stage was sustained from 7:00 a.m. until 1:00 p.m., easily the most serious flooding since the 1889 disaster. Parts of downtown were described as "neck-deep, waist-deep, or knee-deep." The telephone system failed. Trolleys were discontinued. People carried their furniture upstairs. Sandyvale Cemetery was covered four feet deep. Passengers arriving at the train stations were stranded.

When the waters receded in the afternoon, the damage had been staggering. The community began urging action. Ideas sprang forth: tunnels to move floodwater past the city or the construction of walls or levees. Ex-Mayor Horace Rose wrote an open letter to the *Tribune* stating that the March 1907 flood had cost $400,000 in damages plus lost wages. These costs would recur. Action was essential.[671]

The O'Connor Decision

Meanwhile the only thing the city had done was to take action against building inside the ever-contested 225-foot Stony Creek right-of-way. To the Fearl case were added two more—injunction suits against Lowman Griffith and W.C. Krieger, each seeking to build within the channel.[672]

Judge Francis O'Connor issued a ruling in the Griffith case. His opinion attacked Johnstown's policy and accused the city of avoiding the issues by picking on "little people" while shying away from giants like the B&O, PRR and Cambria Steel. O'Connor wrote that Johnstown had the authority to condemn a 225-foot right-of-way, pay compensation and construct channels to handle the flooding. O'Connor's opinion reasoned that the city was seeking an easy remedy for a costly, difficult action.[673]

Mayor Alex Wilson proposed a river commission, and he would chair it. The group met and recommended a referendum in November 1908 to approve $1 million in bonds to finance flood works. Next, John Fulton, the superannuated but prestigious engineer,

recommended that preliminary engineering and cost estimates be developed before any referendum vote. Fulton's pronouncement gave the councils an excuse to do nothing. No referendum was held.[674]

Let the Sleepy Dogs Lie

The city was spared its periodic flooding for several years. Everyone drifted into the wishful thinking that the Hinckston Run Reservoir completion in 1905 plus the massive Quemahoning Dam in 1911–12 meant Johnstown's flooding days were over. Apathy returned, and other issues crowded the civic agenda.

Nature, however, got an overdue revenge. During an August 1920 flood, a 100-foot section of the retaining wall built in 1902 by Tom Fearl collapsed, sending dirt and debris into the river. When Mayor Joe Cauffiel sought to prevent Miss Agnes Fearl from rebuilding the wall, the Pennsylvania Water Supply Commission overruled him. No permit would be needed for reconstructing what had previously existed, whether the thing had been illegal or not. Cauffiel wrote the commission:

> I would like to know from you or your department just what your commission sets in session for. I will take no action whatever if they build the river shut.[675]

The Early Winter of 1936

The events planned for Daniel Shields's mayoral inauguration on January 6, 1936, got off to a slow start. By daybreak, six inches of snow covered the ground and more kept falling. Although late, Judge John McCann from Ebensburg managed to reach Johnstown to administer the oath. The early January weather was a preview of the next six weeks: one snowstorm after another plus a little rain.

By January 21, most public improvement projects were deferred, and the WPA men working on them were given snow removal duties. Deep snowdrifts were common in the higher elevations around the city.[676]

By late February, Johnstowners were becoming nervous about snowmelt. Three warming spells brought flood threats. Each time, however, the temperature dropped and little snow melted.[677] Massive ice jams had formed in the rivers, especially the Stony Creek. Workmen used dynamite to blast the slabs into smaller pieces that would pass downstream.[678]

Saint Patrick's Day

By Tuesday, March 17, it had been raining intermittently for four days. With the rivers already up, a steady downpour had begun around eight o'clock Monday evening.

Robert Tross, owner of a men's store, moonlighted for the U.S. Weather Bureau. He maintained a rain gauge and made crude observations of water levels and flows in the rivers. By 8:00 a.m. on Saint Patrick's Day, 1.25 inches of rain had fallen in the past twelve hours—not an unusually heavy amount, but the earth was saturated and frozen, and snow

was on the ground higher up. At 9:00, Tross noted the Stony Creek was up more than 8 feet above its base stage. The rain was falling harder than it had during the night. No one was alarmed. High water was common in springtime. The schools, banks, offices, businesses, shops and department stores opened as usual. Movie theaters began seating at 11:00 a.m.

Wednesday—the day after Saint Patrick's Day—was to have marked Spring Opening Days, a three-day sales promotion. The newspapers were full of advertisements. Merchants had bigger inventories. Two young girls, Mercedes Schonvisky from Morrellville and Mary Ann Whetstone from Everett, the two "Miss Springtime" winners, were expected to be guests of the Johnstown Board of Merchants at the Fort Stanwix Hotel. They were to be driven in a promotional parade with the mayor the next day. At ten o'clock on Tuesday morning, they were scheduled to be photographed with the mayor. The session was postponed—Mary Ann Whetstone had not arrived from Everett.

Instead of being photographed, Mayor Shields was meeting with Bob Tross, who was giving him important news: the rivers were still rising. A stage of fifteen feet or more could be expected by afternoon. Cellars downtown would probably be flooded.[679]

When told by the city engineer that the rivers were rising fifteen inches every half hour, Shields dispatched policemen to advise merchants to move their inventories to higher places.[680] At noon, Tross looked at his rain gauge—another 1.29 inches had fallen since eight o'clock. The rain continued.

Also around noon, Mary Ann Whetstone arrived from Everett and checked into the Fort Stanwix. She had been driven over roads with water a foot deep. After a promotional luncheon, the two young ladies got ready for their downtown visits. When they stepped outside and saw the flooding, everyone realized there would be no tour. Both girls were marooned at the Fort Stanwix. Mercedes Schonvisky fainted.[681]

Valley Pike in the Eighth Ward was reported under water at about 12:15 p.m.—its first flooding since the roadbed had been elevated twelve years earlier. The stage of the Stony Creek at the Franklin Street Bridge was reported at fourteen feet and the rivers kept rising.[682] At about 1:00, basements in downtown were becoming flooded and sewers were backing up. At about 2:00, the water began escaping the riverbeds at a low point along Stonycreek Street downtown.

Howard Custer had an office in the First National Bank building at Main and Franklin. At 1:30, he walked to the Franklin Street Bridge and observed water "overlapping the banks at many points." Hoping conditions would be getting better, Custer returned to his office. By 2:00 he observed that Main and Locust Streets were covered.

Custer reported people were trying to leave downtown. Cars were stalling near city hall, and motorists were unable to get through the junction at Main and Clinton. He also wrote that water was "coming down Bedford Street." He went up to the twelfth floor of his building and watched the water rising up the steps of the Johns Monument in Central Park, submerging the cannon nearby.[683]

The schools let out at about two o'clock. John Shields, the mayor's youngest son, walked from Joseph Johns Junior High on Market Street to his home at Walnut and Locust Place. On Vine Street, downriver from the school, water was knee-deep. His walk home, however, had been free from floodwater.[684]

Helen Price had a 1:30 appointment at the National Radiator office. When departing at 3:00, she observed that Central Avenue and the entire area of the U.S. Steel plant were under water. Continuing through Southmont to her Westmont home, she got caught in a traffic jam of people escaping low areas.[685]

Swift Currents and Rescue Efforts

From the First National building, Howard Custer began to notice swift currents moving through the streets and open areas. Several pianos from the Porch Brothers Piano Company at Vine and Franklin floated across Main Street and Central Park.

The rapid flows over the streets and open areas were caused by water being higher in the Stony Creek River than in the lower, swifter Little Conemaugh. Into this mix, there were also strong flows coming down the steeper streets like Bedford and Frankstown Roads, plus the wave effects caused by bridges and the Stony Creek's meandering.

One of the more unusual effects of the rising, swift waters was the decapitation of Joseph Johns's bust from his monument in Central Park. While no one saw it happen, a floating tub must have bumped the statue with enough force to dislodge the head, which fell into the tub causing it to sink.

Swift overland currents Tuesday afternoon were causing severe losses, problems and tragedies. Mayor Daniel Shields had gone to his private company office in the Capitol Building at Vine and Franklin. In helpless horror he watched Foster "Red" Buchanan, a cameraman and photo-shop proprietor, get swept away. He also witnessed a heroic effort by Myron Morrison, the Sears-Roebuck manager, trying in vain to save him. Buchanan's camera was later found. Two flood pictures he had taken before drowning were developed and published

Robert Tross and his store clerk also had a narrow escape from entombment in Tross's Main Street shop. There was no way to get upstairs in the store without going outside. Afraid of getting trapped and drowned, they chose to leave, but encountered a swift, powerful current. Someone threw them a rope. Both reached the second floor safely.

Two transit company employees and four passengers were rescued from a trolley stranded on Main Street at the First National. As the water kept rising, the men had tried to enter the bank but the door would not budge. With darkness approaching, two employees of the Home Ownership Loan Corporation, Dell Comiskey and John Philson, tied a fire hose to something solid, trailed it through a second-floor window and got it to the trolley where it was also secured. The six men climbed the hose and entered the building through a window. Once inside, they were given dry clothes and whiskey.[686]

An exceptionally dangerous part of downtown was the area along Vine and Union Streets near the incline plane, where the waters were swift, erratic and deep. The city fire department maintained two rescue boats. Other small craft and canoes were also used in rescue work.

Countless people were pulled to safety and were ferried over to the incline plane cars. Over a two-day period the facility hauled almost four thousand people to Westmont. "Billy" Grubb, the company's superintendent, worked through Tuesday night into Wednesday until he was exhausted.[687] Women gave out coffee and sandwiches.[688]

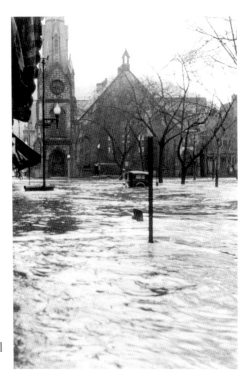

A view of the Franklin Street Methodist Church and Central Park during the afternoon of March 17, 1936.

While there were many successful rescues, there were also tragedies. Trapped in her home, Mrs. Jacob Fruhlinger had climbed onto her refrigerator to escape the rising water. She drowned. Nearby, Ralph Herrod and Robert Wood from Westmont had rescued three groups of people in their canoe by pulling it along a rope secured between the incline itself and its ramp. On the fourth trip the canoe capsized. One passenger, Donna McKee, a high school student, was saved. "Jimmy" Langham, a ten-year-old, and Mrs. Cecelia Seifert Wehn were drowned.[689]

Gregory Kostoff, a used-furniture-shop owner in Cambria City, drowned at his store. Nearby, Joseph Runko drowned at home. Daniel Gallagher from Pine Street in Hornerstown drowned downtown on Main Street. Seen falling off the Woodvale Bridge, Tony Weisback from Prospect, was never found.

There were other deaths attributed to the flood, but not by drowning. The flood also caused strokes, heart attacks, exposure and even suicides.

The Longest Night

At 4:22 p.m. on Tuesday, March 17, 1936, the Pennsylvania Telephone Company system ceased functioning in Johnstown. Despite efforts to prevent it, the electric system failed before nightfall. The traction company's power station on Baumer Street got flooded out in the afternoon. Even had the power been maintained, every trolley line was badly flooded at some point.

During this longest night, Johnstown was a city of contrasts. With the power system not working, there was darkness everywhere. One could see occasional flashlight flickers in the

windows of tall buildings. The Bethlehem Steel building on Locust Street and the incline plane, however, were both lit thanks to Bethlehem's power system remaining in service.

Daniel Shields's family members had moved furniture and rugs to the second floor of their Walnut Street home. There had been no communication with the mayor since earlier in the day. The gas still worked so the family could cook a hot evening meal amidst the water rising inside their home. John Shields's bicycle had a battery-powered light that got used sparingly all night long, chiefly to follow the steady ascent of the water up the stairs, which finally halted around midnight at the fifth interior step.

Worry was everywhere. Family members separated by individual circumstances were unable to contact one another. Well over one thousand people were held up in the taller downtown buildings. City Hall was jokingly renamed "Hotel City Hall." Customers trapped in Glosser Brothers Department Store helped store employees move merchandise to higher levels. Later there was group singing. The store distributed food and made use of practical merchandise like flashlights and automobile batteries to overcome the darkness. Someone connected a radio receiver to a battery so everyone could enjoy the radio. This was comforting until a news program mentioned a risk of the Wilmore Dam breaking. People rescued other citizens who were struggling outside by helping them enter the building through the fire escape at Good Alley. There was even talk of an annual Saint Patrick's Day reunion for everyone marooned in the Glosser store.[690] The scene was similar in the Penn Traffic store.

Things were not so pleasant for the Bell Company operators and employees trapped on the Snook Hardware second floor. Everyone went without food for twenty-four hours. There was constant fear caused by the water's ominous rise to a level just below their floor.

People were trapped in the Joseph Johns School, in banks and in the Public Safety Building. About 125 patrons were marooned in the Cambria Theater and another 100 were trapped inside the State Theater. There were no reports of panic in any downtown building.

The loneliest of many frightened people must have been Andrew Tkac, an eighteen-year-old Cambria City youth who sought safety by climbing onto the Ten Acre Bridge. Cold and wet, Tkac remained alone throughout the night. Fourteen hours later he descended.

At about 10:15 p.m., the rainfall stopped. Since Tross had no rain gauge after midday, he could only estimate the total rainfall by averaging several rain-gauge readings from around Johnstown. He concluded that from noon until 10:15, another 3 inches had fallen. In addition to snowmelt, there had been approximately 5.5 inches of rainfall in just over twenty-six hours.

Trapped in another building near the Shields' home, George Buchanan, a clerk with the Johnstown Water Company, had the good sense to mark times and water elevations on a wall. The crude graph showed that the cresting in downtown had occurred at about 12:15 a.m. on March 18. Fifteen minutes later, the water started to recede.

A New Day

When dawn finally arrived, the waters were still going down. At long last there was a trace of sunshine. Daylight and receding water lessened tensions. Instead of the fear of drowning and being caught inside a collapsing building, new anxieties had to do with the way things

would be after the flood. People were separated from family and friends. There was no way to communicate. Many did not know what they would find when they got home.

Floodwaters continued to cover much of Johnstown. Rowboats were moving policemen and firemen searching for people needing assistance. Wrecked automobiles were all over the place. Howard Custer wrote that from the roof of the First National, he could see "utility wires shaking violently"—possibly an effect of automobiles and huge objects lodged against utility poles being shaken by swift water. The governor's plane was seen flying overhead. Early in the morning, trucks bearing workers in hip boots began bringing food and water and rescuing people trapped in the buildings.

Policemen and National Guardsmen were patrolling the streets. Although most store windows and many entrance areas were smashed, there was no looting. By early afternoon the waters had dropped so as to be confined within the riverbanks. An oozy, brown slime coated everything. Some streets and sidewalks were heaved up. Cans, cars, furniture, uprooted trees, tree limbs and litter were all over the place.

The Bridges

The Ferndale Bridge disappeared about 7:30 p.m. on Saint Patrick's Day. The Poplar Street Bridge connecting Kernville and Hornerstown vanished at an unknown time at night.[691] The Maple Avenue Bridge (near the railcar shop) was also washed away at an unknown time. The Franklin Street Bridge somehow survived the highest water but collapsed around 9:30 a.m. Wednesday. Bethlehem Steel's footbridge was also destroyed. The city's new concrete bridges survived without damage.

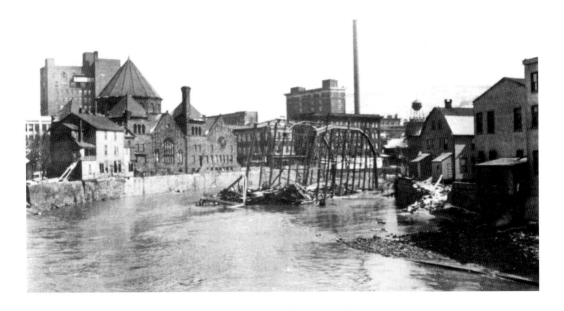

The Franklin Street Bridge collapsed on March 18, 1936, ironically after the high waters had receded.

To the Hills! To the Hills!

There had been unsubstantiated reports of upstream dam failures on Saint Patrick's Day and during the night. While frightening, no one could take them seriously. People marooned in houses and buildings, being isolated from one another and cut off from communications, were unable to hear wild reports.

Just before three o'clock Wednesday afternoon, based on a news item broadcast by an amateur operator, Gerald Coleman, word spread like wildfire that an unspecified dam had broken. Almost everyone took this to mean the Quemahoning Dam. A repetition of the 1889 disaster was believed imminent.

Firemen and policemen alike, thinking what they were hearing was true, went about urging people to get to high ground. "To the hills! To the hills!" rang out everywhere. A stampede was underway. Horns sounded. People hastened on foot. There was panic in the streets. Andrew Shields, one of the mayor's sons, rushed into the family's home and urged everyone to get out at once.

Flornell Shields, the mayor's wife, took more time than her children wanted. The secretary-treasurer of the Catholic Benevolent Society, a membership-based insurance provider, she insisted on taking the books. She also took time to put on a favorite possession, a fur coat. The family then proceeded across the Walnut Street Bridge, up the Prospect Viaduct, onto the hill.

Frank Foster (of the department store family), recently released from the hospital for an appendectomy, ran full force up Prospect Hill. Patients were evacuated from Lee Hospital. In a short time, crowds of people had left the city only to spend time in the cold, drizzling rain.[692]

The scene on Prospect Hill could be found on similar high places around Johnstown. The incline plane remained in operation during the escape. Not waiting for a car, some people climbed the steep hill to Westmont.

A determination was finally made that no dam had broken and the Quemahoning was safe. No one ever knew for certain who had originated the report. A formal complaint was filed against Gerald Coleman. He admitted he had broadcast the news but stated he had given out what had been told him. Shields continued to believe Coleman was the instigator, but charges were never filed.

A Few Parameters

Post-flood studies done by the U.S. Army Corps of Engineers estimated that the Little Conemaugh River at Johnstown had crested about 7:30 p.m. on March 17 with a flow of 30,000 cubic feet per second (cfs). The Stony Creek River had crested about four hours later, discharging approximately 59,000 cfs. The Conemaugh River, just below the Point, had peaked around 12:30 a.m. Wednesday, discharging roughly 81,000 cfs.[693]

Water elevations were erratic due to swift movement and flow obstructions caused by bridges and buildings. It was determined there had been simultaneous water-level variations of up to two feet at different locations astride the same river stations.

In the area of the Point, homes were flooded up to sixteen feet above the street. At city hall, the floodwater reached 14 feet 4 inches above the sidewalk. Two short blocks away at the Public Safety Building, the peak level was 14 feet 1 inch. At Joseph Johns Junior High School the water crested at 9 feet 2 inches above the ground. On Chestnut Street in Cambria City a few houses were flooded up to 13 feet, well above their second floors. The water crested 10 feet above the street at DuPont Place and Central Avenue in Moxham.

Floodwaters had covered all of downtown and Cambria City, most of Kernville, a large part of Hornerstown, the low areas of Woodvale and Old Conemaugh Borough, parts of Rosedale, Coopersdale, Morrellville, most of the Bethlehem Lower works, all of Central Avenue in Moxham including the entire Lorain Steel Plant, and Valley Pike, Hay Street and the Cochran Junior High School grounds in the Eighth Ward. Of the city's twenty-one wards, only the Twelfth and the Nineteenth were free from water. The flood also covered all of the low areas in Ferndale, Riverside and Benscreek.

Within Johnstown City, floodwaters had covered 1,118.2 of its 3,689 total acres—just over 30 percent. Seventy-seven buildings were completely destroyed and another 2,925 were damaged. Private property alone had suffered losses of about $41 million.[694]

His Finest Hours

Like thousands of others, Mayor Daniel Shields had also been marooned downtown. He was in his own Capitol Building. Having seen Red Buchanan getting swept away, Shields knew any effort to wade the streets was fraught with danger. Besides, two weeks earlier, he had been released from a several-day stay in Lee Homeopathic Hospital for a leg infection.

When daylight finally arrived, he could see the devastation and the water still rushing across downtown. Somehow Shields got rescued and went immediately to the only building with electric power—the Bethlehem Steel offices on Locust Street. Not only was there electricity, but early Wednesday morning Bethlehem had also restored its telephone and telegraph systems. Through them Shields could contact the outside world. General Manager L.R. Custer gave the mayor a dry office with telephone, telegraph and electric current.

This space in the Bethlehem office building quickly became a flood-recovery command post. Small but functional space was also given the state police, National Guard, Red Cross, WPA and other disaster-relief agencies, all of which would be working with the mayor.[695]

Everything was completely new to Daniel Shields, mayor for just over two months. He had never been involved in a disaster and had no experience interacting with high-level state and federal officials or with the Red Cross. His talent was charm and an ability to work with others.

That Wednesday afternoon an airplane brought Robert Bondy, the director of disaster relief for the American Red Cross, to Johnstown. Both he and other staff members accompanying him joined the mayor at the Bethlehem building. Their arrival gave Shields the one thing he most needed—expertise. Bondy was one of the most seasoned disaster experts in the world; and he was ready, willing and able to help.[696]

Shields promptly issued an emergency proclamation. Citizens were forbidden to loiter about the streets. Sightseers were not allowed in the city. A general curfew would go into effect every night at nine o'clock. All sales of intoxicating liquor whether by bottle or "by the drink" would cease until further notice. A system of individual passes was devised.

In addition to overseeing the recovery and security efforts, Mayor Shields made several radio talks describing what was going on and assuring everyone that the recovery was progressing. His programs were modeled after President Roosevelt's "fireside chats."[697]

Martial Law

Governor George Earle had flown over Johnstown the morning of March 18. While not conferring with Shields, he ordered units of the National Guard and the state police mobilized for service in and near the city.

The National Guard brought 1,838 officers and men comprising the 112th and part of the 110th Infantries, the 304th Cavalry Squadron and a hospital company all to Johnstown soon after the floodwaters had receded. In addition, Lynn Adams, a major in the state police, quickly arrived with 81 troopers, and Captain D.E. Miller of the Pennsylvania Highway Patrol brought another 80 patrolmen. Shields had them all work through Police Chief Harry Klink.

Johnstown was under a sort of martial law, with Shields in charge. The city soon became so regimented that people with legitimate business had difficulty getting about. There was, however, no looting. While there was some sightseeing that interfered with the clean up and recovery, it was kept to a minimum.[698]

The Lost Ones

From the disaster's beginning, there were people not knowing the fate and whereabouts of family and friends. Husbands were unable to contact wives. Children had gotten separated from parents and siblings. Four members of one family were each trapped in separate locations with no single member knowing the others' whereabouts.

The WJAC radio station got energized thanks to an emergency power source. Its manager, J.C. Tully; his assistant, Mrs. Fred Gist; and the announcer, A.J. Reed, continued broadcasting news of missing and separated persons.[699]

The Red Cross

The Red Cross staff quickly assessed problems and went into action. Thousands were homeless. People were unable to reach their homes, and many homes were either destroyed or were uninhabitable. The Red Cross established twenty refuge centers where the homeless were housed temporarily in schools, fire halls, churches and public buildings. The centers were also used to feed thousands of people who either lacked food or a means of preparing it.

One center was located in two nearby Daisytown schools—better equipped than most others because their electric power was never lost. The Windber and South Fork Red Cross chapters contributed food, clothing, fuel and the services of several nurses. During the first week after the flood, over six hundred people were being housed in the Daisytown center. By Sunday, March 22, only seventy remained.[700]

In time, families were reunited. Homes got cleaned up, dried out and repaired. As the refugee centers ceased being needed for dormitories, they were continued as feeding stations. By March 27, the Red Cross was still feeding eleven thousand people.

With the normal food distribution system through grocery stores in shambles, the Red Cross created twelve commissaries, mostly in school buildings, where people were able to procure food for preparation in their own homes. By late March, about 35,000 people were still being supplied with rations.

The Red Cross also provided seven first-aid stations, each with nursing care. A common ailment was semi-asphyxiation, a condition affecting people working in damp, mildewed basements. The Red Cross designated twenty-one coal distribution sites where coal companies dumped coal at no cost, and people were free to pick up small quantities to heat their homes.[701] The organization also did extensive work helping people restore their way of life in small, important ways. The technical term was "rehabilitation." Out of 12,093 case requests, the Red Cross aided 11,659 with donations of furniture, radios or other things for normal living.[702]

As part of its quick actions to bring food, shelter, medical care and disaster expertise and organization into the stricken city, the American Red Cross in 1936 spent $1,377,417 in Cambria County alone. It was Red Cross policy to buy and spend locally where possible, a strategy to help revive battered local economies.

The WPA and the CCC

Already mobilized in and around Johnstown and becoming quickly augmented with workers assigned from other counties, the WPA began cleaning up mud and debris from streets, lots, homes and building entrances. Within the first five days of the flood, 6,385 total men using 350 trucks had removed 1,251,559 cubic yards of mud and debris from streets and open areas and 31,000 cubic yards from cellars. Almost everything was dumped into the rivers where graders pushed it into swift channels in hopes of its getting carried downstream before another heavy storm. Damaged or ruined cars were towed to garages or junkyards. In addition to the muck, WPA workers disposed of meat, seafood and countless animal carcasses.[703] The spoiled food and animal remains were burned outside the city. Tons of quicklime were spread.

As late as March 28, WPA leaders in Johnstown estimated the clean up was half finished. It seemed never to end. People cleaning muck from their cellars would haul it outside and dump it onto streets that had already been cleaned. Some streets were cleaned several times.[704]

The Civil Conservation Corps' being in Johnstown was fortuitous. Not only did the CCC rescue people from flooded homes and businesses, but its members also actively patrolled

parts of Johnstown on March 18 as special policemen. The CCC also cleaned individual homes, churches and other places. As of March 30, the CCC had cleaned six hundred homes, mostly in Kernville.[705]

Bridge Replacement

The flood had washed away the Franklin Street (Kernville), Poplar Street, Ferndale, Riverside and Krings Station Bridges. It had also severely damaged the Maple Avenue Bridge near the Franklin Borough boundary. More than $400,000 in WPA funds was secured to help pay for bridge replacement and repair. Each replacement was done by contract based upon competitive bidding.

The Franklin Street Bridge carried heavy traffic volumes including a trolley line. The replacement cost was over $140,000 and the new bridge was bigger, heavier and wider than the older one. It was also placed higher over the river with approach slopes on each end.

A new Hickory Street Bridge replaced the washed-out Poplar Street Bridge. The new span was better connected with the southeastern end of Napoleon Street and sat higher over the river. The Hickory Street Bridge cost $105,000.

The old issue of where to locate the Ferndale-Moxham Bridge was quickly settled when business owners on each side of the river expressed concern that replacement delay would be financially ruinous to them.[706] The new span to Ferndale was placed on the same site as the former one but was bigger, wider and had sidewalks. The price was $93,300.

Outside the city, the new Krings Station Bridge and the Riverside Bridge cost respectively $44,500 and $58,000. All five new bridges were installed and put into use in 1937 using WPA resources.[707]

The Rehabilitation Committee

On March 20, a large rehabilitation committee was created. Mayor Daniel Shields was chairman. The group met for the first time on March 23 with about one hundred business and civic leaders present. The mayor was praised for outstanding leadership. Everyone pledged cooperation. The committee would pursue three basic goals:

1. Returning the community to normalcy.
2. Procuring federal and state aid to restore roads and bridges, and to clean the rivers and clogged sewers.
3. Solving Johnstown's future flood problems.

The Return to Normalcy

By April, most of the surface-area clean up had been accomplished and things were returning to normal. Families were reunited and in most cases were living at home or with relatives. Most basements had been pumped out and the mildewed smells were being aired away. Walks and streets were repeatedly hosed down.

The Cambria Works of Bethlehem Steel had been affected by water and mud but its facilities suffered no structural damage. Each day brought announcements of orders being filled. On April 1 Bethlehem officials announced that everything in Johnstown was functioning at the pre-flood production rate. Rumors of a total or partial shutdown were denied at all levels.[708]

No local newspapers were printed on March 18 and 19. The *Tribune* was printed on Friday, March 20, and the *Democrat* was published on Saturday, March 21, in Windber. Beginning Monday, March 23, both regular papers were composed in Johnstown but printed in Altoona through an arrangement with the *Altoona Mirror*.[709]

Johnstown's overlapping telephone situation contributed to an uneven service return. The Bell System was never flooded and its more limited facilities were quickly restored. The Pennsylvania Telephone Company's switching system, housed in the basement of its Jackson Street building, had been completely flooded. Service was restored in increments, but everything was back to normal by March 26.[710]

Almost all stores in Johnstown had reopened by the end of the first week, but many were in "make-shift quarters" such as upper levels.[711] The banks were all open by March 24.[712] Electric power service was uneven. Many areas around the city never lost power. The street lighting in downtown and Cambria City was resumed on March 29 after twelve nights of darkness.[713] Trolley service had been held up until the Johnstown Traction Company could reactivate its Baumer Street plant. The electric motors of the trolley fleet also had to be reconditioned and the tracks had to be cleaned. By March 24, limited bus service was being provided to the edge of downtown and by March 30, five trolley lines were in service.[714]

On March 24, units of the National Guard began pulling out. The 110th Infantry was first to depart. Five days later they would all be gone. The morning of March 28, 520 officers and men paraded to the PRR station, escorted by the regimental band. They all passed in review at the Cambria Theater where the mayor and General Edward Martin, occupying a reviewing stand atop the marquee, greeted them.[715] Meanwhile, state police and highway patrol officers had been withdrawing each day. All were gone by April 2.

Some two weeks after the Saint Patrick's Day Flood, the first phase of Johnstown's recovery was over. While there were serious inconveniences, most services were back and the community was largely cleaned up. On May Day, the Misses Springtime renewed their Johnstown tour. Both girls collected their cash prizes and chose their wardrobes.[716]

Heavy Lifting

Three weeks after the flood, Dan Shields was at the peak of his popularity. The *Johnstown Democrat*, often critical of the mayor, wrote on April 6:

> *In times of disaster men are made—others fall far short of expectations. Forgetting political affiliations, one individual stands out as "tops" in the whole scheme—Johnstown's mayor, Daniel Shields. "Dan" thrived on abuse and punishment. Bereft of home and separated from his family for seven days after the flood, Johnstown's mayor became a mayor in fact. He functioned. He "clicked." We'll finish with Shields thusly: He came through.[717]*

Goals and Progress

The key goals occupying public officials were bridge replacement, dredging enormous silt and other deposits from the rivers, unclogging sewers and achieving a permanent solution to Johnstown's long-standing flood problems.

On Saint Patrick's Day in 1937, the Johnstown community looked back in various ways—news summaries and editorials, testimonial advertisements and a "Bury the Flood Banquet" sponsored by the Advertising Club, where forty upbeat letters from business and public officials were read.

No business of consequence had left Johnstown or had been forced to close because of the flood. Indeed the recovery had created employment and had pumped dollars into the economy. The rivers in the city were piled up with silt and other debris. At risk of disease, children had to be kept from playing in huge silty sandpiles. Although critically important, river dredging had been difficult to arrange because of WPA program regulations and the laws and rules governing navigable waterways. An earlier application for almost $900,000 had been rejected because much of the proposed dredging was judged a "flood control project." On July 27, 1936, however, work began through two separate contracts drafted to meet programmatic requirements.

Two More Floods

Meanwhile the city experienced two more flood scares. On Sunday and Monday, January 10 and 11, 1937, the Stony Creek River rose to a few inches above flood stage. A much more serious flood occurred on April 26, when the Stony Creek reached a stage of 17.53 feet in midmorning. Floodwater got to be 5 feet deep in parts of downtown.

II. FLOOD PROTECTION FOR JOHNSTOWN: THE CHANNEL WORKS

Even before Johnstown had finished cleaning up from the Saint Patrick's Day flood, civic leaders were thinking about a permanent solution to the city's century-old flooding problems. The *Tribune* began to repeat editorials urging a massive scheme for relocating the Stony Creek River and replacing the PRR's Old Stone Bridge. The one-hundred-member Johnstown Rehabilitation Committee appointed a subcommittee on flood control. It met on April 16 and recommended two upstream reservoirs—one on each river. The impoundments would be in addition to widening and reconditioning the rivers.

The flood strategies for Johnstown had to be part of a bigger national picture. Flooding was a recurring problem for many Ohio River Basin communities. The March 1936 flood had struck Pittsburgh, Wheeling and Cincinnati, among other places. Whatever would be done for Johnstown would have to be part of a larger scheme of solutions; Johnstown

would have to work through the federal and the state governments. Plans had been under preparation for years to protect Pittsburgh and Cincinnati. Any program for Johnstown had to be in harmony with these long-standing plans.

The lead agency for the federal government's efforts was the Army Corps of Engineers. The very day of the flood-control subcommittee's first meeting, it was announced that Major W.E.R. Covell would become Pittsburgh District Engineer. Covell was a career military officer and top man in the West Point class of 1915. His appointment proved fortuitous for Johnstown.[718]

The mayor, Councilman Fulton Connor, Larry Campbell of the chamber of commerce, and others had all become active with what was going on between the state and federal governments and a tri-state flood-control authority serving the Ohio River Basin. A bill, the Omnibus Flood Control Act of 1936, had been pending in Congress for weeks. After the March floods throughout the Ohio River Basin, its enactment was inevitable.

Meanwhile, Daniel Shields and Larry Campbell had begun to lobby aggressively against an item in the proposed legislation—a major impoundment below Johnstown near Saltsburg. Their basic concern was that if it were built, there would be less need for a flood-control reservoir above Johnstown.[719]

Joseph Gray, the local congressman from Spangler, ignored the city's pressures to remove the Saltsburg Dam from the bill. He secured funding for an Army Corps of Engineers study to address Johnstown's flooding. Absence of an Army Corps plan with cost estimates had prevented Johnstown's inclusion in the 1936 legislation. Gray's strategy was to get the plan prepared and provide for Johnstown by amending the statute later.

Lieutenant Colonel Covell had arrived in Pittsburgh in May. The Johnstown study was his first as district engineer. Work was underway on the Johnstown flood study by mid-June 1936. Among other things, the Army Corps of Engineers team from Pittsburgh was carefully considering a huge reservoir that might be located near Holsopple, upstream of Johnstown.[720]

FDR's Visit

On Tuesday, August 11, it was announced that President Roosevelt would make a personal visit to the Johnstown area to tour the Conemaugh River Valley. Roosevelt's visit doubtless fit into his 1936 reelection strategy.

While it had been stated that he would not be speaking, arrangements were made for WPA workers to leave work early. Crowds began packing into Johnstown as if it were "circus day" a generation earlier. Andrew Shields, one of the mayor's sons, was chosen to drive the president, the mayor, Governor Earle, General Markham (head of the U.S. Army Corps of Engineers) and Colonel Covell in Charles Schwab's Packard limousine. Police lined the route and secret service agents remained all around the car.

Roosevelt toured Johnstown, the potential dam site and other places. He gave a short speech at Roxbury Park as his distant cousin, Theodore Roosevelt, had once done. The president then continued a motor tour through the city. The tour schedule had included passing by the Shields family's newly constructed home on Somerset Street. No stopping was

President Roosevelt tours Johnstown on August 13, 1936. Lt. Col. W.E.R. Covell briefs the president about Johnstown's flood control options. Covell was district engineer for the Pittsburgh office of the U.S. Army Corps of Engineers. Mayor Daniel Shields is seated at the president's left.

anticipated. At this point during the tour, Shields said something like, "Now Mr. President, we have a little surprise. Don't get excited. Everything will be all right."

When Andrew Shields brought the car to an unexpected halt, a startled secret service agent shouted, "What the hell's going on here!" A photographer had been waiting to take a special group photograph of the Shields family and a few friends together with the president seated in the car. Once accomplished, the motorcade continued.[721]

Roosevelt had gotten to the city by special train at about five o'clock in the afternoon. His tour throughout the Johnstown area had taken about two hours. Prior to the train's midnight departure, Shields, the four councilmen and City Engineer Lee Wilson met with FDR in the presidential railroad car.

The president of the United States, in the company of the highest officials of the U.S. Army Corps of Engineers, had promised flood relief in general and a huge upstream dam in particular for Johnstown.[722]

The Corps Flood Study

The Army Corps of Engineers' Johnstown flood study, one of the most important reports ever done for Johnstown, was finished the following May. It contained a comprehensive summary of the city's flooding problem and a feasibility analysis of alternative solutions.[723]

The earlier thinking had been for what is now the Conemaugh River Dam to have been constructed near Saltsburg where it would impound the runoff from 1,374 square miles in a reservoir with a capacity of 283,000 acre-feet. Subsequent investigations showed that a reservoir at that location might leak. A decision was then made to locate the dam at its present location, the Bow Site, upstream of Saltsburg where, with an estimated capacity of 208,000 acre-feet, it would control a tributary basin of 1,347 square miles. Since the latter drainage basin would be almost the same size but its reservoir capacity would be 30 percent smaller, there was concern that the Conemaugh Reservoir at the Bow Site would not reliably contain severe floods and therefore needed to be augmented by more reservoirs.[724] Should any impoundments be located above Johnstown, the city would also receive flood protection, as would Pittsburgh and other downstream areas.

A total of thirty-two dam sites above Johnstown were evaluated and their costs estimated.[725] The study also investigated the feasibility of channel works along Johnstown's three rivers. Since the optimum size, shape, invert-grade profile and other features affecting their peak capacities would logically be guided by whatever system of reservoirs might be built upstream, a number of channel work alternatives were considered. These alternatives and their estimated costs would vary depending upon which of the several configurations of flood-control reservoirs would complement them.

If channel works alone (no reservoirs upstream) were constructed, the report concluded that the best point of diminishing returns and maximum excess of benefits over costs would be reached when designed to lower a "project flood" by 14.9 feet over what would happen if nothing were built at all.[726] In 1937 this alternative was estimated to cost $9,420,000.

If channel works were designed in conjunction with a major reservoir on the Stony Creek River near Hollsopple, $7.6 million would be needed. This dam and channel works combined would lower a "project flood" by 18.4 feet over what would occur if nothing were done at all. In short, with an $11,408,000 impoundment near Hollsopple, the optimum investment in channel works through Johnstown would have been $1,780,000 less than the optimum channel works alternative with no upstream reservoirs.

The First Johnstown Amendment

An amendment to the 1936 legislation, passed on April 27, 1937 (when the city was undergoing yet another flood), authorized one or more reservoirs above Johnstown if the feasibility were established by the corps of engineers. The amendment neither provided additional funding nor mentioned channel works or levees.[727]

While this amendment spoke of possible reservoirs, everyone knew the Omnibus Flood Control Act would have to be amended again if Johnstown was to become protected by channel works. The most promising impoundment site had already been judged infeasible but smaller sites were still being assessed.[728]

On May 14, 1937, Mayor Shields, Councilman Fulton Connor and City Engineer Lee Wilson appeared before a special subcommittee of the House of Representatives Appropriations Committee dealing with flood control. Wilson urged that Johnstown

receive protection against a flood equal to half again the peak discharge of the 1936 flood, meaning flood-control works adequate to handle or prevent a discharge of 120,000 cfs below the Point.[729]

The Second Amendment—Channel Works

Thanks to Senator Royal Copeland of New York, the 1936 Omnibus Flood Control Act was amended a second time and signed into law by the president on August 28, 1937. It added some simple language: "flood protection shall be provided for said city [Johnstown] by channel enlargement or other works." No additional funds were authorized through the amendment.

By law, Johnstown was to receive "flood protection." The law, however, did not define "flood protection." The only clarification of legislative intent came during Covell's testimony before the House of Representatives Committee on Flood Control on June 9, 1937, about two months prior to the enactment of the amendment. The spirit of his testimony was that Johnstown should be receiving flood works adequate for complete protection against a recurrence of the 1936 flood:

COL. COVELL: *In the Omnibus Flood Control Act of 1936 there was approved a project of nine dams for the Pittsburgh area…That act has been amended by the Congress permitting the chief of engineers to shift the location of any or all those dams. That gives the chief of engineers authority to build a dam or dams above Johnstown.*

THE CHAIRMAN: *Will it give any protection against a recurrence of the 1936 Flood?*

COL. COVELL: *One dam alone cannot, or a series of dams on all the streams cannot; that is, the dams at the particular places cannot give complete protection against a 1936 Flood.*

THE CHAIRMAN: *They must be supplemented by local protective works?*

COL. COVELL: *Therefore, the dams must be supplemented by something else such as channel improvements. It is entirely possible to protect Johnstown completely against the 1936 Flood by channel improvement alone.*

THE CHAIRMAN: *What do you mean by that, by the deepening and widening of the channel of—*

COL. COVELL: *Of the river through Johnstown; yes, sir.*[730]

The Recommendation

Eight days prior to enactment of the Johnstown channel works amendment, a recommendation went forward from the Cincinnati division engineer to the chief of engineers in Washington:

a. *$7.6 million be spent for general channel clearing and enlargement for Johnstown,*
b. *and a flood-control reservoir be constructed on the Stony Creek near Hollsopple to cost $11,408,000 including land acquisition.*

Four weeks after the channel amendment had become law, a determination was made by the chief of engineers in Washington that the Hollsopple Reservoir was infeasible due to cost and old coal mines. It would not be built.

When the decision was made, the recommendation for channel works stood firm at the estimated $7.6 million (the cost of channel works to complement an upstream reservoir that would not be built). No effort is recorded or mentioned anywhere of anyone pursuing the optimum channel works alone (no reservoir) alternative that had been estimated to have cost $9,420,000 and which would have lowered a "project flood" by almost fifteen feet.

The hydrology of the Saint Patrick's Day Flood in Johnstown was studied extensively. The waters exceeded the flood stage by fourteen feet. Nonetheless, in the 1937 corps report, it was estimated that the $7.6 million to be invested in channel improvements would reduce a "project flood" by thirteen and a half feet. The 1936 flood involved just over half the discharge of a project flood. The report made no distinction between the channel works' capacity to lower the peak crest of a project flood and that of another 1936 flood. This statement appeared in the report, however: "Such a degree of channel improvements would reduce a March 1936 Flood by about 13.5 feet."

In short, the final channel project approved for Johnstown had been planned as if there would be a flood-control reservoir at Hollsopple, which was never provided. While one might read a legislative intent that "flood protection" for Johnstown meant protection against the equivalent of a 1936 flood that had crested fourteen feet above flood stage, the recommendation would in fact provide for works that would lessen a major flood crest by thirteen and a half feet.

After the Johnstown channel works amendment was signed by the president on August 28, 1937, Pennsylvania's secretary of forests and waters, Dr. James Bogardus, suggested three small reservoirs be installed within the tributary system of the Stony Creek. After review by the corps of engineers, they were not pursued. Johnstown's flooding would be prevented or lessened by channel works alone.[731]

Construction

Separate contracts were let in stages for six construction units plus one sub-unit for infrastructure relocation. Construction began at the downstream terminus of the project and proceeded upstream. Work actually began on August 23, 1938. There was no wartime postponement. Federal authorities were already convinced that Johnstown's steel mills were vital to the war effort and might become damaged in a flood. The total cost—$8,361,318—was 10 percent greater than the original estimate. Final inspection took place on November 27, 1943.

Flood-Free Johnstown

Inspection and project acceptance by the Army Corps of Engineers in Johnstown was occasion for a big celebration. To promote the city and dispel a flood-prone reputation, the community's leadership organized a Flood-Free Johnstown Committee and, among other things, promoted

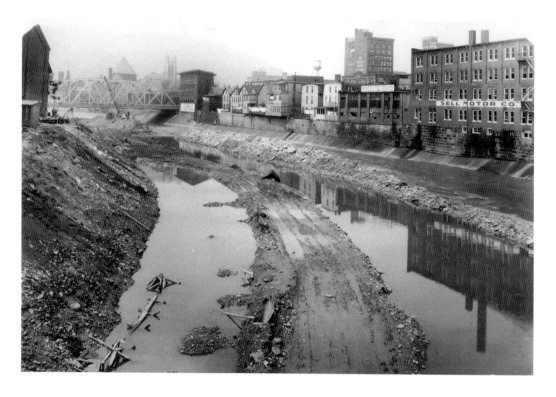

The Johnstown Flood Control Project under construction. This view (approximately 1941), taken from the Haynes Street Bridge, looks downstream toward the new Franklin Street Bridge.

a national advertising campaign. Editorials, newspapers and magazines nationwide told of Johnstown's channel works and its new "flood-free" status. Franklin Roosevelt wrote a letter to Walter Krebs, chairman of the Flood-Free Johnstown Committee:[732]

> *Johnstown from now onwards will be free from the menace of floods. Happily for the future of Johnstown, its citizens can now devote all their energies to their ordinary pursuits without worry over the impending hazard of uncontrolled waters.*

While the corps of engineers had developed technical studies indicating that the channel works would not completely contain a repeat of the Saint Patrick's Day Flood, and had also calculated that on rare occasions Johnstown might experience floods discharging 150,000 cfs or more below the Point (which would flood the city hall area about seventeen feet deep even with the new channel works in place), Colonel Gilbert Van Wilkes, the Pittsburgh district engineer, stated, "the project will enable the channels to pass a flood equal to that of March 1936 <u>at barely above bank-full stage</u>. [emphasis added] We believe that the flood troubles of Johnstown are at an end. We thank the people of the city for their cooperation and salute the 'Flood Free City of Johnstown.'"[733]

BIBLIOGRAPHY

Alexander, James. *Jaybird: A.J. Moxham and the Manufacture of the Johnstown Rail*. Johnstown: Johnstown Area Heritage Association, 1991.

American Red Cross, Cambria-Somerset Chapter. "An Operational History of the American Red Cross, volume 2, 1946–1978." Privately printed, n.d.

Bates, Frank, and Frank Goodnow. *Municipal Government*. New York: Century Company, 1919.

Berger, Karl, ed. *Johnstown: The Story of a Unique Valley*. Johnstown: Johnstown Area Heritage Association, 1985.

Biographical and Portrait Cyclopedia of Cambria County, Pennsylvania. Philadelphia: Union Publishing Co., 1896.

Biographical Sketch of Robert E. Bondy. *Who Was Who in America*. Volume 10 (1989–1993). New Providence, NJ: Marquis Who's Who.

Brody, David. *Labor in Crisis: The Steel Strike of 1919*. Champaign: University of Illinois Press, 1965.

Burgess, George, and Miles Kennedy. *Centennial History of the Pennsylvania Railroad Company, 1846–1946*. Philadelphia: The Pennsylvania Railroad Co., 1949.

Cassady, John. *The Somerset County Outline*. Scottsdale, PA: Mennonite Publishing Co., 1932.

Chalfant, Harry M. *Father Penn and John Barleycorn*. Harrisburg, PA: The Evangelical Press, 1920.

Cooper, Ramon. "The Flood and the Future: The Story of a Year in City Government at Johnstown, Pennsylvania." Authorized by Johnstown City Council, December 29, 1936.

Cowley, Malcom. "The Flight of the Bonus Army." *New Republic*, August 17, 1932.

Custer, Dale H. "A Document on the Second Johnstown Flood." *Pennsylvania History*, June 1963.

Dusza, Father Donald W. "The Legacy of Prince Gallitzin—A History of the Altoona-Johnstown Diocese." Altoona, PA: Altoona-Johnstown Diocese, c. 1995.

Eggert, Gerald G. *Steelmasters and Labor Reform, 1886–1923*. Pittsburgh: University of Pittsburgh Press, 1981.

Elder, Cyrus. "Johnstown as a Result of Environment." Keynote address, Johnstown Centennial Celebration, October 5–7, 1900, printed in "History of the Centennial Celebration of Johnstown, PA." Johnstown Centennial Executive Committee, 1901.

Foster, William Z. *The Great Steel Strike and its Lessons*. New York: B.W. Huebsch, 1920.

Gable, John. *History of Cambria County*. Topeka, KS: Historical Publishing Company, 1926.

Gates, John D. *The Du Pont Family*. New York: Doubleday, 1979.

Glosser, Ruth. "A Precious Legacy—Louis Glosser and Bessie Greenberg Glosser." Unpublished manuscript in Johnstown Library, 1998.

Hay, Anna M. "Genealogical Sketches of Hay, Suppes and Allied Families." Privately published, 1923. Courtesy of Fred Suppes.

Hornback, Florence M. *Survey of the Negro Population of Metropolitan Johnstown, Pennsylvania*. Johnstown: Published jointly by the *Johnstown Tribune* and the *Johnstown Democrat*, 1941.

Interchurch World Movement, Commission of Inquiry. *Report on the Steel Strike of 1919*. New York: Harcourt, Brace, and Howe Co., 1920.

Iron Age, various issues.

Jenkins, Phillip. *Hoods and Shirts: The Extreme Right in Pennsylvania*. Chapel Hill: University of North Carolina Press, 1997.

Johnstown Board of Education. "The Public Schools—the Pride of Johnstown." 1929.

Johnstown City Directory. Frank C. Hoerle, publisher. Various years.

Johnstown City Planning Commission. "The Comprehensive Plan of Johnstown." 1917.

Johnstown (Daily) Democrat, various issues.

Johnstown Tribune, various issues.

Johnstown Weekly Democrat, various issues.

"Laws, Ordinances and Rules of the City of Johnstown." City of Johnstown, Pennsylvania, 1897.

McCullough, David G. *The Johnstown Flood*. New York: Simon and Schuster, 1968.

Marcus, Irwin M. "The Johnstown Steel Strike of 1919: The Struggle for Unionism and Civil Liberties." *Pennsylvania History*, Winter 1996.

Miner, Curtis. *Down at the Club: A Historical and Cultural Survey of Johnstown's Ethnic Clubs*. Johnstown: Johnstown Area Heritage Association, 1994.

———. *Forging a New Deal: Johnstown and the Great Depression, 1929–1941*. Johnstown: Johnstown Area Heritage Association, 1993.

Morawska, Ewa. *For Bread With Butter: Life Worlds of East Central Europeans in Johnstown, Pennsylvania, 1890–1940*. Cambridge: Cambridge University Press, 1985.

———. *Insecure Prosperity: Small-town Jews in Industrial America, 1890–1940*. Princeton: Princeton University Press, 1996.

Mosley, Leonard. *Blood Relations: The Rise and Fall of the Du Ponts of Delaware*. New York: Atheneum, 1980.

Mowrey and Company Business Directory (Western Pennsylvania), 1901.

Olds, Marshall. *Analysis of the Interchurch World Movement Report on the Steel Strike*. New York: G.P. Putnam and Sons, 1922.

Paskoff, Paul A., ed. *The Iron and Steel Industry in the Nineteenth Century*. New York: Facts on File, Inc. 1989.

Pennsylvania Bureau of Mines. Annual Reports, various years. Glosser Memorial Library.

Pittsburgh Dispatch, various issues.

Porter, Bessie Glenn. "A History of Moxham." Unpublished manuscript in Glosser Memorial Library, 1976.

Rohrbeck, Benson W. *The Trolleys of Johnstown, Cambria, and Somerset Counties*. West Chester, PA: Ben Rohrbeck Traction Publications, 1991.

Schlesinger, Arthur M. *The Age of Roosevelt—the Coming of the New Deal*. Boston: Houghton-Mifflin Co., 1958.

Schroeder, Gertrude G. *The Growth of Major Steel Companies—1900–1950*. Baltimore: Johns Hopkins University Press, 1953.

Shappee, Nathan Daniel. "A History of Johnstown and the Great Flood of 1889: A Study of Disaster and Rehabilitation." PhD diss., University of Pittsburgh, 1940.

———. "Spoilation and Encroachment in the Conemaugh Valley Before the Johnstown Flood of 1889." *Western Pennsylvania Historical Magazine*, March 1940.

Sherman, Richard B. "Johnstown v. the Negro: Southern Migrants and the Exodus of 1923." *Pennsylvania History Magazine*, 1962.

Smith, Robert R. "The Steel Strike in Johnstown, Pennsylvania, 1919." Master's thesis, Indiana University of Pennsylvania, 1982.

Stewart, Maxwell S. "The Second Johnstown Flood." *The Nation*, April 8, 1936.

Storey, Henry Wilson. *History of Cambria County, Pennsylvania*. Volume 1. New York: The Lewis Publishing Company, 1907.

Swank, James M. *Progressive Pennsylvania: A Record of the Remarkable Industrial Development of the Keystone State*. Philadelphia: J.B. Lippincott, 1908.

U. S. Army Corps of Engineers, Pittsburgh District. "Report Upon the Proposed Project for the Protection of Johnstown, PA and for Supplementation of the Reservoir System Project for the Protection of Pittsburgh, Authorized by the Flood Control Act of 1936." May 1937.

U.S. Congress. Senate. U.S. Immigration Commission. *Immigrants in Industries*. Part 2: "Iron and Steel Manufacturing." 61st Cong., 2d sess., 1911. S. Doc. 633.

U.S. Department of the Interior, National Park Service. "Historic Resource Study—Cambria Iron Company." Washington, D.C.: GPO, 1989.

U.S. Department of Labor, Children's Bureau. Infant Mortality, Results of a Field Study in Johnstown, Pennsylvania. Washington, D.C.: GPO, 1915.

Waters, W.W. *BEF: The Whole Story of the Bonus Army*. As told to William C. White. New York: John Day Company, 1933.

Wish, Harvey. *Contemporary America: The National Scene Since 1900*. New York: Harper, 1955.

Winograd, Leonard. *The Horse Died at Windber: A History of Johnstown Jews of Pennsylvania*. Lima, OH: Wyndham Hall Press, 1988.

Woolfe, Anne. "History of Johnstown Water Company." Johnstown: Johnstown Water Company, n.d.

NOTES

Chapter 1: Carlic and Spphires in the Mud: Johnstown at the Beginning of the Twentieth Century

1. "P.L. Carpenter Buys the Capital," *Johnstown Tribune*, May 25, 1899.
2. "Cambria Steel Company," ibid., August 22, 1898.
3. "Cambria's Reorganization Plan," and "Cambria's Stock Is Very Active," ibid., September 29, 1898.
4. For a better understanding of the dynamics of the steel industry around 1900, consult (among other works): Paul A. Paskoff, ed. *The Iron and Steel Industry In the Nineteenth Century* (New York: Facts on File, 1989); and Gertrude G. Schroeder, *The Growth of Major Steel Companies, 1900-1950* (Baltimore: Johns Hopkins University Press, 1953).
5. "Cambria's Rumored Big Deal," *Johnstown Tribune*, June 4, 1898.
6. "Rumored Steel Combine," ibid., August 20, 1898.
7. Lorain Steel was initiated as the Johnson Steel Street Rail Company. In 1888 it became the Johnson Company and was in the process of being relocated to Central Avenue in the Moxham Section of Johnstown. In April 1898, the company was acquired by its own creation, the Lorain Steel Company, after a decision had been made and implemented to locate much of the company and the biggest part of its major expansion at Lorain, Ohio.
8. "C. I. Stock Away Up—What Do These Stock Reports Mean?" *Johnstown Tribune*, August 31, 1898.
9. Paskoff, *Iron and Steel Industry*, 69.
10. John "Bet-a-Million" Gates was a well-known, trust-era dealmaker.
11. Cyrus Elder, "Johnstown as a Result of Environment" (keynote address, Johnstown Centennial Celebration, October 5–7, 1900). Printed in "History of the Centennial Celebration of Johnstown, PA" (Johnstown Centennial Executive Committee, 1901). The Johnstown Centennial was a carefully planned commemoration, the work of many participants and committees. Its planners had hoped to bring President McKinley to Johnstown but he could not fit such a visit into the schedule of his reelection campaign.
12. John E. Gable, *History of Cambria County*, (Topeka, KS: Historical Publishing Company, 1926) 1:262.
13. "Largest of Iron Furnaces," *Pittsburgh Dispatch*, April 23, 1899.
14. "Straight Talk," *Johnstown Tribune*, May 21, 1906. This article describes a dinner meeting hosted by Charles S. Price, general manager of Cambria Steel and a future president of the company. Price was seeking to encourage Johnstowners to purchase Cambria Steel Company stock. Among a number of other matters, he discussed the one-time issue—then almost a decade old—of relocating the mills to a new location on Lake Erie.
15. There was speculation that the Indiana and Cramer Pike was built as a "sweetener" in the hopes its roadbed would become a railroad right-of-way and open up the area it served to development.
16. "No More Pulls Up Whiskey Springs Hill," *Johnstown Weekly Democrat*, October 5, 1900.
17. The Cambria City Bridge was the site of the present "footbridge," which still uses its old pier and abutments. McConaughy Street no longer exists because of later urban redevelopment activities in Cambria City.
18. See Chapter 3, section VIII, "Abandonment of the Iron Street Corridor."
19. Mr. Don Hysong, former yardmaster in Johnstown for the PRR and CONRAIL. Personal communication with author.
20. Benson W. Rohrbeck, *The Trolleys of Johnstown, Cambria, and Somerset Counties* (West Chester, PA: Ben Rohrbeck Traction Publications, 1991).

21. "Report of the Board of Health." *Johnstown Tribune*, January 29, 1900.

22. "Thompson Letter," ibid., March 6, 1899; "Leave Huntsville Field," ibid., August 8, 1901.

23. Governor William Stone (speech, Johnstown Centennial Celebration, October 5–7, 1900). "History of the Centennial Celebration," 24; Bessie Glenn Porter, "A History of Moxham," (unpublished manuscript in Glosser Memorial Library, 1976).

24. "Sold His Brick Interests," *Johnstown Tribune*, July 10, 1899; also Biographical Sketch of A.J. Haws in *Biographical and Portrait Cyclopedia of Cambria County, Pennsylvania* (Philadelphia: Union Publishing Co., 1896).

25. James R. Alexander, *Jaybird—A. J. Moxham and the Manufacture of the Johnson Rail* (Johnstown: Johnstown Area Heritage Association, 1991), 55.

26. For a discussion of industrial consolidation in the tin plate industry, see Chapter 2, section I, "Johnstown Industry," specifically the subsection *Donner*.

27. The U.S. Steel Corporation had been legally incorporated on February 25, 1901, having acquired, among other entities, Carnegie Steel and Federal Steel, the latter of which owned Lorain Steel . During 1901, U.S. Steel began to function like an integrated, trust-type corporation. Its operations got underway April 1, 1901, and most corporate reports and financial statements commenced as of that date.

28. "Steel Combine Will Not Hurt Johnstown," *Johnstown Tribune*, March 6, 1901; "Had Cambria An Offer?" ibid., April 4, 1901; "More Rumors About Cambria," ibid., April 5, 1901; "Official Says That Combination Would Be Natural and Advantageous," *Johnstown Weekly Democrat*, June 7, 1901.

29. "Steel Combine Will Not Hurt Johnstown," *Johnstown Weekly Democrat*, March 6, 1901.

30. "The Conemaugh Steel Company," *Johnstown Tribune*, June 7, 1901; "Cambria's Capital Enlarged," *Johnstown Weekly Democrat*, August 16, 1901.
This was a replay of the 1898 capital-financing strategy used when Cambria Steel had been created from the Cambria Iron Company.

31. "CSC Passes to PRR," *Johnstown Tribune*, June 25, 1901; "Cambria and Conemaugh One," ibid., August 13, 1901; George H. Burgess and Miles C. Kennedy, *The Centennial History of the Pennsylvania Railroad Company, 1846–1946* (Philadelphia: The Pennsylvania Railroad Company, 1949), 514. This account confirms the logic expressed by the "unnamed spokesman."

32. "Making Steel at Franklin," *Johnstown Weekly Democrat*, May 3, 1901.

33. "The Cambria Steel Company's New Works," *Iron Age Magazine*, February 6, 1902; "Cambria's Plans Are Vast," *Johnstown Tribune*, February 27, 1901. The *Tribune* article furnishes a description of construction then underway at the Franklin site.

34. "New Water Company Wants Charter," *Johnstown Tribune*, January 27, 1900; "The Dam On The Quemahoning," ibid., June 30, 1900; "Not Being Built," ibid., January 25, 1901.

35. "Cambria is Making Cars," ibid., January 21, 1901; "Cambria's New Car Order," ibid., June 18, 1901; "PRR Needs Cars Badly," ibid., November 14, 1901; "New Plant To Manufacture 40 Cars Daily," *Johnstown Weekly Democrat*, August 16, 1901.

36. Annual Report, Pennsylvania Bureau of Mines, 1900; ibid., 1903, Glosser Memorial Library.

37. Ibid., 1900. Evans's letter was dated February 23, 1901.

38. Ibid., 1903. The Rolling Mill Mine was a massive coal mine that honeycombed generally under Westmont. The main entrance was across the Stony Creek River, just upstream from the Point. It first opened in 1855 and was closed down in 1931. "Slav Arrested for Lighting Cigarette in Mine." *Johnstown Tribune*, September 13, 1902.

39. "Johnstown Trust Chartered," *Johnstown Tribune*, December 14, 1899; "Johnstown to Have Another Bank," *Johnstown Weekly Democrat*, May 17, 1901; "A New Bank For the City," *Johnstown Tribune*, May 16, 1901; "Bank Talk On the Street," ibid., July 5, 1901; "New Bank Will Soon Be Open," ibid., October 26, 1901; "New Bank Begins Operations," ibid., October 31, 1901; "Banks Will Consolidate," ibid., March 19, 1902.

40. "Penn Traffic's Grand Opening," ibid., October 3, 1901. This issue features many Penn Traffic advertisements.

41. "New Electric Light Plant," ibid., August 21, 1901.

42. "Cheap Light, No Dividends," ibid., October 10, 1902; Gable, *Cambria County*, 1:179–83.

43. The continued development of the electrical utility business in Johnstown is discussed in the section "Public Utility Developments" in Chapter 2.

44. "Use New Phones Sunday Next," *Johnstown Tribune*, August 1, 1901.

45. "Letter from a Businessman," ibid., March 25, 1902; "Kicking Against Higher Rates," ibid., March 28, 1902, "A New Company the Next Move," ibid., March 29, 1902; "Bell People Put In A Bid," ibid., March 31, 1902; "Were Urged To Boycott," ibid., April 1, 1902; "Telephone Improvements," ibid., April 17, 1902.

46. "Street Car Franchises," *Johnstown Tribune*, September 9, 1899; "A Profitable Railway," January 30, 1901.

47. "The Deal Is Closed. Tom Johnson Street Railway Stock In Local Hands," *Johnstown Tribune*, May 4, 1902.

48. Home refrigerator appliances began to be sold commercially in the mid-1920s, although somewhat primitive early models were beginning to become available about a decade earlier. The ice industry in communities such as Johnstown was a key business.

49. Anna M. Hay, "Genealogical Sketches of Hay, Suppes and Allied Families" (privately published, 1923).

Courtesy of Fred Suppes. See also "Ice Rate War," *Johnstown Tribune*, April 4, 1901; "Ice War Now One Of Prices," ibid., April 6, 1901; "Consumer Ice Company Officers," ibid., October 19. 1901; "New Ice Plant Building," ibid., December 14, 1901; "Talk of Ice Consolidation," ibid., November 20, 1902.

50. "Memorial Hospital Completes 50 Years of Community Service," *Johnstown Tribune*, February 2, 1942.

51. Department of the Interior, National Park Service, "Historic Resource Study, Cambria Iron Company" (Washington, D.C.: GPO, 1989), 147–49.

52. Use of the word *pest* to describe a medical facility merits some clarification. *Pest*, derived from *pestilence*, was a commonly used word for *plague* in this era. *Pest* is a root word for *plague* in a number of languages.

53. "Plans for a New Hospital," *Johnstown Tribune*, April 19, 1902; "New Johnstown City Hospital," ibid., April 21, 1902.

54. "Many New Homes To Be Built," ibid., February 24, 1900; "An Architect's Busy Year," ibid., January 19, 1901; "Big Store To Be Made Bigger," ibid., February 13, 1902; "Johnstown's New Record—Led All Towns Of Its Size In Money-Order Business Last Month," ibid., April 12, 1901.

55. The text of the code can be found in "Laws, Ordinances, and Rules of the City of Johnstown," City of Johnstown, Pennsylvania, 1897.

56. These had been Conemaugh Borough (which came to be known as "Old Conemaugh Borough"), Woodvale, Cambria City, Minersville, Millville, Prospect (Peelorsville), Grubbtown (Eighth Ward) and the Moxham section of Stonycreek Township. Moxham had been an unincorporated village, a sort of private development. Its developers, A.J. Moxham, Tom and Albert Johnson, and others, had been working for overall municipal consolidation. Moxham became part of the city in 1889 as part of the Seventh Ward. By court decree it was designated the Seventeenth Ward in 1891.

57. "Morrellville, We Welcome You," editorial, *Johnstown Tribune*, January 5, 1898; "Mayor Wagoner Opposed Annexation," ibid., January 6, 1898; "Coopersdale Is Knocking," ibid., January 18, 1898; "Question Veto Power," ibid., March 9, 1898; "Superior Court Rules Morrellville Is Part of City," ibid., June 30, 1898; "Coopersdale Comes In," ibid., December 6, 1898.

58. "Annexation of Roxbury," *Johnstown Tribune*, June 7, 1900; "Do Not Want to Come In," ibid., June 16, 1900; "Roxbury is Not Annexed," ibid., December 3, 1900; "Roxbury to Try Again," December 12, 1900; "Roxbury Bound to Come In," December 29, 1900; "The Fight Not Over Yet," ibid., February 2, 1901; "Our Roxbury Determined to Come In," ibid., February 22, 1901; "Roxbury Annexation Final," ibid., September 9, 1901; "Select Council Meeting," *Johnstown Weekly Democrat*, February 22, 1901.

59. Nathan D. Shapee, "Spoliation and Encroachment in the Conemaugh Valley Before the Johnstown Flood of 1889," *Western Pennsylvania Historical Magazine*, March 1940: 42ff; Henry W. Storey, *The History of Cambria County, Pennyslvania* (The Lewis Publishing Company, 1907), 1:323. Storey did not clarify exactly what he had meant by "within the limits of the city." The city did not exist in 1870. He probably meant the limits as they were when he was authoring his history.

60. Storey, *Cambria County*, 326.

61. "Cambria Plans Are Vast," subsection "Filling Up the River," *Johnstown Tribune*, February 27, 1901.

62. "City Officials Move At Last," ibid., February 28, 1901; "The River Narrowing Question," ibid., March 27, 1901; "To Take Up River Filling," ibid., May 22, 1901.

63. "Judge Barker's Suggestion," *Johnstown Tribune*, October 8, 1902. Discussion of the river encroachment issue is continued in the "River Encroachment" section of Chapter 11. Ironically Thomas Fearl became a victim of his own project. The following quote appeared in the *Johnstown Daily Tribune* on February 28, 1902: "Thomas Fearl…had a narrow escape from being drowned. The water has washed out the upper end of his new wall, and when he took hold of a barrel of lime, it exploded burning Mr. Fearl's face and hand rendering him unconscious."

64. "Streets Not Western Plains," *Johnstown Tribune*, July 28, 1900.

65. Johnstown City Directory (Frank C. Hoerle, publisher), 1899, 1901 and 1903; Mowrey and Company Business Directory (Western Pennsylvania), 1901.

66. "Making an Automobile," *Johnstown Tribune*, July 26, 1900; "Auto's Unfortunate Trial Trip," ibid., August 6, 1900; "Automobiles" (special centennial issue), *Johnstown Tribune*, February 28, 1953.

67. "Plan to Avoid a Tollgate," *Johnstown Tribune*, February 11, 1902; "Credit Belongs to the Republicans," ibid., February 15, 1901; "City Councils in Session," ibid., May 21, 1902.

68. "Mayor Files Objections," ibid., January 24, 1902.

69. "Many Varieties of Smellers," ibid., July 28, 1899.

70. *Johnstown Tribune*, July 18, 1900.

71. "That Garbage Grab," *Johnstown Weekly Democrat*, August 29, 1902; "Bid to the Councilmen," *Johnstown Tribune*, November 18, 1902. See also the subsection "Refuse Collection and Disposal" in Chapter 1.

72. See also "Hospitals" in Chapter 2.

73. "Voice from Massachusetts to Johnstown Parents," *Johnstown Weekly Democrat*, August 27, 1902; "Vaccination of Millmen," ibid., October 3, 1902; "The *Democrat* Wildly Flies Against Facts on Vaccination," *Johnstown Tribune*,

October 4, 1902; "Vaccination and Smallpox, Statistics Based on Pesthouse Cases," ibid., October 14, 1902. The 1902 smallpox epidemic caused temporary closing of some schools; teachers were quarantined like anyone else when someone in their residential dwelling had been afflicted.

74. "Some 300 Typhoid Cases, Investigation Discloses About That Number in the City Now," *Johnstown Tribune*, October 14, 1901; "Many Victims of Disease," ibid., December 31, 1902.

75. "City Public Schools Are Filled," *Johnstown Tribune*, September 4, 1901; see also "Johnstown Schools" in Chapter 3.

76. "Year's Work of Cambria Library," *Johnstown Tribune*, May 7, 1901.

77. Gable, *Cambria County*, 66–67.

78. Special legislation in this sense meant a law that applied only to one situation and was not applicable in a general way affecting a whole category of like situations.

79. "The New County Movement," *Johnstown Tribune*, March 10, 1889; "Will Not Abandon Fight," ibid., March 19, 1903; "Responsibility Now On Stineman's Shoulders," *Johnstown Weekly Democrat*, March 20, 1903.

80. Immigration Commission, *Immigrants In Industries*, part 2: "Iron and Steel Manufacturing," 61st Congress, 2d sess., 1911, S. Doc 633, 32–33.

81. Department of Labor, Children's Bureau, *Infant Mortality, Results of a Field Study in Johnstown, Pennsylvania* (Washington, D.C.: GPO, 1915), 31.

82. Ewa Morawska's project dealt with Johnstown's eastern and southeastern European immigrant community, but excluded those from Italy, Germany, Greece, Scandinavia and the British Isles, except for contrast. She observed that by the time of the 1900 census, the City of Johnstown had over 5,000 people whose origins were from central and southeastern Europe. She also estimated that there were about 1,000 to 1,500 such people (circa 1900) who lived immediately outside the city. *For Bread with Butter: Life Worlds of East Central Europeans in Johnstown, Pennsylvania, 1890–1940* (Cambridge: Cambridge University Press, 1985), 92. Immigration Commission, *Immigrants in Industries*, 340.

In the Johnstown of the late 1880s through the early twentieth century, the term "Hun" was loosely used to describe persons from the Austro-Hungarian Empire, whether of Magyar or Slavic background. "Slav" was loosely used to describe persons who spoke a Slavonic language but was also used by the uninformed to describe Magyar Hungarians.

83. Immigration Commission, *Immigrants in Industries*, 330–31.

84. Ibid., 485.

85. "Cambria City's Big Burden," *Johnstown Tribune*, July 15, 1902.

86. Immigration Commission, *Immigrants in Industries*, 404.

87. Ibid., 437.

88. In many cases the Johnstown immigrants from the old Austro-Hungarian Empire sided with the Russian and Serbian cause from the outset of the Great War (see Chapter 8).

89. Curtis Miner, *Down at the Club: A Historical and Cultural Survey of Johnstown's Ethnic Clubs* (Johnstown, PA: Johnstown Area Heritage Association, 1994).

90. "Slovaks and Italians Here," *Johnstown Tribune*, April 23, 1898. Henry Edward Rood was an author in this era. The *Tribune* was republishing something that had appeared elsewhere but did not credit the source.

91. James Moore Swank was a brother of Tom Swank, owner-editor of the *Johnstown Tribune*. The two brothers also had three sisters. One, killed in the 1889 flood, had been married to Cyrus Elder, Cambria Iron Company solicitor in the 1900 era. A second had been married to John K. Lee, the physician for whom Lee Hospital was later named. The third was one of the wives of Powell Stackhouse, president of the Cambria Iron (Steel) Company.

92. James M. Swank, *Progressive Pennsylvania: A Record of the Remarkable Industrial Development of the Keystone State* (Philadelphia: J.B. Lippincott, 1908), 7.

93. Leonard Winograd, *The Horse Died At Windber—A History of Johnstown's Jews Of Pennsylvania* (Lima, OH: Wyndham Hall Press, 1988). Ewa Morawska estimated that at the turn of the century there were fifteen to twenty families of German Jews.

94. Nathan Daniel Shapee, "A History of Johnstown and the Great Flood of 1889: A Study of Disaster and Rehabilitation" (PhD diss., University of Pittsburgh, 1940), 86–87.

95. Ewa Morawska, *Insecure Prosperity: Small-Town Jews in Industrial America, 1890–1940* (Princeton: Princeton University Press, 1996), 26ff. *Insecure Prosperity* is a companion work to Dr. Morawska's *For Bread With Butter*.

96. Ibid., 41.

97. "Rosh Hashanah and Yom Kippur," *Johnstown Tribune*, September 24, 1902.

98. Storey, *Cambria County*, 186ff.

99. "High Jinks at the Smith House," *Johnstown Tribune*, October 12, 1899; "Black Man—White Woman," ibid., May 5, 1900; "Raised a Row on a Street Car," ibid., July 24, 1901; "Thought He was in the Coop," ibid., November 9, 1901; "Harbored Another Man's Wife," ibid., November 14, 1901; "Fourth Ward House Raided," ibid., March 6, 1902; "Accused of Frightening Women," ibid., August 12, 1902; "Colored Hotel Man Fined $50," November 19, 1902.

100. "Hotel Men Draw Color Line," *Johnstown Tribune*, February 24, 1900.

101. "Afro-American Union League," *Johnstown Tribune*, August 30, 1900. Johnstown black community history is continued in Chapter 7, "Leaks in the Roof of Paradise," and is also discussed further in the second volume of this history.

102. "Jerry Spriggs Roasted the Ox and it Was Declared the Finest Ever—How He Did It." *Johnstown Tribune*, July 27, 1901; "Emancipation Celebration," ibid., October 8, 1901; "Celebrating Freedom Day," ibid., October 21, 1901; "Celebration of Emancipation Day," ibid., September 24, 1902.

103. "Close of the Theatrical Season," ibid., May 16, 1900; "Local Theatrical Openings," ibid., August 21, 1901.

104. "Cambria Theater. Tomorrow Night. Lyman H. Howe's High Class Motion Pictures," ibid., April 29, 1901.

105. "Features Of The Wild West," ibid., May 28, 1902; "Circus Draws a Big Crowd," ibid., May 31, 1901.

106. "Show Day in Johnstown," ibid., May 12, 1902.

107. "A Cordial Greeting For Bryan," ibid., January 15, 1902.

108. Johnstown City Directory, 1903, 518–20.

109. "Amicus Club Scored a Big Success Last Night," *Johnstown Tribune*, February 22, 1902; "Popular Club Comes of Age," ibid., March 18, 1902.

110. For more on parks and recreation in Johnstown, see Chapter 3, section XI, "Parks, Playgrounds and Recreation." "Whipped In First Round," *Johnstown Tribune*, December 6, 1898; "Westmont Borough 1892–1992" (manuscript, Pennsylvania Room, Glosser Memorial Library).

111. "No Baseball Park on the Point," *Johnstown Tribune*, December 27, 1900.

112. "Notable Baseball Program," ibid., May 21, 1901; "Baseball Game Saturday," ibid., August 7, 1901; "Johnstown Team Playing P.A.C.," ibid., August 17, 1901; "Johnstown and Brooklyn" and "No game Yet With Monarchs," ibid., September 20, 1901; "Busy Booking Baseball Games," ibid., April 25, 1902.

113. "Why Houses Are Not Pulled," *Johnstown Tribune*, October 10, 1901. The mayor in question, Lucian D. Woodruff, was a Democrat and this account came from a Republican newspaper. Other representative *Tribune* articles about vice situations in turn-of-the-century Johnstown: "Charges Against Sallie St. Clair," August 17, 1899; "High Jinks at the Smith House," October 12, 1899; "With Police and Aldermen," June 22, 1901; "Heard in the City Courts," July 12, 1901; "After the Gambling Houses," July 13, 1901; "Taken From Disreputable House," August 7, 1901; "To Face Liquor-Selling Charge," August 14, 1901; "Lizzie Thompson's Trial," September 9, 1901; "Harbored Another Man's Wife," November 14, 1901.

Chapter 2: Good Times and Bad Times: The Johnstown Economy from 1900 until the Great Depression

114. "Years Work of Big Mill," *Johnstown Tribune*, March 18, 1903; "Annual Meeting of Cambria Co.," *Johnstown Weekly Democrat*, March 20, 1903.

115. "Cambria's Report Most Encouraging," *Johnstown Tribune*, January 7, 1904; "Cambria's Report…," *Johnstown Weekly Democrat*, January 15, 1904.

116. "Year's Business," *Johnstown Tribune*, March 15, 1904; "Big Local Plant Did Well in Bad Year," ibid., March 21, 1905.

117. "New Plate Mill," ibid., April 12, 1905.

118. "Cambria's New Office," ibid., November 11, 1905; "Tremendous Job [Hinckston] Nearing Completion," *Johnstown Weekly Democrat*, March 24, 1905; "Cambria Will Erect New Office Building," ibid., November 3, 1905.

119. "Cambria's Good Year," *Johnstown Tribune*, March 21, 1906.

120. "Has Cambria Control Been Sold by PRR?," ibid., September 7, 1906; "A Lot of Denials," ibid., September 8, 1906; "Another Spurt by Cambria," ibid., December 1, 1906. See also "Cambria Steel Stays Put" in Chapter 1.

121. "Straight Talk," ibid., March 21, 1906.

122. Whatever may have been Frick's motive, Cambria was apparently a small consideration in his vast, complex and changing scheme of things. Neither of the two major Frick biographies mentions Cambria Steel at all. Later revelations established that he had once owned 37,200 shares—just over 4 percent of the company.

123. "Boom in Cambria Steel as it's Viewed in Philadelphia," *Johnstown Democrat*, January 5, 1907; "The Boom In Cambria Steel," ibid., January 7, 1907.

124. A.J. Cassatt was originally from Pittsburgh. He was the brother of Mary Cassatt, the famous expatriate impressionist artist. For PRR's acquisition of a controlling interest in Cambria Steel, see Chapter 1, section III, "The Johnstown Economy," specifically *Refinancing Cambria Steel: The PRR's Controlling Interest.*

125. "Steel Business Is On the Mend," *Johnstown Tribune*, February 6, 1908; "Cambria Had Another Good Year," ibid., March 17, 1908; "Cambria Announces Wage Reduction…," ibid., March 17, 1909.

126. "Lake Quemahoning To Be Biggest…," ibid., February 20, 1909; "Vast Strength, Unique Method of Construction Marks Work on Quemahoning…," ibid., July 8, 1909; "Giant Water Tunnels are Merged Under Green Hill," ibid., March 21, 1910; "Quemahoning Dam Done in October," ibid., December 27, 1911; "Entire Town to be Inundated…," *Johnstown Weekly Democrat*, July 29, 1910.

127. "Good Showing Made by Cambria's 1909 Report," *Johnstown Tribune*, March 15, 1901.

128. "Cambria's New President Has Had a Very Active Career," ibid., October 2, 1912.

129. "Charles S. Price Elevated…," *Johnstown Weekly Democrat*, November 19, 1909.

130. "Cambria Board Tables the Resignation of…Price," *Johnstown Tribune*, September 19, 1912; "Philadelphia Comment on Cambria Steel Affairs," ibid., September 20, 1912. Both of these were reruns of Philadelphia newspaper articles.

131. "Cambria May Figure with Schwab in Combination Deal," ibid., September 23, 1912.

132. "Fred Krebs Elected U.S. Bank Official," *Johnstown Weekly Democrat*, November 8, 1912.

133. "Inventor, Engineer…," *Johnstown Tribune*, January 22, 1915.

134. If Donner did not suggest Ferrell and Coolidge be invited, he certainly would have approved it. Their presence at this occasion, supposedly intended for Johnstown civic leaders to get to know Donner, seems bizarre. "Three Steel Presidents Honored at a Brilliant Banquet Last Night," *Johnstown Tribune*, December 6, 1912.

135. "Transfer to Philadelphia is Move After Foreign Trade," ibid., September 18, 1914.

136. "J.L. Replogle is to Leave Cambria," ibid., January 25, 1915.

137. "Street Rumors of Cambria Merger," ibid., June 5, 1915; "Steel Merger Near at Hand?," ibid., July 19, 1915; "Present Good Time for Big Steel Merger," ibid., July 20, 1915.

138. "Cambria Unite with Midvale Is the Latest," ibid., September 18, 1915; "Guessing on Cambria," ibid., September 22, 1915; "Sale of Cambria Steel for $25,000,000 is Latest Philadelphia Report," ibid., September 24, 1915; "Morgan Fight on Schwab Indicated by Midvale Purchase…," ibid., September 27, 1915. Note, no issues of the *Johnstown Democrat* for 1915 have survived.

139. When Cambria Steel's latest numbers were announced, October 1915 had become the busiest month in the company's history—122,069 tons produced and shipped. The industry in general and Cambria Steel in particular had made a dramatic upward turn. Orders were flowing in.

140. "Block Merger of Cambria Is Now Reported," *Johnstown Tribune*, December 23, 1915.

141. "Cambria Recall of Scrip Due to Replogle Influence is Philadelphia's Belief," ibid., January 21, 1916.

142. I have not been able to determine exactly why Replogle's venture failed. Donner had many powerful and influential friends and was opposed to it. Perhaps Charles Schwab was secretly scheming to prevent an American Steel Corporation from coming into existence and filling the vacuum he was hoping to fill with his Bethlehem Steel Corporation. Replogle had, however, managed to spring the Cambria Steel controlling interest from the PRR. Others would assemble the ultimate deal.

143. While there is no proof, William Donner might well have masterminded the entire thing. Replogle (who would later become one of the outstanding personalities in the American steel industry) was inexperienced in this sort of high-level corporate intrigue. The same can be said for Edwin Slick, a mill operator and an inventor. Donner had years of experience working with the likes of Henry Clay Frick and Andrew Mellon and was well respected among the management of the PRR. The counter coup had Donner's markings, and he was not the sort of person to spell out his deal making to anyone.

144. "Midvale Buys Cambria at 81" and "Identity of New Owners Kept Secret Until Today," *Johnstown Tribune*, February 7, 1916; "Big Profits Taken by Financiers and Holders of Cambria—Slick's Part," ibid., February 8, 1916; "J. Leonard Replogle and Others Buy Large Cambria Steel Co. Holdings," *Iron Age*, November 18, 1915; "The Midvale Acquisition of Cambria," ibid., February 17, 1916.

145. "Cambria Steel Company Breaks Ground for Two Blast Furnaces at Franklin Plant to cost $3,000,000; $4,000,000 Wheel Plant Soon," *Johnstown Tribune*, December 27, 1916.

146. See Chapter 9 for more on the steel strike.

147. "Steel Prices Cut 25 to 35 Percent Under Last Quarter of 1918 Figures" and "Pessimistic Tone in Steel Market, Business Scarce," *Johnstown Tribune*, March 21, 1919; "Midvale's Annual Report Issued; Rail Situation is Holding Back Steel Mills," ibid., March 3, 1921.

148. The financial data is generally consistent from year to year. Net profit here refers to gross revenues less the sum of all operating costs, federal taxes including an excess-profits tax in 1918, depreciation and depletion, and the Cambria Iron Company fixed dividend payment. Common stock dividends are yet to be paid from net profits. This data all comes from the *Johnstown Daily Tribune* papers: April 1, 1918 (data given for two years); April 1, 1919; March 14, 1920; March 3, 1921; March 6, 1922; and from "Midvale Shows a Net Loss," April 3, 1923.

149. "Steel Officials Inspect Cambria Steel Company Plants" ibid., May 2, 1922.

150. "Midvale to Bethlehem?," ibid., May 17, 1922.

151. "Midvale Represented in Conference with Attorney General on Steel Merger," ibid., May 25, 1922.

152. "Midvale Merges With Inland and Republic in Three-Plant Combine," ibid., June 2, 1922.

153. Both Schwab and Replogle were well known nationally and in Washington, D.C. circles thanks to their service to the nation during the First World War. (See "Leaders and Heroes" in Chapter 8.) Replogle maintained enough of a local residence to vote in Johnstown until he retired to Florida.

154. "Midvale-Republic-Inland Merger is Not Popular in Johnstown," *Public Ledger*, June 28, 1922.

155. "Midvale Steel Merger Held Up by Government," *Johnstown Tribune*, September 1, 1922. See also Schroeder, *Major Steel Companies*, 101–02.

156. "The Merger," editorial, *Johnstown Tribune*, September 4, 1922. I believe, but cannot prove, that Charles Schwab torpedoed the deal. He had the talent, the motive and the contacts to pull it off.

157. Gable, *Cambria County* 282–83. Gable had first been a newspaper reporter in Johnstown, next secretary of the Johnstown Chamber of Commerce and later secretary of the Cambria County Fair, one of Schwab's pet projects. Gable would have been close to Charles Schwab and was no doubt present at the event honoring him.

158. "Bethlehem Will Acquire Midvale," *Johnstown Tribune*, November 25, 1922; "Voting Stock in Merger Exchange—Schwab's Word," ibid., December 28, 1922.

159. "Tiger of France to Spend Sunday at Cresson; in Mr. Schwab's Private Car Will Go Through Johnstown," ibid., December 9, 1922; "French Tiger Spends Sunday in Mountains," ibid., December 11, 1922.

160. "Bethlehem Officially Takes Over Cambria Steel Plant; Some Changes in Personnel," ibid., April 2, 1923.

161. "Charles M. Schwab Talks to Rotary," ibid., June 18, 1924.

162. "President Grace Gives Bethlehem Steel Report," ibid., January 25, 1924; "Bethlehem 1923 Income…," ibid., March 18, 1924; "Improvements at Gautier to Get Underway…," ibid., June 25, 1924; "Bethlehem Passes Quarter Dividend…," ibid., July 24, 1924; "Prosperous Era Seen as Plant Operations Continue…," ibid., December 11, 1924.

163. "Bethlehem Book Tells of Growth…," ibid., October 23, 1925; "Steel Official…Optimistic…," ibid., November 26, 1925; "Edison Talks about His Johnstown Benzol Plant," ibid., March 15, 1915.

164. "Bethlehem Heads Here…," ibid., May 31, 1928; "Bethlehem to Spend $5,000,000 More," ibid., April 30, 1929; "Bethlehem Steel's Great Improvement Program Inspected," ibid., December 5, 1930.

165. Bethlehem Corporation photography and news releases appear in the *Johnstown Tribune* on the following dates: December 10, 11, 12, 13, 16, 17, 19, 20, 22 and 24, 1930; January 31, 1931; and February 14, 1931. There may have been others in the same timeframe inadvertently overlooked during my research.

166. "To Double its Moxham Plant," *Johnstown Tribune*, November 30, 1906; "Work is Pushed at Lorain Plant," ibid., February 11, 1907; "Quarter Million Building at Moxham Plant," *Johnstown Weekly Democrat*, February 15, 1907.

167. Alexander, *Moxham*, specifically "From Local Mill to National Prominence," 45–61, and "The Johnstown Foundry and Switchworks," 66–69.

168. "Local Radiator Companies Are Part of $25,000,000 Merger: John Waters Chairman…," *Johnstown Tribune*, August 8, 1927; "Heads of Six Radiator Concerns in Big Merger," ibid., August 31, 1927; "John H. Waters Chosen President of National Radiator Corporation," ibid., January 9, 1930.

169. "A Clearing House," ibid., May 22, 1906.

170. "Moxham's First Bank to be Open Tomorrow," ibid., May 9, 1919.

171. "U.S. Bank Has Purchased Hannan Block," ibid., May 26, 1919; "U.S. National Bank to Erect Tallest Building in Johnstown," *Johnstown Weekly Democrat*, October 18, 1919.

172. "New Trust Company Open for Business," *Johnstown Tribune*, April 15, 1921.

173. "Dale Deposit Bank to Open Tomorrow," ibid., June 21, 1921.

174. "Invitations to New Building and Affiliation Notices," ibid., October 25, 1923.

175. "Trust Company in New Headquarters," *Johnstown Tribune*, January 21, 1924; "First National to Open Branch Bank," ibid., July 7, 1924; "Morrellville Deposit Bank is Merged With Title Trust," ibid., September 30, 1924; "U.S. National Has Purchased Conemaugh Bank," ibid., November 29, 1924; "Shareholders of Local Banks Meet," ibid., January 14, 1925; "Eight Banks Re-elect Boards for 1927; Two New Directors Named," ibid., January 11, 1927; "Seven Local Banks Use Clearinghouse…," ibid., March 5, 1927; "Johnstown State Deposit Bank Bought by Downtown Bank," ibid., December 22, 1927; "Union National Bank is Absorbed by the First National," ibid., January 23, 1928; Johnstown City Directories, 1920, 1924, 1925, 1927 and 1929. I have also made extensive use of an article: "Brief History of Banking in Johnstown" that appeared in late May or early June 1921 in *Money and Commerce*.

176. Andrew Gleason, Johnstown attorney, personal interview, September 11, 2000; Perry Nesbitt, retired city clerk and close friend of Dan Shields, personal interview, October 24, 2000.

177. The other new directors were John Waters, Percy Allen Rose, Jacob Kress, Patrick Lavelle and Joseph Morgan. "Last Touches…Gas-Electric Merger," *Johnstown Tribune*, December 9, 1909; "New Men at Helm of Merger," ibid., December 22, 1909.

178. "Seeks Annulment of Light Charter," ibid., July 18, 1910.

179. "New Yorkers to Retain Control of Citizens' Light Company," ibid., January 10, 1911.

180. "Says West Penn is Surely Coming," ibid., January 6, 1912; "Power Company Knocking at Door is a Monster," ibid., January 10, 1912.

181. "Citizens May Buy Charters," ibid., January 17, 1913.

182. "Immense Power Plant at Seward Will Be Erected by New York Company," ibid., November 7, 1919.

183. "Electric Plant One of Biggest East of Mississippi," ibid., September 15, 1921.

184. The Pennsylvania Railroad Company used the Bell Company. Its employees in and near Johnstown were strongly encouraged to be Bell customers in the event of a call out for special work or an emergency. Large businesses

were compelled to use both systems, and when listing their telephone numbers in advertisements, published both numbers.

185. "The Telephone Situation," *Johnstown Tribune*, April 21, 1906.

186. "Chairman Ainey Takes Depositions in the Local Telephone Controversy," ibid., January 26, 1922.

187. "Telephone Company Asks for Increased Rates," ibid., February 26, 1927; "The Telephone Rates," editorial, ibid., March 3, 1927; "To File Protest in Phone Case…," ibid., March 18, 1927; "All Telephone Rates Are Increased as of May 1st…," ibid., April 1, 1927; "Council Authorizes Phone Rate Protest…," ibid., April 5, 1927; "Partial Victory Won in Telephone Rate…," ibid., May 11, 1929; "New Telephone Rates…in Effect First of July," ibid., May 18, 1929.

188. "Sale of Local Phone Company is Now Assured," ibid., October 12, 1929; "Sale of Johnstown Telephone Company Formally Announced,: ibid., January 24, 1930; "Telephone Office Will Be at Erie," ibid., February 19, 1930.

189. Anne Wolfe, "History of Johnstown Water Company" (Johnstown: Johnstown Water Company, n.d.); "Water Meters to Be Put into Every Home in City," *Johnstown Tribune*, July 20, 1914.

190. "More Beds for Hospital," ibid., May 27, 1903; "Memorial Completes 50 Years of Community Service," ibid., February 2, 1942.

191. "For Benefit of Hospital," ibid., January 17, 1905; "Local Hospitals' Needs Recognized," ibid., March 25, 1911; "Ready Response to Appeal for Hospital," ibid., March 28, 1912.

192. "Memorial Board of Incorporators Convenes," ibid., June 8, 1915.

193. "Addresses by John Kendrick Bangs and Fred Krebs Open Big Financial Campaign," ibid., July 6, 1916; "Magnificent Efforts of Workers Send Grand Total to $140,000," ibid., July 26, 1916.

194. "Expect to Dedicate Addition to Memorial Hospital," ibid., December 17, 1926.

195. "Ready Response to Appeal for Hospital," ibid., March 28, 1912; "Our Legacy," editorial, ibid., April 5, 1912.

196. "Structure in Dale Borough Will Be Ready for Use in a Short Time," ibid., January 10, 1906; "City Hospital Transferred to New Hands," *Johnstown Weekly Democrat*, November 16, 1906; "To Canvass For New City Hospital," *Johnstown Tribune*, September 27, 1907.

197. "Fritz Homestead for New Hospital," *Johnstown Tribune*, August 30, 1910; "Mercy Hospital Deal is Closed," ibid., August 17, 1910; "Mercy Hospital Opens January 20," ibid., January 3, 1911; "Additions to Mercy Hospital Nearing Completion," ibid., October 27, 1911; "First Annual Report Shows Splendid Work For Mercy Hospital," ibid., August 14, 1912; "Will Build an Addition Soon," ibid., May 24, 1915; "Magnificent Hospital for Johnstown…," ibid., April 8, 1916. Among the Johnstown leaders active with Mercy Hospital at the time of its beginning were: Evan Du Pont, Patrick Lavelle, David Barry, Abraham Cohen, Charles Mayer, James Thomas, Jacob Zimmerman, John McDermott, Harry Swank, Charles Emmerling, James P. Greene, Samuel Lenhart, J.C. Ryan and Joseph Freidhoff.

198. "Lee Hospital's New Home Will Be $150,000 Three-Story Edifice," *Johnstown Tribune*, April 18, 1928; "Cornerstone for Lee Hospital Laid Yesterday," ibid., June 28, 1928; "Lee Hospital Will be Formally Opened…March 28th," ibid., March 23, 1929.

199. "Municipal Hospital Addition," ibid., March 7, 1904; "Donate to City Hospital," ibid., March 22, 1904.

200. "Support of Home-Capital Stores…Pointed Out by Speaker," *Johnstown Weekly Democrat*, December 6, 1927.

201. "New McCrory Store Draws Big Crowd," *Johnstown Tribune*, March 10, 1927.

202. "M. Nathan and Bro. Inc. to Retire from Local Merchandising Field," ibid., November 18, 1929.

203. "Cupp Chain Stores…Sold to National Concern," ibid., December 27, 1928.

204. Other large retail department stores were Foster's at Main and Bedford, Schwartz Brothers on Main Street, John Thomas and Son at 520 Main Street, and Nathan's facing Main Street across from Park Place. Quinn's on Clinton Street, a long-standing Johnstown institution, closed in 1921. Glosser Brothers is discussed below.

205. "Two Acres of Floor Space," *Johnstown Tribune*, March 13, 1903; "Fine Addition to Mercantile Johnstown," *Johnstown Weekly Democrat*, March 13, 1903; "Building Boom is On," *Johnstown Tribune*, April 2, 1903.

206. "Site is Chosen for Federal Building," *Johnstown Weekly Democrat*, March 5, 1905; "Site at Locust and Market is Favored…," *Johnstown Tribune*, January 15, 1909; "Federal Building Corner Stone Laid," ibid., November 19, 1912.

207. "Work is Started on Four-Story Addition to Nathan Store…" *Johnstown Tribune*, August 15, 1921.

208. See Chapter 3, section I, "The Struggle Against Civic Futility," specifically *Consequences of Chaos: Johnstown* Fires.

209. "On Site of Burned Opera House," *Johnstown Tribune*, March 18, 1904.

210. "Penn Traffic Formally Opens its $500,000 Business Palace," ibid., March 5, 1908.

211. "P.S. Fisher to Have Erected a Fine Four-Story Building," *Johnstown Weekly Democrat*, August 17, 1906.

212. "Fine Home Planned for $500,000 Trust Company," *Johnstown Tribune*, February 19, 1907.

213. "Splendid New Swank Building Formally Opens Tomorrow," ibid., May 5, 1908.

214. "Facts About Swank Hardware," ibid., November 4, 1920.

215. "New Building to Be Tallest in Johnstown," *Johnstown Weekly Democrat*, April 10, 1908.

216. "Plans For Twelve-Story Building Accepted by Bank Directors," ibid., April 28, 1911.

217. "Public Reception Will Mark Formal Occupancy…," *Johnstown Tribune*, October 25, 1923.

218. "7-Story Building to Be Erected on J.K. Love Property, Main Street," ibid., July 11, 1913.

219. "Again Report of Fine New Station for Johnstown," *Johnstown Weekly Democrat*, May 13, 1904; "Beautiful New Station Officially Dedicated to Service of Johnstown," *Johnstown Tribune*, October 12, 1916.

220. Ruth Glosser, "A Precious Legacy—Louis Glosser and Bessie Greenberg Glosser (1854–1929)" (unpublished essay, 1998, Johnstown Public Library), 1–11; "Glosser Brothers' Store Celebrating Anniversary; Short Successful Life," *Johnstown Tribune*, November 11, 1920; "One-Floor Store of Glosser Brothers is Still Expanding," ibid., August 8, 1921; "Glosser Brothers Move to Their New Glosserteria," ibid., September 27, 1921; "Glosser Firm to Expand Largely," ibid., January 30, 1923.

221. "Glosser Brothers Erect New Addition…," *Johnstown Tribune*, November 24, 1926; "Glosser Brothers 20 Years in Business," ibid., October 11, 1926; "Glossers' Circus Parade…," ibid., June 1, 1926.

Chapter 3: Public Affairs from 1900 until the Great Depression

222. For a description of the Johnstown municipal government, its organization and functioning around the turn of the century, see Chapter 1, section IV, "The Local Polity."

223. "Only a Smoldering Mass," *Johnstown Tribune*, November 6, 1903; "Opera House Fire," *Johnstown Weekly Democrat*, November 6, 1903.

224. "Wants a Paid Department," *Johnstown Tribune*, December 8, 1903.

225. "In a Busy Session," ibid., January 20, 1904.

226. Water Street between Franklin and Napoleon Street was later renamed Somerset Street. Later it was abandoned primarily to help Sani-dairy expand.

227. "Whose Business Is It?," editorial, *Johnstown Tribune*, March 29, 1906.

228. "A Fire Commission," ibid., April 18, 1906. The first commissioners were G.W. Wagoner, an ex-mayor, physician and one of the founders of the Conemaugh Memorial Hospital; J. Earl Ogle, a real estate and insurance broker; George Haberkorn, a mechanic; J.B. McAneny, a physician; and E.B. Entwisle, plant manager at Lorain Steel and former chief engineer.

229. "Paid Fire Department Brings Down Insurance," *Johnstown Tribune*, October 18, 1907.

230. "Public May See New Fire Auto in Action," ibid., May 19, 1913; "Horse-Drawn Apparatus of Fire Department Retired from Service; Gallant Steeds Go," ibid., August 3, 1922.

231. Frank G. Bates and Frank Goodnow, *Municipal Government* (New York: The Century Company, 1919), 191–96.

232. "Mr. Price's Prediction," *Johnstown Daily Democrat*, April 13, 1910; "Charles S. Price Predicts 100,000 Population Here Within Few Years," *Johnstown Weekly Democrat*, April 5, 1910; "Johnstown Leads the Way," editorial, ibid., April 15, 1910; "Committee to Reform City Government," *Johnstown Daily Democrat*, April 15, 1910; "Civic Committee Energetically Takes up its Responsible Work," ibid., April 18, 1910. Members of the Civic Improvement Committee included W.W. Bailey, editor-publisher of the *Johnstown Democrat*; H.S. Endsley, solicitor for Cambria Steel; James P. Green, president of Cambria Brewing Company and a member of the common council; James Thomas, general manager of A.J. Haws Brick Company; John Waters, president, National Radiator Company; Anderson Walters, publisher of the *Johnstown Tribune*; Dr. G.W. Wagoner, former mayor and leading physician; George M. Wertz, state senator and political boss; L.D. Woodruff, former mayor and journalist with *Johnstown Democrat*; and Mayor Alexander Wilson.

233. "Ask People to Support Commission Government," *Johnstown Tribune*, March 7, 1911.

234. Bill 367, Pennsylvania Acts of the Legislature, 1913.

235. Department of Accounts and Finance (this director was vice-chairman of the council.); Department of Public Safety; Department of Streets and Public Improvements; Department of Parks and Public Property.

236. "Quo Warranto Matter Still to be Settled," *Johnstown Weekly Democrat*, April 19, 1910. A quo warranto proceeding is an action in court challenging a public official's lawful right to hold his or her office.

237. Cauffiel's machinations in electric utility matters are discussed in Chapter 2, section III, specifically the subsection *The Guffey-Queen Syndicate*.

238. "The Mayor Elect," editorial, *Johnstown Weekly Democrat*, November 10, 1911; "A New Order of Things," *Johnstown Tribune*, November 10, 1911; "Mayor Cauffiel," editorials, ibid.

239. "Police and J&SC Men in a Merry War," *Johnstown Tribune*, March 16, 1912; "Bridge Street Fight to Court," ibid., March 18, 1912.

240. "Mayor Hangs Veto on Subway Ordinance," ibid., April 22, 1912; "Councils Pass Bill Over Veto…," ibid., April 24, 1912.

241. "Mayor's Mass Meeting…"; "The Mayor's Meeting," editorial; and "Mayor's Veto is Not Heeded by Councils," *Johnstown Tribune*, August 1, 1912.

242. "Big Field for the Vice Commission…," ibid., January 4, 1912.

243. "Besmirch Girls' Characters," ibid., October 30, 1914. Anderson Walters, publisher of the *Johnstown Tribune*, was also a Republican leader identified with the dry, anti-George Wertz faction. He obviously welcomed the chance not

only to "take a shot" at Wertz but also at a rival newspaper.

244. "Johnstown…New Official Toggery," *Johnstown Tribune*, December 1, 1913; "City Business Only For Those New Councilmen," ibid.

245. "Vote 3 to 2 to Buy Water Plant," ibid., August 11, 1914.

246. "Work?," editorial, ibid., April 3, 1914.

247. "New City Officials Take the Oath of Office…," ibid., January 3, 1916.

248. For more on Johnstown during these time periods, see Chapter 8 and Chapter 9.

249. The more sensational features of Cauffiel's second term are covered in Chapter 5, section II, "Cauffiel's Republic of Virtue in His City of the Plain," and Chapter 7, section IV, "Rosedale."

250. "The New City Administration," editorial, "Inaugural Message to New Council," *Johnstown Tribune*, January 7, 1924; "The Mayor's Message," editorial, ibid., January 8, 1924. The achievements of Franke's second term are explored later in this chapter in sections VII, VIII, IX, X, XI, XII and XIV.

251. "Message of Mayor is Summary of Progress," ibid., January 6, 1925; "City Council Reorganizes at Noon…," ibid., January 4, 1926; "Zone Ordinance Passed Finally by City Council," ibid., January 5, 1926; "Mayor Franke Urges Many Improvements in Annual Message," ibid., January 3, 1927; "Mayor Franke Reviews Attainments of Past Four Years," ibid., January 2, 1928; "Mayor Franke Dies," obituary, *Johnstown Tribune-Democrat*, April 7, 1975; Gable, *History of Cambria County*, biographical sketch of Louis Franke.

252. "James P. Thomas Sells Home on Somerset Street," *Johnstown Tribune*, September 30, 1916.

253. "Auto Car Line to Westmont," *Johnstown Weekly Democrat*, August 20, 1906; "Get Autos Next Week," *Johnstown Tribune*, September 2, 1909. A photograph of the four auto buses appeared in the October 9, 1909 *Tribune*.

254. "Lively Talk of New Trolley Line," *Johnstown Tribune*, February 21, 1908; "Trolley Line to Southmont Next," ibid., September 17, 1909. See also Chapter 4, section II, "Trolley and Regional Passenger Railroads," subsection, *A Tragedy* for more on the trolley accident.

255. See also Chapter 4, section II, "Trolley and Regional Passenger Railroads," subsection *Pressures for New Service*.

256. "New Town of Woodvale Heights," *Johnstown Tribune*, January 10, 1903; "Bustle about Woodvale Heights," ibid., July 30, 1908; "Pretty is Woodvale Heights," *Johnstown Weekly Democrat*, March 27, 1903.

257. "Viewmont Most Aptly Named," *Johnstown Tribune*, September 1, 1908. Early residents included Dr. J.B. Lowman, surgeon in charge of Cambria Hospital; Marshall Moore, superintendent of mining for Cambria Steel; A.W. Swarts, a real estate and insurance broker; P.C. Isaacs, a lumberman; and Dr. Charles Hannan, a physician.

258. See Chapter 4, section I, "Regional Roads and Turnpikes," subsection, *The Jungle Road*.

259. "Highland Section Rapidly Selling," *Johnstown Tribune*, October 8, 1909.

260. "Ferndale Lot Sale Brings up Question of City Park Again," ibid., July 22, 1913; "Destruction of Beautiful Trees in Evan Du Pont's Park," ibid., April 15, 1914; "Ferndale's Land Values Soaring," ibid., June 6, 1914.

261. "Greater Johnstown," editorial, ibid., November 30, 1905.

262. "Want In City," ibid., November 15, 1906.

263. "Real Reason Stonycreek Township Does Not Enter City," *Johnstown Weekly Democrat*, December 17, 1909. Constable Hollow was the stream valley of Sams Run, upstream of Moxham. As such, it was what today is Lorain Borough plus a small section of Stonycreek Township.

264. "Greater Johnstown Boosted in Council," *Johnstown Weekly Democrat*, February 18, 1910; "Steps for Greater Johnstown," *Johnstown Tribune*, February 17, 1910.

265. "Lower Yoder on Annexation," *Johnstown Tribune*, February 23, 1910.

266. "Throw Cold Water On Plan," ibid., February 21, 1910; "Opposition in East Conemaugh," editorial, ibid., March 29, 1910; "Welcome the Discussion," editorial, ibid., March 18, 1910.

267. "Ferndale Against Joining the City," ibid., August 16, 1911.

268. "Cauffiel at Annexation Meeting in Stonycreek," ibid., November 25, 1911; "Stonycreek Votes to Join the City," ibid., December 6, 1911; "Stonycreek Made Third Precinct of Seventeenth Ward," *Johnstown Weekly Democrat*, December 15, 1911. "Stonycreek" was erroneously used in these headlines. Walnut Grove was a part of Stonycreek Township—not all of it.

269. "Mayor Revives Annexation Talk," *Johnstown Tribune*, June 5, 1913; "Come In, Westmont," ibid., July 9, 1913; "Annexation Coming Says Burgess Rush," ibid., July 11, 1913; "Westmont Citizen Urges Mass Meeting…," July 14, 1913; "Brownstown Will Try for Annexation," ibid., July 14, 1913; "Annexation Antis of Westmont Awake," ibid., July 21, 1913; "Boroughs Get in Elsewhere," *Johnstown Weekly Democrat*, July 29, 1913.

270. "New Borough Incorporated," *Johnstown Tribune*, November 4, 1915.

271. "Rosedale Now is Dwindling," ibid., September 13, 1915; "Pretty Little Village of Rosedale is Doomed," ibid., June 23, 1916.

272. The committee members were: Louis Franke, mayor and chairman; J. Kennard Johnson, secretary of the chamber of commerce; John Ogden, general superintendent of Cambria Steel; John Ryan, Ryan-Correll Company; D.M.S. McFeaters, Johnstown Trust Company and a school board member; John Cooney, cashier of First National Bank of East Conemaugh; and J.C. Francis, chief clerk of the wire mill.

273. "The Greater Johnstown," editorial, *Johnstown Tribune*, April 21, 1917; "Boroughs to Vote Greater Johnstown," ibid., April 28, 1917.

274. "Court Approves the Annexation," ibid., August 13, 1918; "Bill Annexing Oakhurst Goes on the Calendar," ibid., November 26, 1918; "Annexation Decree Being Awaited Now," ibid., Febrary 24, 1919.

275. *Commonwealth ex rel. v Dale Borough*, 272 PA 189 (1922).

276. "Annexation Move in Southmont is Temporarily Put Off," *Johnstown Tribune*, January 9, 1923; "Annexation Move Must Be Held Off Until Next Year," ibid., August 23, 1923.

277. "Expect to Renew Effort to Annex," ibid., May 9, 1925; "Annexation Hope is Dispelled in Vetoing of Bill," ibid., May 20, 1925; "Annexation Facts…," ibid., November 27, 1928; "Debate on Annexation of Borough to City…," ibid., October 15, 1929.

278. "Pass Bridge Bill," ibid, January 17, 1906.

279. "Pennsy Gets Time Extension" (subsection of "Front Foot Gets a Black Eye"), ibid., July 21, 1910; "Mayor Sends Final Message," ibid., January 18, 1911.

280. "Councils to Hear Favorable Report," ibid., May 16, 1910.

281. "Wants Bridge at Haynes Street Built Before Next Fall," ibid., March 13, 1917.

282. "Grade Crossing Bills to a Special Committee…," ibid., November 16, 1910.

283. "Conference of B&O Men with Mayor Ends in Disagreement," ibid., March 22, 1913; "Begins Campaign to Eliminate All Grade Crossings," ibid., October 13, 1916.

284. "Council Acts on New Bridge Bills," ibid., August 22, 1916; "New Moxham Bridge to be as Originally Designed," ibid., October 3, 1916.

285. "Question of Grade-Crossing Elimination is Given Airing," ibid., April 27, 1917.

286. "Fatalities Prevented by Fortunate Circumstances," ibid., March 22, 1916; "Not Our Fault Says Du Pont," ibid., "Traffic Can Be Resumed in 60 Hours," ibid.

287. There were also two footbridges—one at Johns Street and the other at Haynes Street—and there was also the Incline Plane Bridge, an extension of the Incline Plane itself.

288. The Cambria City Bridge was also known as the McConaughy Street or First Avenue Bridge. It connected Iron Street in old Millville (Lower Works area) with Cambria City. All trolleys and most traffic between downtown and beyond and Cambria City and beyond used this bridge until the Hillside (later Roosevelt) Boulevard went into use in 1930, and Iron Street was abandoned.

289. "Immediate Steps Taken to Make Bridges of City Safe," *Johnstown Tribune*, July 20, 1916; "Thousands of Dollars into Bridges, Streets, and Sewers in Two Years," ibid., January 4, 1918.

290. "City Takes Over Two Bridges, Will Rush Completion," ibid., January 4, 1918.

291. "Conemaugh and Stony Creek Rivers on Rampage; Temporary Bridges Damaged; Others unharmed," ibid., February 13, 1918.

292. "Investigation into Franklin-Conemaugh Bridge Which Collapsed Yesterday…," ibid. February 2, 1918.

293. "Conemaugh-Franklin Bridge…," (with photograph), ibid., November 12, 1924.

294. See section VIII, "The Abandonment of the Iron Street Corridor," later in this chapter. "Formally Approve Detail Plans of Two New Bridges," *Johnstown Tribune*, March 28, 1923; "Award Contracts for Construction of Two Proposed New Bridges," ibid., October 9, 1923.

295. "Tear Out Bridge…," *Johnstown Tribune*, June 3, 1924; "Engineer Reports All City's Work is Near Completion," ibid., December 19, 1924; "Road-Bridge Projects for Past Four Years Recounted…," ibid., March 9, 1928.

296. "Members of Council Ask Elimination of Woodvale Crossing," ibid., June 22, 1926; "City Will Be Heard in Capital," ibid., February 18, 1927; "Commission Will Hear Argument in Bridge Case," ibid., March 18, 1927; "City Ordered to Pay 55%…," ibid., July 19, 1927; "Withhold Action on Maple Avenue Bridge Project," ibid., November 25, 1927; "City is Opposed to Erection of Maple Avenue Bridge Now," January 31, 1928; "Bridge Building Order Rescinded…," ibid., September 10, 1932.

297. "Woodvale Bridge Start Planned for December," ibid., October 21, 1955; "Maple Avenue Contract Let," ibid., December 8, 1955.

298. "The Ferndale Bridge," editorial, ibid., March 26, 1926; "Complaint is Filed by Ferndale Borough on Grade Crossings," ibid., October 18, 1926; "Ferndale Bridge Property Damage Would Be Heavy," ibid., June 23, 1927; "Moxham Residents Ask for New Span at Bridge Street," ibid., April 17, 1928.

299. "New B&O Station on Baumer Street is Planned by Company," ibid., November 24, 1924; "Washington Street Will Be Widened Under New Agreement With B&O," ibid., December 9, 1924; "New B&O Station on Baumer Street…This Year," March 19, 1925; "B&O Station is Ordered Removed by Council," ibid., July 12, 1927; "Loading Platform of B&O Ripped Away…," ibid., July 19, 1927; "New B&O Station Will Probably Be Erected This Year," ibid., January 19, 1929; "River Excavation to be Carried Out Within Five Years," ibid., September 10, 1929; "$365,000 Program…to Begin At Once," ibid., March 17, 1930.

300. "Bethlehem Proposal on Iron Street Not Acceptable to City," ibid., April 5, 1924; "Councilmen Plan Early Start…," ibid., April 24, 1924; "Councilmen Invited to Second Parley on Iron Street Change," ibid., May 27, 1924;

"Repairs to Iron Street Promised by City Council," ibid., March 21, 1925; "Complete Details of Agreement on Iron Street Project," ibid., June 11, 1925; "Synopsis of Agreement," ibid., August 18, 1925; "Iron Street Agreement Signed...," ibid., August 26, 1926.

301. "Bridges at Point Will Be Erected Early Next Year," ibid., November 4, 1926; "Hillside Boulevard Plans Are Advanced," ibid., November 23, 1926; "Johns Street Span Approved By Board," ibid., January 14, 1927; "Walker Insists County Will Have Some Say...on Bridges," ibid., April 23, 1927; "Joint Supervision of Bridge Construction Approved," ibid., May 24, 1927.

302. "Ferris Engineering...Low Bidder," ibid., June 28, 1927.

303. "River Wall Plans...," ibid., November 16, 1927.

304. "May Build Subway...Early Next Year," ibid., November 25, 1927; "City Prepares to Build River Walls for Point Project," ibid., November 29, 1927; "Ferris Engineering Co. Low Bidder on Walls at Point," ibid., February 28, 1928; "Pittsburgh Firm Given River Wall Contract Over Mayor's Protest," ibid., March 6, 1928; project photographs, ibid., March 24, 1928; "Will Confer with Pennsy Officials Regarding Subway," ibid., June 11, 1928; "Subway Bill Passes...," ibid., June 26, 1928; project photographs, ibid., June 14, 1928; "Awaiting Approval of State Board on Railroad Projects," ibid., August 9, 1928; "Company Ready to Begin...Subway at Point," ibid., February 25, 1929; "Expend Huge Sum in Point Improvements...," ibid., April 27, 1929; "City Council Awards Foley...Retaining Walls," August 29, 1929.

305. "Big Construction Projects Attract Public Attention," ibid., November 7, 1929; "Boulevard Will be Opened; Iron Street to Close," ibid., October 29, 1930; "City Prepares to Abandon Highways to Cambria Plant," ibid., November 12, 1930.

306. "Traffic Problem Made More Acute by Loss of Park," ibid, June 3, 1924; "1 ½ Hour Parking Rule," ibid., June 23, 1929.

307. "New Signaling Device Put into Operation...," ibid., June 2, 1924; "More Experiments by Traffic Squad," ibid., June 1, 1924; "Traffic Signal Device is Used for First Time," ibid., April 17, 1925; "Campaign Planned by Traffic Squad," ibid., November 19, 1926; "Traffic Lights...," editorial, ibid., September 3, 1929.

308. "A Terrible Toll," editorial, ibid., January 2, 1925; "Safety," editorial, ibid., July 25, 1925; "Fifty-One Killed...," ibid., December 29, 1929; "Coasting Mishaps...," and "Automobile Accidents Take Lives," ibid., January 3, 1927.

309. Bill 452, Acts of the Pennsylvania Legislature, 1927.

310. "Johnstown's Sewerage Question," *Johnstown Tribune*, March 10, 1911; "Dr. Matthews on Need of a Sewer System for City," ibid., May 11, 1911.

311. Trunk sewers are the large sewers that collect sewage from many "lateral sewers" or "laterals" that serve individual neighborhood streets. With some exceptions, trunk sewer lines tend to be installed near streams. "Cauffiel Outlines Improvement Plan," *Johnstown Tribune*, December 4, 1911; "Sewer Problem is a Real One," ibid., June 10, 1913; "Sanitary Sewer System for City," ibid., January 2, 1914.

312. "Some of Present Sewers Useless in New System," ibid., April 29, 1914.

313. "State Approves City's Sanitary Improvement Plans; Time Limit Set," ibid., April 21, 1915.

314. "Mayor's Annual Message," ibid., January 2, 1917; "Sewer System is Complicated Layout," ibid., October 19, 1938.

315. "Improvements in City During 1923 Totaled over Million Dollars," ibid., February 4, 1924.

316. "Mayor Franke Reviews Attainments of Past Four Years," ibid., January 2, 1928; "Much Mileage of Sanitary Sewer System Now Used," ibid., November 1, 1928.

317. "Cresswell Gets Park at Roxbury," *Johnstown Weekly Democrat*, February 5, 1904; "Cresswell Buys...," *Johnstown Tribune*, February 2, 1904.

318. "To Spend $50,000," *Johnstown Tribune*, September 23, 1904; "Luna Park New Name of Roxbury Resort," *Johnstown Weekly Democrat*, March 31, 1905; "Luna Park's Final Touches," *Johnstown Tribune*, May 26, 1905; "Crowds Delighted with Luna Park," ibid., May 31, 1905; "25,000 Were Visitors at Fair at Luna," *Johnstown Weekly Democrat*, September 29, 1905.

319. "No Interstate Fair at Luna This Year," *Johnstown Weekly Democrat*, August 14, 1908.

320. "Luna To Undergo Transformation at Hands of New Lessees," ibid., March 11, 1910.

321. "Greater Valley Park Plan," ibid., September 23, 1904; "Island Park Directorate," *Johnstown Daily Tribune*, January 23, 1906.

322. John Cassady, "The Somerset County Outline," (Mennonite Publishing House, 1932), 244–45.

323. Crystal Beach was located on and near the present (2004) site of Saint Andrews Catholic Church.

324. "Sale of Crystal Beach to Lorain Steel Impending," *Johnstown Tribune*, March 22, 1930; "Amusement Park at Crystal Beach Being Remodeled," ibid., May 3, 1930; "Leasing of Lorain Park for Season Gives Crystal Beach Excellent Picnic Facilities," ibid., June 21, 1930; "Crystal Beach Pool Covered as Low-Lying Land is Filled," ibid., December 14, 1942.

325. "Miss Schoenfeld's Review of Her Recreation Survey," ibid., May 16, 1912.

326. "President Nokes Reviews Work of Year by the Recreation Commission," ibid., February 11, 1913.

327. "Peter Carpenter Head of Park Board," ibid., June 2, 1913.

328. Aside from Carpenter and Nokes, the other members were Herman Baumer, John H. Morley, Dr. Louis Wesner, James C. Taylor and Thomas R. Parfitt. Five of the seven had been on Nokes's commission. "Park and Recreation Board Meets and Has Organization," *Johnstown Tribune*, January 24, 1914.

329. "Constable Hollow Offered for Park," ibid., June 2, 1914; "Will Contribute $1000 Toward Parks for City," ibid., June 5, 1914.

330. "The Park Question," editorial, ibid., January 21, 1915.

331. "P.L. Carpenter Offers the City Yoder Falls," ibid., June 29, 1915.

332. "Park Purchase Defeated; Vote in Council 3-2," ibid., January 2, 1917.

333. Johnstown City Planning Commission, "The Comprehensive Plan of Johnstown" (1917), 131ff., 139.

334. The "Highland Park" near Moxham is a different tract from the "Highland Regional Park" that straddles the Richland–Stonycreek Township line and is operated by the East Hills Recreation Commission.

335. "The Mayor's Message," editorial, *Johnstown Tribune*, January 6, 1920.

336. "Border Dam Crowded With Happy Bathers…," ibid., July 28, 1919.

337. "Lorain Steel Company to Formally Open its Big Bathing Pool Soon," ibid., September 2, 1920; "Lorain Swimming Pool Formal Opening Will Take Place Tomorrow," ibid., June 17, 1921.

338. "New Fichtner Pool, Morrellville, Is Being Prepared…," ibid., April 1, 1922; "Municipally-Operated Swimming Pool is Very Successful—Buettner," *Johnstown Weekly Democrat*, October 27, 1923.

339. "City Engineer Says Point Structure No Longer Safe," *Johnstown Tribune*, April 22, 1924; "Development of Point for Recreation Purposes," ibid., March 5, 1925; "Officials Desire to Issue Bonds for Big Point Stadium Plan," ibid., August 18, 1925; "Contract Awarded for Erection of Stadium at Point," ibid., January 19, 1926; "Big Stadium Ready to Handle Crowds for Monday Opener," ibid., July 3, 1926; "Big Football Game," editorial, ibid., October 7, 1926; "Johnstown is Football Mecca as Crowds Arrive…," ibid., October 16, 1916; "City Gets $4080 as its Share…," ibid., November 19, 1926.

340. "City Public Schools Are Filled," ibid., September 4, 1901; "Total Enrollment of 5,411," ibid., September 11, 1901; "Supt. Adee Makes His First Report," ibid., September 13, 1911; "City Schools had 7,767 Pupils on Opening Day" (comparative data for 1912–13–14), ibid., September 1, 1914; "Second Week of School Year Brings Enrollment," ibid., September 8, 1915; "13,000 Pupils Affected by Order Not to Open City Schools…," ibid., August 25, 1916; "Enrollment Figures for City Schools Announced," ibid., September 14, 1918.

341. The Johnstown High School building became the Joseph Johns Junior High School in September 1926.

342. Johnstown Board of Education, "The Public Schools—the Pride of the City of Johnstown" (1927).

343. Johnstown City Directory, 1911–12. (This directory gives numbers of teachers for each school by naming each teacher individually.)

344. "Controllers for Small Board," *Johnstown Tribune*, November 11, 1908.

345. "Shields President of School Board…," ibid., March 1, 1911.

346. "Decapitation to be the Fate of Independent School Instructors," *Johnstown Democrat*, June 8, 1911; "Shall the Schools Be Feminized?," editorial, ibid., June 9, 1911; "Political Steam Roller Does its Work Real Well," ibid., June 10, 1911; "Turn on the Light," editorial, ibid., June 19, 1911.

347. Report to the Johnstown School Board about the Gary, Indiana, School System from the Special Ad Hoc Committee. This is an undated letter but was received in June 1917. Courtesy of the Greater Johnstown School District, where the report is on file.

348. It was a common practice to refer to school superintendents, principals and certain male school teachers as "professor" in the first quarter of the twentieth century.

349. "Prof. Stockton Superintendent of Public Schools," *Johnstown Tribune*, April 10, 1918; "Superintendent of City Schools Has Issued a Statement," ibid., April 11, 1918.

350. "Immediate Resumption of Modified School Building Program Urged," ibid., December 17, 1918.

351. "New High School in Central Part of City Needed," ibid., September 14, 1921.

352. Gable: *History of Cambria County*, biographical Sketch of Herbert Stockton; John Stockton, H.J. Stockton's son, personal interview, June 23, 2000.

353. "Pupils Enrolled…Exceed Last Year," *Johnstown Tribune*, September 3, 1919; "Marked Increase…Schools Crowded," ibid., September 8, 1920; "First Day Totals Show Enrollment…," ibid., September 7, 1921; "Statistics Indicate Enrollment…," ibid., September 6, 1922; "Enrollment…Less Than Last Year," *Johnstown Weekly Democrat*, September 5, 1923; "Enroll Over 500 More…," *Johnstown Tribune*, September 4, 1924; "Increase of 402 Pupils…," ibid., September 14, 1925; "Local Public Schools…," ibid., September 7, 1926; "13,748 Pupils In City Schools…," ibid., February 1, 1929; "13,033 Children Return to Work…," ibid., September 3, 1929. See also Johnstown Board of Education, "Public Schools."

354. Father Donald W. Dusza, "The Legacy of Prince Gallitzin—A History of the Altoona-Johnstown Diocese" (c. 1995), 135–73, 283, 289. Also Johnstown City Directories, especially 1918, 1920, 1922.

355. "Plans Are Laid for a Catholic High School Here," *Johnstown Tribune*, January 13, 1922; "Enrollment at City Schools Less Than Last Year," *Johnstown Weekly Democrat*, September 5, 1923; "The Johnstown Catholic High School,

Eighth Ward…," ibid., October 15, 1923.

356. "Safety Building for City Among Most Pressing Needs," *Johnstown Tribune*, December 13, 1922.

357. "City Secures Second Ward Ground as Site for Safety Building," ibid., August 3, 1923; "Want Proposals on Plans of New Safety Building," ibid., October 2, 1923.

358. "City Authorizes…Bond Issue for Safety Building," ibid., October 17, 1924; "Unusual Competition for Contract on New Public Safety Home," ibid., January 13, 1925; "Work Upon Safety Structure Goes Forward Rapidly," ibid., August 12, 1925; "Safety Building is Now Occupied by City Bureaus," ibid., September 20, 1926; "Johnstown's New Public Safety Building…," ibid., September 22, 1926; "Safety Building Dedication…," ibid., December 8, 1926.

359. Judge John Kephart recused himself in the Walters-Bailey case because of his close association with both men. "Direct Allegation of Fraud…," *Johnstown Tribune*, November 11, 1924; "Court's Decision on Westmont…," ibid., November 12, 1924; "The Climax," editorial, ibid., November 19, 1924; "Bailey Takes His Case to High Court," ibid., November 24, 1924; "Walters Wins Congress…," ibid., June 8, 1926.

360. Anonymous letter from Ku Klux Klan to George Wolfe, October 31, 1923. Courtesy of the Wolfe family of Johnstown.

361. See Chapter 7, section IV.

362. Andrew Gleason, personal interview, September 11, 2000; "Gus M. Gleason, 59, Dies…," *Johnstown Tribune*, October 6, 1941.

Chapter 4: Highways and Transit Developments from 1900 until the Great Depression

363. "Opposition to…Working Out the Road Tax," *Johnstown Weekly Democrat*, January 7, 1910.

364. "Country Roads in Need of Mending," ibid., February 5, 1904; "1511 Miles County Roads," *Johnstown Tribune*, October 26, 1903; "After the Autos," ibid., May 25, 1904; "After the Autos," ibid., August 3, 1904.

365. "Form Auto Club," *Johnstown Tribune*, July 28, 1905; "Fastest Auto Run," ibid., July 16, 1906; "Johnstown Family Crossing Continent," ibid., May 4, 1908; "Murdock Party Reaches City," ibid., May 22, 1908; "Coast to Coast in Only 25 Days," ibid., May 27, 1908; "Traveled 5854 Miles on Roads of Europe…," ibid., June 14, 1910; "Love's Automobile Breaks All Records," *Johnstown Weekly Democrat*, May 24, 1907.

366. Act 220, Laws of Pennsylvania, 1905; "New Road Laws of Pennsylvania," *Johnstown Weekly Democrat*, November 3, 1905.

367. "Patchwork Bane of Good Roads," *Johnstown Tribune*, October 1, 1909.

368. "A Turnpike Scheme in Somerset County," ibid., February 10, 1905; "A Road Meeting at 'Hank' Miltenberger's," ibid., May 5, 1905; "After the Pikes," ibid., June 14, 1906; "Toll Road Suit is Knocked Out," ibid., January 28, 1907; "Pike Company Gets $18,000," ibid., April 19, 1907; "Pike Viewers Upheld in Court," ibid., January 7, 1908; "Tolls Taken Off Valley Pike," ibid., March 2, 1908; "Last Toll Road in County Gone," ibid., July 10, 1908; "Only One Toll Highway into City Soon," ibid., May 23, 1916; "Haws Turnpike Case Tomorrow," ibid., August 21, 1916.

369. The Jungle Road, or "Wertz Road," should not be confused with the Wertz Road or Street in Johnstown that leads off of Bedford Street. It was today's Ohio Street that extends through Lorain Borough, Stonycreek Township and Geistown Borough.

370. "Negligent Road Supervisors in Danger of Law's…," *Johnstown Weekly Democrat*, June 11, 1909; "Should Send Them to Jail," editorial, ibid.; "If Grand Jury Approves Scheme…," ibid., September 10, 1909; "Grand Jury Turns Down Road Scheme…," ibid., September 17, 1909; "Negligent Road Supervisors in Danger…," *Johnstown Tribune*, June 11, 1909; "About to Realize Good Roads Hopes," ibid., June 26, 1909; "Decide on Roads to Be Improved," ibid., June 31, 1909; "The Road Business," editorial, ibid., September 9, 1909.

371. "Association Will Boom Good Roads…," *Johnstown Weekly Democrat*, September 24, 1909; "1000 Members…New Organization," ibid., September 25, 1909; "Session of Good Roads Committee," *Johnstown Tribune*, September 25, 1909; "Good Roads," editorial, ibid.

372. "Grange Scores Highway Department," *Johntown Tribune*, December 24, 1909; "375 Automobiles in City," ibid., October 18, 1911.

373. "New Routes in Highway Bill," *Johnstown Weekly Democrat*, April 28, 1911; "$4,500,000…Cost of Roads…," ibid., June 30, 1911; "Millions for Good Roads…," *Johnstown Tribune*, February 16, 1911; "Prompt Action Got Fine Road…," ibid., March 10, 1911; "Almost 2,000 Auto Owners in Johnstown," ibid., November 30, 1916; "Cunningham Talks Roads," ibid., January 20, 1916; "Penn Highway Meeting Date," ibid., March 9, 1916; "Delegation Committee Is… Organizing…," ibid., March 16, 1916; "Officers Elected…Penn Highway Assn.," ibid., March 27, 1917; "Improved Road to Lincoln Highway Soon," ibid., April 26, 1917; Act 193, Laws of Pennsylvania, 1911; Act 191, ibid., 1913; Gable, *Cambria County*, Chapter 5; "Road Across U.S. Proposed by Auto Men," *Johnstown Weekly Democrat*, November 8, 1912.

374. "Greatest Highway Program in County History," *Johnstown Tribune*, February 14, 1919.

375. "Forty Miles of Road Work Under Construction," *Johnstown Weekly Democrat*, November 19, 1919.

376. The section "Leaders and Heroes" in Chapter 8 describes Murdock's meeting with Menoher in France during the war.

377. "New Menoher Highway Proposed and Gains Favor With Public," *Johnstown Tribune*, December 23, 1919.

378. Gable, *Cambria County*, 103.

379. "Bond Issue for County Roads Said to Be a Step Toward Better Housing," *Johnstown Tribune*, May 3, 1920; "Road Boosters to Hold Meeting in North of County," ibid., May 8, 1920.

380. "County Officials Confer Relative to Road Program," ibid., January 20, 1922; "Chamber of Commerce Hears Report on Good Roads in Cambria County," ibid., April 29, 1922.

381. Gable, *Cambria County*, 99–101. A concise overview of the highway program in the Greater Johnstown Area in the halcyon days of its post-World War One development can be found in a *Johnstown Tribune* article of April 29, 1922, "Chamber of Commerce Hears Report on Good Roads in Cambria County."

382. Leonard Mosley, *Blood Relations: The Rise and Fall of the DuPonts of Delaware*, (Atheneum, 1980), 151.

383. "Busiest Man of All, Joyful, Located," *Johnstown Weekly Democrat*, October 14, 1904; John D. Gates, *The Du Pont Family* (Doubleday, 1979), 199.

384. "Will Go to Court," *Johnstown Tribune*, August 14, 1906.

385. "Du Pont Says Service Will Be Improved," ibid., August 21, 1906.

386. "Du Pont Promises a Geistown Line," ibid., August 27, 1907; Geistown was a part of Richland and Stony Creek Townships until it was incorporated as a borough in 1930.

387. "Street Cars Run in Morrellville," ibid., December 1, 1908. The extension of trolley service through Southmont to Westmont is discussed in Chapter Three, section V, "Suburban Growth and Development," subsection *Southmont*.

388. "Local Trolley Stockholders to Exchange Share For Share," *Johnstown Tribune*, December 14, 1909.

389. "Johnstown Traction Company Chartered," *Johnstown Weekly Democrat*, February 25, 1910.

390. "Trolley Complaints…City Will Act…," *Johnstown Tribune*, January 26, 1917.

391. "Trolley Company Must Pay Debts, Committee Says," ibid., May 3, 1919.

392. "Traction Troubles," editorial, ibid., December 27, 1917; "Six New Trolley Cars…," ibid., March 9, 1920; "One Man Trolley Cars Again Come in For Attention," ibid., May 9, 1923; "One Man Trolley Cars Sanctioned," ibid., May 15, 1923.

393. "Two Score Years Spanned Rise and Fall of District Trolley Lines," ibid., April 16, 1948. (This is an extended article on transit and inter-urban rail.)

394. "All Delighted With New Line," ibid., January 11, 1910.

395. "Good Day's Business on Johnstown-Ebensburg Line," *Johnstown Weekly Democrat*, January 26, 1912.

396. "Many Are Injured…Near Echo," *Johnstown Tribune*, August 12, 1916; "The Wreck," editorial, August 14, 1916.

Chapter 5: The Wrath of Grapes: Temperance, Morality, Prohibition and Crime

397. "Old Established Liquor Places Are Refused License by Judge Stephens," *Johnstown Weekly Democrat*, March 7, 1913.

398. Political cartoon, *Johnstown Tribune*, April 26, 1905; "The Liquor Laws," editorial, ibid., December 13, 1912; "'Hogging' of License Applications Began during the Barker Regime," *Johnstown Weekly Democrat*, February 9, 1912; "Judges Laid Low By Booze," ibid., February 14, 1912.

399. "The Liquor Organization," editorial, *Johnstown Tribune*, February 5, 1915.

400. "Lying Critics Routed," editorial, *Johnstown Weekly Democrat*, February 6, 1903.

401. "Remonstrance is Signed by Over Thousand," ibid., January 31, 1907.

402. Harry M. Chalfant, *Father Penn and John Barleycorn*, (The Evangelical Press, 1920). This work, biased in favor of Prohibition, gives a good layman's summary of the Brooks High License Law of 1887 and the way it operated in Pennsylvania as seen from the temperance perspective.

403. "Organize a Cambria County Branch of Anti-Saloon League," *Johnstown Tribune*, March 18, 1907.

404. "Local Preachers to Start a Local Option Petition," ibid., February 2, 1909.

405. "Anti-Salooners' Convention is On," ibid., March 15, 1909; "Anti-Saloon Convention Ends," ibid., March 16, 1909.

406. "Recommends the Rev. William Sunday," ibid., November 14, 1910.

407. "Councils Deny Permission to Erect a Tabernacle…," ibid., January 18, 1911; "Scores Opponents of 'Billy' Sunday," ibid., April 21, 1911.

408. "Sunday Coming Here Anyway Says Rev. Dr. Hays," *Johnstown Weekly Democrat*, May 5, 1911.

409. "Anti-Saloon League is for Local Option," ibid., February 2, 1912.

410. "Wants Point For Billy Sunday," *Johnstown Tribune*, June 3, 1913.

411. "Cohorts of Sin and Disciples of Satan Are Vigorously Denounced by Billy Sunday in Opening Evangelistic Campaign in Johnstown," ibid., November 3, 1913.

412. "Billy Sunday Turns Old Town Topsy," ibid., November 10, 1913.

413. "Evangelist Sunday and Ma Sunday at Head of Sunday School Parade," ibid., December 8, 1913.

414. "Thousands of Men Cheer When Mayor Grips Hand of Evangelist Sunday," ibid., Decmeber 8, 1913.

415. "Rev. Sunday Completes Labors and Leaves City…," ibid., December 16, 1913.

416. "Manager Scherer Has Written Billy Sunday…," ibid., October 21, 1913; "Every Courtesy Will Be Extended

Eva Tanguay at Sunday Meeting," ibid., November 29, 1913.

417. "Pavlowa Gives Johnstown a Real Treat," ibid., November 24, 1913; "Many Visitors in Johnstown," ibid.

418. "Explosion Shatters Windows…Causing Near Panic," ibid., December 15, 1913,

419. "Sunday Anti-Liquor League is Launched," ibid., December 24, 1913; "Anti-Liquor Association Will Push Remonstrances," ibid., December 27, 1913.

420. "Year in Jail is Before Him Who Carries a Flask," ibid., January 16, 1920.

421. "Aged Man Sent to Jail for One Day Less Than a Year," ibid., January 17, 1920.

422. "Drank Poison as Beverage; Dies…," ibid., April 8, 1920.

423. "Openly Selling Whiskey in Johnstown for Fifty Cents a Drink; Beer Too," ibid., May 10, 1920.

424. "Two Drinks…,Sends Boy to Asylum," ibid., August 23, 1920.

425. "Bottles Drinks From His Mouth to Obtain Evidence," ibid., December 10, 1920; "Three Hotelmen Arraigned; Two Fail to Appear," ibid., December 13, 1920.

426. "Firm's Officers Are Under Bail in Liquor Case," ibid., August 23, 1920.

427. "U.S. Sleuths Make Big Haul of Wet Goods," ibid., October 27, 1920.

428. "Hints of Whiskey Ring…Center in Johnstown," ibid., November 15, 1920; "U.S. Commissioner Not Sure of Whiskey Ring; Defends Federal Agents," ibid., November 16, 1920.

429. "Another Big Shipment of Whiskey Arrives," ibid., November 29, 1920.

430. "The Tippling House Ordinance," editorial, ibid., December 15, 1920.

431. "Mayor Wants Help in Fight Against Liquor Traffickers," ibid., December 15, 1920.

432. "New Sleuth Bobs Up in Liquor Case; Employed by Mayor," ibid., December 24, 1920.

433. There was no law against owning alcoholic beverages acquired prior to Prohibition. This "private stock" could legally be given as a gift but not sold.

434. "Mayor Uses Police Power to Close Up Bars…," *Johnstown Tribune*, December 29, 1920.

435. "Prohibition Sleuth Arrested by Police for Getting Drunk," ibid., January 4, 1921.

436. "Injunctions in Liquor Battle Are Continued by Order of the Court," ibid., January 4, 1921.

437. "Mayor Cauffiel Opens War on Violators of Prohibition Statutes," ibid., September 12, 1921.

438. "Chief of Police is Suspended…," ibid., February 16, 1922; "Chief Briney Cleared and Restored to Duty," ibid., February 28, 1922.

439. "Mayor's Sleuths Put Under Arrest," ibid., February 16, 1922.

440. "On the Front Page," editorial, ibid., August 21, 1922.

441. "What's Going On?," editorial, ibid., August 24, 1922.

442. "Shields Held in Bail…," ibid., May 2, 1924.

443. Perry Nesbitt, associate and a close friend of Daniel Shields, personal interview, October 2000. Nesbitt died in May 2001.

444. Beer could be legally produced during Prohibition but its alcoholic content could be no more than $1/2$ of 1 percent. What had become commonplace in Pennsylvania and probably elsewhere was the brewing of low-alcohol beer and its alcoholic content being secretly enhanced until it could be called "real" or "true" beer.

445. "Held For Court in Liquor Case," ibid., April 9, 1925.

446. "Daniel J. Shields…," ibid., February 11, 1926; "Emmerling Case May Go to Jury…," ibid., February 12, 1926; "Three Found Guilty…," ibid., February 15, 1926; "Motion For a New Trial," ibid., February 17, 1926; "Taft Denounces Judge's Ruling…," ibid., April 11, 1927; "Court Order for New Trial," ibid., July 25, 1927; "D.J. Shields Asks For New Trial," ibid., May 22, 1928.

447. "Government Will Not Oppose Plea…," *Johnstown Tribune*, March 21, 1927; "Daniel J. Shields Case Opens…," ibid., March 29, 1927; "Main Witness in Shields Case…," ibid., March 31, 1927; "Black Hint…," ibid., April 4, 1927; "Mystery Man in Shields Case…," ibid., April 5, 1927; "Shields Found Guilty on Two Bribery Counts," ibid., April 6, 1927; "Shields Will Be Sentenced," ibid., May 24, 1927; "D.J. Shields Asks for New Trial…," ibid., May 22, 1928; "New Trial Again Refused…," ibid., July 6, 1928; "Shields Sentenced…," ibid., July 24, 1928; U.S. Department of Justice, FBI, Files 58–145 and 23–1507. Both files are on Daniel J. Shields. The former deals with the trial. The FBI apparently had been concerned that Shields would be attempting "jury tampering" and tailed him all over the place. No such evidence was uncovered. The latter file deals with Shields's petition to restore his civil rights. This was subsequently granted, but the date was not given.

448. "Dynamite Outrage Upon Woodvale Store…," *Johnstown Tribune*, March 15, 1922; "Commonwealth Rests Case in 'Blackhand' Trial…," ibid., December 15, 1923; "Two Defendants Found Guilty on Two Counts for Alleged Blackmail," ibid., December 21, 1922; *Commonwealth of PA v. Nicoletti & Esposito*, 82 PA Sup. Ct. 26 (1923).

449. "Improvised Bomb Containing 22 Sticks of Dynamite…," *Johnstown Tribune*, October 7, 1925.

450. "Salvatore" was also spelled "Salbator." "Terrific Explosion Damages Building in Sixteenth Ward," ibid., April 9, 1926; "Riverside Residence Bombed…," ibid., April 14, 1926.

451. "Three Killings Are Believed Result of Feudal Grievances," ibid., April 13, 1926.

452. "Joe Ippolito, Wife, and Children Lived in Fear…," ibid., June 17, 1927; "Joe Ippolito Is Found Guilty…," ibid., June 18, 1927.

453. "Many Witnesses Called by Commonwealth for Lima," ibid., December 11, 1928; "Tony Lima Accused of George G. Cupp Murder…," ibid., December 14, 1928.

454. "Is Law and Order Helpless?," editorial, ibid., March 29, 1929; "Special Grand Jury Reports…," ibid., July 31, 1929.

455. At the time of Cauffiel's dealings with Rager, Shields was incarcerated in the Washington, D.C. jail at Lorton, Virginia. Shields and Cauffiel were bitter enemies.

456. "Warrants Are Issued for Mayor Cauffiel and J. Rager," *Johnstown Tribune*, January 14, 1929; "Mayor Cauffiel is Required to Appear in Court," ibid., February 2, 1929.

457. "Verdict Against Joe Cauffiel for Copper Deal," ibid., June 2, 1925; "Joseph Cauffiel Defending Action for $2,500,000," ibid., March 24, 1927.

458. The *Johnstown Tribune* carried detailed reporting of the Cauffiel trial between March 13 and 16, 1929. There was also an editorial, "Ashamed," that ran on March 18, 1929.

459. "Motion for New Trial," *Johnstown Tribune*, April 5, 1929; "Mayor Refused New Trial," ibid., April 8, 1929; "Sentence Upheld in Cauffiel Case," ibid., November 22, 1929; "Cauffiel Must Serve Jail Sentence: Supreme Court Refuses to Review Case," ibid., December 6, 1929.

Chapter 6: Johnstown Civic Organizations: 1900 to 1930

460. "Plan Auto Trade Tour of County," *Johnstown Tribune*, May 21, 1910; "Trade Extension Tour to North County Big Success," *Johnstown Weekly Democrat*, July 15, 1910.

461. "Chamber Wins in Phone Protest," *Johnstown Tribune*, December 21, 1910.

462. "A Brilliant Banquet is Already Assured," ibid., December 3, 1910; "Keynote Sounded For a Bigger, Better City," ibid., December 7, 1910; "The Chamber of Commerce Banquet," editorial, ibid., December 7, 1910; "Past Year One of Accomplishments by the Industrial Committee," ibid., January 4, 1912. For a discussion of the Constable Park proposal, see Chapter 3, section XI, "Parks, Playgrounds and Recreation," subsection, *Park Plans*.

463. "Chamber of Commerce is After New Members," *Johnstown Tribune*, February 17, 1912; "Chamber of Commerce Opens its Campaign Tonight," ibid., February 20, 1912.

464. "To Broaden Work of Chamber," ibid., November 12, 1912; "Would Broaden Chamber's Work," ibid., February 27, 1913.

465. This is my conclusion based on examining a number of accounts of chamber meetings. The press did not discuss any rift. One can also see the policy split discussed in *The Spectator Magazine*, put out by the students of Johnstown High School in May 1911, when the chamber was less than one year old. A student, with the initials WRT, conducted interviews and wrote a perceptive article, "The Chamber of Commerce." Describing its mission, the student explained the meticulous credit information and program while mentioning the broader, more dynamic community mission.

466. "Chamber of Commerce Work Program Adopted," *Johnstown Tribune*, July 11, 1914; "Samuel Wilson New Secretary," ibid., July 10, 1914.

467. "First Edition of *Doings* Now Out," ibid., November 11, 1914; "Publicity Men Discuss Successor For *Doings*," ibid., May 31, 1915.

468. "Two Holidays on Sunday Give Committee a Task," ibid., May 17, 1915; "Committee Means Business and Will Begin Work at Once," ibid., May 25, 1915.

469. "Say Keep Hands Off Candidates," ibid., May 27, 1915.

470. "Report of Survey by Roland B. Woodward Read at Chamber of Commerce Gathering," ibid., April 27, 1917; "The Woodward Report," editorial, ibid.

471. David Barry, First National Bank; Herman Blough, employee at Cambria Steel; A.B. Crichton, mining engineer and coal operator; Reverend. D. Dembenski, pastor of St. Casimir's; Nelson Elsasser, Nathan's department store manager; William Foster, Foster's department store; S.H. Heckman, Penn Traffic store manager; Harry Hesselbein, managing editor of the *Tribune*; George Kline, merchant; P.H. Mahaffey, Friedhoff and Mahaffey plumbing company; D.S. Muckley, superintendent at Cambria Steel; J.M. Murdock, Lumberman; Tom Nokes, Johnstown Poster advertising manager; Phillip Price, Johnstown Automobile Company president and son of the late Charles S. Price; John Ryan, Wholesale Grocery company owner; Tillman Saylor, attorney and city solicitor; William Sunshine, banker and politician; Harry Swank, Swank Hardware Company officer; H.M. Tarr, Johnstown Grocery Company president; H.L. Tredennick, Haws Brick Refractory president.

472. The chamber's role during the war is discussed in more detail in Chapter 8, "Over Here for Over There"; during the 1919 steel strike in Chapter 9, and its highway advocacy in Chapter 4, section I.

473. "Reorganization of Local Chamber of Commerce Planned," *Johnstown Tribune*, May 12, 1921; "John E. Gable Resigns as Secretary of Chamber of Commerce," ibid., September 28, 1923.

474. "Industrial Survey by Local Chamber," ibid., September 14, 1925.

475. "Plan for Industrial Financing Revealed…," ibid., January 25, 1927.

476. "Drive to Secure Industrial Fund," ibid., May 5, 1927; "Business Men Endorse Industries Financing…," ibid., May 19, 1927; "Boost Industrial Fund…Final Sum $57,360," ibid., May 20, 1927.

477. "Increased Budget For Industrial Fund Advised," ibid., April 3, 1928; "Chamber of Commerce Budget Drive Opens…," ibid., May 11, 1928.

478. "Survey of Nearby Local Industries to be Undertaken," ibid., July 12, 1928; Johnstown Industrial Financing Services, Promotional Advertisement, *Johnstown Tribune*, July 17, 1928.

479. "City's Newer Industries Making Steady Progress," *Johnstown Tribune*, March 30, 1929.

480. "Completed Survey by C. of C. Imparts Voluminous Data…," ibid., July 27, 1929; From July 27 through August 7, each daily issue of the *Tribune* published excerpts from the report "Industrial Survey." The eighty-two-page report itself has not been located.

481. "A Juvenile Court," ibid., December 3, 1904; "Work is Started," ibid., January 17, 1905; "Ladies Unable to Find a House," ibid., January 17, 1905; "Plans of the Civic Club," ibid., November 23, 1905; "Work of Civic Club in Behalf of Children," ibid., May 24, 1907; "Committee List for Civic Club," ibid., October 9, 1907; cartoon about picnic at Luna Park, ibid., June 24, 1908; "Civic Club Advocates Playgrounds…," ibid., May 18, 1909; "Handsome Fountains of Civic Club are Placed," ibid., June 23, 1911; "Poverty and Disease," *Johnstown Weekly Democrat*, February 4, 1910; "Dibert Heads…Club Again," *Johnstown Tribune*, May 20, 1912. The Civic Club's study of park and recreation needs is discussed in Chapter 3, section XI, subsection, *The Schoenfeld Report*.

482. "An Associated Charities Movement Launched Here," *Johnstown Tribune*, December 30, 1913; "Associated Charities Is Formally Launched," ibid., February 7, 1914; "William S. Gray Elected Head of Welfare Board," ibid., November 11, 1925.

483. "The Ad-Press Banquet," editorial, ibid., December 2, 1913; "Cooperation," editorial, ibid., December 4, 1914; "Spirit of Real Cooperation for Civic Betterment at Ad Press Dinner," ibid., December 4, 1914.
"Ad-Press Club Banquet—A Real Forum for Ideas," *Johnstown Daily Democrat* (exact date uncertain, probably November 10, 1915.) Source Joseph Cauffiel Scrapbook at Glosser Memorial Library

484. "Country Club is Organized," ibid., April 9, 1903.

485. "Country Club to Change Locations," ibid., February 28, 1921; "Sunnehanna is Name Under Which Country Club is Organized," ibid., April 4, 1921; "Sunnehanna Country Club Opening Attended By Over 450 Members and Friends," *Johnstown Weekly Democrat*, September 4, 1923.

486. Original members of the Johnstown Motor Club were J.M. Murdock, Anderson Walters, M.L. Bracken, Harry Hesselbein, George Swank, John Leppert, P.L. Carpenter and Tom Nokes.

487. "Plans Launched For Formation of Motor Club Here," *Johnstown Tribune*, September 8, 1923; "Motor Club to Affiliate With National Body," ibid., October 23, 1923; "Johnstown Motor Club is Granted Membership in National Organization," *Johnstown Weekly Democrat*, October 27, 1923; "Motor Club Board…," *Johnstown Tribune*, March 21, 1925.

Chapter 7: Leaks in the Roof of Paradise: The Johnstown Black Community

488. "Johnstown's Colored Population…," *Johnstown Weekly Democrat*, October 30, 1903.

489. I was unable to procure a copy of the play *The Clansman*, but did obtain the two Dixon novels from which the play was derived. They are extremely racist and contain lines such as: "For a Russian to rule a Pole, a Turk to rule a Greek, or an Austrian to dominate an Italian is hard enough; but for a thick-lipped, flat-nosed Negro exuding his nauseating animal odor, to shout in derision over the hearths and homes of white men and women, is an atrocity too monstrous for belief."
 "Black hordes of former slaves, with the intelligence of children and the instincts of savages, parade daily in front of their unarmed former masters." Quotes from Thomas Dixon Jr., *The Clansman* (1905; reprinted by University of Kentucky Press, 1970).

490. "Protest Against *The Klansman*," *Johnstown Tribune*, November 10, 1906; "Klansman Will Not Be Stopped," ibid., November 12, 1906.

491. Florence M. Hornback, "Survey of the Negro Population of Metropolitan Johnstown, Pennsylvania" (Johnstown: *Johnstown Tribune* and *Johnstown Democrat*, 1941).

492. Special Section on "Black History," *Johnstown Tribune-Democrat*, February 12, 1980; Interchurch World Movement, Commission of Inquiry, "Report on the Steel Strike of 1919" (New York: Harcourt, Brace and Howe Co.: 1920). Johnstown Interviews (1920). Saposs Papers, University of Wisconsin.

493. Two new churches were formed in Rosedale in the post-1917 era: The Shiloh Baptist Church, organized by the Reverend R.T. Schnell, and a Bethel AME Church organized by the Reverend J.H. Flagg. The Bethel AME Church expanded into East Conemaugh and Franklin Boroughs.

494. Richard B. Sherman, "Johnstown v. the Negro: Southern Migrants and the Exodus of 1923," *Pennsylvania History Magazine*, 1962:454–64. Even Johnstown's YMCA was closed to blacks. In 1919 the Reverend P.H. Williams sought to start a YMCA for black men in the basement of the AME Zion Church on Haynes Street. His effort apparently failed. Williams left the city in 1920. See "YMCA Organized for Colored Men," *Johnstown Tribune*, January 18, 1919.

495. "Importation of Negroes Opposed," *Johnstown Tribune*, August 2, 1919.

496. "Police Recoreds Being Smashed During Month of April, Say 'Cops,'" *Johnstown Democrat*, April 17, 1917.

497. "City Takes Steps to Stop Possible Race Riots Here," ibid., July 31, 1917.

498. "Officer Shot to Save Self," ibid., December 4, 1918; " Negroes Brutally Attack and Rob a Haynes Street Shoemaker…," ibid., August 2, 1920; "Two Negroes are Shot in Dispute Over Poker Game," ibid., May 9, 1921; "Rosedale Negro Dies of Gunshot Wounds in Fight," ibid., November 10, 1921; "Hold Colored Man on Murder Charge," ibid., November 12, 1921.

499. "Resolutions Are Adopted Against Ku Klux Klan," *Johnstown Tribune*, September 24, 1921.

500. "Resolutions…Against the Ku Klux Klan," ibid., September 24, 1921; "Anti Ku Klux Klan Drive Begun," ibid., September 28, 1921; "Ku Klux Klan Holds Secret Meeting Here," ibid., January 27, 1922; "Ku Klux Klan Takes in Another Big Class," ibid., April 22, 1922.

501. "Ku Klux Holds Ceremony…on Green Hill…," with photograph, ibid., August 25, 1922.

502. "YWCA Gets $75 From Ku Klux Klan," ibid., September 22, 1922.

503. "Ku Klux Klan, 15 Strong, Visits Dale," ibid., March 12, 1923.

504. "The Klan and Others," editorial, ibid., November 28, 1922.

505. Phillip Jenkins, *Hoods and Shirts: The Extreme Right in Pennsylvania* (Chapel Hill: University of North Carolina Press, 1997), 71–72.

506. "Catherine…Attacked by Negro," *Johnstown Tribune*, June 20, 1923; "Ku Klux Klan Demonstration," ibid., June 21, 1923.

507. "Negro Charged With Felonious Shooting," ibid., June 29, 1923; "Rosedale Woman Held…," ibid., July 24, 1923; "Rosedale Negroes Are Fined For Fighting," ibid.; "Three Arrests in Theft at Rosedale," ibid., August 20, 1923; "Claim that Murderer Was Hidden in Rosedale," *Johnstown Weekly Democrat*, August 20, 1923.

508. Two of the four injured police officers died later. Otto Nukem died on September 13, 1923. He had been the least seriously wounded policeman in the Rosedale tragedy. He died of heart failure that was not believed to have been related to the incident. Captain Otto Fink, the most seriously wounded, died November 2, 1923. The others recovered.

Both the *Johnstown Democrat* and the *Johnstown Tribune* had extensive coverage of the Rosedale Incident. See issues of August 31, 1923 and September 1, 1923. See also Sherman, "Johnstown v. the Negro," 454ff.

509. "Mayor Cauffiel Hands Out Three Heavy Fines," *Johnstown Tribune*, September 6, 1923.

510. "Mayor Denounces Agents Who Send in Undesirables," ibid., January 17, 1923. After the Rosedale shooting, an investigation into Mayor Joe Cauffiel's demeanor toward blacks was initiated by Governor Gifford Pinchot. It was conducted by Sergant George W. Freeman of the Pennsylvania State Police. This produced reliable accounts of Cauffiel saying such things (in police court) as: "Nigger, do you know what would happen to you down South? They would take you out and hang you. You have fifteen minutes to leave Johnstown, one hour to leave the county, five hours to leave the state, and seven hours to get below the Mason-Dixon Line."

It was also reported Cauffiel had once ordered two black youths to be "shot at sunrise." Blank cartridges were used, and one of the two collapsed from fright. When asked why he had done this, Cauffiel answered, "Scares the hell out of them, and they'll leave." See "Mayor May Stand Trial for Alleged Shooting at Negro," *Johnstown Tribune*, March 31, 1921.

511. Mayor Joe Cauffiel, a devotee of Billy Sunday (see Chapter 5, section I), was not the sort of man to take needless theological risks. Biblically, the number seven recurs in connection with many themes: God created everything in seven days; Solomon created the Temple in seven years; Paul wrote letters to seven cities or districts. Seven also recurs throughout the Book of Revelation. The expulsion order was released seven days after the Rosedale Incident—six years would have been too few and eight years would have been too many.

512. "Mayor Cauffiel Says Undesirable Negroes Must Quit Johnstown," *Johnstown Weekly Democrat*, September 7, 1923.

513. Hornback, "Negro Population," 17.

514. Ibid.

515. *Literary Digest*, October 6, 1923:18; "Playing With Fire," editorial, *Johnstown Weekly Democrat*, September 8, 1923.

516. "Twelve Crosses Burned by Ku Klux Klan Here," *Johnstown Weekly Democrat*, September 8, 1923.

517. On file in the Pinchot Papers, U.S. Library of Congress (Manuscript Division).

My Dear Governor:

In reply to your telegram beg to advise you that your complainant did not lay all the facts before you.

Johnstown has been over run by many negroes from the South, paroled from the southern prisons. Inside of three weeks time three of our officers have been buried, two are lying in the hospitals, mortally wounded. One is recovering. All this is due to a shooting affair by a negro crazed by moonshine and dope. Our citizens were aroused and we had difficulty in maintaining order. The citizens could not distinguish between Mexicans and the copper colored negroes and for their own protection and for the preservation of the good name of our city they were advised to leave. Only the lawless ones were advised to leave.

I have endeavored to combat against this the best I knew how. We appealed to your State Police and had six of your men for about a week. The captain of our Police Department is lying at the point of death from a bullet wound

inflicted by the negro now dead and the minds of the people are still stirred to the utmost. I cannot say what may happen if the Captain dies. If your State Police Department would try to close up the booze joints and dope joints now existing in Franklin Borough, adjacent to Johnstown, and one of the worst hell holes in the State, we would not have had this trouble. You can readily see why I have restricted the colored people from having any meetings of any kind except church services. I do not know what the press has stated to you but I have given you my text in full.

My duty is to preserve peace and order and you can readily see how difficult the proposition is with characters of this kind and nature. Our native negroes and some of the others are law abiding and there is no complaint against them. It is only the lawless pack that have no regard for law or order or life and there was no discrimination against the black race. After this trouble it was a difficult proposition to hold the citizens in obeyance [sic].

518. "State Troopers Called to Lilly," *Johnstown Tribune*, March 25, 1924; "Defense Contends Two Witnesses For State Did Shooting at Lilly," ibid., June 19, 1924.

519. "Two Killed, Two Dying, Many Injured in Clash of Lilly Citizens With Ku Klux Klan…," ibid., April 7, 1924. There are two separate news articles beneath the above headline.

520. "Habeas Corpus Hearing For 26 Men Under Arrest Following Lilly Affray," ibid., April 8, 1924; "Secret Conference of Judge and Attorneys in Ku Klux Klan Case," ibid., April 9, 1924; "Bail is Refused For 26 Alleged to Have Been in Lilly Affair," ibid.

521. "State Police Summoned to Beaverdale," ibid., April 11, 1924; "Lewistown Klansmen Protest," ibid.

522. "Poorbaugh Funeral Occasion for Large Gathering of Klan," ibid., April 28, 1924.

523. "Mrs. Reuben Miller Laid to Rest With Klan Rites," ibid., July 10, 1924.

524. "Unveiling of Monument in Grandview Cemetery…For Late Owen Poorbaugh," ibid., October 13, 1924. The Poorbaugh KKK monument, a massive, somewhat gaudy, sculpture, has since vanished. No one associated with managing Grandview Cemetery knows whether its disappearance was an act of vandalism or a conscious decision of an earlier Grandview management quietly to rid the grounds of an embarrassing, out-of-favor monument.

525. "Grand Jury Will Hear Lilly Riot Cases on First Monday in June," ibid., May 24, 1924; "Complete Jury Chosen for Lilly Riot Case, Challenges Reduced," ibid., June 9, 1924; "District Attorney is Slowly Building Case, to Be Long and Drawn Out," ibid., June 10, 1924.

526. "Cross Burned Close to Viewmont Residences," ibid., July 11, 1924.

527. "Klansmen Induct Big Class of Candidates," ibid., July 24, 1924.

528. "Junior Ku Klux Klan Holds First Ceremony," ibid., August 4, 1924.

529. "Klan Day Will Be Held Next Thursday by Local KKK Unit," ibid., August 9, 1924; "More Than 15,000 Klansmen Attend Annual Gathering," ibid., August 14, 1924; "KKK Picnic Concluded With Ceremonial Burning of Fiery Cross; Big Crowd Attends," ibid., August 15, 1924.

530. "Klansmen Freed By Higher Court; Get Out Nov. 28," ibid., November 21, 1924.

531. "Mount Olive Church Gets KKK Help," ibid., October 29, 1924.

532. Jenkins, "Extreme Right," 65–75.

Chapter 8: Over Here for Over There: Johnstown during the First World War

533. "Foreigners…Called to Colors," *Johnstown Tribune*, July 27, 1914; "Local Austrians Awaiting a Call," ibid.

534. "Austrian Officer is Detained…," ibid., August 13, 1914.

535. "Hungarians Are Being Informed," ibid., August 3, 1914.

536. "Mass Meeting Sentiment Strong Against Austria," ibid., August 4, 1914.

537. "Germans Denounce News Fakirs," ibid., August 10, 1914.

538. "…Italians Leave for War," ibid., July 22, 1915; "Italians Go to the Front," ibid., November 27, 1915. For a discussion of Serbian military recruitment, see the subsection *Serbians and Croatians, Johnstown's Yugoslav Initiative* later in this chapter.

539. "War Pictures Stirred Up Foreigners in Cambria City," *Johnstown Tribune*, July 30, 1914.

540. "Austrian, Prussian, and Russian…in Fight," ibid., October 12, 1914.

541. "Ein Volk, wie das Deutsche, Kann Nicht Untergehen!," ibid., August 18, 1914. Translated courtesy of Attorney Pam Mayer, former publisher of the *Tribune-Democrat*. Few copies of the *Johnstown Freie Presse* have survived. Efforts to locate them have been fruitless. The *Johnstown Freie Presse* continued weekly in German until sometime in 1921.

542. "Allies' Sympathizers Give Generously to German Bazaar," ibid., April 11, 1916.

543. "450 Boys Sign Pledge of Loyalty," ibid., March 30, 1917; "Percy Allen Rose Offers Services to Governor," ibid., April 2, 1917; "Three Patriotic Rallies Held in City…," ibid.; "America First," editorial, ibid., April 3, 1917; "Mayor Franke Asks Display of Stars and Stripes," ibid.; "Remarkable Demonstrations of Loyalty," April 6, 1917.

544. "200…Report at Point," ibid., April 12, 1917; "Johnstown Office Leads All Others," ibid.

545. "Mayor Urges…Every Available Plot Be Planted," ibid., April 12, 1917; "Local Gardening Commission Needs… Seed Supply," ibid., April 17, 1917; "Johnstown Taking Up Gardening…," ibid., May 17, 1917.

546. "Johnstown…Men Ordered to Training Camp," ibid., May 10, 1917.

547. "Johnstown…First Unit to Europe's Battlefront…," ibid., June 4, 1917; " … Ambulance Corps Given Farewell," ibid., June 9, 1917.

548. "Protest Against Draft Quota…," ibid., July 25, 1917; "A Large Quota," editorial, ibid., July 27, 1917; "Conscription Injustice," editorial, ibid., March 19, 1918; "Cambria County Required to Furnish 1655 Men…," ibid., July 23, 1917.

549. "…Comfort Kits in Three Wars," ibid., August 5, 1917; "Smokes for the Boys…," ibid., August 27, 1917; "A Bureau of Information," editorial, ibid., April 10, 1917.

550. "Greatest Throng in City's History Bids Farewell…," ibid., September 4, 1917; "Cheered and Applauded…Boys …Departed for Camp," ibid., September 7, 1917.

551. "Johnstown Subscribes for $1,875,000…," ibid., June 15, 1917; "Second Liberty Loan Success," ibid., October 27, 1917; "Johnstown's Liberty Parade Cheered…," ibid., April 6, 1918; "Subscriptions Still Pouring in…," ibid., October 22, 1918; "Cambria County Exceeds Goal…," ibid., October 25, 1918.

552. "The Red Cross Campaign," editorial, ibid., July 16, 1917; "Three Years Since City Welcomed Colonel Roosevelt," ibid., September 21, 1917; "Cambria County Leads State in Contributions…Red Cross," ibid., May 25, 1918.

553. "Information About Wheatless Days…," ibid., January 29, 1918; "White Bread Not Yet Allowed," ibid., August 3, 1918; "Regulations on Chickens is Embarrassing," ibid., February 4, 1918; "Stores and Meat Markets as Ice Stations…," ibid., June 6, 1918; "P.L. Carpenter Resigns…," ibid., August 29, 1918.

554. "Council Receives Proposed Street Lighting Plan," ibid., January 24, 1917; "Lightless Nights Violated in City," ibid., January 28, 1918; "City to Cooperate in Saving Fuel," ibid., July 19, 1918; "Suggest Stores Close at 5…," ibid., May 10, 1918; photograph, ibid., February 2, 1917.

555. Herman Cron, letter to the editor, ibid., April 6, 1917.

556. Mrs. Charles Suppes was the mother of Walter R. Suppes, who was stationed at Camp Lee at the time. He would later fight in the Meuse-Argonne Campaign in France. After the war he wrote a series of newspaper articles about being "Over There."

557. "Establish Barrier Zones in City," *Johnstown Tribune*, February 15, 1918; "Another Austrian Given…Fine," ibid., April 2, 1918; "…Aliens Given…Tar and Feathers," ibid., April 24, 1918; "…Women…Cause Arrest," ibid., April 17, 1918; "Study of German…to Be Discontinued," ibid., May 10, 1918; "Quartet Club to Eliminate German…," ibid.; "Serbians Will Celebrate When Soldiers Leave," ibid., August 24, 1917; "…1000 at Rally…Local Hungarians," ibid., June 24, 1918.

558. See the section, "Unusual Loyalties" earlier in this chapter. By late October and early November 1915, Austro-Hungarian, German and Bulgarian armies had overrun most of Serbia. Its government leaders and some of the Serbian army managed to escape through Albania. Thanks to Allied ships, they were transported to Corfu, a Greek island located at the southern edge of the Adriatic Sea. Greece was friendly. A Serbian government in exile was established, and its army was regrouped for action later. Here Croatian and Slovenian representatives, all rebel exiles from Austria-Hungary, met with Serbian officials in exile. In June, they all agreed that after the war their peoples would unite in a new nation, Yugoslavia, under the Serbian royal family, Karageorgevich. The Corfu Pact was promulgated in July 1917 as the Corfu Declaration, which served as a basis for the founding of Yugoslavia after the war.

Arguably the first manifestation of an accord between these two peoples with timeworn differences (Serbians and Croatians) occurred in Johnstown in August 1914.

559. "Americanization Move Given Start…," *Johnstown Tribune*, June 28, 1918; "Chief Swabb Asks That Police Have Freer Rein,: ibid., July 11, 1918; "…Americanization Movement," editorial, ibid., June 10, 1918; "Idlers," editorial, ibid.; "Enemies Here," editorial, ibid., July 12, 1918.

560. "Moxham Woman Proud of Her Son," ibid., January 3, 1918; "General Menoher," editorial, ibid., August 5, 1918; "…Murdock Meets General Charles Menoher," ibid., December 5, 1918; "Replogle is in Service of U.S.…," ibid., August 24, 1917; "Replogle's Job is Outlined…," ibid., November 15, 1917; "Sketch of J.L. Replogle," ibid., June 18, 1918; "Replogle Urges…Increase in Steel Production," ibid., August 21, 1918.

561. For a discussion of J. Leonard Replogle's role in the Midvale acquisition of the Cambria Steel Corporation, see Chapter 2, section I.

562. "…Seigh is…First to Shoot German," *Johnstown Tribune*, February 12, 1918.

563. "Private Nick Dalanoudis…," ibid., June 12, 1919.

564. It is known that there were approximately 371,000 Pennsylvanians serving in the United States armed services during World War One. Assuming the same percentage of Johnstown's population was in the services, there should have been approximately 3,055 Johnstown men on active duty. It is known that 1,783 men from Johnstown (Zones One and Two) were drafted and went on active duty. Data on local voluntary enlistment cannot be located.

565. "Johnstown Boy…Lost in Sinking of Destroyer," *Johnstown Tribune*, December 18, 1917; "Special Victory Jubilee Edition," ibid., September 18, 1919.

Chapter 9: The Steel Strike of 1919

566. David Brody, *Labor in Crisis: The Steel Strike of 1919* (Champaign: University of Illinois Press, 1965), 38. See also Irwin M. Marcus, "The Johnstown Steel Strike of 1919: The Struggle for Unionism and Civil Liberties," *Pennsylvania History*, Winter 1996: 96–117.

567. Gerald G. Eggert, *Steelmasters and Labor Reform, 1886–1923* (Pittsburgh: University of Pittsburgh Press, 1981), 108.

568. William Dickson's naïvely optimistic views, career history and interactions with colleagues, friends and rivals are recorded in Eggert's *Steelmasters and Labor Reform*.

569. "Cambria Steel Employees Invited to Meet With Officials," *Johnstown Tribune*, September 23, 1918.

570. "William Z. Foster is Dead at 80; Ex-Head of Communists in U.S.," *New York Times*, September 2, 1961. Foster had earlier been a supporter of William Jennings Bryan, next a socialist and later a member of the Industrial Workers of the World (IWW). He had represented the IWW at the International Trade Union Conference at Budapest, Hungary, in August 1911, where he unsuccessfully challenged the right of James Duncan of the AFL to be seated. Foster fell out with the IWW over some narrow point of ideology involving syndicalism and for a comparatively brief time worked with the AFL through the Carmen's Union.
In 1909, Foster had co-authored a treatise on syndicalism wherein he urged revolution to overthrow the capitalist system. The "Redbook" as it came to be called, was to become a key issue in the Johnstown steel strike of 1919.

571. Brody, *Steel Strike*, 70.

572. "Cambria Adopts 8 Hour Day," *Johnstown Tribune*, October 8, 1918.

573. Eggert, *Steelmasters and Labor Reform*, 120–21; "Midvale Announces its Plan For Collective Bargaining," *Johnstown Tribune*, November 11, 1918.

574. "Cambria Employees Hear Appeal…," *Johnstown Tribune*, March 17, 1919. This was the first mention I personally came across in the local newspapers that have survived.

575. See Chapter 2, section I.

576. Eggert, *Steelmasters and Labor Reform*, 130.

577. "Cambria Steel Co. Defines Policy Regarding Labor," *Johnstown Tribune*, April 2, 1919; "E.E. Slick to Retire from Midvale Company…," ibid., April 3, 1919.

578. Eggert, *Steelmasters and Labor Reform*, 130—32.

579. "Chamber of Commerce Dinner…," *Johnstown Tribune*, May 2, 1919.

580. Brody, *Steel Strike*, 99.

581. Ibid., 100–01.

582. Robert R. Smith, "The Steel Strike in Johnstown, Pennsylvania, 1919" (master's thesis, Indiana University of Pennsylvania, 1982), 25.

583. William Z. Foster, *The Great Steel Strike and its Lessons* (New York: B.W. Huebsch, 1920), 102.

584. "500 Strikers…Picket Duty," *Johnstown Tribune*, September 24, 1919; "Fourth Week of Strike," ibid., October 18, 1919.

585. The IWW was an extremist pro-union organization. Foster's association with this group, and his syndicalist sentiments, frightened Johnstowners.

586. "Foster Cleared of All Charges," ibid., April 7, 1919.

587. Brody, *Steel Strike*, 137–38.

588. Smith, "Steel Strike," 41–42; "Rev. C.C. Hayes Scores Strike Leaders," *Johnstown Tribune*, September 29, 1919.

589. "Strikers Less Active Today," *Johnstown Tribune*, October 2, 1919; "Striker Told to Use Funds He Had Saved," ibid., October 9, 1919; "Moulder Union to Pay Benefits," ibid., January 15, 1919.

590. "Cambria Employment Office Open," *Johnstown Daily Democrat*, October 24, 1919.

591. "Attendance at Local Labor Meetings Show No Decrease," *Johnstown Tribune*, October 20, 1919; "Free Food For Strikers," October 24, 1919; "More Money is Needed…Foster," ibid., October 19, 1919.

592. "Six Hundred Cambria Steel Men Hold Meeting," *Johnstown Weekly Democrat*, November 13, 1919.

593. "Hope Held Out By Organizers," *Johnstown Tribune*, November 7, 1919.

594. Foster, *Steel Strike*, 188–89.

595. "Foster Leaves City Without Talking…," *Johnstown Tribune*, November 8, 1919.

596. "Foster's Plea Raises Large Sum…," *Johnstown Daily Democrat*, November 10, 1919.

597. "Conboy Sends Message to Labor Temple…," ibid.

598. Ibid.; "Conboy Declares He Will Not Abandon Field," ibid., November 11, 1919.

599. "Steel Strike…Nears Turning Point," ibid., November 13, 1919; "Cambria Plant Being Made Ready," ibid., November 14, 1919.

600. "State Troopers Break Up Street Demonstrations…," ibid., November 17, 1919.

601. Brody, *Steel Strike*, 160–61. The *Leader* has not survived for researchers although isolated issues turn up from time to time.

602. I have spent much time and energy trying to unearth some sort of biography of Marshall Olds. To date this has not been successful.

603. "William Z. Foster is Dead at 80; Ex-Head of Communists in U.S., "*New York Times*, September 2, 1961.

Chapter 10: The Great Depression

604. "Charles Schwab Sees Prosperity," *Johnstown Tribune*, October 25, 1929; "Slump in Market Fails to Disturb Steel," ibid., October 30, 1929; "That Stock Market Crash," editorial, ibid., November 24, 1929.

605. "Business," editorial, ibid., January 29, 1930; "Steel Industry is Expected to Hold Tradition," ibid., January 30, 1930.

606. "Bethlehem-Youngstown Steel Merger," ibid., March 10, 1930; "Bethlehem Steel Report in Financial Gossip," ibid., April 25, 1930; "Bethlehem-Youngstown Merger Off," ibid., October 15, 1931.

607. "1930 Table of Assessments and Taxables…Big Decrease in Occupation Valuations…," ibid., March 5, 1930. During this era, the City of Johnstown took advantage of a Pennsylvania law that authorized tax assessments and levies to be made against the value of occupations. In a word, occupations were being treated as taxable personal property and were given an assessed valuation for tax purposes.

608. See Chapter 5, section V.

609. See Chapter 6, section III.

610. "648 Breadwinners…Out of Work," ibid., *Johnstown Tribune*, November 22, 1930; "Bethlehem Plan for… Depression in Full Operation," ibid., November 25, 1930; "Relief Executive Committee Meets," ibid., November 22, 1930; "Relief Agencies Drafted," ibid., November 25, 1930; "More Than 100 Apply," ibid., December 1, 1930; "The Mayor's Proclamation," ibid.

611. "Radicals Attempt Demonstration at City Hall Steps," ibid., February 10, 1931; editorial (no title), ibid., February 13, 1931; "Communists Will Stage a Meeting at Point Stadium," ibid., March 4, 1931; editorial (no title), ibid., March 6, 1931; "Crowd Estimated at 500 at Point," ibid.; William Z. Foster's role in the steel strike of 1919 is discussed in Chapter 9.

612. "Johnstown Has Famine of Tin Cans and Jars," ibid., September 16, 1931; "The Canning Group," ibid., September 26, 1931; "The Canning Kitchen to Feed Needy…," ibid., October 31, 1931.

613. Untitled editorial about emergency relief, ibid., July 21, 1931; "The Community Chest," ibid., September 26, 1931; "Chest Contributions on Opening Day," ibid., October 12, 1931; "Unaudited Figures in Chest Drive," ibid., October 14, 1931; "Crisis Looms…Chest Campaign," ibid., October 15, 1931; untitled editorial about the Community Chest, ibid., October 20, 1931; "…8800 Contributors to…Chest," ibid., November 27, 1931; "Final Meeting of Emergency Relief Group," ibid., December 31, 1931.

614. Andrew J. Gleason, Johnstown attorney, personal interview. As a young man, Mr. Gleason had been a supervisor working with the Pinchot rural road program in Cambria County.

615. In the summer of 1933, the *Democrat*, ordinarily a morning newspaper, became temporarily an afternoon paper only. McCloskey believed there was no good reason whatsoever for this change. The *Tribune*, in turn, began putting out a morning edition but continued with its afternoon editions as well. McCloskey interpreted these changes as being a conspiracy between Krebs and Andrews to wreck the *Democrat*, forcing Georgia Bailey to sell it cheaply. On August 9, 1934, the *Democrat* was purchased by Kreb's *Tribune*. According to McCloskey, Hiram Andrews, who had been managing the *Democrat*, then received $9,000 in deferred compensation. McCloskey described this payment as a bribe. Whatever may have happened, McCloskey continued to charge that Krebs and Andrews conspired to "steal" the *Democrat* from the Bailey heirs.

616. Various issues and fragments of issues of the *Derby* are in the archives of the Johnstown Area Heritage Association. "Macher and McCloskey Get Together Tonight," *Johnstown Tribune*, February 13, 1913; "Councilman McCloskey Dies at 73," ibid., April 7, 1964; Curtis Miner, *Forging a New Deal: Johnstown and the Great Depression, 1929–1941* (Johnstown: Johnstown Area Heritage Association, 1993), 14; also "Life Story of Eddy McCloskey," a campaign flyer, in *Forging a New Deal*. Kate O'Bara, Eddie McCloskey's daughter, personal interview.

617. "Charles M. Schwab Will Be Called to Utilities Hearing," *Johnstown Tribune*, March 13, 1931.

618. Joseph Cauffiel died of cancer on July 9, 1932. He was sixty-one years old.

619. "Johnstown…in Hunger March," *Johnstown Tribune*, December 31, 1931; "Cox Hunger Marchers…," ibid., January 5, 1932; editorial (no title), ibid., January 6, 1932; "Hunger March Bills Assumed by Miss Price," ibid., January 16, 1932.

620. "Chief of Police…Second Ten-Day Layoff," ibid., January 18, 1932; editorial (no title), ibid., January 20, 1932; "McCloskey, Dinner Speaker," ibid., January 27, 1932; "McCloskey Taken from Courtroom," ibid., February 1, 1932.

621. "Hope of…Tranquil Council Proceedings Blasted," February 24, 1932.

622. "Civil Service Heads Resign…," ibid., March 2, 1932; editorial (no title), ibid., May 5, 1932; "Mayor Takes Trio…for Midnight Ride," ibid., May 18, 1932; editorial (no title), May 19, 1932.

623. W.W. Waters, *BEF: The Whole Story of the Bonus Army*, as told to William C. White (New York: John Day Company, 1933), 239–55.

624. Editorial (no title), *Johnstown Tribune*, July 29, 1932; "Field Headquarters of Khaki Shirts…Here," ibid.; editorial (no title), ibid., July 30, 1932; "Bonus Army Descending on Johnstown…," ibid.; "A Real Crisis," editorial, ibid.;

editorials (two, no titles), ibid., August 1, 1932; "General View of…Camp," photo article, ibid.; "Police Break Up Communist Rally," ibid., August 2, 1932; "Fears of Pestilence…," ibid.; editorial (no title), ibid.

625. Malcolm Cowley, "The Flight of the Bonus Army," *New Republic*, August 17, 1932.

626. "Waters Tells Men to Break Camp…," *Johnstown Tribune*, August 3, 1932; editorial (no title), ibid., August 4, 1932; "Evacuation Begins," ibid.; "Gasoline, Money from BEF Relief Funds…," ibid., August 5, 1932.

627. "Echoes of Bonus Army…," ibid., April 7, 1933.

628. "McCloskey Will Turn Attention to Larger Field," ibid., January 7, 1935.

629. "Efficiency Man Holds Meeting With Officials," ibid., May 31, 1932; "Council to Engage Goodrich," ibid., June 21, 1931; "30 Day Furlough," ibid., July 2, 1932; "Faced with $395,772 Decline…City Adopts Furlough," ibid., July 7, 1932; untitled editorial about efficiency study, ibid., July 7, 1932; "City Police…Stick to their Posts," ibid., July 9, 1932; "Efficiency Engineer Suggests Economies," ibid., August 9, 1932; "Launches Study of Police Department…," ibid., September 29, 1932; "Johnstown Request Made to RFC," ibid., October 22, 1932; "Glassford…Civilian Chief…," ibid., "Civilian Supt. of Police Employed…," ibid., November 29, 1932; untitled editorial about death of Chief Charles Briney, ibid., December 3, 1932; "Mayor Will Run Police Department…," ibid., December 7, 1932; "Arthur T. Mahan…Through," ibid., July 11, 1933; "McCloskey Threatens Suspension of Chief Klink," ibid., April 30, 1904.

630. McCloskey believed the Stackhouse and Hillside Park donations were tax deals to benefit Bethlehem Steel but would be bad for the city. Stackhouse Park consisted of steep hills and stream valleys. The coal beneath it had been mined and timbering was forbidden by deed restriction. As it was located outside the city in Westmont, Brownstown Borough and in Lower Yoder Township, McCloskey was opposed to city ownership.

631. "Breach Widens Between Council and Mayor," ibid., December 8, 1932; "…Council Walks Out…," ibid., May 29, 1933; "Council Votes Fund Transfer; Mandamus…Looms," ibid.

632. Daniel Shields and Eddie McCloskey both attended St. John Gualbert's Catholic Church on Clinton Street. They often ushered and took up the collection together. While their respective children were friends with each other, the two remained bitter personal and professional enemies.

633. "Pinchot Calls…," *Johnstown Tribune*, March 4, 1933; "Lehman Acts," ibid.; "Nation Faces…," ibid.; "Bank Holiday," ibid.

634. One might wonder how federal banking authorities could have determined so quickly that the two largest Johnstown banks were in shaky condition. The only explanation would have to do with ongoing bank examinations prior to the state and national bank holidays. Until the crisis had surfaced, examiners must have been reluctant to take aggressive action. "Johnstown Banks Mark Time," *Johnstown Tribune*, March 8, 1933; "Johnstown Banks to Open Two Hours," ibid., March 11, 1933; "Some…Banks…Reopened," ibid., March 15, 1933.

635. "Two Big Banks…Restricted," ibid.; untitled editorial, ibid, March 18, 1933; "Johnstown Banks Resume," ibid.; editorial (no title), ibid., March 20, 1933.

636. "Plans for Reopening U.S. National…," ibid., June 29, 1933; "Continue Plans…U.S. Bank," ibid., June 30, 1933; "Stock Issue of U.S. Bank…," ibid., August 8, 1933; "Trustees Appointed…," ibid., September 11, 1933; "Name John W. Walters…U.S. Bank," ibid., September 14, 1933; "Opening of U.S. Bank Approved," ibid., September 22, 1933; "Open Letter to Our Depositors," ibid.; "Withdrawals…Less Than Deposits," ibid., September 25, 1933.

637. "Five State Banks…," ibid., September 30, 1933; "Title Trust…Liquidated," ibid., November 30, 1933; "Liquidation Process," ibid., December 1, 1933; "Four State Banks…," ibid., January 10, 1934; "Johnstown Bank and Trust…," ibid., June 24, 1934; Johnstown Bank and Trust Co., "History of Johnstown Bank and Trust Co.," (unpublished item in bank's archives, 1983); Gerald Swatsworth, retired bank president and CEO, personal interview, March 20, 2001.

638. "Title Trust Liquidated," *Johnstown Tribune*, November 30, 1933; "Liquidation Process," ibid., December 1, 1933; "Bank Liquidation," editorial, ibid., December 6, 1933; "Mayor to Carry Banking Charge…," ibid., December 7, 1933; "Overflow Crowd," ibid., December 9, 1933; "Appraisal of Title Trust…," ibid., March 5, 1934; "RFC Loan to Title Trust," ibid., August 23, 1934; "Title Trust Checks Go into Mail," ibid., October 15, 1934.

639. "First National Reorganization…," ibid., November 1, 1933; "Four Bank Officials Under Indictment," ibid., November 17, 1933; "New Conservator…," ibid., November 18, 1933; "Further Charges…," ibid., November 21, 1933; "First National Assets…," ibid., December 4, 1933; "Charles McGahan Takes Own Life…," ibid.; "Bank Liquidation," editorial, ibid., December 6, 1933; "Plan…First National…Abandoned," ibid., December 30, 1933; "To Determine Plans of First National," ibid., February 3, 1934; "First National in Receivership," ibid., February 6, 1934; "Correct the Mistake," editorial, ibid., February 8, 1934.

640. Independently of one another, four prominent Johnstowners have advised me that it was widely understood in leadership circles that David Barry had taken his own life.

641. "Bank Depositors Present Demands," *Johnstown Tribune*, February 10, 1934; "Comptroller Punishes Depositors," editorial, ibid., February 13, 1934; "Suggestion to Depositors," editorial, ibid., February 24, 1934; "Cases Against Johnstown Bankers…," ibid., March 12, 1934; "Further Disclosures as Audit…," ibid., March 13, 1934; "Bank Lobby Crowded…," ibid., March 19, 1934; "First National May Make Payment…," ibid., March 21, 1934;

"Former Officers of First National Sued," ibid., March 27, 1934; "First National Appraisal…," ibid., March 29, 1934; "Loan of $4,200,000…Assured," ibid., April 2, 1934; "…Suits, Judgments Filed," ibid., April 5, 1934; "New Investigations…Bank Officers," ibid., April 17, 1934; "5000 Dividend Checks…," ibid., April 24, 1934; "Bankruptcy Suit…Murdock," ibid., May 23, 1924; "Gartland Enters Plea of Guilty to Forgery," ibid., June 12, 1934; "Guilty on All Four Counts…," ibid., June 16, 1934; "David Barry Dead…," ibid., June 21, 1934; "J.M. Murdock Dead…," ibid., July 10, 1934; "Gartland…on Probation," ibid., September 5, 1934; "Stockholders Protest," reader's letter, ibid., October 23, 1934; "Bankers Ordered on Parole," ibid., May 27, 1935; "New Receiver for First National," ibid., December 26, 1935; "Baumer…Future Dividend," ibid., October 28, 1936; "…RFC Loan Paid," ibid., February 13, 1937; "State Secretary of Banking Issues Report…," ibid., April 16, 1937; "Defunct First National Bank to Pay 10 Percent…," ibid., August 24, 1938; "First National Distributing Checks…," ibid., April 24, 1940.

642. Harvey Wish, *Contemporary America: The National Scene since 1900* (New York: Harper, 1955) 449ff., 460.

643. "Won't Give Up the Fight," editorial, *Johnstown Tribune*, August 30, 1933; "Johnstown's Claim to Steel Basing Point Carried to President," ibid., March 17, 1935.

644. "Organization for President's Reemployment Drive…is Officially Launched," ibid., August 9, 1933; "NRA Campaign Opens Monday; Canvas of Homes, Radio Talks," ibid., August 26, 1933; "NRA Code Groups Fold Up Quietly in District Here," ibid., July 25, 1935.

645. "City Will Ask Park Camp…," ibid., October 21, 1933; "Application Made…for Park Camp," ibid., October 26, 1933; "City Officials are Encouraged Over CCC…," ibid., February 21, 1934; "Johnstown Given Park Unit of CCC…," ibid., March 13, 1934.

646. "City Officials Encouraged Over CCC Camp Effort," ibid., February 21, 1934; "CCC Builds Camp in Roxbury Park," April 20, 1934; "New Six-Month Program for Stackhouse Park…," ibid., September 19, 1935; "CCC Camp Workers Convert Rubbish Dump…," ibid., December 31, 1935; "Lawrence Campbell…Hero in Getting Aid of CCC," ibid., March 30, 1936; "CCC Still Needed Here," editorial, ibid., March 16, 1936; "Over 600 Homes Cleaned Up Here by CCC Workers," ibid., March 30, 1936; Miner, *Forging a New Deal*, 32–36.

647. "Efforts to Keep CCC Camp in City Are Unsuccessful," *Johnstown Tribune*, September 21, 1937; "Stackhouse Park Unfinished But CCC Boys Leave," photograph and article, ibid., October 2, 1937.

648. Arthur M. Schlesinger Jr., *Coming of the New Deal: 1933–1935, the Age of Roosevelt*, volume 2 (Boston: Houghton-Mifflin, 1958), 266–71, 277; "Civil Works Project Applications Begin Rolling…," *Johnstown Tribune*, November 24, 1933; "Flood of Civil Works Applications," ibid., November 25, 1933; "Engineers Hit Snag in Preparing…CWA Applications," ibid., December 1, 1933; "Change in…Civil Works Administrator…," ibid., December 22, 1923; "Politics Runs CWA in County…," ibid., January 12, 1934; "1,144 Persons…Get Work Under CWA," ibid., January 17, 1934.

649. "Nearly All LWD Projects Closed Down in County," *Johnstown Tribune*, February 25, 1935; "3500 LWD Employees Dismissed…," ibid., March 1, 1935; "12 LWD Projects Going in County—Employ 304 Men," ibid., March 5, 1935.

650. "City's Isolation Hospital Will Be Dedicated Friday," ibid., June 12, 1935.

651. "City's River Projects are Returned by State as Hardly Warranted," ibid., August 22, 1935.

652. "21 WPA Projects Going With 858 Men Employed…," ibid., September 17, 1935.

653. Many features of the WPA and similar public works relief programs affecting Johnstown in the many months after the 1936 flood are covered elsewhere in this work. The post-flood activities of the WPA and CCC are covered in detail in Chapter 11. "WPA Begins Preparations for Winding Up Cleanup Work…" *Johnstown Tribune*, April 19, 1936; "WPA Flood Force Cut to 300 Men; Near Completion," ibid., April 24, 1936; "City's Big Projects Will Be Revamped at WPA Head's Request," ibid., May 26, 1936; "WPA Workmen Will Be Given Job of Opening Clogged Sewers Here…," ibid., June 15, 1936.

654. "WPA Spends Over $500,000 Under Single Project Here…," *Johnstown Tribune*, May 6, 1937; "Where WPA is Building Big River Wall For City," ibid., September 7, 1937; "Close Up Big WPA Project Under Which Rivers Walls Were Built…," article with photographs, ibid., February 8, 1939.

655. "Eight Projects Filed With WPA By City in 1937," ibid., May 14, 1937; "Accomplishments in Johnstown during 1938," ibid., December 31, 1938; "City Seeks WPA Help in Assembling Data on Delinquent Taxes," ibid., January 23, 1940; "Approval Given to WPA Indexing of Tax Records," ibid., June 18, 1940.

656. "Small Streams Here Cleaned Up, Improved in $170,000 Program," ibid., December 4, 1937.

657. "Mayor Endeavors to Find Solution in Shell Project," ibid., March 30, 1939; "Park Music Pavilion Formally Dedicated…," ibid., June 18, 1940.

658. "Chamber…Directors Reorganize," ibid., May 4, 1934; "William S. Mason…to Head Johnstown Chamber of Commerce," ibid., June 28, 1934.

659. "Definite Steps Taken…New Civic Group," ibid., April 4, 1934; "CCGJ Board…to Advance Local Community," ibid. August 14, 1934.

660. "District Rally of CCGJ…," ibid., February 5, 1935; "CCGJ…67 Different Organizations Affiliate," ibid., February 9, 1935; "CCGJ Divided…For Efficiency," ibid., February 15, 1935.

661. "CCGJ…to Finance Industry," ibid., March 15, 1935.

662. "New Organization…Aid to Industry," ibid., June 22, 1935; "CCGJ Gets Back of Organization for Industries," ibid., June 24, 1935.

663. This data usually represents first-day enrollment. The data should be seen as approximate inasmuch as the counts were constantly changing throughout the year. *Johnstown Tribune*, September 8, 1931; September 15, 1931; September 6, 1932; September 14, 1933; September 5, 1934; September 4, 1935; September 9, 1937; September 7, 1938; September 6, 1939; September 4, 1940.

664. "Cypress Avenue School Project is Underway," ibid., July 8, 1930.

665. "Killius Gives Plans of School Financing in Pre-Term Message," ibid., September 4, 1933.

Chapter 11: The River Strikes Back: The Saint Patrick's Day Flood of 1936

666. For the early background of the river encroachment issue, see the subsection *River Encroachment* in Chapter One, section IV.

667. "Johnstown Defeats B&O," *Johnstown Weekly Democrat*, December 11, 1903.

668. "Another Land Fight," *Johnstown Tribune*, July 12, 1905; "…City Claims Land Upon Which Thomas J. Fearl Seeks to Squat," ibid., July 13, 1905; "Answer is Filed," ibid., March 6, 1906; "Fearl Case to Supreme Court," August 23, 1906.

669. "A Venice at Home," ibid., July 11, 1904.

670. "Streets of City Flooded," *Johnstown Weekly Democrat*, June 8, 1906.

671. "Heavy Rain and Melting Snow Turns City into Vast Lagoon," *Johnstown Tribune*, March 14, 1907; "Crest of Flood Has Passed City," *Johnstown Weekly Democrat*, March 15, 1907; "Something Ought to Be Done," editorial, *Johnstown Tribune*, March 21, 1907; "Says Recent Flood Cost Over $400,000," ibid., April 12, 1907.

672. "Over Mayor Young's Veto," *Johnstown Tribune*, December 4, 1907; "One More River Case is Started," ibid., May 6, 1908.

673. "City Gets a Black Eye in the River Injunction Case," ibid., June 22, 1908.

674. "City Sewer and River Problems Are Treated in Able Fashion," ibid., September 29, 1908.

675. "Retaining Wall is Washed Away," ibid., August 10, 1920; "Council Directs That Stonycreek Be Viewed," ibid., September 14, 1920; "Mayor Obliged to Drop Fight in Fearl Case," ibid., November 18, 1920.

676. "Fine Reception for New Administration," ibid., January 6, 1936; "Highways Slippery Again in Snow, Sleet and Rain," ibid.; "Heavy Snowfall Delays Projects of WPA…," ibid., January 21, 1936; "Roads Drifting Shut Again," ibid., February 18, 1936; Ramon Cooper, "The Flood and the Future: The Story of a Year in City Government at Johnstown, Pennsylvania" (authorized by Johnstown City Council, December 29, 1936), 89.

677. "Colder Weather Expected to Check Rise of the Rivers…," *Johnstown Tribune*, February 25, 1936; "Benscreek Ice Jam…Waters Recede in Colder Weather," ibid., February 28, 1936.

678. "Johnstown Flood Dangers Pass as Ice…Moves Out," ibid., February 26, 1936.

679. "Streams on Rampage," ibid., March 17, 1936. This was the last issue of the *Tribune* published locally for several days.

680. "No Flood Tomorrow, Says Weatherman…," ibid., March 16, 1937.

681. "Lawrence W. Campbell Proved Himself a Hero…," ibid., March 30, 1936.

682. There are a number of reports about river stage elevations and flooding conditions late in the morning and throughout the afternoon of March 17, 1936. There are also a number of inconsistencies. The Poplar Street gauge was washed away, and visual observations of river conditions and elevations during heavy rainfall and high water are unreliable. Also people making observations probably got confused as to exactly what time they had seen what they later reported.

683. Dale H. Custer, "A Document on the Second Johnstown Flood," *Pennsylvania History*, June 1963:347ff.

684. John Shields, personal interviews and conversations, Akers Street, Johnstown, May, June and July 2001.

685. Helen Price, "The Second Johnstown Flood…," *Johnstown Weekly Democrat*, April 6, 1936.

686. "Employees of HOLC Rescue Men Trapped in Trolley," *Johnstown Tribune*, March 26, 1936. A similar account of this rescue is in the Custer article, cited above.

687. "Streams on Rampage," *Johnstown Tribune*, March 17, 1936.

688. "Incline Plane Was Means of…Safety," ibid., April 1, 1936.

689. "Authentic Story of Flood Tragedy…," ibid., April 9, 1936.

690. "Glossers' Store a Haven for 200 During…Flood…," ibid., April 9, 1936.

691. There was no Hickory Street Bridge in 1936. It would eventually replace the Poplar Street Bridge. A short section of Poplar Street, between Franklin Street and the river in Kernville, was later abandoned.

692. "Threat of Dam Scares," *Johnstown Tribune*, March 20, 1926.

693. Army Corps of Engineers, "Flood Control Project for Johnstown, Pennsylvania, Model Investigation Report," (technical memorandum 2-303, November 1943), 12–15.

694. Cooper, "Flood and the Future," 2–4.

695. "Johnstown Already Rising," *Johnstown Tribune*, March 23, 1926.

696. Biographical Sketch of Robert E. Bondy, *Who Was Who in America*, volume 10 (1989–1993) (New Providence, NJ: Marquis Who's Who).

697. "Mayor Shields Delivers Message of Good Cheer By…Radio," ibid., March 25, 1936.

698. Maxwell S. Stewart, "The Second Johnstown Flood," *The Nation*, April 8, 1936.

699. "An Appreciated Service," editorial, *Johnstown Tribune*, March 25, 1936.

700. "Refugee Camps at Daisytown," ibid., March 23, 1936.

701. "Locations Listed of Fuel Centers," ibid., March 24, 1936.

702. American Red Cross, "A History of the Cambria County Chapter of the American Red Cross (1917–1945)," (Johnstown, 1947), 115–24.

703. "Immense Amount of Mud, Debris Removed by WPA," *Johnstown Tribune*, March 24, 1936.

704. "WPA Cleanup Job About Half Done…," ibid., March 28, 1936.

705. "Over 600 Homes Cleaned Up Here By CCC Workers," ibid., March 30, 1936; "Johnstown's CCC Men Will Remain…in Cleaning Up City," ibid., April 3, 1936.

706. "Ferndale Bridge Petition Meeting With Opposition," ibid., April 19, 1936.

707. "Second Year After Flood is Destined to See Bridges Replaced in Local Area," ibid., March 17, 1937; "Year Nineteen Thirty-Seven Proved Bright One in Many Respects For Greater Johnstown District," ibid., January 1, 1938.

708. "Cambria's Operations Same as Before Flood," ibid., April 1, 1936.

709. "Johnstown Already Rising…," ibid., March 23, 1936.

710. "Telephone Companies Are Fast Returning…," ibid., March 24, 1936.

711. "City Stores Resume…," ibid., March 25, 1936.

712. "Three Banks in Johnstown to Resume Tomorrow," ibid., March 23, 1936.

713. "Street Lights On in Two Sections," ibid., March 30, 1936.

714. "Trolley Service Resumed…," ibid., March 30, 1936.

715. "Johnstown Will Be Left on its Own Again…," ibid., March 28, 1936.

716. "Miss Springtime Pays Visit Here," ibid., May 2, 1936.

717. "None Untouched by Johnstown's Great Drama," *Johnstown Weekly Democrat*, April 6, 1936.

718. "Prepare to Ask for Reservoirs, Wider Channels," *Johnstown Tribune*, April 17, 1936; "Major Covell, New District Engineer," ibid.

719. "Fight to Put Johnstown into Flood-Control Bill…," ibid., April 29, 1936; "President's Opposition to Flood-Control Action Not Severe Blow Locally," ibid., May 6, 1936; "Johnstown on 'Map' as Result of Flood Control Conference," ibid., May 19, 1936.

720. "Flood Protection for Local Vicinity Closer to Reality," ibid., August 3, 1936; see also a map in the August 15, 1936 *Tribune*.

721. John Shields, private conversation, July 2001. The account of this sudden detour is also described in a *Tribune* article of August 14, 1936, covering the Roosevelt tour, as though the trip to the new Shields' home were part of the schedule.

722. "Proposed Site of Flood Control Dam is Viewed by President Roosevelt," ibid., August 14, 1936. A number of Johnstowners are of the opinion that FDR spent the night in the Shields' home. This is false. The president spent the night of August 13 on his special train.

723. Army Corps of Engineers, Pittsburgh District, "Report Upon the Proposed Project for the Protection of Johnstown, PA and for Supplementation of the Reservoir System Project for the Protection of Pittsburgh Authorized by the Flood Control Act of 1936." May 1937.

724. After final construction, the Conemaugh Reservoir had a capacity of approximately 270,000 acre-feet.

725. "Army Places Big Stony Creek Dam First on its List," *Johnstown Tribune*, Decmeber 4, 1936; "Local Dam Can Be Ready for Construction Work by Spring, Covell Says," ibid., December 23, 1936.

726. A "project flood" in this report was defined as "the worst condition of flood runoff anticipated—believed to be attainable in the basin…," This was then estimated to be 150,000 cfs below the Point. Estimates of the peak discharge of the 1936 flood vary from 78,000 to 82,000 cfs at the same location.

727. Act Public No. 57, 75th Cong., 1st sess., April 27, 1937, S 1173, Chapter 134.

728. "Seanor Dam Project Not Practical, High Official Discloses," *Johnstown Tribune*, January 29, 1937.

729. "City Officials Ask Dams and Channel Improvements," ibid., May 14, 1937.

730. House Committee on Flood Control, *Hearings on Levees and Flood Walls, Ohio River Basin*, 75th Cong., 1st sess., June 7–11 and June 15–18, 1937.

731. "Army Engineers Study Dam Sites Suggested by State…," *Johnstown Tribune*, January 20, 1938.

732. President Franklin Roosevelt, letter to W.W. Krebs, March 6, 1944. On file at Johnstown Area Heritage Association.

733. Sid A. Weinschenk, "Flood Free Johnstown" (undated brochure, c. late 1943, produced by Flood Free Johnstown Committee); also "It is Now 'Flood Free Johnstown,'" (no author listed, undated item (c. late 1943).

INDEX